EARTH SONGS, MOON DREAMS

PAINTINGS BY AMERICAN INDIAN WOMEN

ALSO BY PATRICIA JANIS BRODER

BRONZES OF THE AMERICAN WEST

HOPI PAINTING: THE WORLD OF THE HOPIS

DEAN CORNWELL: DEAN OF ILLUSTRATORS

GREAT PAINTINGS OF THE OLD AMERICAN WEST

TAOS: A PAINTER'S DREAM

AMERICAN INDIAN PAINTING AND SCULPTURE

THE AMERICAN WEST: THE MODERN VISION

SHADOWS ON GLASS: THE INDIAN WORLD OF BEN WITTICK

EARTH SONGS, MOON DREAMS

PAINTINGS BY AMERICAN INDIAN WOMEN

PATRICIA JANIS BRODER

THOMAS
DUNNE
BOOKS

ST. MARTIN'S PRESS ≈ NEW YORK

THOMAS DUNNE BOOKS.
An imprint of St. Martin's Press.

EARTH SONGS, MOON DREAMS: PAINTINGS BY AMERICAN INDIAN WOMEN. Copyright © 1999 by Patricia Janis Broder. All rights reserved. Printed in Hong Kong. No part of this book may be used or reproduced in any manner whatsoever without written permission except in the case of brief quotations embodied in critical articles or reviews. For information, address St. Martin's Press, 175 Fifth Avenue, New York, N.Y. 10010.

Design by Gretchen Achilles
Page makeup by MM Design 2000, Inc.

Credits and acknowledgments appear on pages 279–284 and 289–290 and constitute a continuation of this copyright page.

Library of Congress Cataloging-in-Publication Data

Broder, Patricia Janis.
 Earth songs, moon dreams: paintings by American Indian women / Patricia Janis Broder.—1st ed.
 p. cm.
 Includes bibliographical references and index.
 ISBN 0-312-20534-1
 1. Indian painting—North America. 2. Indian women artists—Biography. I. Title.
 E98.P23B76 1999
 759.13'089'97—dc21 99-22181
 CIP

First Edition: October 1999

10 9 8 7 6 5 4 3 2 1

FRONTISPIECE.
CAROLINE CORIZ—TESUQUE PUEBLO
TEXTILE PATTERN FROM AN ACOMA POTTERY MOTIF, 1934
26 X 20", TEMPERA ON BOARD
COLLECTION HOWARD AND SUE HUSTON

TO MY HUSBAND, STANLEY

CONTENTS

INTRODUCTION

American Indian women have made an outstanding contribution to America's cultural heritage. They have created a legacy of paintings that offers a unique vision of the Native American world. *Earth Songs, Moon Dreams* will examine this legacy, a treasury of nonritual paintings by American Indian women. The majority of these paintings are by American Indian women who have a strong identity with their ancestors and in their paintings celebrate the history, legends, and the daily and ceremonial lives of their people. Often these artists have given personal interpretations to their histories and legends, interpretations that give their paintings contemporary meaning and vitality. Among contemporary American Indian women, many artists primarily are interested in the aesthetics of painting, while others, inspired by the complex roles of the Native American woman in twentieth-century America, search for an iconography that proclaims a pan-Indian identity. Through painting, these American Indian women achieve a synthesis of tradition and innovation and affirm the continuity of past and present.

An attitude of pride and respect for women pervades the American Indian world and inspires paintings that are visual tributes to generations of American Indian women past, present, and future. In the American Indian world, women are respected and hold positions of honor. Many Native American peoples are matrilineal and matrilocal. Women who bear and raise children are honored for ensuring the continuance of life.

Paintings by Native American women have broadened our vision of the American Indian world. Their legacy of paintings includes subjects generally overlooked by male painters. Whereas male artists focus on the hunt and on the dances of the ceremonial year, American Indian women depict the many chores of daily life that they have performed through the centuries—moving camps, getting water, stripping bark, pounding, grinding, and husking corn, picking chilies, washing wheat, drying hide, and making and selling pottery and craft arts. American Indian women were the first Native American artists to depict the figures in their paintings as individuals rather than as stylized, anonymous images. This interest in the individual culminated in the first examples of portraiture in Indian art. Native American women often have painted genre scenes—mothers with babies and small children, rites of passage such as coming of age ceremonies, weddings, burial and mourning ceremonies, and intimate images of daily life. When Native American women have painted ceremonial dances, they often have selected dances in which women are the primary participants, for example, the dance of the Zuni Olla Maidens and the Delaware Ceremonial Doll Dance. American Indian women have also been inspired to paint events of history featuring female participants; for example, Medicine Women, the great council of Cherokee women, and the women who survived the ordeal of the Trail of Tears.

For centuries, American Indian women have made a major contribution to the artistic legacy of the Native American world. Ritual paintings by women are among the earliest existing two-dimensional art by Native Americans. In the traditional American Indian world, the women of the Great Plains painted geometric designs on clothing, household goods, rawhide artifacts, and ceremonial paraphernalia while men painted figurative images on skins used for tipis, calendars, and winter coats. Historically, American Indian painting was a communal activity, a form of visual prayer focused on achieving universal harmony and the regeneration and sustenance of life. The creation of American Indian paintings was respected as an important ritual in which the painter contributed to the welfare of the people and harmony in the universe. Here was an art distinguished by its vitality and spiritual integrity. Artists were never thought of as individuals with special talents devoted to the creation of independent works of art. Painters won appreciation for making an important contribution to their people and were rewarded with a sense of well-being and inner peace.

The first nonritual American Indian painting can be traced to the second half of the nineteenth century. Nonritual American paintings evolved from contact with the Anglo-European world. Almost every aspect of traditional Native American life on the American continent was changed by the introduction of Anglo-European values and traditions. It was inevitable that American Indian painters, living in a world that was in a continuous state of flux, would develop a sense of identity as artists and would create paintings that were independent works of art. Just as horses, sheep, and European cattle became a fundamental part of life on the American continent, so paper, canvas, and commercial paint became the materials used by American Indian painters. Some American Indian painters proclaimed their cultural identity by retaining the subjects and the techniques of the past, whereas others adopted European techniques to depict their ever-changing world.

In tracing the history of paintings by American Indian women, the first signed works were by Annie Little Warrior and Carrie Cornplanter. Annie Little Warrior used crayon and graphite to complete images of Plains Indian life—ceremonies, buffalo hunts, feasts, and the moving of camp—while Cornplanter painted watercolor images of the daily life of the Seneca People. Tonita Peña (Quah Ah), a self-taught artist, was the first woman to create a visual record of daily and ceremonial life in the Pueblo world. She was a celebrated member of the first generation of painters to win national recognition for her work. Her paintings were included in such landmark events as the annual *Exhibition of the Society of Independents,* organized by John Sloan in 1920; the exhibition at the newly opened Gallery of American Indian Art in New York City in 1922; the *Exposition of Indian Tribal Arts* at the Gallery of American Indian Art in New York City in 1931; and the exhibition *Indian Art in the United States* at the Museum of Modern Art in New York City in 1941.

The first formal art instruction program for American Indian artists began in 1923 when Oscar Jacobson, director of the Art Department of the University of Oklahoma, saw promise in the work of five young Kiowa painters and arranged for Edith Mahier, a professor at the university, to give them instruction and criticism. One of the five was a young woman named Lois Smoky. In 1928 the work of these five artists was exhibited at the International Congress of Folk Arts in Prague, and the following year Jacobson illustrated and discussed their work in the first book on American Indian painting, *Kiowa Indian Art,* published by C. Szwedzicki in Nice, France.

In 1935 Acee Blue Eagle, one of Jacobson's special students in a nondegree program at the University of Oklahoma, became the director of the new Art Department of the Bacone College, an institution founded in 1880 in Muskogee, Oklahoma, by missionaries as an institution of higher education with the goal of providing a Christian education for American Indians. Marian Terasaz, a Comanche woman, was one of Blue Eagle's first students. Blue Eagle and his successors, Woody Crumbo, Dick West, and Chief Terry Saul, inspired an outstanding number of American Indian women to make a major contribution to this nation's legacy of American Indian art. Among the outstanding artists who studied at Bacone College were Marlene Mary Riding In, Ruthe Blalock Jones, Joan Hill, Mary C. Young, Sharron Ahtone Harjo, Mary Adair, Diane O'Leary, Jeanne Walker Rorex, and Joan Brown.

In 1932 Dorothy Dunn founded the Studio, the fine arts program at the Santa Fe Indian School. The school offered classes in design, arts, and crafts, including beadwork, silversmithing, weaving, woodwork, and embroidery. Forty students, aged fifteen to twenty-two, were enrolled in painting classes. Nine of the women attending these painting classes were considered to be "special art students," women who were expected to become teachers. The forty students who were enrolled in painting classes were encouraged to depict the ceremonies and daily rituals of their people and to use as the basic components of compositions the ancient icons and plant, animal, and weather abstractions that Dunn believed were Indian prototypes. These forms were both decorative and symbolic. Dunn's sanctioned style of painting required unmodulated areas of color outlined by a dark tone. The students used plain paper for the background of their work. The five years during which Dunn directed the Studio served as the formative years for many young women who developed into accomplished traditional artists. A partial list of these painters includes Pablita Velarde, Lorencita Bird Atencio, Eva Mirabel, Tonita Lujan, Merina Lujan (Pop Chalee), Margaret Lujan, Eileen Lesarlley, Marcelina Herrera, Caroline Coriz, Lolita Torivio, Agnes Bird, Rufina Vigil,

Eloisa Bernal, Cipriana Romero, Sybil Yazzie, and Geronima Cruz Montoya. Although in the years following their training at the Studio, many talented women did not continue to paint, artists like Pablita Velarde, Eva Mirabel, Merina Lujan (Pop Chalee), and Geronima Montoya credit the Dunn years as the training ground for a successful career.

In the course of the twentieth century, many artists broke with tradition and turned to European modernism to express a more contemporary vision of Indian America. During the summers of 1959, 1960, 1961, and 1962, the Rockefeller Foundation sponsored the Southwest Indian Project directed by Lloyd Kiva New at the University of Arizona. Among the participants were Jimmie Carole Fife Stewart, Mary Morez, and Helen Hardin. The success of the Southwest Indian Project led to the establishment of the Institute of American Indian Arts on the premises of the old Indian School in Santa Fe. In 1962, under the direction of Lloyd Kiva New, the I.A.I.A. initiated a program in which students learned to use the materials and techniques of twentieth-century modern art to express a personal vision of the American Indian world, a vision based on their knowledge of their heritage and an understanding of the contemporary world. Many women are among the institute's outstanding graduates. The following I.A.I.A. artists are featured in this book: Maxine Gachupin, Jeanette Katoney, Lucille Hyeoma, Otellie Loloma (teacher), Linda Lomahaftewa (student and teacher), Gina Gray, Sharon Burnette, Alice Loiselle, Evelyn Teton, Peggy Deam, Yvonne Thomas, Laurie Houseman-Whitehawk, Judy Mike, Anita Luttrell, Connie Red Star, Charlene Teters (student and teacher), and Phyllis Fife.

The work of American Indian women has always been an important part of exhibitions of American Indian paintings. In 1946 Eva Mirabel entered her work in the *First National Exhibition of American Indian Painting,* presented by the Southwestern Art Association at the Philbrook Museum of Art in Tulsa, Oklahoma. In 1953 paintings by American Indian women were included in the exhibition *Contemporary American Indian Painting* at the National Gallery of Art in Washington, D.C., an exhibition of student work selected by Dorothy Dunn. In 1980 an exhibition sponsored by the Indian Arts and Crafts Board of the Department of the Interior, *Four Native American Women Artists' Conceptual Art,* was presented at the Southern Plains Indian Museum in Anadarko, Oklahoma. This exhibition focused on the work of Kay WalkingStick, Emmi Whitehorse, Lois Sonkiss Brill, and Jaune Quick-to-See Smith. In 1981 many Native American women were participants in *The Night of the First Americans* at the Kennedy Center in Washington, D.C., and in 1984 the work of eight Oklahoma women was featured in the traveling exhibition *Daughters of the Earth.* In 1985 the exhibition *Women of Sweetgrass, Cedar, and Sage* was presented at the American Indian Community House in New York City. In 1986 the Navajo Tribal Museum in Windowrock, Arizona, presented *A Salute to Navajo Women in the Arts,* an exhibition featuring paintings by Mary Morez, Michelle Tsosie Naranjo, and Emmi Whitehorse.

Throughout the years women have always been among the winners of the major annual painting competitions at the Philbrook Art Center, the Gallup Ceremonial, the Santa Fe Indian Market, and the Red Earth Competition in Oklahoma City.

Earth Songs, Moon Dreams is neither an encyclopedia nor a directory of American Indian women painters. I have selected artists and paintings for their cultural, historical, and aesthetic merit. I have included artists from a wide variety of American Indian cultures: women whose work has been inspired by the cultures of the Eastern Woodlands, Indian Territory (Oklahoma), the Great Plains, the pueblos of Arizona and New Mexico, California, the Northwest Coast, and the Arctic. I have selected artists whose work represents different periods of American Indian painting—self-taught artists, Indian School artists, contemporary traditional artists, and contemporary modern artists. There are paintings of historical interest and paintings depicting legends that are part of the artist's cultural heritage. I have included paintings of important religious ceremonies, rites of passage, and a wide variety of the rituals of daily life, including rituals of the past and those that are still part of the American Indian world. There are paintings depicting women at work as well as images of domestic and social life.

I have interviewed and corresponded with forty of the artists whose work is included in this book. Whenever possible, I have used their own words to describe their lives and art. I have included women who have tremendous differences in background and beliefs. Some come from rural backgrounds with limited formal schooling while others are university pro-

fessors. Some have great pride in the success of their forebears who assimilated and won recognition for their achievements in mainstream America, whereas others remember that their ancestors were conquered, their cultures destroyed or inevitably changed. These artists are saddened and angered by the histories of their peoples and have created paintings that are political statements focusing on the problems of the American Indian in historic and contemporary America.

This is the first book devoted to paintings by Native American women. Although I have selected ninety artists representing fifty-seven indigenous American cultures, it still is not possible for this book to be truly comprehensive and include all of the many creative painters and the multiple dimensions of Native American painting.[1] I hope that this book will serve as an introduction to this heretofore overlooked subject.

Patricia Janis Broder
September 1998

EARTH SONGS, MOON DREAMS

PAINTINGS BY AMERICAN INDIAN WOMEN

ANNIE LITTLE WARRIOR

Plains

✸

CEREMONY

Annie Little Warrior's *Ceremony* is one of the earliest images of Plains Indian life by an American Indian woman. This painting depicts a ritual dance in a Plains Indian camp. Only women are in attendance at this ceremony. Although the participants in the ritual—the dancers and the drummers— all are men, over forty women form a large square around the dancers. Annie Little Warrior must have documented a ceremony attended by the Women's Society. In all four directions, at the outer edges of the painting are tipis. Women in ceremonial long dresses and shawls stand by the tipis and walk toward the ceremonial square. A large American flag is planted inside the square proclaiming that the scene is set in the postcontact world that Annie Little Warrior knew.

In the center of the square, a chorus of four male singers sits around a large drum which they play to accompany their singing. Two of the dancers carry tomahawks, while another carries a war club and the fourth rolls a hoop. As the war club, the tomahawk, and hoop (the hoop is the symbol of the universe and God's eternal rule) are carried by performers in the War Dance, it is probable that Annie Little Warrior has painted a War Dance in which the women are praying for the success of men in warfare. It also is probable that this is a Cheyenne ceremony, for only Cheyenne men wore headdresses with the feathers extending straight upward.

Annie Little Warrior's work shows considerable sophistication, as she is able to portray the women from all four sides and the men dancing and seated around the drum. All figures are identical in size, and although their costumes are unique, the figures have no individual features. It is clear that Annie Little Warrior wished to document the daily and ritual life of her people in a world that was rapidly changing. Her work includes scenes of both contemporary life and past days— social gatherings, a feast, a buffalo hunt, and women leading horses with a travois. Historically in Plains Indian society, women's painting was limited to decorative design; here is a clear break with tradition.

1. *CEREMONY*
20 X 25", GRAPHITE AND CRAYON ON PAPER
PHOTOGRAPH COURTESY OF THE NATIONAL MUSEUM OF THE AMERICAN INDIAN,
SMITHSONIAN INSTITUTION (251114)

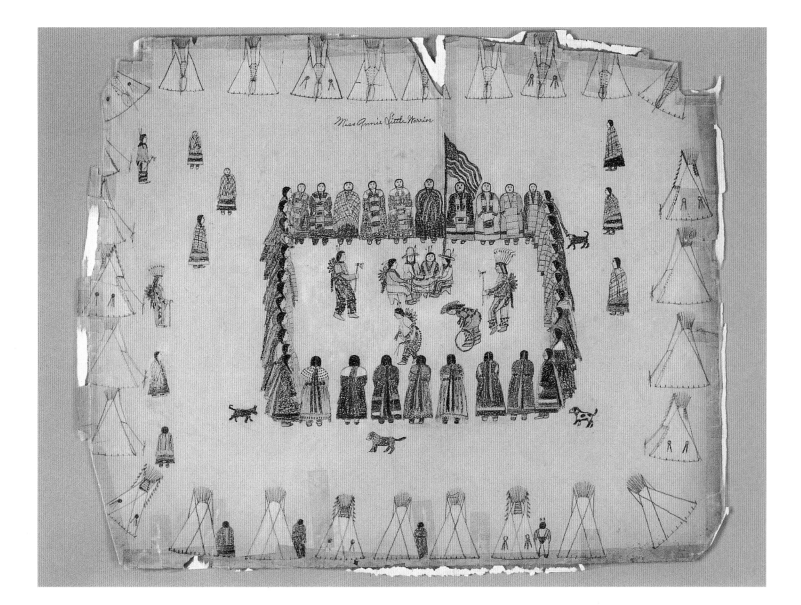

※

TRAVOIS—MOVING CAMP

Annie Little Warrior chose as the subject of this painting the movement of a Plains Indian camp using travois. Centuries after the Spanish introduced the wheel to the Plains Indians, these migratory people continued to use the travois as their principal means of transporting possessions from one location to another.

The travois is an A-shaped rack, built of two poles far enough apart at one end to attach an animal that would drag across the ground whatever was attached to the opposite end. Before the Spanish introduced the horse to the American Indian, the narrow end of the travois was attached to the collar of a dog. As dogs could drag only about fifty pounds, the adoption of horsepower gave the Plains Indians the ability to haul larger loads great distances. Thanks to the horse-drawn travois, the Plains Indians could have larger tipis, as tipi poles could be lashed together to form the frame of a travois.

In Plains Indian society, it was the responsibility of the women to move the children and all family possessions. It was women's job to bundle and unpack all personal belongings, plus tipi covers and buffalo robes, as well as to lash and unlash the travois. Women had the ability to take down and put up tipis in only a few minutes.

Annie Little Warrior has painted a procession of six horse-drawn travois. Although all of the horses are saddled, four of the six women are on foot leading the horses. One woman rides a horse and uses a lead line to guide an attached horse that is dragging a travois. Her daughter is seated on the travois horse. Another woman rides a travois-hauling horse, her daughter walking behind. The rider's legs are close to the horse's side so that the travois poles cover her legs. In the top left of Little Warrior's work, a brave and his son, followed by a dog, lead the procession, while two braves leaning on staffs follow behind. Although the braves wear the traditional Plains Indian dress, including feathers atop their heads, one carries a gun, which underlines this European contribution to the Plains Indian world.

The women wear traditional long dresses and moccasins and their hair is in braids. All of Little Warrior's images are two-dimensional and the figures all are in profile. Following the tradition of Plains Indian skin painting, there is neither background, foreground, nor landscape elements. There is no indication of location, season, or time of day. Among the Indian figures, men are the largest and children the smallest. Little Warrior carefully selected the poses of women and the horses, and she suggested motion by the positions of their feet.

Annie Little Warrior's name is at the bottom of the painting, written in a script that suggests someone with more sophisticated writing skills may have added the name. The acknowledgment of an individual artist is a tradition brought to the Indian world by the white man. In traditional Plains Indian society, those with artistic skills drew images or painted as an anonymous contribution to their people. The Plains Indian women traditionally used their skill to decorate domestic and ritual objects; there is no record of an individual recognized as an artist. As the signature is a prominent part of Little Warrior's artistic creation, it is evident that her identity as an artist had considerable significance. The signature reads: "Miss Annie Little Warrior," a European classification of this Plains Indian woman.

2. TRAVOIS—MOVING CAMP
12³⁄₈ X 19⁷⁄₈", GRAPHITE AND CRAYON ON PAPER
PHOTOGRAPH COURTESY OF THE NATIONAL MUSEUM OF THE AMERICAN INDIAN,
SMITHSONIAN INSTITUTION (251116)

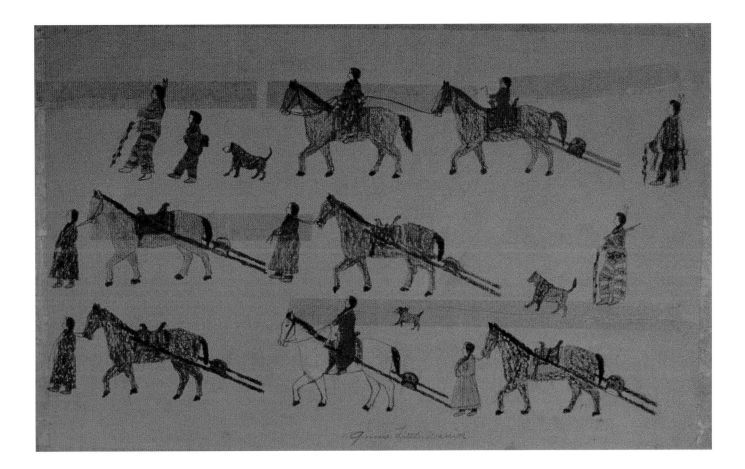

INDIAN WOMAN POUNDING CORN

The watercolor paintings of Carrie Cornplanter are among the earliest known representations of traditional Native American life by an American Indian woman. Cornplanter, a young Seneca woman, was born in the 1880s. She is the older sister of Jesse Cornplanter, a Seneca author, illustrator, and painter as well as an important member of the Seneca community. He was chief of New Town, a village of the Snipe Clan; Ritual Chief of the Longhouse; and head singer of such major Seneca ceremonials as the Great Feather Dance. Carrie and Jesse were the last descendants of the Seneca leader, Cornplanter, who achieved renown in the days of George Washington.

In the traditional Seneca world, women occupied positions of great importance. Women owned the houses, fields, and crops, and all property, titles, and rights passed through the female line. All clans were divided into lineages. A lineage was a core of mothers, sisters, and daughters who comprised a "Longhouse family." Each Seneca village was a cluster of one hundred Longhouses. A matron, an older woman admired for her qualities of leadership and diplomacy, was the head of each lineage. Men held all official positions in the tribal government. Although they were the tribal chiefs, or sachems, women maintained control of the government because the matrons of each lineage chose the sachems, evaluated them, and, on occasion, warned the sachems of their errors. If necessary, the matrons asked the council to dispose of an unsatisfactory sachem, and when a sachem died, they selected his successor.

Among the primary duties of the matron was the coordination of the economic activities of the female members of her clan. Matrons organized and directed the women's work in the field and determined their contribution of food to public festivals and to charity. Traditionally, Seneca men cleared the land, while women prepared the land for planting, planted, cared for, then harvested the crops, and cooked the harvested food. Women also controlled the distribution of cooked food. Men never asked for food. When a husband

returned home, regardless of the hour, his wife set a predetermined meal in front of him.

In precontact days, men provided food from the hunt and fishing, while women cultivated the fields and provided food collected in the wild. However, during times of war and during the period following white settlement in Seneca territory, the Seneca men concentrated on trapping and bartering beaver pelts for guns and ammunition. This change resulted in a shortage of game, which upset the balance of food production. Women, therefore, had to increase food cultivation.

The primary crops cultivated by Seneca women were corn or maize, squash, and beans. In years of prosperity, surplus crops were divided and stored for future use. Cornmeal was the primary ingredient of most Seneca cooking. Women's important contribution in providing food for the Seneca people was ritualized and celebrated in song and dance at the Green Corn and the Harvest Festivals.

In *Indian Woman Pounding Corn,* Carrie Cornplanter has painted an all-important chore of Seneca women, the production of cornmeal. Cornplanter depicts the traditional method of using a dumbbell-shaped pestle and a vertical log mortar to pound the corn. Cornplanter's woman stands next to a fire over which a pot is suspended. Although this work is not dated, Carrie Cornplanter completed the majority of her paintings in the period from the last decade of the nineteenth century to the first decade of the twentieth century.

Cornplanter's painting gives the viewer a glimpse of her Seneca community, the Cattaraugus Reservation. On the left, in the distance, is a Seneca log house and a woman pounding corn in front of the house. Over the horizon a coming storm gives the women a sense of urgency in completing their work. Cornplanter included a Seneca brave striding into the area where a woman is working. It is interesting to compare his naked-to-the-waist dress, which includes feathers in his hair, with the woman's Victorian costume, a dark ankle-length dress with long sleeves and a ribbon tying back her hair.

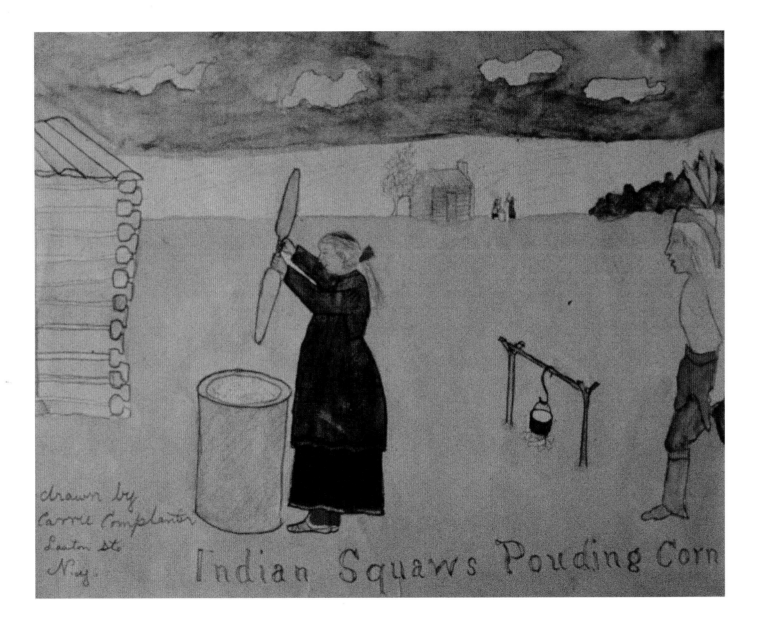

Within the image: "drawn by / Carrie Complanter / Laiton St. / N.y." and "Indian Squaws Pouding Corn"

3. *INDIAN WOMAN POUNDING CORN*

7⁷/₈ X 9⁷/₈", GRAPHITE AND WATERCOLOR ON PAPER

PHOTOGRAPH COURTESY OF THE NATIONAL MUSEUM OF THE AMERICAN INDIAN,

SMITHSONIAN INSTITUTION (112914)

LOIS SMOKY (1907-1981)

✸

KIOWA FAMILY

Lois Smoky was truly a pioneer American painter. One of the first Indian women to participate in a formal art education program, Smoky was one of five Kiowa artists featured in *Kiowa Indian Art,* the first book on American Indian painting. She also was a participant in the first nationwide museum tour focused on American Indian paintings. Born in 1907 near Anadarko, Oklahoma, Smoky was the descendant of generations of hunters and craft artists. She was the grand-niece of A'paitan, the last chief of the Kiowas.

Smoky was first encouraged to paint by Susie Peters, field matron at the St. Michael's Mission School in Anadarko. Peters, who taught many young Kiowa art students, believed that her protégés deserved training that she couldn't provide. She showed examples of their work to Oscar Jacobson, director of the art department at the University of Oklahoma, who recognized talent in Lois Smoky's work, as well as in the work of four other young Kiowas, Stephen Mopope, Monroe Tsa Toke, Jack Hokeah, and Spencer Asah. In 1923 he arranged for Edith Mahier, a professor of art at the University of Oklahoma, to give them instruction and criticism. Following Jacobson's instructions, Mahier encouraged them to "use no models, but draw from the memory of what they have seen and heard at the firesides and in the tipis of their camps."[1] The five young Kiowa artists lived in a large house near the university, which Smoky's parents rented for them.

In 1928 the paintings of the Five Kiowas won acclaim as the most interesting part of the American entry at the International Congress of Folk Arts in Prague. The following year, Jacobson authored a book on Kiowa painting, *Kiowa Indian Art.* This book, which included a folio of thirty-two full-sized color reproductions of paintings by the Five Kiowas, was published by C. Szwedzicki in Nice, France. Following publication of his book, Jacobson arranged for the exhibition and sale of paintings by the Five Kiowas in art museums across the United States and in Hawaii. In 1950, Jacobson wrote a second book and folio of American Indian paintings, *American Indian Painters,* which included the work of major American Indian painters from across the United States. Lois Smoky's painting *Mother and Babe* was included in the 1950 edition. In his preface to this book, Jacobson wrote of the Five Kiowas:

> The truly modern phase of modern Indian art began with the Kiowas, who are Plains Indians. They were the first to be able to develop their art without losing the essential elements of their tradition. They enriched it with a personal expression; they breathed life into the rigid and impassive figures of the past. They possess an extraordinary natural flair for color and for composition.[2]

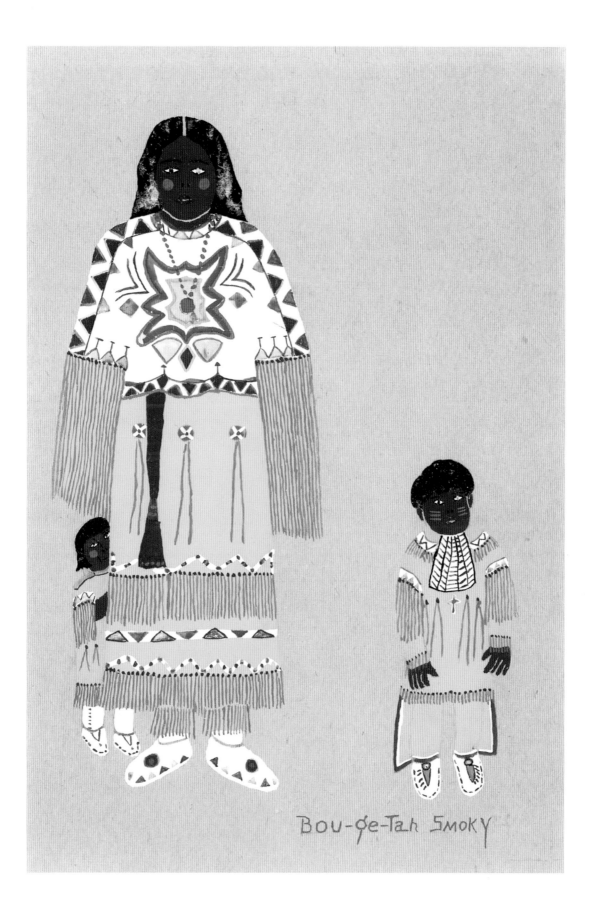

Bou-ge-Tah Smoky

LOIS SMOKY (1907–1981)

Bou-ge-tah (Coming of the Dawn) ♦ Kiowa

❈

LULLABY

Traditionally, in the Plains Indian world, narrative painting was the domain of men, who painted figurative images on tipis and on skins which served as historical narratives, calendars, and winter counts. Women painted symbolic designs on crafts and clothing. For centuries craft arts and clothing were the domain of the Kiowa female. Lois Smoky was the first Kiowa woman to cross this historical barrier and follow a path of individual creativity. She again broke with tradition by becoming a participant in the Jacobson group of Five Kiowas. She was the first Plains Indian woman to work as a professional painter, exhibiting and selling her work at museums and local shops.

From the start, her male colleagues did not accept Smoky. Jacobson recalls:

> While the first five Kiowas were in the university, there was noticeably, among the men, a certain resentment toward Lois for participating in such an unlady-like activity. The resentment found expression in several, small, unkind annoyances to her, even to the extent of mutilating her work.[1]

Smoky worked with the Kiowa group for only a year before yielding to cultural and personal pressures. Her place in the Kiowa group was taken by James Auchiah. Smoky married, raised a family, and stopped painting.

During Smoky's lifetime, she completely lost her identity as a painter. For decades, the group known as the Five Kiowas was thought to be five men. Smoky was indeed one of the original Five Kiowas as documented by Jacobson. It is her work, not that of James Auchiah, that was published in Jacobson's 1929 volume, *Kiowa Indian Art*. In recent years, the work of Smoky has been rediscovered and rightfully appreciated. She now has taken her rightful place as the pioneer mother of Plains Indian painting.

During her brief artistic career, Smoky's favorite subject was the Kiowa mother and child. She came from a family in which generations of women had been celebrated for their skill in beadwork. In *Lullaby,* Smoky painted detailed images of the beautiful Kiowa beadwork of the cradleboard, the moccasins, and the mother's traditional two-piece buckskin dress, which is also distinguished by elegant beadwork.

5. *LULLABY*

9 X 6¹/₄", TEMPERA ON PAPER

COLLECTION THE THOMAS GILCREASE INSTITUTE OF AMERICAN HISTORY AND ART, TULSA

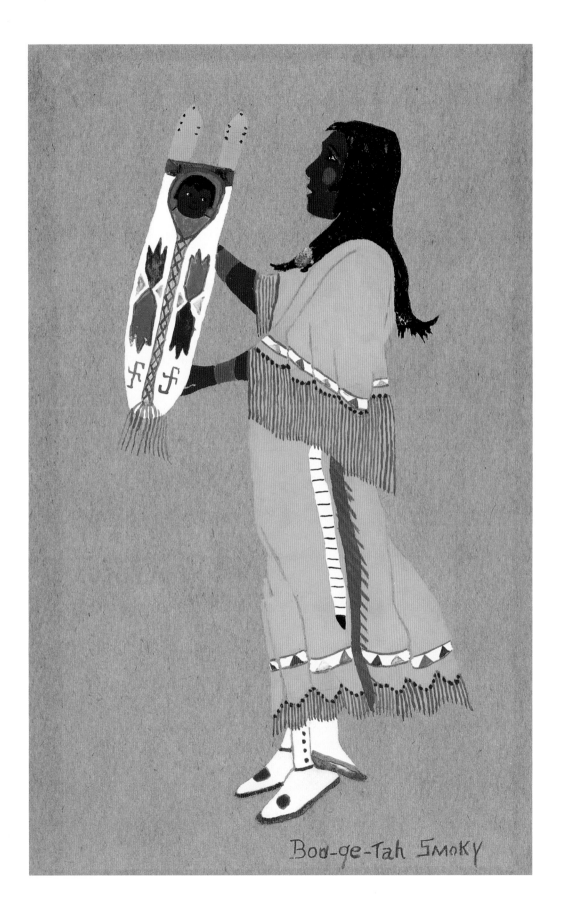

Boo-ge-Tah Smoky

TONITA PEÑA (1893–1949)

Quah Ah (White Coral Beads) ♦ San Ildefonso Pueblo

❋

PREPARING BLUE CORN, ca. 1930

Tonita Peña was the first woman from a Rio Grande Pueblo to paint the daily and ceremonial life of her people. Born in 1893 at the San Ildefonso Pueblo to Vigil and Navidad Peña, she was baptized Maria Antonia Peña. The third of four children, young Tonita attended the San Ildefonso Day School from 1899 until 1905. There, at age eight, she first was introduced to painting when an innovative teacher, Esther B. Hoyt, gave her students wax crayons and suggested that, since they all participated in Pueblo dances, they should think of dancing and recreate their thoughts in color.

One day a visitor to the day school, Dr. Edgar Hewett, a professor of archeology at the University of New Mexico and director of the School of American Research in Santa Fe, admired the crayon drawings of young Tonita Peña, furnished her with watercolors and papers, and encouraged her to paint the events of daily life at the pueblo. Her first watercolor images included women making and painting pottery, winnowing wheat, grinding corn, and dancing on feast days. Years later, Tonita Peña told artist Pablita Velarde: "I drew little figures and he liked them so I drew lots of them. I painted pictures of everything I could think of. I don't know what he did with them, but anyway he paid me money for them and kept me in paint and paper."[1]

When Tonita was twelve years old, following the deaths of her mother and sister, her father decided to send her to Cochiti to live with her aunt and uncle, Martina Vigil and Florentino Montoya. In 1895 Maria Martinez, the renowned San Ildefonso potter, praised Martina Vigil, calling her the finest of present-day potters. Florentino Montoya won fame as a painter of pottery. The move was difficult for Tonita because she was away from her home and lifelong friends and because the people at Cochiti spoke Keres, a language different from the Tewa language spoken at the San Ildefonso Pueblo. As she adapted to life at a pueblo with new customs and rituals, she learned pottery making from her aunt, pottery painting from her uncle, and she continued to find joy in narrative painting. Many years later, her son, the artist Joe Herrera, remembered his mother telling him that whenever she included images of pottery in her paintings, they were copies of pots she had made and decorated.

For a short time, Tonita Peña attended St. Catherine's Indian School in Santa Fe; however, in 1908, when she was fourteen years old, her aunt and uncle called her back to Cochiti, for they had arranged for her to marry Juan Rosario Chavez. A year later she gave birth to a daughter and three years later a son. That year, her husband died and Tonita returned to her studies at St. Catherine's. The following year, however, her aunt and uncle arranged for Tonita to marry Filipe Herrera, and in 1920, the couple had a son, Joe. Later that same year, Filipe was killed in an accident at the iron mines where he worked.

All during the years of childbearing and tragic marriages, Tonita remained a protégée of Edgar Hewett, who encouraged her to continue painting and purchased the majority of her work for the art museum in Santa Fe. When Dr. Hewett died, Dr. Kenneth Chapman, an authority on Pueblo pottery decoration, offered support to the young painter.

In 1922, at age twenty-nine, Tonita Peña married Epitacio Arquero, a farmer who raised chilies, squash, corn, and beans and who held many important tribal offices at the Cochiti Pueblo. In 1940, 1943, 1944, and 1951 (two years after Tonita's death), he served as governor of the Pueblo. Although she had painted Pueblo ceremonies throughout her career, during her husband's terms as governor, Tonita Peña was accused of betraying tribal secrets. Arquero was forced to defend his wife's ceremonial paintings by explaining that she only depicted dances that could be seen by any tourist. After Tonita Peña's death in 1949, her husband collected all of her personal possessions and her paintings and placed them in an old shed and burned the building and its contents.

By this time, Tonita Peña was a well-known and highly successful artist whose work was exhibited in several muse-

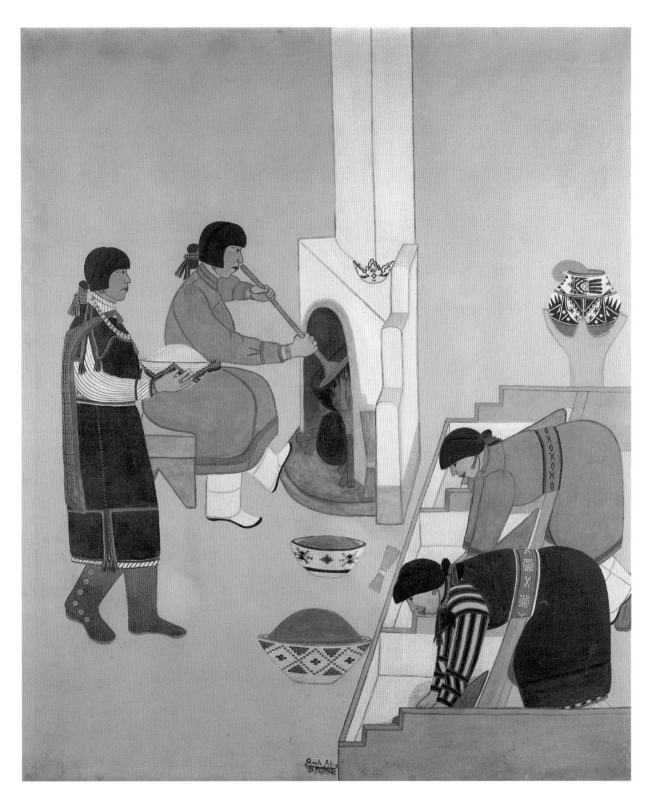

6. PREPARING BLUE CORN, ca. 1930

73 X 60", INDIA INK AND OIL ON CANVAS, COLLECTION HOWARD AND SUE HUSTON

PHOTOGRAPH BY JOHN BIGELOW TAYLOR, NEW YORK

ums and known to galleries and collectors across the Southwest. Always interested in encouraging the young, Tonita Peña had taught art at both the Santa Fe Indian School and at the Albuquerque Indian School. For many years, Tonita Peña and Pablita Velarde would display and sell their work under the portal at the Palace of the Governors in Santa Fe. Pablita Velarde recalled, "I never could understand how Tonita could have all those children, run a home, help her husband with crops, and still have time to do so many paintings."[2] Young Pablita Velarde looked to Tonita Peña as a role model, recalling, "She was the only Indian woman I knew or heard of when I was young, and she helped me to paint."[3]

During her lifetime Tonita Peña completed many murals. In the 1930s she joined a group of Pueblo artists commissioned to complete a series of murals for the dining hall of the Santa Fe Indian School. Her mural, *Preparing Blue Corn,* depicts two women grinding corn, a woman carrying a ceremonial basket of cornmeal, and a woman tending fire in the *horno* (a Pueblo oven), where a pot of cornmeal is cooking. Throughout her life, Tonita Peña was an active participant in every stage of corn preparation—planting, tending, and harvesting the corn, roasting, shucking, grinding, and finally cooking traditional dishes with Pueblo corn.

TONITA PEÑA (1893–1949)

Quah Ah (White Coral Beads) ♦ San Ildefonso Pueblo

✹

BIG GAME ANIMAL DANCE, ca. 1925

During the fall and winter months, the Pueblo People believe that the earth is sleeping. After the crops have been harvested, it is time for hunting and the celebration of hunting rituals. Historically, the Indian people hunted only to obtain the necessities of life. Hunting for sport and the needless killing of animals was unknown in the Pueblo world. Individuals were not permitted to hunt alone and when a hunting party returned, every part of the kill—flesh, bones, skin, even internal organs—was utilized. Today, dancers representing buffalo, curly horned mountain sheep, mountain goats, antelope, deer, and elk are focal participants in the Big Game Animal Dance, a visual prayer for a successful hunting season.

Many years ago, before the mass destruction of the buffalo herds, the buffalo hunt was the most important ritual hunt. The buffalo provided the Indian people with food, clothing, shelter, tools, and fuel. The Pueblo People believed that the buffalo was a medicine animal, possessing powers to carry away sickness and to influence snowfall and temperature. Although buffalo hunting belongs to the past, buffalo dancers still are participants in the Big Game Animal Dances, which are among the most colorful and spectacular Pueblo ritual ceremonies. Traditionally, at least one dancer impersonates the Buffalo Mother who is the mother of all game. The Buffalo Bull dances with a step that is heavier than the lighter and more feminine tread of the Buffalo Mother.

Tonita Peña included buffalo, antelope, longhorn sheep, and deer in her painting *Big Game Animal Dance*. She carefully depicted the headdress of each animal dancer. The buffalo headdress is made of horn and rawhide as well as buffalo fleece. The headdresses of the longhorn sheep, antelope, and deer include the actual horns of these animals. Prayer feathers are attached to all of these headdresses. Many of the animal dancers lean on sticks, simulating the motion of these four-legged animals.

Big Game Animal Dance has many of the characteristics that distinguish Tonita Peña's best work. In the painting she has included a group of four drummers and a large chorus, all highly realistic representations of participants of this dance. Tonita Peña achieves a sense of realism because the drummer and chorus are individualized, each with a different dress and facial expression. Their steps are lively and the mouths of the singers are open. The dancers appear to be in motion and there is a feeling of liveliness and animation as they respond to the music of the drummers and chorus. As Tonita Peña truly loved color, this is a highly colorful painting. Both the chorus and the group of drummers include women because Tonita Peña wished to depict the important role of women in Pueblo life.

Following the tenets of traditional Indian painting, Tonita Peña does not use a ground line or background images, nor does she achieve a sense of distance by the diminution of figures. Although the dancers are two-dimensional, she achieves the appearance of three dimensions by placing the dancers, chorus, and drummers in a variety of diagonal lines.

Tonita Peña was often a participant in Pueblo ritual dances. In 1933 Ina Sizer Cassidy wrote of the artist:

I have watched Tonita Peña of Cochiti . . . with watercolors and virgin paper, absorbed in materializing her concept of the ceremonial dances and I have watched her plastering the walls of her *adobe* home, small palms outspread smoothing the velvety brown mud over the surface with care and creative concentration.

I have also watched her in the ceremonial dances in the plaza, her consecrated hands waving evergreen wands, rhymthically keeping time to the measured beat of the drum, and the tread of her bare feet on the hot earth, and there is in all of these

activities the same creative aesthetic quality which had made her one of the outstanding Indian painters of New Mexico and I believe the only Indian woman to attain distinction in this newly revived expression.[1]

Big Game Animal Dance was first purchased by Margretta Dietrich, one of the first patrons of American Indian painting. Dietrich purchased many of Tonita Peña's early watercolors, and in time, her collection of American Indian paintings was considered among the world's finest.

EARTH SONGS, MOON DREAMS

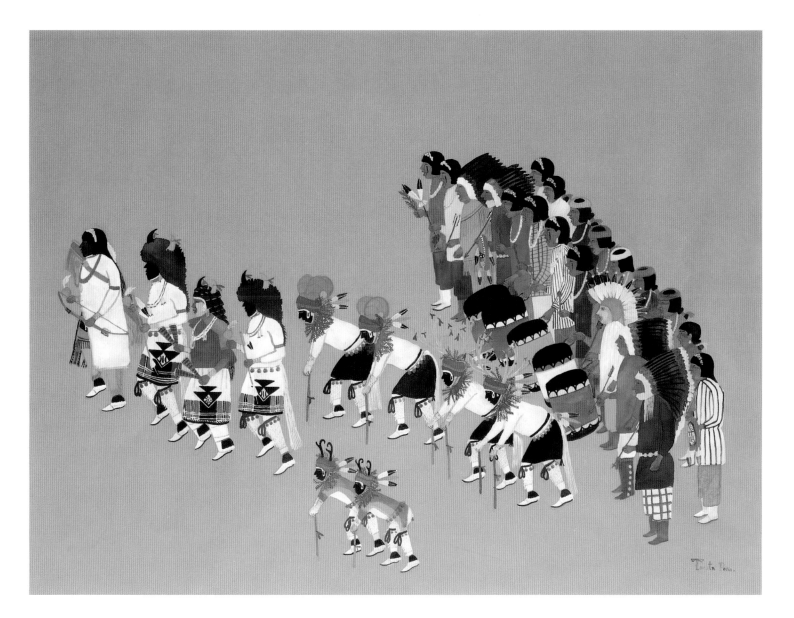

7. *BIG GAME ANIMAL DANCE*, ca. 1925
22 X 29³/₄", WATERCOLOR ON PAPER
COLLECTION HOWARD AND SUE HUSTON

TONITA PEÑA (1893–1949)

Quah Ah (White Coral Beads) ✦ San Ildefonso Pueblo

✦

CEREMONIAL DANCE

Ceremonial Dance is a vibrant watercolor that captures the beauty and energy of the Green Corn or Tablita Dance at a Rio Grande pueblo. Not only was Tonita Peña the first woman to create a visual record of life at the Rio Grande pueblos, but she was also a pioneer in focusing on the important role women played in Pueblo ceremonies.

In *Ceremonial Dance,* Tonita Peña depicts a ritual dance that is a visual prayer for spring rains and for the germination of the seeds that will produce an abundant corn crop. This dance features two *moieties* (divisions of the Pueblo People): The squash or pumpkin, which is a *moietie* of the summer people, and the turquoise, which is a *moietie* of the winter people, alternately dance from sunrise to sunset. In *Ceremonial Dance,* Tonita Peña depicts a moment when the squash-pumpkin people are dancing. The dancers thank the rain-bringing spirits for sending lightning, clouds, and fog, gifts of nature promising rain that will nurture the growing corn crop.

Tonita Peña focuses on two lines of participants, six men and six women. The men wear traditional Pueblo dance kilts and atop their heads are the softest feathers from the breasts of birds, which symbolize the Breath of Life. The women, who dance barefoot, wear yellow *tablitas* (squash-colored headdresses) which are in the shape of terraced clouds, symbols of rain. The women wear the traditional black woven *mantas* and rain sashes.

A group of singers performs in a circle next to the dancers. In front of the chorus, a drummer provides a rhythmic beat. The dancers, chorus, and drummers all wear sprigs of evergreen, which are symbols of growth and everlasting life. The participants in the chorus and the drummer wear colored shirts and trousers that are split at the ankles, indicating the Spanish influence on Pueblo dress.

The ceremonial leader, waving a long pole, a sun symbol, over the dancers, performs a ritual of purification and blessing. Atop the ceremonial pole are eagle feathers, which are symbols of power; parrot feathers, which are symbols of rain; a fox tail, a reminder that the Pueblo People believe that long ago men had tails like their animal ancestors; and a gourd, which contains secret seeds to ensure fertility and survival in the Pueblo world.

In Tonita Peña's paintings, the drummer is always portrayed with accuracy of design and careful detail. Her third husband, Epitacio, was admired as one of the finest drum makers at the Cochiti Pueblo. The Cochiti drum is a two-headed cylindrical drum made from hollow sections of a cottonwood log. The drum in this painting, which features regular lacing over a natural wooden side, is a Cochiti drum. Behind the drummer is the Koshare, or clown, whose body is painted with black-and-white stripes and whose face is whitened with sacred cornmeal. He is a priest whose role is as "delight maker," and his subtle gestures and actions have great symbolic importance.

Dorothy Dunn, in *American Indian Painting of the Southwest and Plains Areas,* pays tribute to Tonita Peña's watercolors of ceremonial dancers:

> Quah Ah's ceremonials conform to established patterns and yet they lack the impersonal, formal approach usually observed in ceremonial painting. Her dancers are conventional and yet they are very living people. Her singers sing the most lustily of any in Indian paintings. The heavy women dance lightly on their toes, the drummers beat powerful rhythms from the big resonant drums and the staff bearer sways his weighty emblem of fructification over the heads of the dancers. Her Koshare appear not as spirits but as men disguised as spirits. There can be no exception in Quah Ah's paintings but only straightforward, simple representation which amounts to realistic illusion in its own way.[1]

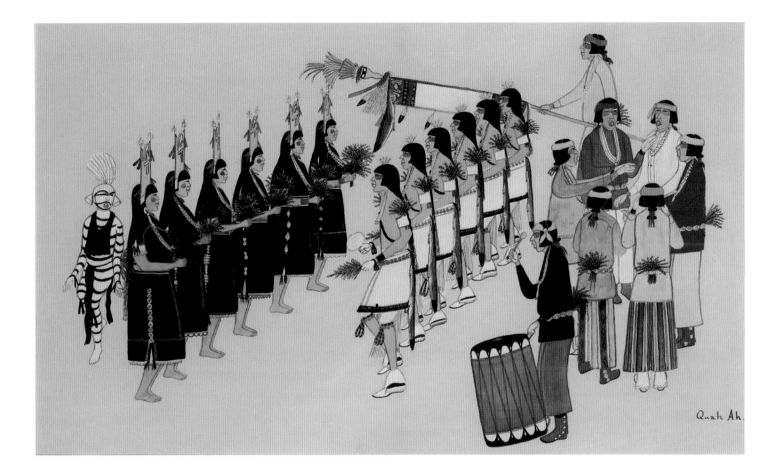

8. *CEREMONIAL DANCE*

14 X 22¹/₂", WATERCOLOR ON PAPER

COLLECTION R. C. CLINE LAND CO., INC., AMARILLO

EVA MIRABEL (1920–1967)

Eah-Ha-Wa (Green Corn) ♦ Taos Pueblo

⊛

PICKING WILD BERRIES, 1940

Picking Wild Berries was one of Eva Mirabel's most admired paintings. Mirabel submitted this painting to a competition at the Museum of New Mexico and won the Margretta S. Dietrich Award. In 1953 Dorothy Dunn chose this painting to be included in the exhibition *Contemporary American Indian Painting* at the National Gallery at Washington, D.C.

Eva Mirabel was born in 1920 at the Taos Pueblo and was educated at the Santa Fe Indian School where she was a favorite pupil of Dorothy Dunn, the director of art education. Dunn wrote in praise of her protégée: "Eva Mirabel (Eah-Ha-Wa) had the ability to translate everyday events into scenes of warmth and semi-naturalistic beauty."[1] In 1946 Mirabel was the only woman to enter the *First National Exhibition of Indian Painting* at the Philbrook Museum of Art in Tulsa, Oklahoma. Her entry was a painting of a Pueblo drummer. Over the years, her paintings were a feature of exhibitions at the Gilcrease Museum, the Philbrook Museum of Art, and the Museum of Northern Arizona.

A versatile painter, Mirabel portrayed vegetal forms, forests, animals, and, above all, the inhabitants of the Taos Pueblo as they pursued the activities of daily and ceremonial life. She also enjoyed success as a muralist, completing commissions for murals at the Santa Fe Indian School, the Veterans' Hospital and Library in Albuquerque, the Arkansas Valley Park in Pueblo, Colorado, and the Pittsburgh Planetarium.

Mirabel excelled at creating highly decorative images based on visual reality. In *Picking Wild Berries,* she used warm, subtle colors, delicately detailed patterns, and skilled brushwork to create a glowing tribute to a routine chore. Mirabel always paid close attention to all decorative details, such as the patterns of the berry-pickers' dresses.

Traditionally, at the Taos Pueblo, women picked fruits like tomatillo, which were boiled and ground into a paste and eaten with clay. Juniper, a favorite berry, was first heated in a pan and then eaten. Some small berries were picked and eaten raw. Mirabel's imagery—her imaginative portrayal of the leaves of the berry bushes and the summer trees and the needles of the tall pines—helped to transform this painting of the traditional ritual of the daily life at the Pueblo into a decorative tapestry that is both realistic and imaginative.

9. *PICKING WILD BERRIES,* 1940
17 X 22", TEMPERA ON PAPER
COLLECTION HOWARD AND SUE HUSTON

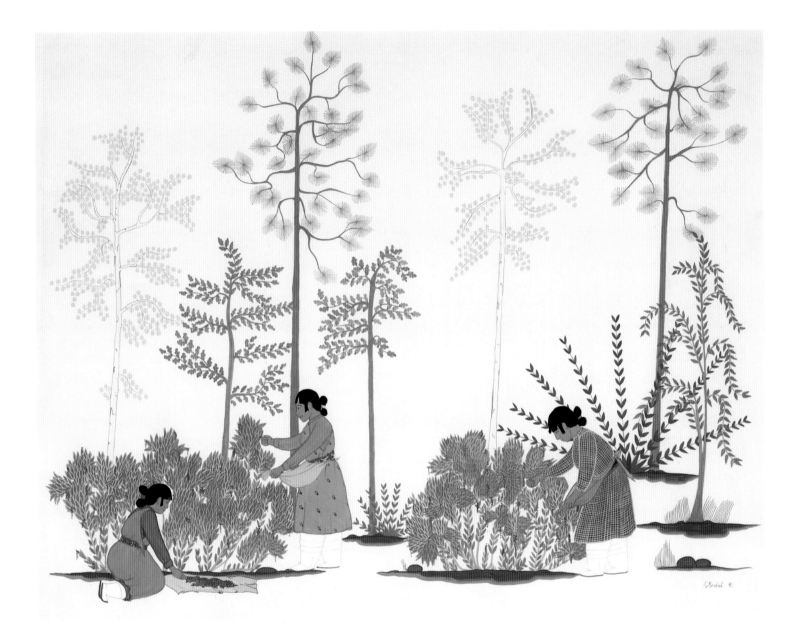

EVA MIRABEL (1920–1967)

Eah-Ha-Wa (Green Corn) ♦ Taos Pueblo

TAOS WOMAN CARRYING BREAD, 1958

During her lifetime, Eva Mirabel had the opportunity to travel and experience life in different parts of the United States. During World War II, when she served as a member of the Women's Army Corps, she retained her identity as an artist, painting a series of murals for the army. Following her discharge from service, she spent a year at Southern Illinois University in Carbondale, studying and teaching as artist-in-residence.

After spending several years away from her people, Mirabel chose to study at the Taos Valley Art School in 1949. She returned to the Taos Pueblo where she lived for the remainder of her life. She was an active participant in Pueblo communal life and a frequent participant in ritual dances. During these years, Mirabel completed a series of paintings of individuals participating in the traditional rituals of daily life at the pueblo. These paintings are among the first portraits of individuals by an American Indian artist. Dunn described Mirabel as "an unintentional portraitist, achieving character with a few deft lines."[1]

Unlike the generic figures of traditional Indian painting,

Mirabel's image of a young woman carrying bread is of an individual with distinct facial features and expression. The bread carrier wears traditional Pueblo dress, including a brightly colored wool shawl, turquoise beads, and white buckskin boots. Her hair is cut in the style traditionally worn by young married women. Mirabel paid close attention to realistic detail, such as the woven design on the breadbasket and on the colorful rain sash.

Mirabel painted in the sanctioned style of the Dunn Studio—flat, unmodulated areas of color, defined by darker outlines. The bread carrier steps forward, a woman of action, but in the Dunn tradition there are no painted background images or details, only the plain paper.

Mirabel chose to paint the woman carrying bread because through the centuries, consuming, baking, and trading bread had been an essential part of Taos life. At the great Taos trading fair, which was a meeting place of the Plains and Pueblo people, the baked bread of the Pueblo was the favorite food of the Plains people who were nomadic herders and had no tradition of baking.

10. *TAOS WOMAN CARRYING BREAD*, 1958
6¼ X 5", TEMPERA ON PAPER
PRIVATE COLLECTION

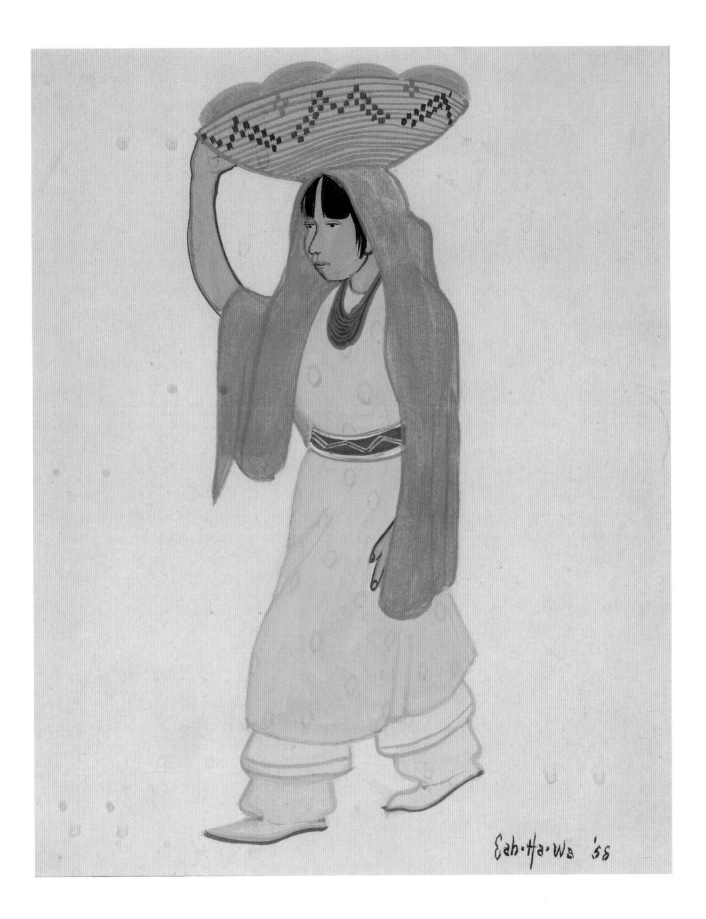

EVA MIRABEL (1920-1967)

Eah-Ha-Wa (Green Corn) ♦ Taos Pueblo

❋

WASHING WHEAT

In *Washing Wheat* Eva Mirabel has painted the final stage in the cultivation and production of grain, the basic ingredient in the bread which for centuries at the Taos Pueblo was a primary trade item with the Plains Indians and with the Navajo. Each year, the harvest fairs at the Taos Pueblo were important economic and social events. Until the 1930s wheat and corn were the principal crops of the Taos Pueblo; however, after the agriculture crisis of the 1920s and the revolution in transportation technology, wheat farming no longer was a major part of the Taos economy. Since that time, a small amount of wheat continues to be cultivated and some bread still is traded.

Wheat, as well as the method for cultivation, was originally brought to the North American continent by the Spanish. At harvest time, wheat was cut by hand using a sickle. The men then cleared and fenced off a space and watered down the ground until it became hard. Then, in the center of the clearing, they made a pile of the cut wheat, which was held in place by a center pole. The men next stood on top of this pile of wheat and pitchforked it down into the area surrounding the pile. Finally they drove horses and goats around the fenced-in area so that the strong tread of the horses's hooves and the goats's feet would force the grain kernels from the husks.

The Taos women would separate all remaining grain from the husks by gently shaking a basket filled with husks, then hand-tossing the mixture from the basket so that the lighter husks flew away and the grain remained in the basket. Then, using a loosely woven basket as a sieve, they washed the grain at the edge of the stream that runs through the Pueblo. In Mirabel's painting, a woman kneels by the Taos Pueblo stream to wash the newly threshed wheat in her basket. A second Taos woman, with a full basket of wheat on her head, approaches, about to join the first woman in washing the wheat.

Mirabel, in her painting, followed the tenets of Dorothy Dunn's sanctioned style as taught at the Studio. She has painted flat areas of color outlined by a darker tone, her colorful forms standing in contrast to the unpainted white background. She includes cattails and another variety of greenery that grows by Taos streams. The women wear *mantas* and white deerskin leggings, the traditional dress that historically was worn for daily activities at the Pueblo. Mirabel's painting is one of delicacy and grace, a poetic tribute to a labor that once was a central part of Taos Pueblo life.

11. *WASHING WHEAT*

14 5/8 X 15", TEMPERA ON PAPER

COLLECTION THE THOMAS GILCREASE INSTITUTE OF AMERICAN HISTORY AND ART, TULSA

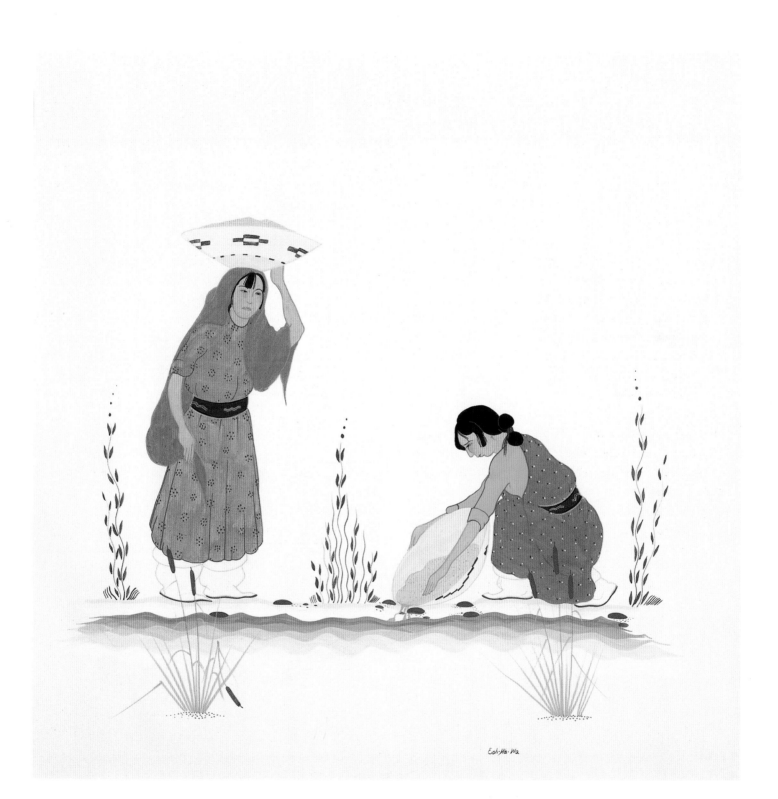

Eah-Ha-Wa

TONITA LUJAN

Khup Khu ♦ Taos Pueblo

※

TAOS WOMEN HUSKING CORN, 1934

In *Taos Women Husking Corn,* Tonita Lujan has painted a traditional task of Pueblo women. Lujan's painting includes six women wearing brightly colored dresses and husking the newly harvested crop. In the front center of the painting are examples of the yellow, red, black, and blue corn already husked. Four women are seated, husking the corn. The stripped husks lie in huge piles behind these women, and the great pile of corn yet to be husked is in the center of the painting. Behind this unhusked corn, a young woman offers a selection of different colored corn to an older woman. These are the best ears which will be laid aside for seed. Some husks and stems are left on them, so that the husks can be braided and the ears hung up to dry. The harvested ears of corn will be spread out to dry on the roofs of the Pueblo houses. During the winter, the women will sort the dry corn and throw away any moldy ears and then, if necessary, continue to dry the corn. Corn Dances, ritual prayers for the germination and growth of the corn and for an abundant harvest, are an important part of Taos ceremonial life.

Educated at the Santa Fe Indian School, Tonita Lujan was a student of Dorothy Dunn at the Studio. Following the Studio style, she painted two-dimensional forms with no background. Dunn encouraged her pupils to sell their paintings so that they might understand the possibility of financial reward for their artistic efforts. *Taos Women Husking Corn* was purchased by the avid collector and generous patron of the Studio Margretta Dietrich. In 1936 Tonita Lujan married the Kiowa painter George Keabone and the couple had two sons. There is no record of Lujan's painting after the late 1930s.

12. *TAOS WOMEN HUSKING CORN,* 1934
13¹/₄ X 10¹/₈", TEMPERA ON PAPER
COLLECTION DOROTHY DUNN KRAMER
PHOTOGRAPH COURTESY OF MUSEUM OF INDIAN ARTS AND
CULTURE/LABORATORY OF ANTHROPOLOGY, SANTA FE (51385/13)
PHOTOGRAPH BY BLAIR CLARK

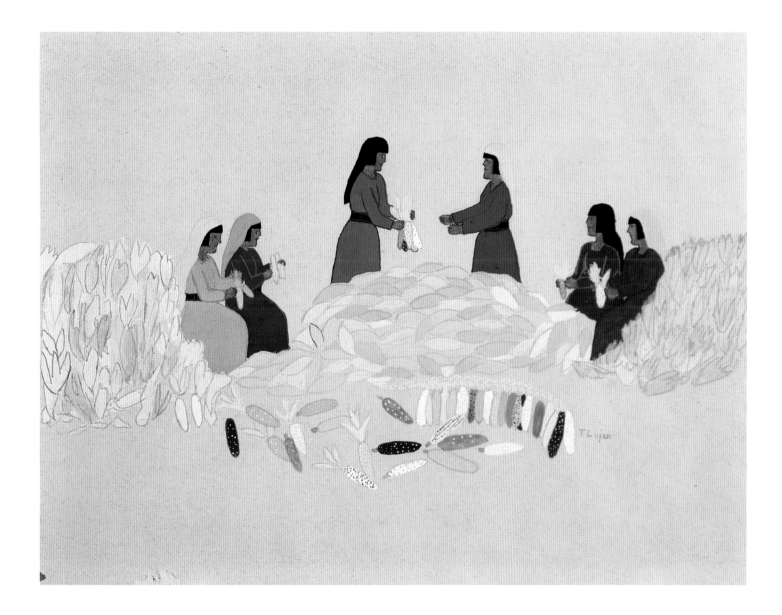

MERINA LUJAN (1908–1993)

POP CHALEE (Blue Flower) ♦ Taos Pueblo

❈

THE FOREST, 1936

Pop Chalee in *The Forest* celebrates the animals—deer, squirrels, porcupine, coyote—brightly colored butterflies, birds, rushing streams, and colorful seasonal foliage of the forest that covered the mountains north of the Taos Pueblo. One of Dorothy Dunn's prized students, Pop Chalee created unique tempera tapestries of the woodlands, a personal tribute to the wonders of the natural world which are an integral part of Taos Pueblo life. Dunn wrote of Pop Chalee's work:

> Pop Chalee does a forest fantasy where little animals frisk about beneath mythical trees. It is pure invention and decoration done with lively, delicate grace, combining something exotic—perhaps the small stylized details of India, her mother's homeland—with the balanced composition so traditionally Pueblo.[1]

This painting offers a glimpse into a fantasy world, a world of fragile beauty filled with agile animals, brightly colored birds, and butterflies, and delicate patterns of filigree branches and leaves.

Pop Chalee had Asian, European, and American Indian family roots. Her mother was the daughter of Frederick Ludenberg, a well-known European sculptor who was a colonel in the Swiss army, and an East Indian mother who met the colonel when her family was vacationing in the Swiss Alps. Pop Chalee's mother was a small child when her parents settled in Taos. When she came of age, she married Joseph Cruz Lujan, a Taos Indian who was the interpreter for John Collier. Their daughter, Pop Chalee, was born in Castle Gate, Utah.

While still a small child, Pop Chalee was sent to her father's family in Taos, where she was raised by her grandfather and participated in the rituals of traditional Pueblo ceremonial life. As Pop Chalee matured, she attended the Santa Fe Indian School, where she received her first formal art education in Dorothy Dunn's classes. At sixteen, she married Otis Hopkins, an instructor at the school.

Pop Chalee was the niece of Tony Lujan, a Taos man who is remembered as the fourth husband of Mabel Dodge (1879-1962), who endeavored to transform the small desert community of Taos into a cultural oasis. Among her visitors were Leo Stein, D. H. Lawrence, Paul Strand, Carl Jung, Leopold Stokowski, Marsden Hartley, John Marin, and Georgia O'Keeffe. During the 1920s and 1930s, thanks to Dodge's vision, many outstanding avant-garde artists created some of their best work in New Mexico.

Mabel Dodge also played a major role in the life of Pop Chalee, for she encouraged the young Taos girl, who already was married and the mother of two small children, to reenter Dunn's classes and devote time to her painting. Unlike many American Indian women who ceased to paint following marriage and children, Pop Chalee continued to paint throughout her life. In 1936 Pop Chalee wrote of the goals of the Studio:

> Our work is flat and simple, leaving things out that are not important, but making a beautiful picture. We do all our paintings by memory, using simple things that happened in our lives. By painting our ceremonial dances, hunts, and home life, and making designs of them, we preserve our tribal culture, recording it in pictures filled with beauty and imagination.[2]

In 1990 Pop Chalee was chosen to receive the Governor's Award for Excellence and Achievement in the Arts. At the time of her award, Pop Chalee wrote of her art:

> Watercolors are the medium of my people. . . . Watercolors are natural to work with. They are clean and fresh. I balance all my work. I learned as a child about the rhythms and values of my culture and have applied that to my paintings. But whatever I paint I try to paint what is in my heart.[3]

EARTH SONGS, MOON DREAMS

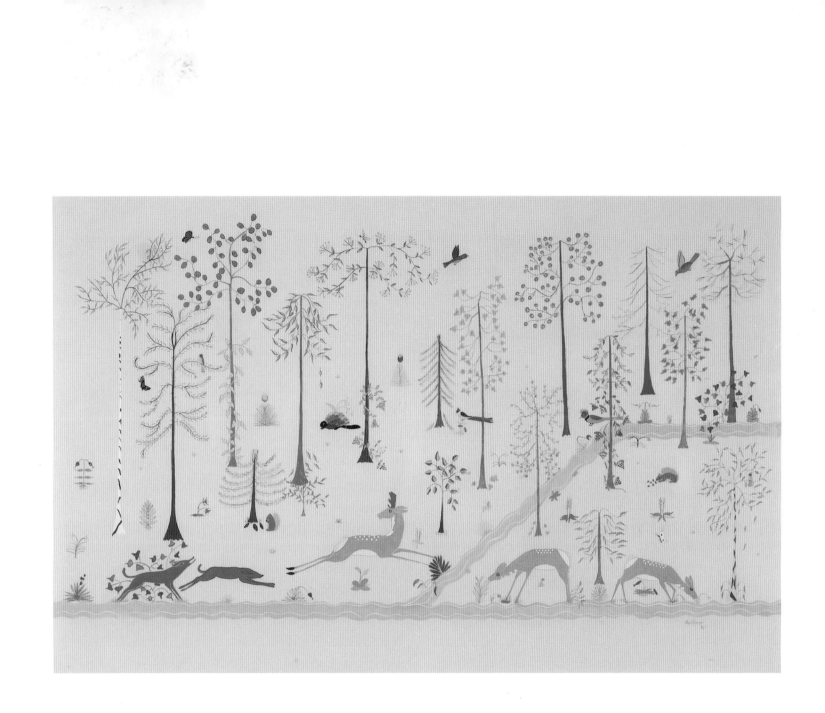

13. *THE FOREST*, 1936

13⁷/₈ X 21³/₄", TEMPERA GOUACHE ON PAPER

PRIVATE COLLECTION

MERINA LUJAN (1908-1993)

POP CHALEE (Blue Flower) ♦ Taos Pueblo

☀

FOREST SCENE

Pop Chalee's paintings of the sacred world of the Taos forests are a unique blend of her imagination and the inspirational beauty of the trees and animals of the New Mexico woodlands. To the north of the Taos Pueblo are the forests, mountains, and sacred Blue Lake which for centuries have been an important part of life at the Taos Pueblo. The forest is a sanctuary for wildlife and a source of firewood and building materials for the pueblo. Sacred Blue Lake is the primary source of pueblo water. In 1970 forty-eight thousand acres of mountain and forest land, including Blue Lake, were returned to the Taos Pueblo by an act of Congress.

Pop Chalee's work expresses her fundamental belief in the role of nature in her art:

> The art of all people living close to nature expresses in varying degrees their yearning towards spiritual expression. The art of ancient Egypt had its own peculiar forms, forms derived from the physical characteristics of the land and lives affected by the land in their struggle for existence.
>
> It is the same with the art of the American Indians. Theirs is an art that depicts animals and the forces of nature. In my own work I endeavor to capture through two-dimensional forms the grace and beauty of the things that I love, things that I have known until they have become a part of my subconscious. And I find that these elements of nature, whether animate or inanimate, lend themselves to a purity of design and form that does not need the embellishments of contemporary civilization to give them a sense of life.[1]

Pop Chalee is one of the few American Indian artists to celebrate the wonders of night in the natural world. Following the Dunn tradition of painting watercolor images on plain, colored paper which serves as the background, Pop Chalee used black paper to create a fantastic portrait of her nocturnal visions of the forest. Idealized deer, bear, squirrels, rabbits, and skunks frolic or simply enjoy life in this Pueblo Eden. Birds and butterflies provide colorful accents in a tapestry of night. Flowers, shrubs, and stylized trees—both curvaceous fir trees and trees with delicate, leafy branches—are the primary wonders of a fantastic world that is the unique product of Pop Chalee's imagination.

A member of the Native American Church, Pop Chalee recalled, in 1990, the ecstatic experience of a religious ritual that inspired her to use black paper to depict night in the pueblo forest:

> I went to a peyote meeting and I saw colors I didn't know were in this world. I saw colors in their pure, pure form, beautiful clean colors. Since then I've sometimes painted on black paper because I can get my colors to really stand out. A lot of people are afraid of colors, but I am not because I love them. I live with colors in my paintings.[2]

Because Pop Chalee often paints stylized deer frolicking in the forest, she has been called a "Bambi painter." It is conceivable, however, that the work of the young Taos artist served as an inspiration for Bambi. In 1936 Pop Chalee exhibited her woodland fantasies at Stanford University. Disney did not begin sketches for Bambi until 1937 and the film was not released until 1941.

Pop Chalee had a rich and productive life devoted to the arts. A lifelong advocate of Native American education and the rights of the Native American people, she hosted a radio series. In 1947 in a traditional Navajo ceremony, Pop Chalee married Ed Lee Natay, the son of a Medicine Man and Navajo leader. His field of expertise was American Indian songs and chants.

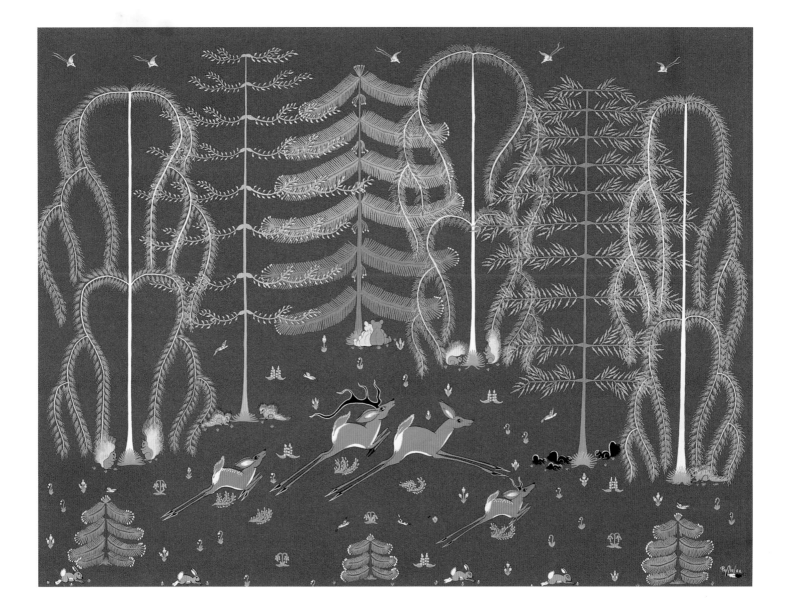

14. *FOREST SCENE*

19¹/₄ X 25", TEMPERA GOUACHE ON PAPER

COLLECTION THE THOMAS GILCREASE INSTITUTE OF AMERICAN HISTORY AND ART, TULSA

ELOISA BERNAL

Taos Pueblo

TAOS RAGGED FEATHER DANCE, 1938

Eloisa Bernal painted *Taos Ragged Feather Dance* in 1938 while she was still a student of Dorothy Dunn and Geronima Montoya at the Studio, the art school of the Santa Fe Indian School. The previous October, she had exhibited her work at the *American Indian Exposition and Congress* in Tulsa, Oklahoma. In her painting, Bernal focused on daily and ceremonial life at the Taos Pueblo. The Taos Ragged Feather Dance is a social dance that is usually held in the spring. This dance offers the young people of the pueblo the opportunity to forget the problems and tensions of winter. It is a day of relaxation and a chance for the young men and women to socialize as they join in the dance.

Indian people have lived in the Taos Valley since about 900 A.D. and at the Taos Pueblo since the mid-fourteenth century. Annually, the Taos Valley was the location of a great trading fair, a meeting place of the Plains and Pueblo People. Each year, Ute, Apache, Commanche, and Navajo met to exchange goods. Because the Taos Pueblo was the site of this annual meeting of Plains and Pueblo People, it is the pueblo most influenced by the Plains culture in dress style, secular dances, and music.

Bernal in this painting documents a social ritual, the Ragged Feather Dance, in which the dress of the dancers shows the influence of the Plains Indian People. The men wear the feathered headdresses and bustles of the Plains Indian People. Bernal has included such details as the beaded collars, the sashes, and the colorful tassels of the women's dresses. The Taos women wear moccasins rather than the deerskin leggings of traditional Pueblo dancers and their hair is divided and tied by bows. The women carry arrows and bunches of feathers, and the men carry staffs with feathers tied to the end. The long, brightly colored dresses of the women are unlike any worn at Pueblo social dances.

15. *TAOS RAGGED FEATHER DANCE,* 1938
9³/₈ X 13⁵/₈", TEMPERA ON PAPER
PRIVATE COLLECTION

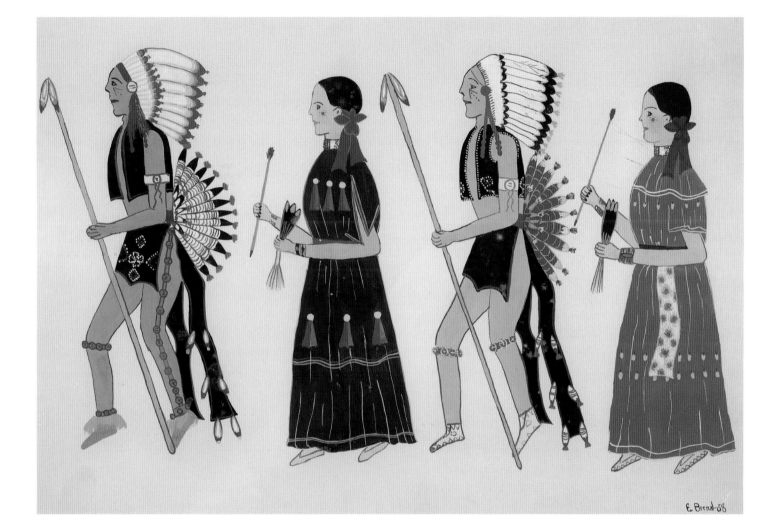

E. Bernal-58

MARGARET LUJAN (b.1928)

Taos Pueblo

✸

TAOS GIRL, 1945

In 1945 Margaret Lujan, a young woman from the Taos Pueblo, painted *Taos Girl,* a watercolor representation of a young married woman. In this historically accurate image of a Pueblo woman, Lujan, a student of Geronima Montoya at the Studio, followed the artistic principles of Dorothy Dunn.

Traditionally at the Taos Pueblo, the focus of a woman's life was marriage and family. Girls married young, often as early as thirteen or fourteen years old. The hairstyle—cut bangs and a chignon bun at the nape of her neck—as well as the dress—a ceremonial shawl and whitened deerskin boots—indicate that Lujan's image is of a married woman. (Only married women wear these deerskin boots; unmarried girls wear moccasins.)

Girls learn from childhood that one of their primary roles in Pueblo life is providing food for their families. For centuries, women have gathered the fruits of wild plants that grow in the vicinity of the pueblo and traditionally spend many hours working to transform the harvested corn into cornmeal, a primary ingredient in Taos Pueblo cooking. They use the flat roofs of the pueblo buildings to dry corn and cure jerky, strips of deer meat that the hunters have brought to the pueblo. At the Taos Pueblo, women build the beehive ovens and bake the renowned Taos bread.

Historically, at the Taos Pueblo, women have been cast in supporting roles. Men occupy all positions of leadership in both sacred and secular activities. When, in the 1850s, boarding schools were established by the federal government, Taos Pueblo leaders determined that only boys could attend. During these years only one boy per family was permitted to go away to boarding school, for male labor was required at the pueblo. Girls from the Taos Pueblo were first permitted a boarding school education in 1900.

For decades boarding school offered the only educational opportunities for Taos Pueblo children. When eventually a regional school was established for the Taos Pueblo children, it only provided instruction through the third grade. It was not until 1924 that a new school building was completed which permitted Pueblo children to have further education without leaving the community. Because boys were expected to work in the fields with their fathers, by 1925 girls made up the majority of students in the upper classes of the new local school. These educated girls were the first to object to the custom of forced participation in a lakeside ceremonial dance that took place in late August each year. All unmarried girls and childless women were expected to submit to this ceremony in the mountains.

Lujan in her work followed the Dunn principle of accuracy in detail. Her work is distinguished by her knowledge of Pueblo dress, such as the traditionally folded boots of the Taos girl. The upper parts of these boots have ample deerskin, which is folded and can be unfolded and attached to the sides, offering protection to the horseback rider. Her work exemplifies the Studio's style of unmodulated areas of color outlined by a dark tone. The plain white paper serves as a background.

Margaret Lujan showed an independent sophistication and knowledge of three dimensions in her painting. The pose of the woman gives a sense of movement and space. Lujan provided the woman with specific features which make her an individual, not a two-dimensional stereotypical figure or an icon of the Taos Pueblo.

16. *TAOS GIRL, 1945*
10^1/$_2$ X 6^1/$_2$", WATERCOLOR ON PAPER
PHOTOGRAPH COURTESY OF THE NATIONAL MUSEUM OF THE AMERICAN INDIAN,
SMITHSONIAN INSTITUTION (236018)

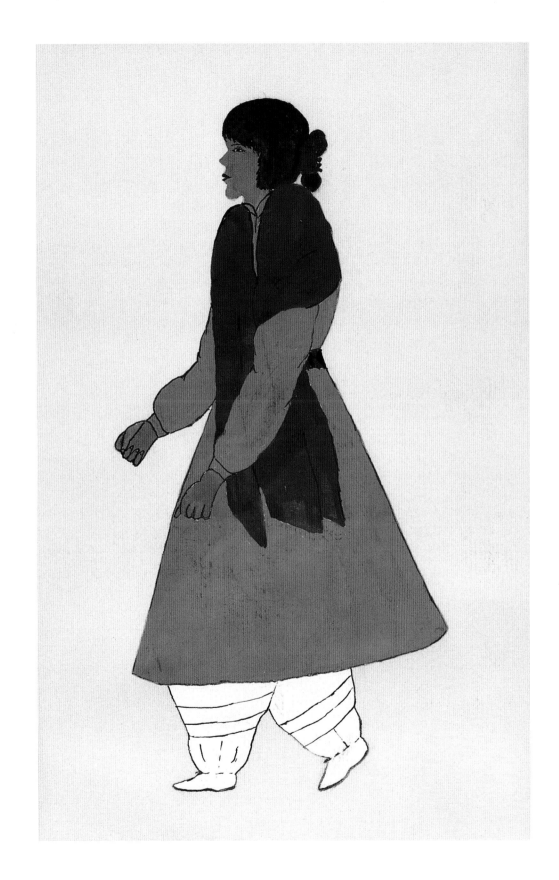

LORENCITA BIRD ATENCIO (1916–1995)

T'o Pove (Flowering Piñon) ♦ San Juan Pueblo

HARVEST DANCE

Lorencita Bird Atencio was born at the San Juan Pueblo. As a child, she attended the San Juan Day School, then the Santa Fe Indian School, where she studied painting with Dorothy Dunn. She completed her formal education at the Sherman Institute, an Indian school in Riverside, California, where she had her first experience as a teacher. During her student years and during the first few years following her studies, she continued to paint and annually exhibited her work at the *Indian Arts Exhibition* at the Museum of New Mexico. Atencio's paintings are excellent examples of the Dunn style, emphasizing stylized, two-dimensional forms that are both decorative and symbolic. Dunn was an advocate of the flat application of opaque watercolor, or casein, and the use of firm and even contours. In 1953 Dorothy Dunn selected one of Atencio's student paintings for the exhibition *Contemporary American Indian Painting* at the National Gallery of Art in Washington, D.C.

Following graduation, Atencio returned to New Mexico where she worked as an instructor in traditional Pueblo crafts. As she began to devote more and more of her time and efforts to teaching, painting became a secondary part of her life; however, she continued to paint for many years. After marriage and the birth of her three children, she followed the tradition of her people and focused her life on home and family. Although there is a very limited record of her artistic creations after 1950, it is known that she continued to work at embroidery and weaving. As an active participant in communal Pueblo life, she made clothing, women's *mantas* and men's dance kilts for Pueblo rituals.

In *Harvest Dance,* Atencio painted one of the most important sacred rituals of the ceremonial life of the San Juan people. The Harvest Dance is a ritual prayer for rain, which will ensure the growth of the young corn, and for an abundant harvest, which was crucial in the sustenance of life at the pueblo. This ceremony, which begins at sunrise and lasts until sunset, is performed each summer.

The female participants in the Harvest Dance carry products of the annual harvest—ears of corn, gourds, melons, and baskets woven from wild grasses. They wear ceremonial dresses known as *mantas*. Having extensive experience in weaving and embroidering *mantas* for the San Juan ceremonials, Atencio has painted each *manta* carefully, devoting special attention to details. Atencio has included a bride, because each year at the Taos Pueblo brides are presented in the course of this sacred dance.

Joining the dancers are the Koshares, priests who serve as "delight makers" or clowns in ceremonial activities in the plaza. They often satirize the foibles of humanity and thus act as teachers. Their satiric gestures and actions have great symbolic importance. At the time of the Harvest Dance, the Koshares also participate in ceremonial rights focused on sacred corn that has been cultivated in the Kivas, which are sacred ceremonial chambers. The bodies of the Koshares are painted with stripes and their faces whitened with sacred cornmeal. It is an honor to be selected for the Koshare Society, because those chosen are men of experience and wisdom. Both the woman and the Koshare who are in the center of the circle of dancers carry sprigs of evergreen, the symbol of procreation and eternal life.

17. *HARVEST DANCE*
13¹/₂ X 10", WATERCOLOR ON PAPER
COLLECTION THE PHILBROOK MUSEUM OF ART, TULSA, MUSEUM PURCHASE 1995.7.5

LORENCITA BIRD ATENCIO (1916–1995)

T'o Pove (Flowering Piñon) ✦ San Juan Pueblo

✺

WOMEN GETTING WATER, 1935

In *Women Getting Water*, Lorencita Atencio painted a scene of everyday life in the Pueblo world. For centuries, the most sacred ceremonials have been ritual prayers for rain to nourish the crops and to ensure the continuance of life at the pueblo. The Pueblo People treat water with great respect and are never wasteful, for they recognize the importance of water. Thousands of years ago, ancestors of the contemporary Pueblo People had to abandon their cliff dwellings because of severe draught and built villages like the San Juan Pueblo in the valley of the Rio Grande River.

Two women are the central figures in Atencio's water ritual. One woman kneels as she ladles water into a special water jar. The other woman, having filled her jar, has placed it on her head, and in the traditional manner, carries the water to her home. Behind the women is a lush growth of water plants, cattails, and grasses, which suggest that this is a time when water is plentiful. Atencio painted the grasses and water plants with great care, paying close attention to detail. She devoted the same attention to the delicately embroidered and woven patterns of the women's clothing.

This painting was exhibited in the 1937 *Fifth Annual Studio Exhibition* at the Santa Fe Indian School. Olive Rush, a popular New Mexico artist of the time, described the painting as having "a millefleur background, Southwest millefleur, with no reflection of the French."[1] In 1953 this painting was included in the exhibition *Contemporary American Indian Painting* at the National Gallery of Art in Washington, D.C.

18. *WOMEN GETTING WATER*, 1935
10 X 13", TEMPERA ON PAPER
COLLECTION HOWARD AND SUE HUSTON

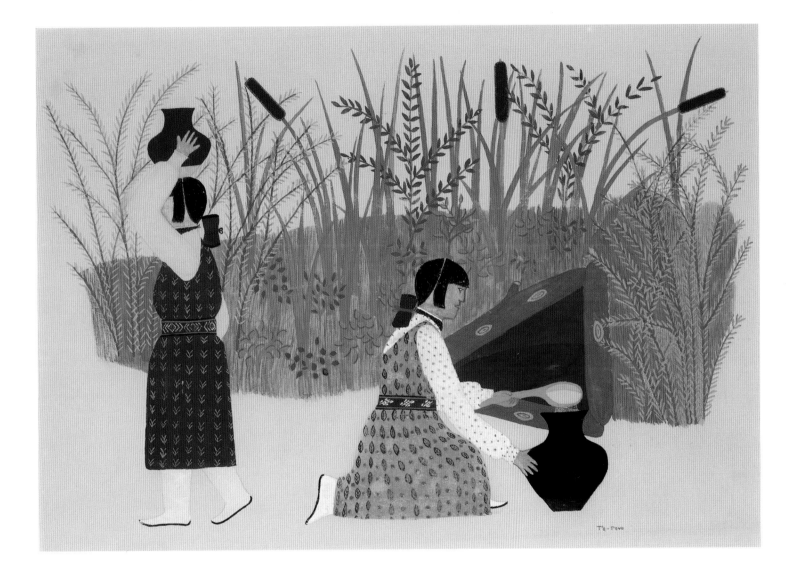

GERONIMA CRUZ MONTOYA (b. 1915)

Pó tsúnu (Shell) ◆ San Juan Pueblo

✸

BASKET DANCERS, 1978

Geronima Montoya was the director of the Studio, the school of fine and applied arts at the Santa Fe Indian School, from 1937 until 1962 when this art school gained independent status as the Institute of American Indian Arts. During her years directing the Studio, Montoya won distinction for inspiring the accomplishments of many young American Indian artists. Her students developed into some of the most distinguished artists of their day. Among her students were Quincy Tohoma, Ben Quintana, Gilbert Atencio, Joe Herrera, Theodore Suina, and Beatien Yazz.

Born in 1915 at the San Juan Pueblo, Geronima Cruz Montoya was the daughter of Crucita Trujillo, a potter, and Pablo Cruz. She attended the San Juan Day School until fourth grade, when she transferred to the Santa Fe Indian School where she lived as a boarder and became a protégée of Dorothy Dunn. Upon graduation, she was appointed assistant director.

Although she has devoted a great portion of her life to teaching and developing the artistic potential of her people, Geronima Montoya has also made a major contribution as a traditional painter of Pueblo life. In 1959 she was honored with a one-person show at the Museum of New Mexico in Santa Fe. Montoya says of her art:

> My style of painting is very simple. My subjects are mainly traditional dances, home scenes and designs.

My inspiration comes from Mimbres figures, pictographs and petroglyphs. I continually experiment with new forms and styles.[1]

One of Montoya's favorite ceremonial subjects has been the Basket Dance, a traditional woman's dance at the San Juan Pueblo. Throughout her life Montoya has been an active participant in Pueblo ceremonial activities. The contents of these baskets in the dance are symbolic—not only of the food, a necessity for the continuance of life at the pueblo, but of the seeds which are planted and in time come to fruition. The Basket Dance offers an invocation of fertility for the potential harvest and a visual prayer that life will continue from generation to generation. An important part of the Basket Dance is the women's consecration to childbearing and to the sustenance of life at the pueblo.

In her painting *Basket Dancers,* Montoya offers detailed images of six women wearing traditional *mantas,* ceremonial shawls, and white buckskin leggings. She has painted individual features for each participant in the Basket Dance. Each dancer carries a woven basket decorated with a different colored design and a sprig of evergreen, the symbol of life. A small evergreen tree, the symbol of continuance of life, is on each side of the line of dancers. In their hair are feathers from the breast of a young bird. These feathers represent the Breath of Life.

19. *BASKET DANCERS,* 1978

9⁷⁄₈ X 17", TEMPERA ON BOARD

PRIVATE COLLECTION

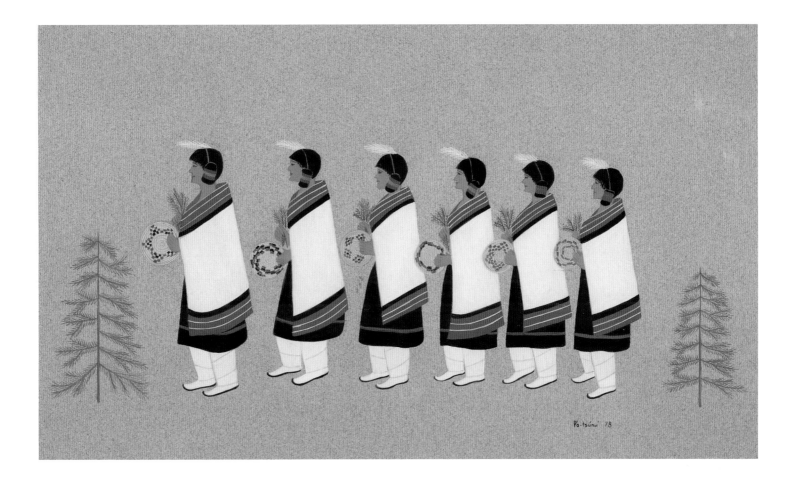

GERONIMA CRUZ MONTOYA (b. 1915)

Pó tsúnu (Shell) ✦ San Juan Pueblo

❋

PUEBLO CRAFTS, 1938

Geronima Montoya has had a major role in awakening the artistic creativity of her people at the San Juan Pueblo. In 1963 she started a program of art education at her pueblo, and in 1968 she founded the Oke'Oweege Artistic Cooperative there. This organization, devoted to the production and sale of fine and craft arts, continues to flourish today. In 1979 Montoya said of her people:

My people live in a landscape that stretches in all directions, even toward the sky. They have developed their way of life, their beliefs, and their ceremonies in accordance with the patterns and happenings on the earth and in the sky. They have created dances, songs, poetry, and ornamental designs expressive of the natural and cultural phenomena. The veneration of all these natural features and forces has brought forth fine arts from the Pueblo peoples.[1]

In 1938 Geronima Montoya painted *Pueblo Crafts,* a personal tribute to the creativity of Pueblo women. This painting depicts five women wearing traditional costumes and hairdos, working on the craft arts that have great importance to the Pueblo—pottery, weaving, embroidery, and animal skin items.

Montoya includes a woman making pottery, a woman weaving a ceremonial rain sash, a woman embroidering a white cotton ceremonial robe, and two women making the white buckskin leggings that are worn by the Pueblo women in ritual dances.

For centuries, long before the Spanish brought sheep, and therefore wool, to the Pueblo world, Pueblo women had skill in weaving cotton for clothing. By 1300 A.D. the Pueblo People were trading food staples for deerskins from the Athapaskan newcomers, who were hunters. The new availability of buckskin made important changes in daily and ceremonial Pueblo dress possible.

Pottery originally came to the Pueblo world from Mexico. Pueblo women were the potters, making household and storage vessels. Traditionally, Pueblo pottery is made from coils of local clay, baked and decorated with geometric or animal designs. Montoya's painting includes examples of the red polished pottery, which is typical of that made at the San Juan Pueblo. San Juan Pueblo pottery traditionally featured polished slip (clay coating) on the upper two-thirds of the vessel. One of the most sophisticated innovations in centuries, the technique for polished matte surface finish was developed by Maria and Julian Martinez of the San Ildefonso Pueblo.

20. PUEBLO CRAFTS, 1938

29$\frac{1}{4}$ X 12$\frac{1}{8}$", TEMPERA ON BOARD

COLLECTION DOROTHY DUNN KRAMER

PHOTOGRAPH COURTESY OF MUSEUM OF INDIAN ARTS AND

CULTURE/LABORATORY OF ANTHROPOLOGY, SANTA FE (54002/13)

PHOTOGRAPH BY BLAIR CLARK

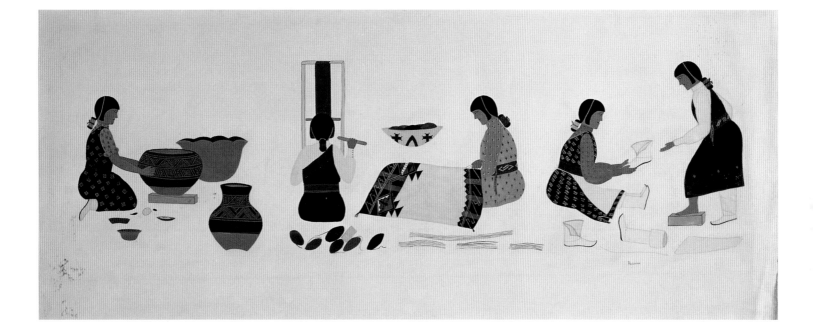

LOLITA TORIVIO

Acoma Pueblo

✵

ACOMA WOMAN PICKING CHILI, 1936

Acoma Woman Picking Chili was part of Dorothy Dunn's personal collection of American Indian paintings. Torivio, a student of Dunn's at the Studio, followed the tenets of her teacher by painting two-dimensional stylized images and choosing as a subject an activity of daily life that was one of the annual rituals of her people, the inhabitants of the Acoma Pueblo. Dunn wrote of Torivio's work, "Lolita Torivio emanated a child-like sincerity and simplicity. She painted a comprehensive range of activities of field and home in lovely color, imparting to them much of the serenity and peace of Pueblo life."[1]

Both red and green chilies are a desired part of the Pueblo diet. The harvest of green chilies, the first young pods, begins in late July and continues through the summer. These young chilies are perishable and must be picked with great care. The ripe red pods are picked from late summer until early autumn.

Chili peppers were brought to North America from Mexico. Although it is documented that Cortés and the conquistadors found chilies in the Aztec world and that by 1600 the Spanish colonists had planted seeds in the Espaniola Valley, it is conceivable that the Pueblo People, thanks to trade with the Mexican Indians, had chili peppers in the precontact world.

Torivio in her paintings depicted the harvest of the mature red chilies. Torivio also included decorative stylized branches bearing autumn squash. The Acoma woman harvesting the chili wears a traditional Acoma dress and hairdo. Torivio departed from the sanctioned Dunn style by painting images that extend beyond the painted border. These images—delicate boughs of autumn greenery and the white deerskin boots of the Acoma woman—give her painting a sense of three dimensions and animation. In 1937 she exhibited her work at the *American Indian Exposition Congress* in Tulsa.

21. *ACOMA WOMAN PICKING CHILI*, 1936
12 5/8 X 10 5/8", TEMPERA ON BOARD
COLLECTION DOROTHY DUNN KRAMER
PHOTOGRAPH COURTESY OF MUSEUM OF INDIAN ARTS AND
CULTURE/LABORATORY OF ANTHROPOLOGY, SANTA FE (54002/13)
PHOTOGRAPH BY BLAIR CLARK

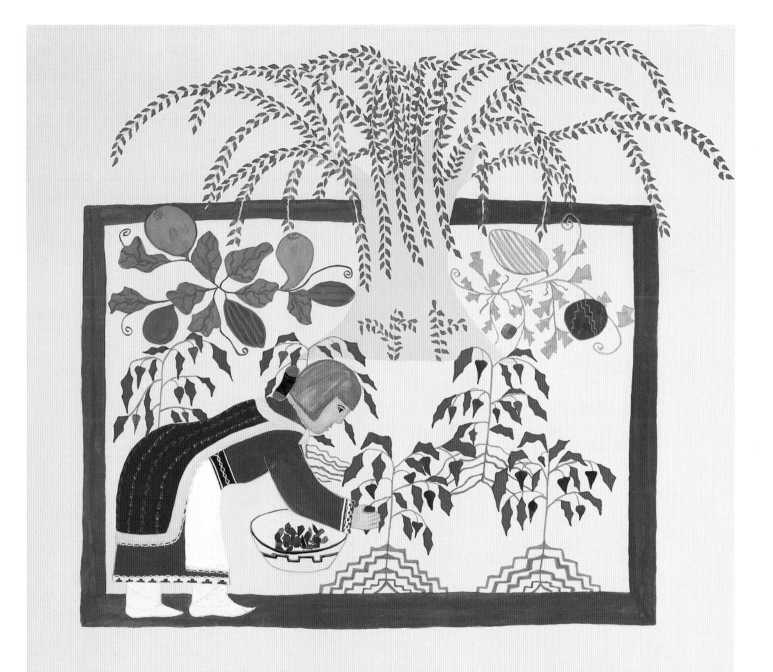

CIPRIANA ROMERO

Cochiti Pueblo

❋

COCHITI WOMEN GRINDING CORN

In *Cochiti Women Grinding Corn,* Cipriana Romero has painted one of the most important household duties of Pueblo women—the grinding of corn. Through the centuries, corn was the primary staple of the Pueblo diet, and every activity in the cycle of planting, harvesting, husking, and grinding corn was ritualized. On both a spiritual and a secular level, corn is all-important to the Cochiti People. The Cochiti, who are one of the Keresan-speaking groups of people, believed in a Corn Mother who sent all that grows to the Pueblo worlds and was the mother of all the Keresan People. In her painting Romero depicts the ritual grinding of corn, which is an important part of the young woman's coming of age ceremony. Women play an all-important role in Cochiti life, for the Cochiti People are both matrilocal and matrilineal.

Romero has painted four women grinding corn in fixed wooden bins that contain graded *metates,* milling stones with shallow troughed tops. The women grind the corn by rubbing the kernels over the *metates* using a two-handed smaller stone, called a *mano.* Traditionally, the women use three grades of *metates* to break, crush, and then pulverize the corn. The ground corn is the basic ingredient in tortillas, a paper-thin bread. Ground corn also can be added to gruels and stews.

Romero, who studied at the Santa Fe Indian School, has painted the women grinding corn against a background of plain white paper. These simplified and stylized figures are identical in size and shape, and the women are in identical positions. Although Romero portrays these women wearing their hair in the traditional style of young Cochiti women and dressed in traditional Cochiti ceremonial *mantas,* she does not depict them as individuals. Lacking defined facial features, these stylized figures are differentiated only by the colors of their shirts. Romero has transformed these four figures into icons, symbols of their roles in the Cochiti world. Thanks to their labor, corn will be transformed into meal. For another year there will be food in the Cochiti world and corn will sustain the Cochiti People.

22. *COCHITI WOMEN GRINDING CORN*

6 X 8¹/₂", CASEIN ON PAPER

PRIVATE COLLECTION

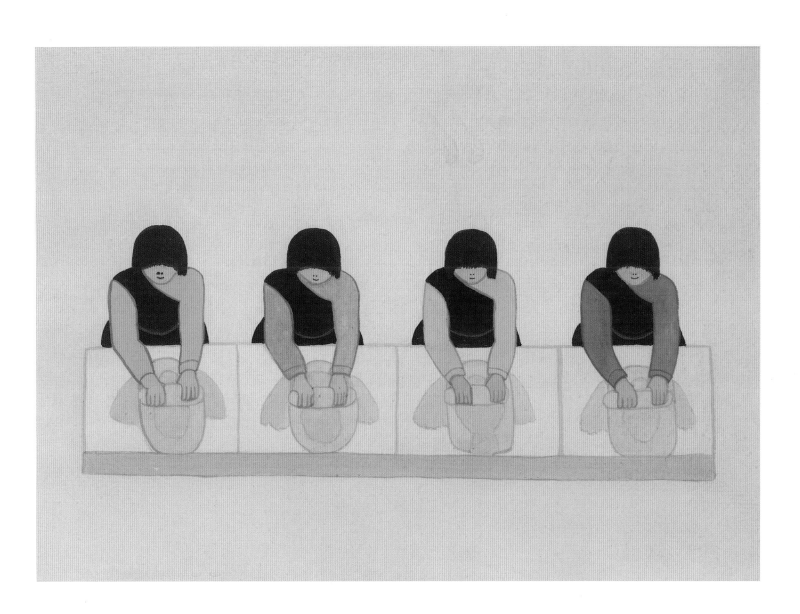

MARCELINA HERRERA

Ha·we·la·na ✦ Zia Pueblo

AFTER THE DEER HUNT, 1935

Marcelina Herrera, in *After the Deer Hunt,* has painted a sacred ritual of the Pueblo People. This painting depicts a ritual of mourning, a ceremony in which the men, women, and children of the Pueblo pay their respects to the spirits of the deer that have sacrificed their lives so that the Pueblo People may be nourished by their flesh. It is winter, the time of the year for animal hunts, and the people sit in respectful attendance as a fire blazes in the fireplace. The Pueblo People honor the deer and give thanks for their beneficence. They pray that the spirits of the deer will be pleased and send other animals to provide food for the Pueblo so that life there will continue.

The three deer in the painting, two bucks and a doe, are ceremonial deer. They are hunted and killed by a special ritual. A hunter or a couple of hunters track the ceremonial deer until the tracks of the animals are found. The men follow the tracks, sometimes running night and day, until the deer grows weak, because deer must graze to maintain their strength. The hunters then can catch up with the deer, throw it to the ground and smother it. It is important that no blood is spilled in the killing of a ceremonial deer. The bodies of the ceremonial deer are treated with great respect. They are covered with special blankets and decorated with turquoise.

The nonceremonial deer are hunted by an entirely different method. Men dressed like deer—with antlers on their heads, buckskins on their bodies, their legs and arms painted white, and short sticks in their hands imitating forelegs—drive the deer into a fenced area where they are killed and used for food.

In the Pueblo world, every part of the hunted animal is utilized: skin for clothing and drums; sinew for sewing, bowstrings, and all kinds of fastenings; bones for tools; and hooves for rattles. The Pueblo People are primarily vegetarians, but meat is eaten on special ceremonial occasions.

Herrera studied with Dorothy Dunn at the Studio at the Santa Fe Indian School. She was a prized student of Dunn, who described Herrera's work as "visual legend."[1] Dunn ultimately acquired *After the Deer Hunt* for her private collection, and in 1953 she selected this painting for an exhibition at the National Gallery of Art in Washington, D.C.

23. *AFTER THE DEER HUNT*, 1935
11 X 14", TEMPERA ON PAPER
COLLECTION HOWARD AND SUE HUSTON

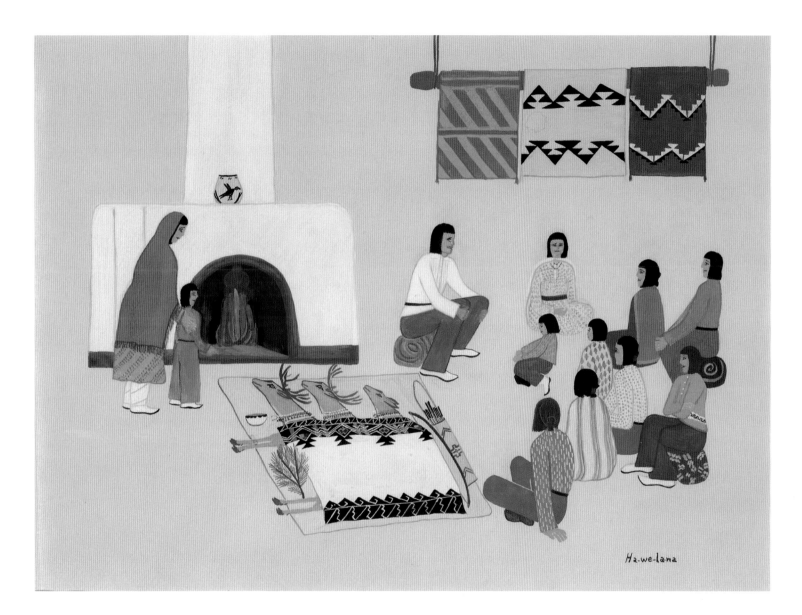

EILEEN LESARLLEY

Zuni

※

ZUNI GIRLS WITH OLLAS, 1935

In 1935 Eileen Lesarlley, a young Zuni woman who was a student at the Studio, painted *Zuni Girls with Ollas*. Ollas are the traditional jars used through the centuries by the Zuni women to carry water. The ability of the Zuni women to carry ollas on their heads is a prized skill developed from youth. Even today the "Olla Maidens" sing and dance at intertribal gatherings, including the Gallup Ceremonial, where they are an admired and cherished group of performers.

The Zuni Pueblo is over eight hundred years old. At Zuni, the economic unit is the individual household which is comprised of an extended family. In the Zuni world, women are all-important. Descent is matrilineal and residence is matrilocal. In the Zuni household, each woman owns her own room and a series of adjoining rooms. The father's household is in charge of ritual activities, whereas the mother's household and lineage is in charge of all economic activities.

Historically, Zuni women made both household and ceremonial pottery. Ollas, the water jars, are a prime example of household pottery. Traditional Zuni pottery was a black design painted on a white slip covering of the vessel. Those designs included deer, stylized birds, large stylized circular rosettes, scrolls, and a variety of geometric patterns.

Contemporary Zuni pottery is a polychrome pottery, black and red painted on white slip; however, the Zuni women exercise restraint in their use of red. The ollas in Lesarlley's painting are excellent examples of contemporary Zuni polychrome ollas.

Lesarlley has painted a line of Olla Maidens in traditional dress—a *manta,* a ritual cape, an apron, a rain sash, and white deerskin boots. Their hair is dressed in the traditional manner of married women and they wear elaborate jewelry, including turquoise and silver bracelets and rings, and silver squash-blossom necklaces. In *Modern by Tradition: American Indian Painting in the Studio Style,* Bruce Bernstein and W. Jackson Rushing wrote a significant analysis of Lesarlley's work:

> Careful inspection of Eileen Lesarlley's *Zuni Girls with Ollas,* of 1935, reveals that each figure and the pot she balances on her head are just different enough to suggest individuality, while the overall uniformity of the girls and the formality of their pose and posture hint at the sublimation of the individual into that abstract entity that is a totality of a culture that emphasizes the communal good.[1]

During the 1930s, Lesarlley was a student of Dorothy Dunn at the Studio. Dunn, pleased with the work of her Zuni pupil, wrote:

> Eileen Lesarlley's paintings were of the women of Zuni, done in a static, decorative style with intricate detail. The woven pattern of a belt, the embroidered hem of an apron, the clustered setting of turquoise in a ring, were painstakingly wrought. Her drawing was deliberate, her color bright, set off by stark black and whites, her composition as formal as ceramic design.[2]

24. *ZUNI GIRLS WITH OLLAS*, 1935
19³/₈ X 12¹/₄", TEMPERA ON BOARD
COLLECTION DOROTHY DUNN KRAMER
PHOTOGRAPH COURTESY OF MUSEUM OF INDIAN ARTS AND CULTURE/LABORATORY
OF ANTHROPOLOGY, SANTA FE (54009/13)
PHOTOGRAPH BY BLAIR CLARK

RUFINA VIGIL

Sah-wa ✦ Tesuque Pueblo

❁

MASS AT FIESTA, 1936

Mass at Fiesta is one of the first American Indian paintings of a ritual of the Catholic Church. Rufina Vigil was one of the first Pueblo painters to devote her efforts to genre paintings, realistic yet poetic portraits of daily and ceremonial life at the pueblo.

Tesuque is the southernmost of the six Rio Grande Tewa Pueblos. (It is nine miles north of Santa Fe.) Situated on the Tesuque River, this pueblo came under Roman Catholic influence in 1598, with the appointment of Frey Christobal de Salazar, a Franciscan to the Tewa province. Until the Pueblo Revolt of 1680 the Tesuque mission was known as San Lorenzo. Opposed to their forced conversion to Catholicism and the prohibition against traditional Pueblo religious rituals, in 1680, on the eve of the Pueblo Revolt, the inhabitants of Tesuque burned all church paraphernalia and murdered the priests assigned to the mission.

The Catholic Church ultimately relaxed its sanctions against indigenous religious practices, and in time the Tesuque People embraced both Catholic and Tewa ceremonialism. The Tesuque Feast Day, November 12, honors San Diego, the patron saint of the Pueblo. On this day the Tesuque People attend Catholic Church services as depicted in Vigil's painting. They participate in traditional Pueblo dances and feast on Pueblo delicacies.

Vigil studied painting with Dorothy Dunn at the Studio. In her book *American Indian Painting of the Southwest and Plains Areas,* Dunn wrote of the young Tesuque painter:

Sah-wa [Rufina Vigil] was one of the most versatile young women. She painted in a deliberate, indepen-dent style all aspects of the life of her Pueblo. Equally facile were her renditions of her ceremonial, genre, and abstract design. She had great patience with fine detail and was adept at composition.[1]

As guest curator of the 1953 exhibition *Contemporary American Indian Painting,* at the National Gallery of Art at Washington, D.C., Dunn included *Mass at Fiesta*. From June 1955 until May 1956, this painting was included in an exhibition of sixty paintings assembled by the University of Oklahoma's College of Fine Arts for the United States Information Service in Rome. This exhibition traveled throughout Europe.

In *Mass at Fiesta,* Vigil followed the traditions of two-dimensional color areas, which are a trademark of the Studio, but her use of a distant vanishing point in her portrayal of the religious sanctuary gives her painting a sense of perspective. Vigil paid close attention to realistic detail in her images of the people sitting, kneeling, and standing in the sanctuary. The men wear silver concha belts and their hair is tied in traditional knots at the napes of their necks. The women wear elaborately pat-terned prayer shawls and white deerskin leggings. A huge brown dog lies on the floor among the worshipers.

Following her studies with Dunn, Vigil worked inde-pendently for several years. In 1943 her work was featured at a one-person show at the Marshall Fields department store in Chicago, part of a promotion of Southwest Indian art. During World War II, Vigil, a master of detail, worked as a draftsman at Los Alamos. There is no record of her painting after this time.

25. *MASS AT FIESTA,* 1936
13 X 10", TEMPERA ON PAPER
COLLECTION HOWARD AND SUE HUSTON

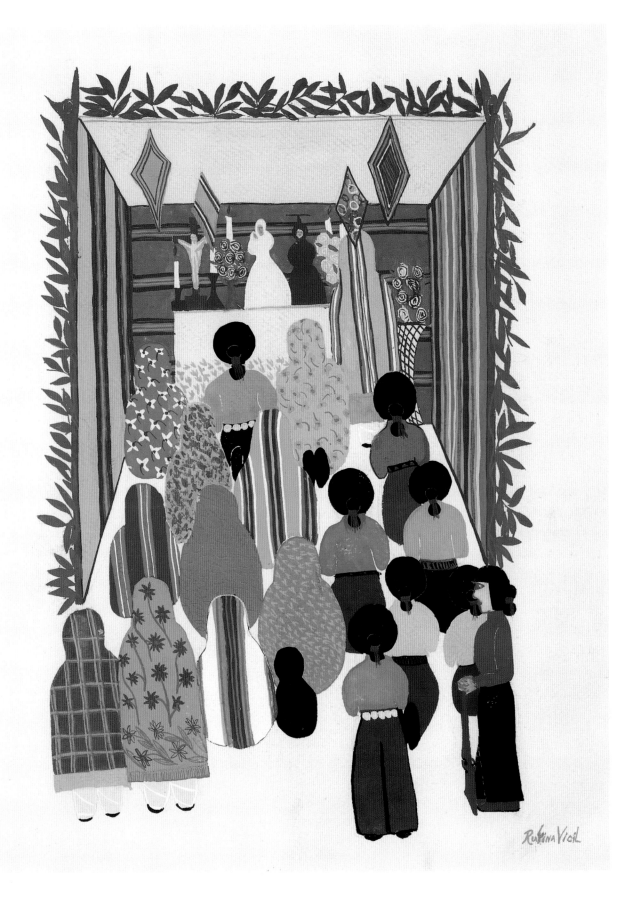

CAROLINE CORIZ

Tesuque Pueblo

✸

TEXTILE PATTERN FROM AN ACOMA POTTERY MOTIF, 1934

Caroline Coriz was one of the first Pueblo women to participate in the course of instruction at the Studio. *Textile Pattern from an Acoma Pottery Motif* was painted in 1934 during her student days at the Studio. Coriz's teacher, Dorothy Dunn, was fundamentally a romantic and an idealist. She believed that each of her students had innate artistic ability and that her role was to bring forth from her students their intrinsic knowledge of the art of their peoples. Believing that native peoples would intrinsically understand their vocation to create the art of their heritage, Dunn showed her students the craft arts of their ancestors.

Dunn believed that contemporary Native American art must be based on truly authentic Indian art—rock art, ceremonial chamber paintings, and hide paintings, as well as the best examples of indigenous pottery and weaving. Students visited the Laboratory of Anthropology at the Museum of New Mexico in Santa Fe to see examples of weaving, pottery, and jewelry and to study the design motifs. In 1932 Dunn herself completed a series of watercolor studies of nineteenth-century pottery designs that included the study of a nineteenth-century Acoma water jar. The students followed Dunn and copied the ancient designs before they attempted independent compositions.

Textile Pattern from an Acoma Pottery Motif was inspired by a visit to the Laboratory of Anthropology. Rather than use an Acoma design as an interesting part of her painting, Coriz used this textile pattern as the entire composition. Using the authentic colors of Acoma pottery—black, russet, and white—Coriz completed a work that is geometric rather than narrative in focus and quite modern compared with the work of her peers. Dunn must have been pleased with her student's choice of design motif because in 1968 she herself used the same Acoma pattern for the inside papers of her book, *American Indian Painting of the Southwest and Plains Areas*.

The craft arts of the Acoma Pueblo were creations of artistry and precision. The design motifs of Acoma weaving, like those of Acoma pottery, are distinguished by their intricacy of design. Although there is often an absence of spiral and circular forms in traditional Acoma pottery and weaving designs, the triangle is one of the most important design elements and frequently was subdivided to produce multiple triangles. Using a white background, traditional Acoma artists created geometric designs based on intricate subpatterns of solid colors interspersed with white squares.

Weaving has been an accomplished skill of the Acoma Pueblo since about 750 A.D. During this period, cotton was the primary woven fiber, and the art of weaving cotton reached its high point in about 1400 A.D. At Acoma, as throughout the Southwest, weaving was transformed in about 1600 following the arrival of the Spanish and the introduction of sheep. From that time on, the majority of weaving was in wool. In the late nineteenth century, commercial dyes and new designs were introduced to the Pueblos, although many weavers continued to follow the basic designs of the past.

Coriz, having had the opportunity to study examples of weaving from ancient days, was inspired to paint a design motif of the prehistoric period. Bruce Bernstein and W. Jackson Rushing in *Modern by Tradition: American Indian Painting in the Studio Style* said of Coriz's painting:

> Viewed through a modernist lens, this is a scintillating geometric abstraction—a perfectly pleasing, self-referential pattern.... Like Pueblo culture in its *ideal* form, the individual units are woven into a seamless whole, organic vitality is ordered and balanced by a clear, if complex, system; movement is dynamic and yet restrained and predictable; and the constant folding of the past into the present (cyclical rhythm) is overtly manifest.[1]

26. *TEXTILE PATTERN FROM AN ACOMA POTTERY MOTIF*, 1934

26 X 20", TEMPERA ON BOARD

COLLECTION HOWARD AND SUE HUSTON

PABLITA VELARDE (b. 1918)

Tse Tsan (Golden Dawn) ♦ Santa Clara Pueblo

The art and life of Pablita Velarde stand as the fulfillment of the dreams of Dorothy Dunn. In 1932, the same year in which Pablita Velarde entered eighth grade at the Santa Fe Indian School, Dorothy Dunn, having moved from Chicago to Santa Fe, established the school's fine arts program, the Studio. Dunn's goal in founding the Studio was to establish American Indian painting as one of the cultural treasures of America and to give instruction and advice to a generation of potential artists so that they would create paintings that would present to the world the cultural legacy of the indigenous peoples of America. Bruce Bernstein and W. Jackson Rushing, in their book on the Studio, defined Dunn's objectives:

> Her stated objectives were subtlety transformational for their time: to foster appreciation of Indian painting among students and the public, thus helping to establish it in its rightful place as one of the fine arts of the world; to produce new painting in keeping with high standards already established by Indian painters; to study and explore traditional Indian art methods and production in order to continue established basic painting forms, and to evolve new motifs, styles, and techniques in character with the old and worthy of supplementing them; and to maintain tribal and individual distinction in the paintings.[1]

Pablita Velarde was born at the Santa Clara Pueblo in 1918, the third child of Herman and Marianita Velarde. Her fraternal godmother, Qualupita, a Medicine Woman, chose her name, Tse Tsan, which means "Golden Dawn." At age three, soon after her mother had died of tuberculosis, Tse Tsan was stricken with an infection that resulted in two years of blindness.

Trying to support his family by farming and fur trapping, Herman Velarde struggled to find time to care for his family. When Tse Tsan was nearly six years old, her father sent her and two sisters to St. Catherine's Indian School, a boarding school in Santa Fe run by the Catholic Missionary Sisters of the Blessed Sacrament. (A younger sister remained at home.) There Tse Tsan was placed in kindergarten, taught English, and given the Christian name Pablita, the Spanish feminization of Paul.

When school was not in session the girls returned to the pueblo and stayed with their grandmother, Qualupita, from whom they learned the customs, basic beliefs, and rituals of the Pueblo People. Like most Pueblo children of the period, they were raised with the dual religious faiths—Pueblo and Christian. On occasion, the sisters would have the opportunity to visit the nearby Puye Ruins and learn of the life and history of their ancestors. Pablita often watched and imitated her elders making the world-renowned Santa Clara pottery.

After completing grades one through six at St. Catherine's Indian School, Pablita Velarde entered the eighth grade at the Santa Fe Indian School, a boarding school run by the Bureau of Indian Affairs, and found great pleasure in Dorothy Dunn's art instruction. Dunn encouraged her students to base their work on their own cultural traditions and to depict incidents of daily life or the pageantry of ceremonial rituals. She advised the children to avoid images that had become clichés—tipis, peace pipes, and warbonnets—to concentrate on their indigenous symbolism, and to include distinctive images that were representative of their people. Above all, Dunn desired cultural authenticity, insisting on correct details of dress and hairstyle.

Pablita Velarde was the first full-time female student to participate in the Dunn program, and she took all of the art courses offered. Her work was included in *The Santa Fe First Annual Exhibition of the Studio Artists*. Olive Rush wrote of the work of Pablita and her sister, Rosita (her elder sister, a part-time student, left the school before graduation): "The Velarde sisters, Pablita and Po-ve of Santa Clara, find their best expression in picturing the people of their pueblo in their daily tasks, women making pottery, or husking corn, or winnowing wheat—all beautifully expressed."[2]

In the traditional Pueblo world, life as a painter was not

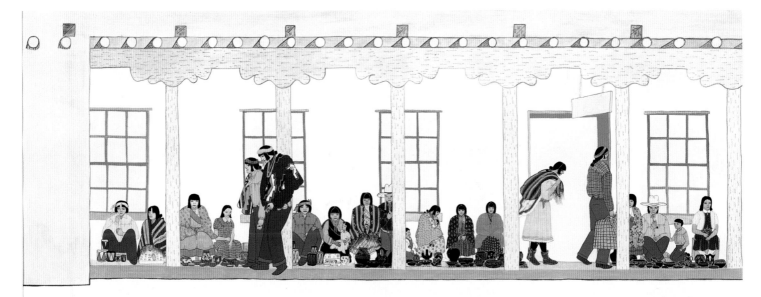

27. *PUEBLO CRAFTSMEN—PALACE OF THE GOVERNORS*, 1941

14¹/₂ X 25³/₄", TEMPERA GOUACHE ON PAPER

COLLECTION THE THOMAS GILCREASE INSTITUTE OF AMERICAN HISTORY AND ART, TULSA

considered suitable for a woman; therefore, when Pablita was sixteen years old, her father insisted that she leave the Santa Fe Indian School and transfer to Espanola High School where she could learn typing and other secretarial skills. After eighteen months, Pablita had completed all of the business courses offered by the school and transferred back to the Santa Fe Indian School for the final half year. She graduated with her class, the first from her family to receive a high school diploma. Following graduation, Pablita Velarde worked for two years directing the art program at the Santa Clara Pueblo Day School.

In 1938 Pablita Velarde was offered a job by Ernest Thompson Seton, the well-known author who founded the Boy Scouts of America. A resident of Santa Fe who was interested in the American Indian people and their history, Seton hired Pablita to care for his children during a long lecture trip through the eastern United States. Pablita and the Seton family traveled east to New England, down the East Coast, across the South to Arkansas, then returned to Santa Fe by a southern route.

Following this trip, which gave Pablita exposure to places that she did not know existed, she accepted an offer in early 1939 by Olive Rush to paint a mural for the Maurice Maisel Trading Post. In this mural she painted a group of Santa Clara women selling pottery. Dunn wrote of the mural:

> The inscrutable, solid strength of character of Pueblo women is contained here in a massive, simple way that is more emotional in effect than passively decorative. Yet, there is decoration, too, in the clothing and pottery, and in the faces—each a different design in itself. The calico dresses are minutely patterned with almost mechanical exactness, and the pottery forms are shaped firmly and painted precisely, as in life.[3]

Upon completing the Maisel mural, Pablita Velarde was hired by Dale King, director of the United States Park Service, to paint a series of murals depicting the life of the Cliff Dwellers of the area of Bandelier National Monument.

By 1940 World War II had begun in Europe, and the United States government, in order to concentrate on preparation for war, cut the funds allocated to the Park Service. Pablita Velarde's job was terminated. In need of money, she took a job in Espanola decorating drum tops and on weekends traveled to Santa Fe to sell her paintings. In Santa Fe she sat with her paintings under the portal of the Palace of the Governors with the group of Pueblo artists who sold pottery, silver jewelry, beads, and other handcrafts. Thanks to her success with mural commissions and the sale of her paintings under the portal, Pablita Velarde was able to support herself. In 1939 Pablita with her family and hired assistants began to build a home on a piece of family land given to her by her father. It was unheard of in the Pueblo world for a Pueblo woman to live in her own home, a home that she had built and paid for by her artistic creations.

In *Pueblo Craftsmen—Palace of the Governors,* Pablita Velarde painted the artisans selling their crafts. This painting is typical of Velarde's early work, which followed the traditions and techniques of the Studio. This two-dimensional, brightly colored painting, which includes exact details of costume, is an accurate portrait of the daily scene in front of the Palace of the Governors. Dunn believed that art could enable students to achieve financial independence, that "painting has proved to be one of the best means of income whether or not artists leave the pueblos and reservations. It has been one of the most flexible means of relocation."[4] Throughout her life, painting gave Pablita Velarde not only a vocation, a mission to give visual permanence to the life and legends of her people, but independent means to pursue her goals.

PABLITA VELARDE (b. 1918)

Tse Tsan (Golden Dawn) ✦ Santa Clara Pueblo

✦

SONG OF THE CORN DANCE

In 1933 two students at the Studio, Pablita Velarde and Andrew Tsihnahjinnie, were invited to participate in the Works Progress Administration's Santa Fe Mural Project, which consisted of a series of murals devoted to the life and land of the American Indian people. Pablita Velarde painted the domestic life of the Santa Clara Pueblo, and Tsihnahjinnie painted hunting scenes and animals of the Navajo world. In the course of this project, Pablita Velarde had the opportunity to work with such well-known professional artists as Raymond Jonson and Kenneth Chapman. Upon completion of the murals, the work of both the professional artists and the students was exhibited at the Laboratory of Anthropology in Santa Fe and at the Corcoran Gallery in Washington, D.C.

This project served as Pablita Velarde's introduction to the theories and techniques of mainstream twentieth-century art. Dunn wrote, "That was a chance for the modern-yearning Indian young people to see how well their amazingly *modern* traditional motifs might unite with some of the most advanced ideas of the modern world.... Many elemental concepts of art ... are neither old or new but eternal and commonly shared."[1]

Although frequently criticized for her devotion to the traditional art of the Indian people, Dunn believed that the "object of the studio's work is not to perpetuate old forms entirely, but to study ... and appreciate them and develop new forms related to and worthy of succeeding the old ones."[2] Thanks to her experience in the mural project, Pablita Velarde's art developed into a personal blend of narrative and abstract art.

During the 1930s Dunn's students had the opportunity to participate in several mural projects. Because of her outstanding skills, Pablita Velarde was among those chosen. In 1933 Santa Fe artist Olive Rush chose Pablita, then a young girl in eighth grade, to be one of three students to make a series of mural paintings depicting the Pueblo People and Pueblo life. Her painting of a Santa Clara girl was sent to *The Century of Progress Exhibition* in Chicago. In 1933 another innovative project at the Studio was a series of earth-pigment murals devoted to the sciences—astrology, geology, biology (botany and zoology), physics, and chemistry. This project was undertaken with the hope of demonstrating that art could complement science. Pablita Velarde was chosen for the botany mural.

In the winter of 1934 Paul Cove, a Parisian artist and ethnologist, visited the Studio and arranged for an exhibition of the students' work at the Musée d'Ethnographie at the Trocadero. At this exhibition, which opened in Paris in June 1935, Pablita Velarde's work was greatly admired. The following year Dorothy Dunn described Velarde's work, "Pablita Velarde [Tse Tsan] was a steady, serious worker, most adept at scenes depicting potters and homemakers of Santa Clara. Her painting was decorative yet lifelike, with careful attention to authentic detail. In her ceremonial paintings, her resourcefulness led her to choose the more unusual and little-known aspects for depiction."[3]

As she became a mature artist, Pablita Velarde began to work with a more complex palette, one based on muted earth colors, and to become interested in more sophisticated compositions. Initially, she experimented with three-dimensional art, the techniques of shading and perspective that she ultimately rejected. Influenced by Raymond Jonson, who transformed the art of the past into innovative compositions, Velarde developed a style of painting that, although always fundamentally narrative, utilized two-dimensional forms and abstract motifs.

During this period, Velarde chose to work with earth colors made from hand-ground pigments. At the Studio she first had learned to use natural earth pigments and the techniques of *fresco secco* in which she prepared the paint from natural pigment and then applied these pigments to a chosen surface with a mixture of glue and water. In *Song of the Corn Dance* her white is gypsum, her black is coal, and the light gray is pomaced volcanic ash. The dark gray is clay from the Santa Clara Canyon; the green is loose earth near Flagstaff; the gold is found near the Laguna Pueblo; the red is clay from La

Bajada Hills, and the coral clay is found in Clarksdale, Arizona. The light beige is the earth from Velarde's backyard.[4] Dunn wrote of the progress of Pablita Velarde's art:

> Native earths, first assembled and prepared for modern use by the Santa Fe Indian School Studio while Pablita was a student there, now constitute her principal medium for *fresco secco*. She more effectively and appropriately employs these natural paints in her abstract motifs adapted from ceramic designs, mural figures, and similar sources than in more naturalistic representations.[5]

In *Song of the Corn Dance,* Pablita Velarde created an innovative composition that includes three singers, a standard bearer, a drummer, and a Quirano, a clown or Koshare who wears a headdress of cornhusks. The standard bearer holds a sacred staff decorated with eagle feathers, painted with traditional water designs, and topped with a fox skin, a sack of new seeds, and parrot feathers. At this sacred ceremonial prayer for the success of the crops and the well-being of the people, all of the dancers must past beneath this staff. Overhead, a pottery vessel surrounded by abstract lightning, clouds, and a rainbow spills sacred rain over the ceremonial participants.

28. *SONG OF THE CORN DANCE*
23 3/4 X 15 3/4", TEMPERA GOUACHE ON UNTEMPERED MASONITE
PRIVATE COLLECTION

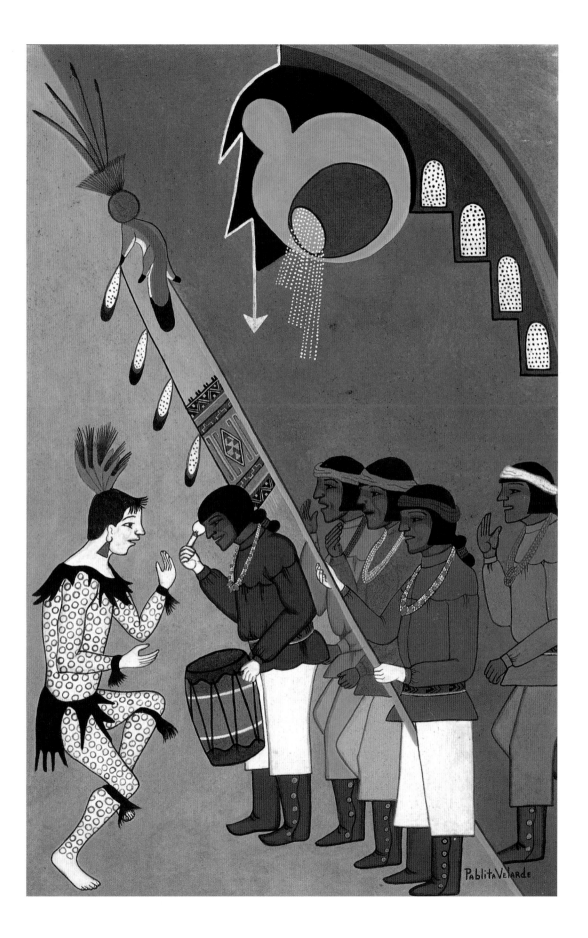

PABLITA VELARDE (b. 1918)

Tse Tsan (Golden Dawn) ♦ Santa Clara Pueblo

❋

DANCE OF THE AVANYU AND THE THUNDERBIRDS, 1955

Pablita Velarde is a pioneer, one of the first American Indian women to succeed in devoting her life to the creation of art. Painting for more than sixty years, Velarde has created a body of work that celebrates Pueblo life, both secular and spiritual. Not only has Velarde painted the daily and ceremonial life in the Pueblo world, but also she has preserved a wealth of Pueblo legends, the treasured lore of her people.

Throughout her life, Velarde believed she had a mission to record for posterity the life and legends of her people. But in 1965, when she attempted once again to live at the Santa Clara Pueblo, she learned that she no longer could live in the community. She felt many there condemned her for making public the rituals and legends that they believed should remain secret. As the spirit of her pueblo would not nourish her creativity, Velarde returned to Albuquerque.

Pablita Velarde's painting *Dance of the Avanyu and the Thunderbirds* is an innovative work focused on two legendary animals that for centuries have been celebrated by the Pueblo People for their rain-bringing powers. Both the Avanyu and the Thunderbird are water spirits who are all-important in helping to bring the rain necessary for the crops to grow and to provide sustenance and life for the people. Having extensive powers, they are also recognized as fertility symbols for the creation and the continuance of life in the Pueblo world.

The Avanyu is a plumed serpent, a descendant of Quetzalcoatl, the plumed serpent of the Mayan culture. Quetzalcoatl was the god-king who, living at the bottom of the sea, was one of the creators of the world. The Thunderbird is the personification of rain, lightning, and thunder. In Velarde's painting the coiled Avanyu is the central figure in the composition. The Avanyu's tongue, a bolt of lightning, connects him with a Thunderbird. Lightning motifs also are incorporated in the tail of the Avanyu.

Thunderbirds, left and right, form the base of the composition. Velarde depicts the Thunderbirds with heads reminiscent of the waterbird images of prehistoric pottery. Above the Avanyu and the Thunderbirds are stylized cloud forms that pour down showers of rain. Large, curvilinear geometric plumes, which suggest the Avanyu's tail, complete Velarde's composition. The colors of *Dance of the Avanyu and the Thunderbirds* are those of earth and water.

Pablita Velarde was one of the first American Indian women to win international recognition. Not only are her paintings featured in museums across the United States, but they have also been given as official gifts by the United States government to foreign leaders. Her paintings are on display in the Department of Interior and in American embassies in Ecuador and Spain. In 1954 the French government awarded the Palme Académique to Dorothy Dunn and twelve of her students in a ceremony at the Gallup Ceremonial. Pablita Velarde was one of the artists honored for an outstanding contribution to the field of art. In 1977 Pablita Velarde was honored as the recipient of the New Mexico Governor's Award for Outstanding Achievement in the Arts.

29. *DANCE OF THE AVANYU AND THE THUNDERBIRDS*, 1955
13 X 16³/₁₆", WATERCOLOR ON PAPER
COLLECTION THE PHILBROOK MUSEUM OF ART, TULSA
MUSEUM PURCHASE 1955.4

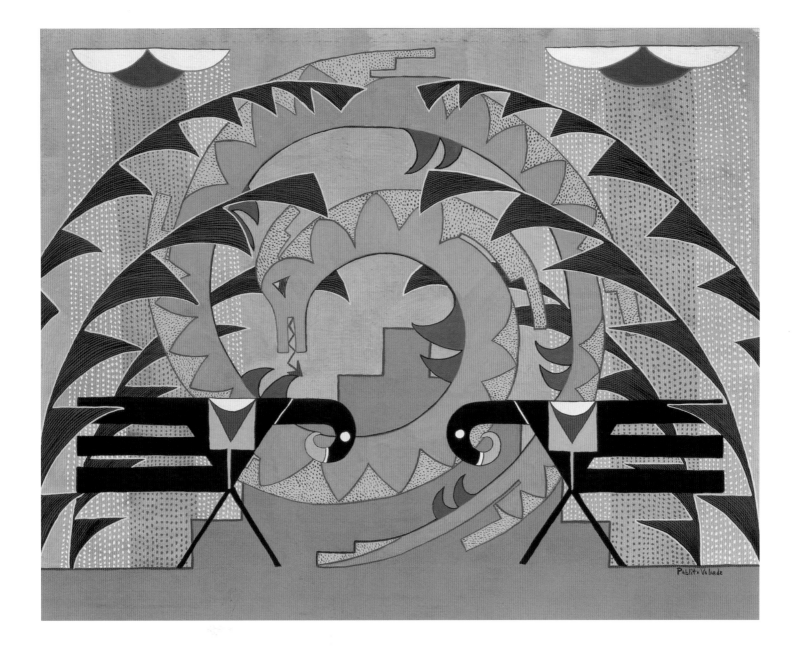

HELEN HARDIN (1943–1984)
Tsa-sah-wee-eh (Little Standing Spruce) ♦ Santa Clara Pueblo

✸

WINTER AWAKENING OF THE O-KHOO-WAH, 1972

Both the life and the art of Helen Hardin represent a harmonious fusion of two cultures—the culture of the American Indian people and the culture of mainstream America. Throughout her life Helen Hardin had a great love for independence, and although her roots were firmly planted in her dual heritage, her art was enriched by her individual creativity and imagination.

Helen Hardin was born in 1943 in Albuquerque. She was the daughter of Pablita Velarde who, by the time of her daughter's birth, had won local recognition as a painter for her murals at Bandelier National Monument and for her narrative paintings of daily and ceremonial American Indian life, which she sold under the portal in Santa Fe.

Helen's father was Herbert Hardin, who was a night watchman at the Bureau of Indian Affairs when he and Pablita married in 1942. Soon after their wedding, Herbert was drafted into the army and Pablita returned to Albuquerque to await the birth of her daughter. When Herbert Hardin was discharged from service, he decided to take advantage of the GI Bill and to study to become a police officer. Pablita and the two children moved with him to Richmond, California, where he attended the University of California at Berkeley. When Herbert graduated with a degree in criminology, the Hardin family returned to Albuquerque where Herbert joined the Albuquerque police department. Herbert had little interest in Pablita's career, and although she had helped to support Herbert and her children during his years in school, once Herbert was established in his work on the police force the couple separated. A year later, when Helen was thirteen, her father married a policewoman.

During childhood, Helen showed artistic talent, and at age six she entered a competition for drawings of fire engines sponsored by an Albuquerque radio station. Helen won this competition intended for boys; however, when the station's sponsor learned the winner was a girl, a doll was substituted for the prize of a fire engine. When she was nine years old, Helen sold her first painting for $1.50 at the Gallup Ceremonial.

Young Helen attended St. Catherine's in Santa Fe, the same boarding school where Pablita Velarde first had experienced the non-Pueblo world. Helen next studied at Pius X High School in Albuquerque. Following graduation in 1960, she won a scholarship to attend a summer program in Phoenix, which was part of the Southwest Indian Art Project. This program, under the guidance of Lloyd Kiva New, served as Helen's introduction to the principles of contemporary art.

Helen enrolled at the University of New Mexico in a course of study focused on art history and anthropology, but after a year she left to attend the Special School for Indian Arts at the University of Arizona, where she could divide her time between study and painting. At age nineteen, she had her first one-person show at the Coronado State Monument near Bernalillo, New Mexico.

Helen's first paintings were examples of traditional Indian art, two-dimensional narrative paintings of Pueblo daily life. It was by chance that her art developed a new dimension. In her senior year at Pius X High School, she had attempted to enroll in every possible art class. Unable to fit an art class into her schedule because of a conflict, she insisted on attending a class on drafting. There she learned to use the compass, the protractor, and the T-square, skills that she incorporated into her art to achieve perfect circles, curves, lines, and edges:

> The school's attitude was that I had had enough painting classes. But I didn't care if I NEEDED it anymore, I had the need to do something during the day that was artistic. In the class, I was always watching what the boys were doing with their drafting tools. I would see images in the circles and curves. I started experimenting, but I didn't use them for my professional painting until 1968–1969.[1]

Nineteen sixty-eight was a critical year for Helen Hardin's art career. That year, while visiting her father, who

at the time was an official at the U.S. Agency for International Development in Bogota, Colombia, she was honored with a reception at the Colombo-Americano BiNational Center and with a one-person show at the U.S. Embassy. In Bogota, those who bought the twenty-seven paintings that Hardin had painted while in Colombia looked upon her work as independent creations, as they had no knowledge of her mother's fame.[2]

Confirmed in her identity as an independent artist, Helen entered and won the first prize for painting at both the Inter-Tribal Ceremonial in Gallup, New Mexico, and at the Santa Fe Indian Market where, as a small child, she literally had sat at her mother's feet. In 1969 Hardin was honored with a one-woman show at the Heard Museum in Phoenix, and she again won first prize at both Gallup and Santa Fe, awards that she would win many times in the future. In 1970 she was the subject of a feature article in *New Mexico Magazine* entitled "Helen Hardin: Tsa-sah-wee-eh Does Her Thing," and Helen became a star of the Indian art world, a recognized independent artist. In 1975 she was the only woman of five artists selected by Arizona State University for a PBS series *American Indian Artists*.

Hardin's early work was in casein and earth pigments. During 1968 and 1969 she began to experiment with acrylics and found greater satisfaction working with this fast-drying medium. She developed a technique in which she applied layers of color and varnishes to achieve a smooth brilliant surface and depth of imagery. Inspired by pottery, ceremonial masks, songs, costumes, rituals, and legends, the paintings were primarily the product of her imagination. She weaved together independent elements and motifs, often symbols of traditional American Indian art, into a spiritual and emotional unity. Her goal was to paint the harmony of the universe, a harmony that in her mature works Hardin was able to give visible form.

A milestone in her artistic career was the Kachina painting *Winter Awakening of the O-khoo-wah,* which in 1972 won first prize at the Scottsdale National Indian Art Competition. The term *O-khoo-wah* means Cloud People. The Pueblo People pray to Kachina spirits whom they believe are Cloud People, spirits who are responsible for the clouds that will bring life-sustaining rain to the Pueblo world. The inspiration for this painting was a recording by an American Indian chorus of a song about the O-khoo-wah, "Cloud People Approaching the Pueblo." The five Kachina masks in the painting are purely the product of Hardin's imagination, whereas the designs on the Kachina costumes are a synthesis of geometric and traditional designs and patterns. *Winter Awakening of the O-khoo-wah* was for Hardin a form of personal prayer.

30 *WINTER AWAKENING OF THE O-KHOO-WAH, 1972*
15 X 30", ACRYLIC ON BOARD
COLLECTION JAMES T. BIALAC, SCOTTSDALE

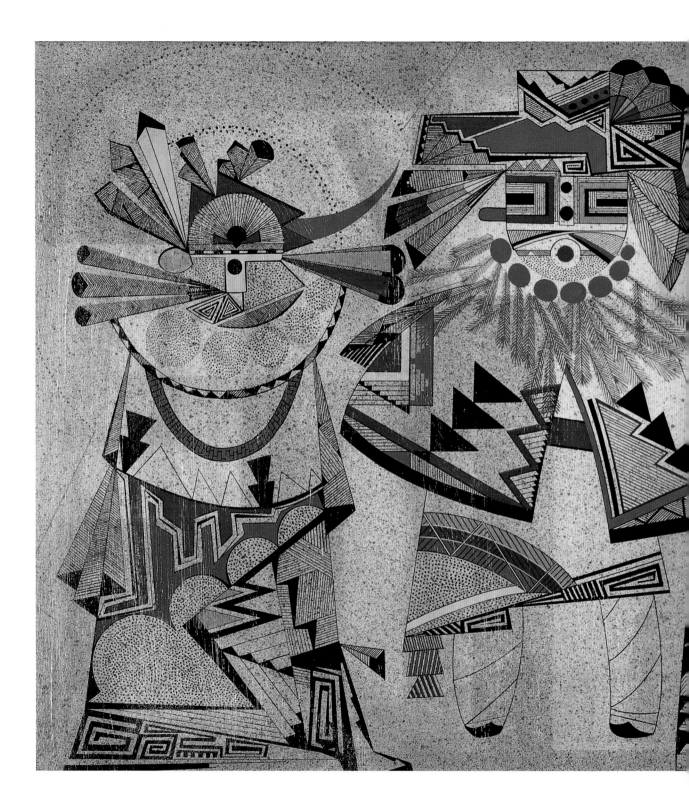

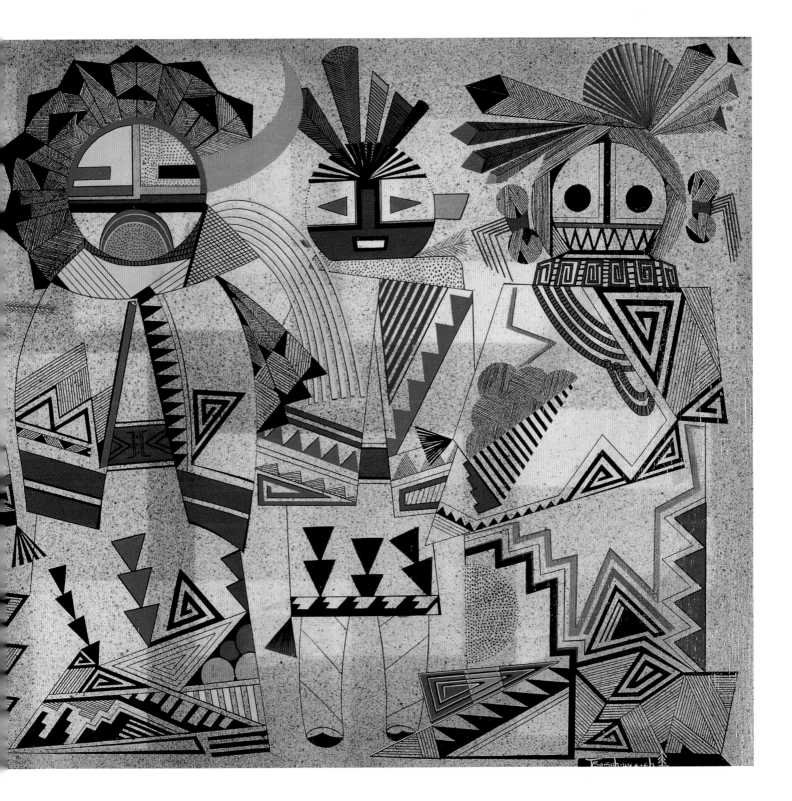

HELEN HARDIN (1943–1984)

Tsa-sah-wee-eh (Little Standing Spruce) ♦ Santa Clara Pueblo

✸

MIMBRES RABBIT

Because many of the Pueblo People believe the Mimbres People to be their ancient ancestors, several contemporary Pueblo artists find inspiration for their painting in the pottery of the Mimbres culture. *Mimbres Rabbit* is Hardin's personal interpretation of a basic Mimbres design motif. Using acrylic paint, drafting tools, and a splatter paint technique, Hardin created a composition in which a traditional Mimbres rabbit figure is a central form in a field of geometric patterns. The rabbit's tail is filled with additional geometric patterns that harmonize with and echo the large geometric forms serving as the background of the painting. These patterns and the pinks, purples, and blues of the geometric designs suggest the creative hand of a modern painter. The rabbit, however, is the color of clay used for ancient pottery, and its shape is reminiscent of the rabbit that was frequently the primary design on Mimbres pottery. Hardin said of her work, "My imagination is the soul of my work . . . I paint my spiritual response to the Indian experience. I use tradition as a springboard and go diving into my paints."[1]

Hardin's work at the time she painted *Mimbres Rabbit* was strongly influenced by the work of Joe Herrera, who was one of the first Pueblo artists to use Mimbres images. Herrera studied at the University of New Mexico with Albuquerque artist Raymond Johnson, who encouraged his students to paint traditional design motifs using the techniques of mainstream modern art. Hardin said of Herrera, "He was one of the first contemporary painters and, as a young girl, I was fascinated by his work even though he was criticized for having broken with tradition."[2]

Hardin relied on her intuitive sense of design in her paintings. She retained the primary form of the Mimbres rabbit image but incorporated this image into a composition filled with highly personalized geometric patterns. *Mimbres Rabbit* is Hardin's personal interpretation of a fundamental motif of the Mimbres People. Inspired by a pre-Columbian pottery image, she used the techniques of modern art to celebrate this icon of Pueblo culture.

31. *MIMBRES RABBIT*
15³/₄ X 11¹/₂", ACRYLIC ON MASONITE
PRIVATE COLLECTION

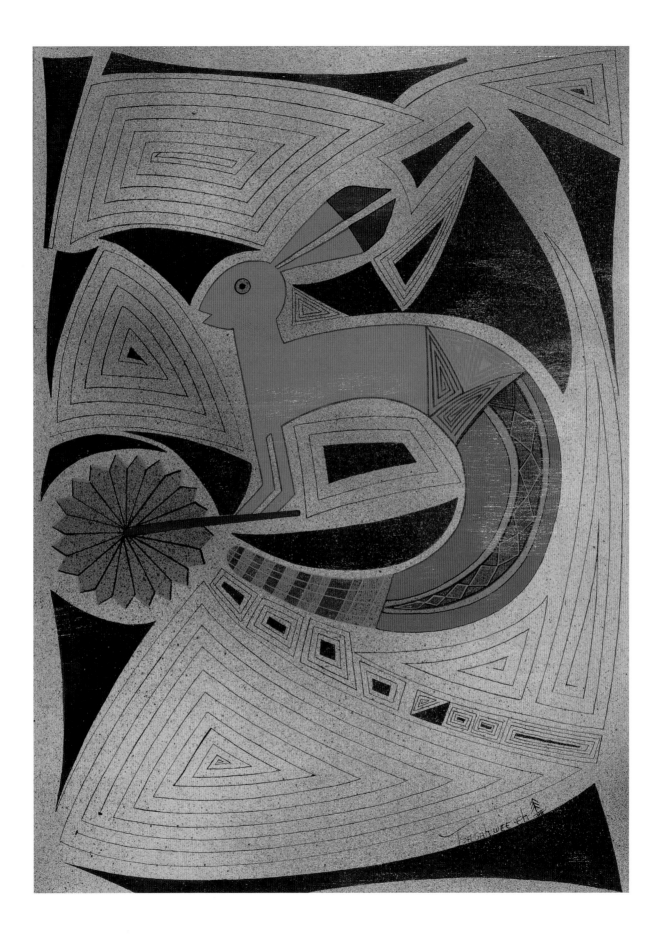

HELEN HARDIN (1943–1984)

Tsa-sah-wee-eh (Little Standing Spruce) ✦ Santa Clara Pueblo

❈

PRAYERS OF A HARMONIOUS CHORUS, 1976

In *Prayers of a Harmonious Chorus,* Helen Hardin has expressed a personal vision of a spirituality that is universal. She has painted layers of overlapping masks to invoke the music and movement of the dancers and chorus at a ceremonial dance. This painting exemplifies Hardin's power, at the height of her career, to create rhythms, harmonies, and echoes in both color and design which express the beauty and the spiritual intensity of the sacred rituals of the Pueblo People.

Hardin describes the colors in the painting as a combination of winter and summer tones. Each mask is an innovative geometric composition focused on the eyes and the mouths of the chorus open in song. The geometric designs of the Kachina masks are purely aesthetic creations. The masks are surrounded by identifiable Pueblo design elements: a turquoise necklace, eagle feathers, squash blossoms, and green boughs. The many brightly colored masks become a single entity, the embodiment of Pueblo ritual song. Here is an interlocking maze of masks that are rooted in her heritage but are the product of her imagination, set against a background of geometric patterns. Hardin describes her art, "Rather than painting a subject, I am inspired by that subject to paint what

I feel from the idea, the song, the ceremony, the mask. Traditional art tells its own story. Contemporary art leaves you with a feeling rather than a story."[1]

Although Helen Hardin, like her mother, Pablita Velarde, had had a Christian education, unlike her mother, she never was able to follow dual spiritual paths, Christian and Pueblo. As Santa Clara Pueblo is patriarchal, Helen never was permitted to participate in the rites of initiation. Like her mother, she was forbidden to participate in Pueblo ceremonials: "The only way I could express myself in prayer was to paint my interpretations of the songs. The Tewas have the most religious songs I have ever heard. They have these incredibly long, long chants, especially with the winter dances. There is so much storytelling going on in them. I just painted what I heard in those songs."[2] As she matured Helen developed independent spiritual beliefs and a personal understanding of the Pueblo Spirit World. She created images of the Pueblo spirits that were true to Pueblo spirituality but that were the product of her own imagination. "I paint as I feel it, not as I see it. I paint the song. I paint the abstract terms associated with that day."[3]

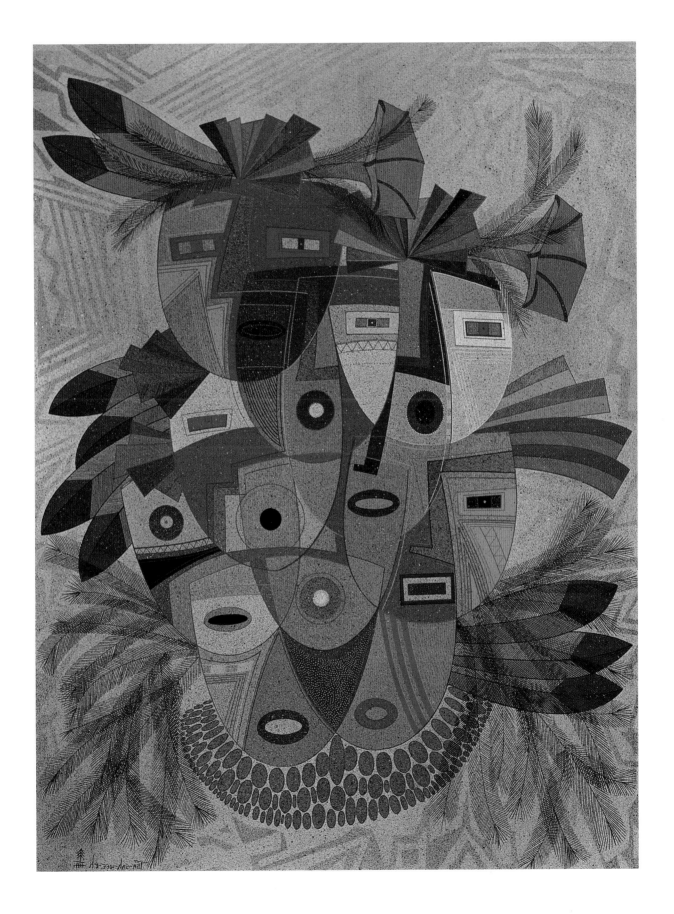

Tsa-sah-wee-eh

MARGARETE BAGSHAW-TINDEL (b. 1964)

Santa Clara Pueblo

✳

TWILIGHT MEETS DAWN, 1995

When in 1990 Margarete Bagshaw-Tindel made the decision to devote her full energy and time to becoming a professional artist, she inaugurated the first three-generation dynasty of modern American Indian women to win recognition as painters. Historically, painting was considered a contribution by those of artistic ability to the tribal good, not the creative expression of an individual; therefore, it is probable that through the centuries, generation after generation of talented women devoted their time and skills to painting symbolic designs on clothing and such utilitarian objects as parfleches and drums. Margarete Bagshaw-Tindel is the daughter of Helen Hardin and the granddaughter of Pablita Velarde, two women who achieved the pinnacle of success. This was an awesome precedent which during her school years deterred Margarete from aspiring to a career as an artist.

In 1982 Margarete, interested in a premedical curriculum, entered the University of New Mexico; however, instead of focusing on the sciences, she studied fine art, pottery, sculpture, dance, and theater, courses that were more in harmony with her true interests and abilities. In 1985 Margarete left the university, married, and had two children. She recalls, "Two-dimensional art was my mother's territory, even after she passed away, I didn't feel I should explore that field."[1] Rather than compete with her famous grandmother and mother, Margarete focused on sculpture and pottery, although occasionally, in private, she attempted a drawing or painting.

Once she began to paint, she realized that this was the work that brought her happiness and fulfillment. "Every time I sit down to draw, it pulls something out. Whether it is religious, motherly, passionate, or feeling, I learn something. People are not static, thus my drawings are recorded instances of my emotional state, which changes from moment to moment."[2] As she began to enter competitions and was invited to participate in a series of museum exhibitions, she began to develop a sense of family tradition. In 1987 she accepted an invitation from the Wheelwright Museum of American Indian Art in Santa Fe to give a lecture on the life and art of her mother, Helen Hardin.

In 1994 she participated in the mural project *Shared Traditions, Universal Perceptions,* funded by City of Albuquerque for the South Broadway Cultural Center, and in 1995 accepted a second mural project *Shared Traditions,* funded by the Indian Cultural Center and the Bank of America for the Indian Pueblo Cultural Center. In 1996 she had her first one-woman show in Galveston, Texas.

Today, Margarete Bagshaw-Tindel is secure in her identity as an artist. In *Twilight Meets Dawn,* she celebrates a turning point in her art, a new direction for her painting. At this time, her sense of composition changed and she realized a new sense of depth and dimension in her art. Bagshaw-Tindel explains, "We think of twilight and dawn as two separate times, but really, they meet somewhere at all times. Life, in every aspect, happens in a circle. *Twilight Meets Dawn* is an illusion."[3] She believes that this painting represents the new person she has become, but although she has turned in a new direction, there always is harmony and a sense of continuity with the past. Bagshaw-Tindel believes that fundamentally life is a circle, that in life the beginning and end meet, just as there is a harmony and an intrinsic bond between twilight and dawn.

The colors of the painting are the harmonious, brilliant spectrum colors of sunset and sunrise. Forms, both curvilinear and angular, and multiple layers of color represent the primary forms and colors of earth and sky. Bagshaw-Tindel writes, "The idea is that life is a continuous circle; one thing always affects something else. Even though there is change, time never stops, it just turns it to something else. The colors harmonize, as well as showing change."[4]

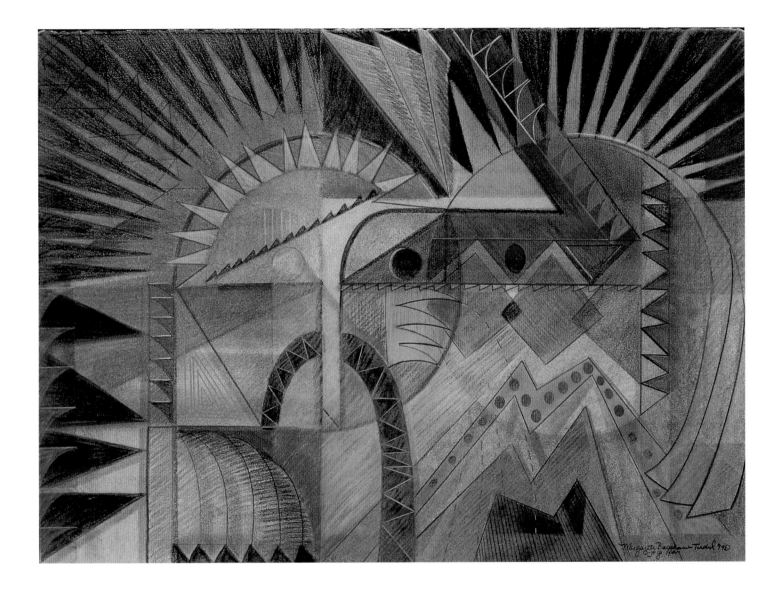

33. *TWILIGHT MEETS DAWN*, 1995

22 X 30", PRISMACOLOR, PASTEL, AND PENCIL ON COTTON RAG PAPER

PRIVATE COLLECTION

PHOTOGRAPH COURTESY OF THE ARTIST

MAXINE GACHUPIN (b. 1948)

Jémez Pueblo

☀

TWO MASKED DANCERS, 1968

In 1968 Maxine Gachupin painted *Two Masked Dancers,* one of the most original representations of participants in a Kachina ceremony. By focusing on cropped images of two masks, Gachupin transformed her painting into a study of geometric patterns and forms, straight lines, semicircles, and circles, and of the colors and texture of the painted surface.

Gachupin's historic home is the Jémez Pueblo, a pueblo which for over three hundred years has closed all Kachina dances to the public. This decision was made in 1693, following the Spanish reconquest of the pueblos and the Spanish reprisals on the Pueblo People for mounting the Pueblo Revolt of 1680. Determined to convert the Pueblo People to Catholicism, the Spanish prohibited all traditional Pueblo religious rituals, especially ceremonies involving Kachinas. The Spanish believed that all indigenous religious ceremonies were pagan and, whenever possible, they destroyed all ceremonial paraphernalia, including Kachina masks.

In time, many of the Jémez People converted to Christianity, as many were able to fuse Christianity with the faith of their ancestors. In celebrating Catholic holidays, there are ceremonial images of the Christian holy family and day-long dances by the two *moieties* of the Pueblo, squash and turquoise, which are traditional ritual prayers for the growth of an abundant corn crop and a successful harvest. At the Jémez Pueblo, those dances that at least in name are Roman Catholic feast days, such as those performed on a saint's name day, are open to the public.

Although the Jémez people do not have Kachina societies, the people of this pueblo have adopted the concept of the Kachina from neighboring pueblos. In secret ceremonies, the Jémez masked dancers personify supernatural spirits. The Jémez Kachinas appear in pairs, a male and female. Often thought of as cloud spirits, they are identified with ancestors who help secure the well-being of the people by bringing rain which is necessary for the crops to grow. The resulting harvest will feed the people and sustain life at the pueblo. At the Jémez Pueblo, Kachina masks often are buried with those who, during lifetime, danced as that particular Kachina spirit.

In *Two Masked Dancers,* one mask has vertical lines at the bottom, which signify falling rain. This is a Bearded Kachina, usually a male Kachina. Both of Gachupin's Kachinas have small feathers at the top of their masks. These tiny feathers come from the breast of the eagle and represent the Breath of Life. Between the two Kachinas are sacred prayer feathers. The wash of light and dark colors, which serves as the background, suggests rainfall.

Gachupin's painting is successful on two basic levels: It pays tribute to her Jémez heritage and reconfirms her faith in the traditional beliefs of her people, and it is a successful abstract composition. As her abstractions are truly personal creations—studies in design, line, and surface texture—Gachupin has created an aesthetic rather than an ethnological study and so is able to maintain the secrecy of the Kachina dance at the Jémez Pueblo.

Maxine Gachupin was born in 1948 at the Jémez Pueblo, which is situated on the Jémez River in New Mexico. She attended the Jémez regional school, St. Catherine's Indian School in Santa Fe, and the Institute of American Indian Arts. She has exhibited her paintings in many museums, including the Museum of New Mexico, the Philbrook Museum of Art, and the Native American Center for the Living Arts in Niagara Falls, New York. She also has been a participant in many Indian art exhibitions, including the *Santa Fe Festival of the Arts* and the *Scottsdale National Indian Art Exhibition.*

34. *TWO MASKED DANCERS*, 1968
36 X 24", OIL ON CANVAS
PHOTOGRAPH COURTESY OF THE INSTITUTE OF AMERICAN INDIAN ARTS MUSEUM,
SANTA FE, PHOTOGRAPH BY LARRY PHILLIPS, SANTA FE

GERALDINE GUTIÉRREZ (b. 1959)
Santa Clara Pueblo / San Ildefonso Pueblo

❋

POTTERY SPIRITS

Geraldine Gutiérrez has a rich artistic heritage. For generations both her maternal San Ildefonso ancestors and her paternal Santa Clara ancestors were outstanding Pueblo potters. Her father, Frank Gutiérrez, is a distinguished Santa Clara potter. A self-taught artist, Geraldine Gutiérrez first attempted to paint at age eight, and by age ten, she had won first prize for her painting of Juan Oñate, a Spanish conquistador. Her earlier inspiration came from watching her maternal uncle, Gilbert Atencio, a San Ildefonso artist, sketch and paint. Atencio was impressed by his niece's early efforts and encouraged her to continue painting. Geraldine's admiration of her uncle led to her decision to work with watercolors in a traditional two-dimensional style.

Geraldine's mother, Helen Atencio Gutiérrez, was highly supportive of her daughter's art and advised her to enter her work in the children's division of the competition at the Eight Northern Indian Pueblo Market and at the San Ildefonso Pueblo and the Santa Clara Pueblo competitions. After enjoying success in these youthful contests, in 1977, at age eighteen, she competed for the first time in the adult division at the San Ildefonso Pueblo and won an award.

Since that time, Gutiérrez has worked as a professional artist and has received regional recognition for her paintings. In 1980 Gutiérrez and her uncle, Gilbert Atencio, were the focus of a two-artist exhibition at the Indian Pueblo Cultural Center in Albuquerque. The following year Gutiérrez completed paintings for a folio of prints that focused on innovative images of traditional Pueblo daily and ritual life. In four compositions, she utilized historical symbols and designs.

Gutiérrez's paintings illustrate her knowledge of her people and their artistic heritage. *Pottery Spirits* is an imaginative composition in which the Sun Spirit rises over a historic San Ildefonso polychromatic water jar. The use of red in polychromatic pottery decoration is a San Ildefonso tradition. Using sacred images from Pueblo mythology, Gutiérrez includes a water serpent, which is a Rain Spirit; turquoise, the sacred stone of the Pueblo People; and handprints, the mark of ancestral generations. Seven Koshares climb over and around this historic vessel. Three emerge from the rim, two climb on the shoulder, and two add their handprints to the base beneath the decorated area. The Koshares carry tiny San Ildefonso ceremonial bowls filled with sacred cornmeal.

The Koshares, clowns who are ritual dancers, represent holy beings. They are key participants in initiation ceremonies, planting and harvest dances, and ceremonies for cures. Historically, there were both male and female clown societies; however, today the vast majority of clowns are men. At dances they frequently are in charge of the collection and distribution of food. Satirizing the errors and foolishness seen daily in the Pueblo world, the Koshares remind the Pueblo People that their purpose on earth is to seek and confirm life. Dr. Peggy Beck, in her introduction to *Koshare, Koyemski and Kossa: Native American Clown Painting,* wrote:

Ritual clowns portray the Road of Life with all its pitfalls, sorrows, and laughter. They dramatize the powerful relationships which structure our lives: our relationship to our environment, the rain, seas, earth, sun, and animals which provide our food; our relationship to our community of which were are a part, whether we like it or not; our relationship to our families and lovers, to our enemies and friends; and our relationships to ourselves, our dreams, hopes, and fears.[1]

35. POTTERY SPIRITS
13 1/2 X 10", WATERCOLOR ON PAPER
PRIVATE COLLECTION

Geraldine Gutierrez 81

MICHELLE TSOSIE NARANJO (b. 1959)

So Whu Wa Tung ♦ Santa Clara Pueblo / Navajo / Laguna Pueblo / Mission

❈

THE FALL IS ENDING SISTERS

Michelle Naranjo has the rich heritage of Native American ancestry; however, married to a Santa Clara man and living in Espanola, an urban center in the heart of the Rio Grande Pueblos, she has primarily a Santa Clara identity. Her paintings are inspired by the cultural legacy of the Santa Clara Pueblo and her painting *The Fall Is Ending Sisters* is a watercolor metaphor of the continuance of life in the Pueblo world.

Michelle Tsosie grew up experiencing both daily and ceremonial life in both Pueblo and Navajo communities. Born in 1959 in Albuquerque, she is the daughter of Carol and Paul Tsosie. In 1977 she graduated from Window Rock High School, in the capital of the Navajo Nation. She devoted one year to completing a program in accounting at the College of Santa Fe.

Naranjo is a participant in both the fashion and the art world. Painting, however, always has been her primary strength, and today she works in a variety of media—pencil, pen, and ink, pastel, watercolor, gold leaf, and mixed media.

During the late 1970s, she participated in many major Indian art exhibitions across the Southwest and entered and won many painting competitions. Among her honors are first prize in the 1978 S.W.A.I.A. (Southwestern Association on Indian Affairs) competition at Indian Market in Santa Fe and the award for the best in the painting division in the 1984 competition of the Museum of Northern Arizona.

The Fall Is Ending Sisters celebrates the harvest of the corn crop and the important role of women in Pueblo life. The central figures in the painting are five Santa Clara women wrapped in blankets. They are giving prayers of thanks for the completion of a successful harvest. They are Corn Maidens, the personification of sacred corn. In the Pueblo world, both corn and women are identified with reproduction and the sustenance of life. The five women sit beneath a terraced structure, a geometric form that suggests both a Pueblo building and terraced clouds, which are symbolic of life-giving rain. Repeated along the bottom of the terraced form is a small design suggestive of fertility, a flute player with a sack of corn kernels on his back. The women's blankets have decorative borders featuring a variety of historic Pueblo water symbols often associated with pottery.

Naranjo's painting is a composition in earth tones. Green stalks bearing multiple ears of fully ripened corn form a border at the base and the upper corners of the painting. The women have long hair and bangs that echo the form of the tops of the corn and the strands of corn silk. The only colors in the painting that are not earth tones are the greens of the cornstalks and leaves. Naranjo covers the terraced structure, which is man-made, with a wash of earth tones, but she uses neither shading nor darkened outlines on the ears and stalks of corn.

This painting is not a genre scene, an image of Pueblo life, because, having no background images, there is no sense of place. These are eternal figures in the cycle of Pueblo life. The Corn Maidens are not individuals, for their faces lack distinct features. Having rosy lips and luxuriant hair suggestive of the bloom of womanhood, they represent women at the height of their reproductive years. The geometric form that serves as their eyes is reminiscent of sacred corn kernels. The women are wrapped in blankets, for it is cold as winter approaches. The loosely wrapped blankets of three women reveal *mantas* and a rain sash, the ceremonial dress of Pueblo women which is worn when performing ritual prayers for the growth of the corn crops.

The Fall Is Ending Sisters is a scene of the total harmony of the Pueblo People with the natural world. All is focused on the growth and harvest of the corn crop and, in turn, the sustenance of life at the pueblo. This painting is a confirmation of motherhood and tradition. Michelle Tsosie Naranjo says of her art, "I wish to express my life as it is, a Native American woman living in today's world, to relay a message, beauty, spirit, motherhood, womanhood, and traditionalism in a very contemporary lifestyle."[1]

36. *THE FALL IS ENDING SISTERS*
12⁷/₈ X 19¹/₂", WATERCOLOR ON PAPER
PRIVATE COLLECTION

SYBIL YAZZIE

Navajo

✦

A CROWD AT A NAVAJO N'DA-A, 1935

Sybil Yazzie has painted a tapestry of Navajo ceremonial life, *A Crowd at a Navajo N'da-a,* which includes 170 Navajo in traditional dress and 59 horses. This painting depicts a social dance, a Squaw Dance. One of the functions of the Squaw Dance is to announce publicly that the girls participating in the ceremony and asking the young men to dance are of marriageable age. Young men come to the Squaw Dance to sing, dance, and look over prospective brides. The Squaw Dance continues all through the night. The women in the Squaw Dance wear traditional fringe shawls and long velveteen dresses. The men wear jeans, velvet shirts, plus cowboy hats (an ever-present sign of acculturation).

In 1937, when Yazzie was still a student of Dorothy Dunn, this elaborate portrait of a traditional Navajo ceremony was exhibited in London and Paris. It was admired by European viewers and praised by one critic as "not naïve and childish, but a finished work of art, expert in craftsmanship, intricate in detail, and unerring in color."[1]

Although this painting is Yazzie's most complex work, throughout her career she was devoted to portraying the daily ceremonial life of the Navajo People. Dorothy Dunn wrote of her gifted student:

> Sybil Yazzie excelled in miniature. Scores of horses and human figures filled her paintings so rich in color and imaginative in statement. Her broadly inclusive ceremonials would shine in the dark or sparkle in the sunlight; she had a gift for selecting the right color hues and values for chosen occasions. Within the larger patterns, her tiny motifs of necklaces, bracelets, belts, hatbands, harnesses, fringes, and like ornaments studded each scene with meticulously wrought decoration.[2]

37. *A CROWD AT A NAVAJO N'DA-A*, 1935
14 X 24", TEMPERA ON PAPER
COLLECTION HOWARD AND SUE HUSTON

SYBIL YAZZIE

Navajo

❋

NAVAJO WEDDING, 1936

Sybil Yazzie not only chose as the subjects of her paintings the pageantry of great ceremonial gatherings of the Navajo People, but portraits of intimate ritual moments in the Navajo world. *Navajo Wedding* depicts a significant rite of passage in traditional Navajo life.

According to tribal law, a girl must be eighteen before she marries and a boy must be twenty-one. In the traditional Navajo world, the boy's father searches for a suitable wife for his son, makes his initial choice, then asks his close relatives whether there are any objections to the union. If none are given, he then goes to the bride's family to ask for her hand in marriage. If they agree to his request, they discuss the dowry, which the young man's family will pay. Whereas in olden times twelve horses was considered to be a generous price, today the dowry is usually cash or an equivalent acceptable gift. Traditionally, the family of the bride sets the wedding date, which is an odd number of days in the future, for example, seven or eleven days. Often a new hogan, a traditional Navajo house, is built for the young couple.

On her wedding day, the bride is bathed and dressed in her best traditional clothing. The bride's family brings the food to the wedding to feed the guests. The mother of the bride cooks unseasoned cornmeal, which she puts in a Navajo wedding basket.

When all the preparations for the wedding are completed, the master of the ceremony, often the bride's father, carrying a water jug or bucket, a ladle, and a bag of corn pollen, leads the procession. The groom, who is not part of the procession, has already entered the hogan through the door, which always faces east. He goes first to the south, then sits on the north side of the hogan. The bride, followed by members of her family carrying the food for the wedding, arrives with a wedding basket filled with mush. She sits next to her prospective husband and places the basket in front of

him, the break in the design of the basket facing east. The master of ceremonies then puts the water jug in front of the bride, gives the ladle to her, and tells her to pour water over the groom's hands so that he can wash. The groom then pours water over his bride's hands and she washes.

The master of ceremonies then takes a pinch of pollen, which he sprinkles in lines on the mush—east to west, then north to south. He then makes a circle of pollen on the mush and tells first the groom, then the bride to take a pinch of mush from the east side of the basket and put it in their mouths. This ceremony completed, the master of ceremonies invites the guests to eat. After the meal, one of the groom's family gives a speech, thanking his hosts for the good food and excellent reception, and instructs the groom on how to be an honorable husband, emphasizing that he must never abuse his wife or be unfaithful. Then a member of the bride's family gives a similar speech of appraisal and advice. Others at the wedding may speak, and when the speeches are completed, the wedding is over and the groom's family returns home.

In 1936 Sybil Yazzie painted *Navajo Wedding,* portraying the moment when the bridal couple has been seated and the marriage ritual will begin. This painting is one of the earliest paintings of the interior of a hogan.

Yazzie has painted a detailed portrait of the sacred ceremony. The bride and groom each sit on colorful traditionally woven Navajo blankets. Beautifully woven blankets also are attached to the hogan walls. Yazzie paid close attention to detail in the traditional Navajo dress of the bridal couple and their guests. The guests wear skirts and shirts of brightly colored velvet, and their hair is dressed in the traditional Navajo style, long hair rolled, then tied with string. In the Navajo world, silver jewelry bestows status, and the wedding guests wear squash blossom and beaded necklaces, concha belts, silver and turquoise bracelets, and *ketohs* or bowguards.

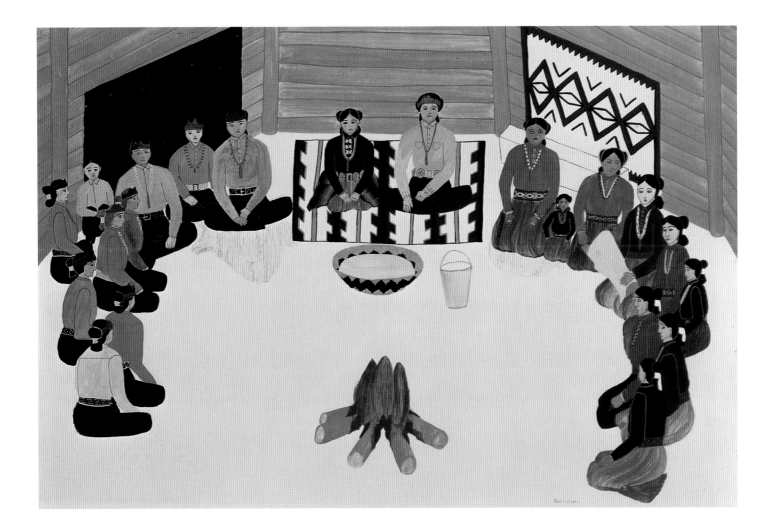

38. *NAVAJO WEDDING*, 1936
19³/₈ X 13³/₄", TEMPERA ON BOARD
COLLECTION DOROTHY DUNN KRAMER
PHOTOGRAPH COURTESY OF MUSEUM OF INDIAN ARTS AND CULTURE/LABORATORY OF
ANTHROPOLOGY, SANTA FE
PHOTOGRAPH BY BLAIR CLARK

SYBIL YAZZIE

Navajo

❋

NAVAJO WEAVERS, 1935

In July 1868, Congress ratified a peace treaty that permitted the Navajo People to return to a 3.5 million-acre reservation in their historic homeland from which they had been forcibly removed in 1863 by troops led by Colonel Christopher (Kit) Carson. Carson's actions were authorized by General James H. Carleton, the newly appointed military commander of New Mexico, who had mounted a campaign to destroy the Navajo and gain for the United States complete control over Navajo land and its resources. Carleton's stated purpose was to protect the Union's line of communication with the West; however, letters written in 1863 make it clear that his primary motive in removing the Navajo from their homes was his belief that Navajo land had deposits of gold far richer than those discovered in California.

Kit Carson carried out a scorched earth campaign, tearing up the corn fields, destroying orchards, slaughtering livestock, and burning Navajo homes. He ordered his soldiers to kill all Navajo men who offered resistance. Over eight thousand Navajo made the three-hundred-mile journey to Fort Sumner, an ordeal that now stands in history as the Long Walk.

The plan to transform the Navajo into village workers and farm dwellers was a failure from the start, and Carleton failed to find gold in Navajo land. When the Navajo returned to the land ravaged by Carleton and his men, the government of the United States, under the conditions of the Treaty of 1868, provided each Navajo with two sheep and a goat and, when necessary, provisions for a period of ten years.

The Spanish had introduced horses, sheep, cattle, and goats to the Navajo world. During the years prior to the Long Walk, the Navajo had acquired thousands of sheep and horses; therefore, with the United States government's encouragement, they easily returned to a tradition of stock raising. As the number of their flocks increased, the raising of sheep, the shearing of sheep, carding, spinning, and dyeing of wool, and the weaving of textiles became fundamental parts of Navajo life. Weaving the wool of the sheep became an all-important craft art in the Navajo world.

It is believed that the Navajo brought spindles and looms and the knowledge of weaving with them to the Southwest. It is thought that three thousand years ago, ancestors of the Navajo, migratory Athapaskans, came from Asia across the Bering Strait to the North American continent, then migrated along the eastern slope of the Rocky Mountains to the southern border of Colorado. The Navajo then traveled southwest to the San Juan Valley in northern New Mexico. In the early eighteenth century, in search of grassy plains and fertile valleys, they migrated southwest to their present-day homeland.

Although weaving had been part of Navajo culture for many years, the Navajo acquired new weaving skills from the Pueblo People who had taken refuge in Navajo territory fearing reprisals from the Spanish following the Pueblo Revolt of 1680. There are, however, many distinctions between Navajo and Pueblo weaving.[1]

The Navajo use a spindle and a round stick about twenty-five to thirty inches long, which is painted on both ends. The whorl is a flat disk, four to five inches in diameter, that acts as a balance. The spinner twirls the spindle with her right hand, using her left hand to spin the loose roll of yarn as it slips off the twirling spindle. As the wool becomes yarn, the spinner winds it on the spindle above the whorl, where it is stored until there is enough to form a ball. Most wool is spun at least twice to obtain the desired smoothness and strength. The Navajo use an upright loom that has two parts, the weaving frame and the poles and crossbeam that hold the frame. The weaver ties the upper and lower bars in place and winds the warp thread between them.

In *Navajo Weavers,* Sybil Yazzie depicts three women working to create an exceptionally large blanket. Two women kneel side-by-side at a giant upright loom. A third woman sits in front of the loom as she prepares the dyed wool for weaving. A giant loom that necessitates two weavers is a rare sight on the Navajo Reservation, an occasion Yazzie wished to record for posterity. The weavers wear traditional dress and their hair is tied in the *chonga,* the hairdo of married women.

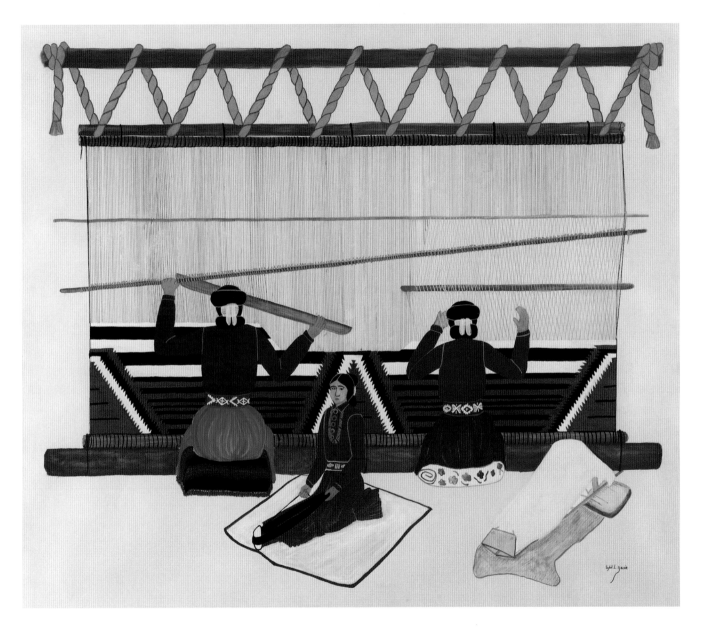

39. *NAVAJO WEAVERS*, 1935

16⁵/₈ X 19¹/₈", WATERCOLOR ON PAPER

COLLECTION THE NEWARK MUSEUM, NEWARK

GIFT OF MRS. AMELIA ELIZABETH WHITE, 1937 (SO119288, 37.173)

PHOTOGRAPH COURTESY THE NEWARK MUSEUM/ART RESOURCES, NEW YORK

MARY ELLEN

Navajo

✹

YEIBICHEI DANCE, 1930s

The Navajo People believe there are two classes of personal forces in the universe, human beings and the Holy People, supernatural beings who are holy because they are mysterious and powerful. The Holy People have great powers over all the people on earth. Many ceremonial rituals help the Navajo to become in tune with the Holy People. The Navajo believe that the universe functions in accordance with specific, set rules. A Navajo must learn these rules and follow them in order to live in harmony and safety, or having strayed, must follow these rules in order to return to harmony and safety.

Mary Ellen, a young Navajo woman who in 1936 and 1937 studied with Dorothy Dunn at the Studio, was one of the first Navajo to use watercolors to portray, with great realistic detail, the sacred ceremonies of her people. In *Yeibichei Dance,* Mary Ellen depicts a special moment in the nine-day Nightway Yeibichei ceremonial. The Yeibichei are dieties, supernaturals, who are principal figures in Navajo ceremonial life. The Nightway, a complex of ceremonials performed according to a prescribed ritual, is believed to be a cure for illness. Singing is performed for nine nights and sand paintings are made on the last four days.

Mary Ellen, in *Yeibichei Dancers,* has chosen the moment when the dancers first come out of the Medicine Hogan led by the singer, who sprinkles sacred cornmeal on the right arm of each Yei ii, or sacred dancer. The dancers, representing male deities, have naked torsos, their thighs and upper extremities whitened. There are an equal number of male and female

Yeibichei dancers. Each male Yeibichei dancer wears a collar of spruce, a loincloth, dark wool stockings with garters and moccasins, a silver concha belt with foxskin suspended in the rear, and bracelets, ear pendants, and necklaces of turquoise, silver, shell, and coral. Each carries in his right hand a gourd rattle, and in his left hand a spruce twig wand. Female Yeibichei dancers wear traditional Navajo dress and hold spruce boughs, symbols of longevity, in each hand. Both male and female Yeibichei dancers wear blue masks with a horizontal streak at the bottom, crossed by four pairs of perpendicular black lines. The dancers are painted and dressed in the Medicine Hogan.

Navajo families from near and far come to this ceremony. They build their fires, which will help to keep them warm, as they will remain until the nightlong ceremony is concluded. Mary Ellen includes a line of male and female Yeibichei dancers surrounded by groups of men and women who have come to witness the Yeibichei ceremony and thus gain the feeling that once again harmony has been restored to the Navajo world.

Mary Ellen's work is distinguished by a special blend of elegance and poetic grace and highly realistic ethnological detail. During her brief career, Mary Ellen participated in *The American Indian Exposition and Congress* in Tulsa in 1935 and in the exhibition *Contemporary American Indian Painting* at the National Gallery of Art in Washington, D.C., in 1953. There is no record of Mary Ellen painting after 1950.

40. *YEIBICHEI DANCE, 1930s*
18 X 24¹/₂", WATERCOLOR ON PAPER
COLLECTION LETTA WOFFORD, SANTA FE

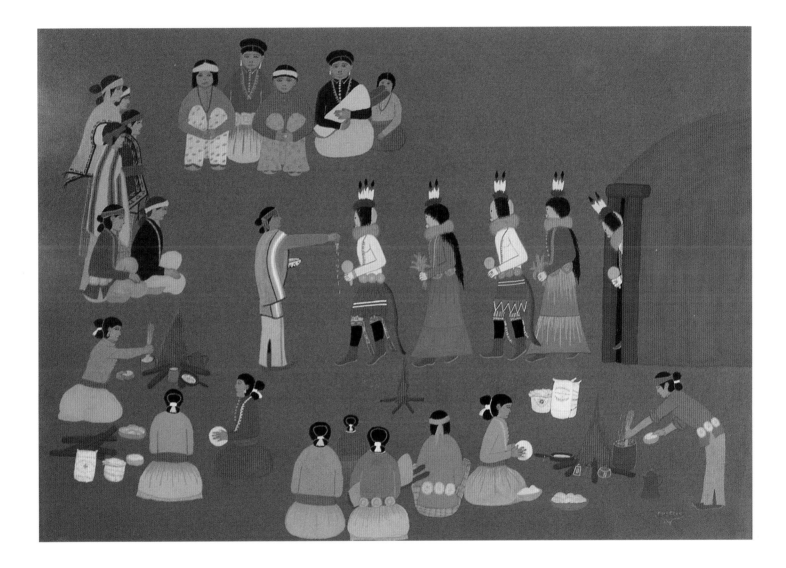

ROSALIE JAMES

Navajo

❋

NIGHT SINGERS AND DRUMMER, 1936

The Navajo People believe that sings are of great importance in ensuring the survival of their people, known as the Diné, and their culture. Navajo dances and sings are held throughout the year for a variety of reasons. Some ritual sings celebrate rites of passage, for example, the Kinaalda, which is a puberty ceremony for young women, and some sings serve as a ritual cure. Often these ceremonies include the creation and destruction of sand paintings. The Navajo believe that sings, special occasions when family and friends gather and enjoy a sense of community, not only protect and heal the body but also help the mind. Traditionally, the Navajo have neither churches nor temples, for they believe that their gods are always with them. The Navajo believe that their homeland is a holy place surrounded by four sacred mountains. San Francisco Peak in the west, Mount Taylor in the south, La Plata Peak in the north, and Blanco Peak in the east.

A majority of the sings are held at night by firelight and the fire never is permitted to go out. A Medicine Man is the lead singer for many sacred ceremonies. He begins the chant and his assistants and other participants join him because the Navajo believe that all singers who impart good thoughts and feelings are a positive addition to the power of the ceremony. The Medicine Man and his assistants memorize the chants and are expected to provide a flawless performance. The chants never have been written and singers provide their own interpretations. A container of water is placed near the singers so that they may keep their mouths moist all through the night. Traditionally, the songs are directed to the Holy People, particularly such deities as Talking God, Changing Woman, and White Shell Woman. Changing Woman, one of the most important Holy People, played a major role in the creation of the Navajo People. She taught the Navajo to control the elements—storms, winds, and lightning—and teaches them to live in harmony with each other.

Rosalie James was one of the first women to study with Dorothy Dunn at the Studio. James in her painting followed the conventions of the Studio. She made domestic and ritual life the primary subject of her art. She created conceptual paintings that were drawn from her memory and imagination. Dunn also encouraged her students to use as their model such precontact sources as Kiva murals and Anasazi pottery images. Rosalie James's figures in *Night Singers and Drummer* have profiled faces and frontal eyes, a convention traceable to Anasazi kiva murals. The singers hold boughs of spruce, an evergreen that symbolizes the continuance of life. The singer and drummer are two-dimensional figures composed of flat areas of color surrounded by dark outlines. James showed an interest in design, as the pants and shirts of the figures are distinguished by geometric and natural decorative patterns. There is considerable sophistication in her choice of colors, which include a great variety of subtle shades and variations in intensity.

The dress of the singers and drummer, like the world of the Navajo, is part traditional and part contemporary. They wear woven rain sashes, headbands, deerskin boots, bracelets and beads of turquoise, all echoes of their heritage, as well as store-bought shirts and pants. A red star surrounded by radiant yellow is on the cheek of each dancer, a decoration that emphasizes that the sing, like the stars, lasts throughout the night.

James's figures are not individuals, but part of the ritual, their mouths identically open in song. (She shows an interest in realism for a couple of the figures have a slight paunch.) James achieves the illusion of three dimensions by the placement of the singers in rows. The gestures of the arms and legs suggest both depth and movement to the beat of the drummer. Rosalie James painted *Night Singers and Drummer* on a sheet of black paper. The figures occupy half of the paper so that half of the scene is the blackness of night through which sound the voices of the singers and the drumbeat. This is the essence of a Navajo ritual chant.

EARTH SONGS, MOON DREAMS

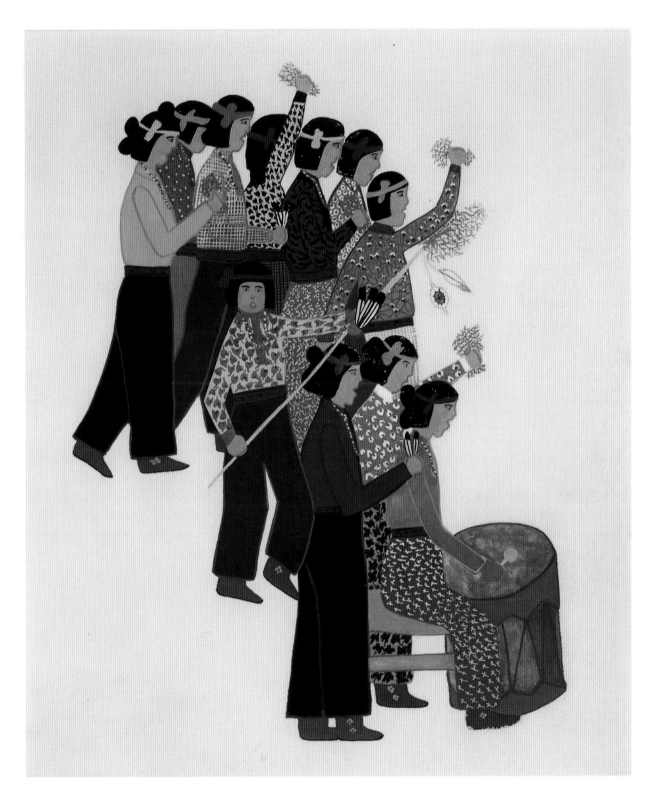

41. *NIGHT SINGERS AND DRUMMER*, 1936

10 X 8", TEMPERA ON PAPER

COLLECTION TOM AND ROBIN ORR

BEVERLY BLACKSHEEP

Geneha ♦ Navajo

✹

NAVAJOLAND, ca. 1990

Beverly Blacksheep lives in the heart of the Navajo Nation, surrounded by the people and images that inspire her paintings. In *Navajoland,* Blacksheep has painted a monumental image of a Navajo woman standing on the desert floor, surrounded by symmetrical images of sheep, local plant forms, hills, and mesas. Overhead, a thin pastel blue semicircle represents the arc of heaven. At the bottom of the painting is a border of concentric geometric shapes which, Blacksheep explains, are symbols of Navajo weaving.[1] Except for the jet black of the Navajo woman's hair, all the other colors—her pale skin and her traditional costume, the sheep, the plant forms, the desert sands, the hills, and the two-dimensional images of desert spires—are reminiscent the Navajo desert with its pastel blues, pinks, and purples.

The Navajo call themselves the Diné (The People). They are descendents of the small bands of people who crossed the Bering Straits from northernmost Asia to Alaska, then journeyed southward. The land, which today is the Navajo Reservation, has special meaning to the Navajo People, for in 1863, the United States government attempted to follow a plan formulated by General James Carleton to resettle the Navajo People on a reservation created at Fort Sumner in southern New Mexico. There, the government planned to transform the Navajo into farmers so that they no longer would be feared as warriors and raiders. All who resisted Kit Carson, who led the troops that captured the Navajo, were shot and their livestock and their food supply destroyed.

This planned resettlement of the Navajo was a failure resulting in poor crops, disease, and death. In 1868 the four-year forced exile was ended by the signing of a treaty between the United States government and the Navajo that established a 3.5-million-acre reservation for the Navajo in their ancestral home, the land from which they had been removed.

Beverly Blacksheep was born on the Navajo Reservation and attended Northern Arizona University, where she majored in interior design. In the course of her education she acquired a knowledge of draftsmanship and color. A self-taught painter, Blacksheep, who describes her style of painting as "traditional contemporary," writes of her art, "My paintings are my connection with the way of life, simple, yet rich in tradition and history. Through my art, I have come to realize a deep appreciation of my heritage and the importance of preserving that heritage for generations to come."[2]

Blacksheep has won many awards for her paintings in the art competitions at the Inter-Tribal Ceremonial in Gallup, New Mexico, and at the Navajo Nation Fair in Window Rock, Arizona. In 1994 her painting *Moonlight Harmony,* which depicts three Navajo ceremonial singers, was chosen as the poster image for the seventy-third annual Gallup Ceremonial.

Blacksheep tries to achieve in her work the sense of harmony between nature and humanity that exists in the Navajo world. In *Navajoland,* the symmetry, the composition, and the absolute stillness of her pastel imagery create a sense of timelessness. Her paintings suggest that Navajoland is eternal and that although the Navajo People and the Navajo Nation have endured hardships in the past, Navajoland will survive and maintain its presence in the future.

42. *NAVAJOLAND,* ca. 1990
16 3/8 X 12 1/2", WATERCOLOR ON PAPER
PRIVATE COLLECTION

JEANETTE KATONEY (b. 1967)

Navajo

✦

BEAUTY OF THE CLOUDS, 1995

The paintings of Jeanette Katoney celebrate the harmony and beauty of the Native American world of the Southwest. Born and educated on the Navajo Reservation, Katoney has lived in accordance with the traditional values and ideals of the Navajo People. Born to a family belonging to the Hardrock Chapter, Jeanette Katoney's childhood home was the arid land near Dinnebito. Her maternal grandmother, Mary WhiteHair, and her mother, Alice WhiteHair Katoney, were admired and respected for their skill as weavers. Jeanette's maternal grandfather, WhiteHair, was a distinguished Medicine Man. Her father, Noah Katoney, having served his apprenticeship with WhiteHair, also became a respected Medicine Man. During Jeanette's childhood, Noah Katoney supported his family by working for the Santa Fe Railroad. Young Jeanette was the baby of a family of four boys and three girls. As the Navajo are matrilineal, Jeanette became a member of her mother's clan, the Salt Clan.

In accordance with the educational system of the Navajo Reservation, at age five Jeanette was sent to boarding school at Rocky Ridge. She lived at Rocky Ridge from kindergarten through third grade, then attended grades four through six at a boarding school in Tuba City, on the border of the Hopi Reservation. By age twelve Jeanette had spent seven years, six months a year, living apart from her family. She next attended Winslow Junior High School, a regional day school, because her father's work with the railroad necessitated that the family live in Winslow. She then was sent to Tuba City High School, another boarding school.

In 1988 Jeanette received a two-year Navajo Nation scholarship to study at Glendale Community College, west of Phoenix. There, she began to study drawing and in 1990, determined to study art, enrolled at the Institute of American Indian Arts in Santa Fe, where she learned the techniques of European painting and made her first attempts at painting with oil. In 1991 she received her Associate of Arts from the I.A.I.A. The following year she enrolled in Northwestern Arizona University in Flagstaff where she studied painting with Bruce Horn, who was a major influence on her art.

In 1993 Katoney left Northwestern Arizona University and began her career as a professional artist. That year she married Bruce Nequatewa, a young Hopi man she had met in high school. Nequatewa was a Kachina carver and metal sculptor. The couple made their home in Hotevilla, a historic Hopi village on Third Mesa. When their daughter Alicia was born, Jeanette was fearful that toxic fumes from oil paints could be harmful, and she began to work with natural sands and pastels.

During her first years as a professional artist, Katoney worked with Joe Ben, Jr., and David Johns, two Navajo painters who influenced the direction of her art. Ben encouraged her to create a series of sand paintings and Johns, who painted abstractions of traditional Navajo subjects, encouraged Katoney to use traditional Navajo symbols and motifs as the basis of innovative personal creations. Johns also instilled in Katoney the importance of returning to her roots. Rather than focusing on traditional European subjects, he advocated the use of material from her own cultural

43. *BEAUTY OF THE CLOUDS*, 1995
19 X 25", PASTEL ON PAPER
PHOTOGRAPH COURTESY OF THE FAUST GALLERY, SCOTTSDALE

background. Since that time, Katoney's art is frequently inspired by the weaving of her Navajo ancestry, especially by the work of her mother. Some of her early paintings follow formal compositions similar to traditional Navajo weavings.

In *Beauty of the Clouds,* clouds swirl through the sky announcing a forthcoming rainstorm. As Katoney lives on the Hopi Reservation, several of her images can be traced to historic Hopi art; for example, the clouds in this painting are terraced clouds, a traditional stylized Hopi icon that can be traced to ancient Hopi ritual art. A primary symbol of the Hopi, clouds are male and the earth is female. On the arid Hopi Mesas high above the desert floor, clouds that promise rain are of major importance because rain, which nourishes the crops, will ensure that life will continue in the Hopi world.

Cloud images, which also frequently appear in traditional Navajo weaving, are the central focus of *Beauty of the Clouds*. It is twilight and the yellows, red, and oranges of the painting hint that sunset soon will begin. The terraced clouds move through the twilight sky, which is partially the blue of daylight and partially the black of night. Katoney's composition is based on four cloud formations. In both the Navajo and Hopi world, four is a sacred number. For the Navajo People, colors also have symbolic meaning. Red represents energy; blue, calm; and ochre, the earth which is reflected in the sky.

MARY MOREZ (b. 1946)

Navajo

※

FATHER SKY, 1969

"May I walk in beauty, may I think in beauty, may I paint in beauty. To pray like this, knowing and doing the beauty way is what my grandparents would have called 'The Navajo Way.' "[1] Both the life and the art of Mary Morez are confirmations of the "Navajo Way."

Mary Morez was born on the Navajo Reservation in a community near Tuba City, Arizona. Marene and Alex Morez, Edgewater Navajo, planned to bring up their children in accordance with traditional Navajo ideals; however, personal tragedy changed the course of their lives. When Mary was two years old Marene died in childbirth and her father decided that his daughter should be raised by her grandparents. Although the Navajo are matrilineal people, a regional judge decided that Mary could live with her paternal grandparents, the familial elders she preferred.

As a small child, Mary enjoyed traditional Navajo life. Although a sickly child, she helped herding sheep, worked with her grandfather in his cornfields, and assisted her grandmother with her weaving. At age five, Mary designed and wove her first Navajo rug. Mary's grandparents instilled in their granddaughter an appreciation for Navajo culture and an understanding of traditional Navajo ideals. During the summer the family often slept beneath the stars. It was while looking at the stars that her grandfather taught her that "space is endless and the mind is too."[2]

By the time she was five years old, Mary was crippled, her legs deformed by bouts with both polio and rheumatic fever. Her grandparents therefore arranged for her, as a participant in a federal government program, to enter the Chicago Crippled Children's Hospital for treatment. Before leaving for Chicago, Mary was sent to the Fort Defiance orphanage to learn English. She spent six years in the Chicago institution and underwent six surgeries.

When, partially recovered, she returned to Tuba City, she learned that her grandfather had died and that the Bureau of Indian Affairs was her guardian. She was sent to the Intermountain Indian School in Utah, a B.I.A. school where the famous American Indian sculptor and teacher Allen Houser was her art teacher. From there she was sent to Phoenix Indian School, where Mary, although she still held her Navajo beliefs, was forbidden to speak the Navajo language and was forced to choose either the Protestant or the Catholic religion.

In Sunday school she was befriended by a teacher, Mary Keim, who brought the child home to meet her family and ultimately, with her husband, adopted young Mary. Mary Morez became an accepted part of this non-Indian family. She traveled with the family and her adopted parents taught her to love books and music. The Keims, believing that Mary should have pride in her Navajo identity, bought her books on Navajo culture and took her to the Heard Museum to see the artistic creations of her people.

Mary reached a turning point in her life when, in 1959, she became a participant in the Rockefeller Project, a summer symposium at the University of Arizona intended to encourage Native American artistic creativity. In the course of the program Mary studied art with Allen Houser, silversmithing with Charles Loloma, pottery from Otellie Loloma, and silkscreening from Lloyd Kiva New. The program instilled in Mary an understanding of the value of both innovation and tradition. During the summer session Mary's roommate was the Santa Clara Pueblo painter Helen Hardin.

At age seventeen, Mary entered the art school of the Chicago Art Institute but found the size to be overwhelming. She applied for and won a scholarship to the two-year program at the Vogue School of Art where from 1961 to 1963 she studied fine arts and fashion illustrations. After graduation she worked as a fashion illustrator. In 1964, following her marriage, the birth of a daughter, and a subsequent divorce, she returned to Phoenix where she worked part-time as a commercial artist and devoted as much time as possible to pen-and-ink drawings.

In Phoenix, Morez met Byron Harvey, a descendant of the founders of the Fred Harvey hotel chain. Byron Harvey, who

was responsible for bringing the Harvey Collection to the Heard Museum, hired Mary to catalog the collection. Harvey went on to serve as patron for her career as a professional artist. In 1969 Morez made the decision to devote full time to painting and graphics, and thanks to Harvey she had a one-person exhibition at the Heard Museum the following year.

Morez married again only to be widowed. She then worked for the Heard Museum as fine arts curator. In 1971 she served as staff consultant to the Museum of Navajo Ceremonial Art (now the Wheelwright Museum of American Indian Art) in Santa Fe. In this position Morez completed a research project on the Navajo religion.

During the early years of her career, Morez's primary source of inspiration was Navajo ceremonial sand painting. *Father Sky,* like many of her most important paintings of this period, was a personal interpretation of a sand painting. Although her paintings appear similar in style and symbolism to the traditional curative sand paintings of the Navajo, Morez never includes in her work the sacred symbols used by the Medicine Men. As a child Morez's life had been saved twice by Medicine Men, and since that time she has had the greatest admiration and respect for these healers.

Traditionally, the Navajo believe that the earth is Mother and the sky is Father. *Father Sky* is a painting of the universal sky. *Father Sky* has a black body that emphasizes the endlessness and the coldness of the universe. The yellow crescent beneath Father Sky represents sunrise, the first morning light. Constellations of stars, both large and small, and the moon fill the central part of Father Sky's body. The moon is over his heart and the largest star is the North Star. A sacred prayer feather is atop his head and turquoise earrings dangle from his ears. He wears a necklace of turquoise, abalone, and coral, and the horns on his head stand for power. A sacred rainbow hangs from each horn as well as a circular disk with a cross that symbolizes the Four Directions. One hand holds a rainbow and the other hand holds a sacred medicine bag. The figure of Father Sky appears against a background that is a wash of earth colors, the sand of the Navajo Reservation. The dark swirls of this color wash represent storms and sacred rain.[3] In *Father Sky,* Morez uses the archetypal forms of traditional sand painting as the primary source of personal creativity, an affirmation of both her Navajo cultural roots and her life in twentieth-century America.

44. *FATHER SKY*, 1969

17 1/4 X 14", WATERCOLOR AND INK ON RICE PAPER

COLLECTION THE WHEELWRIGHT MUSEUM OF THE AMERICAN INDIAN, SANTA FE

PHOTOGRAPH BY HERB LOTZ

MARY MOREZ (b. 1946)

Navajo

✹

ORIGIN LEGEND OF THE NAVAJO, 1969

The art of Mary Morez, like her life, stands as a bridge between two cultures—the traditional Navajo world and twentieth-century America. As a child Morez had many of the experiences of typical contemporary Navajo life, the positive experiences of childhood on the reservation and the negative experiences of Bureau of Indian Affairs boarding schools. Morez remembers the many legends told to her as a child and the sacred ceremonies she attended with her family. During childhood she learned to understand the complexities of Navajo ceremonialism and its symbols. Morez also experienced many of the institutions of mainstream America—hospitals, schools, department stores, and museums.

All through her mature life Mary Morez has been a student of Navajo traditional culture and history. Her focus, however, is wider than simply the world of her ancestors. She interprets Navajo legends so that their centuries-old wisdom might have relevance for all of humanity. Her early paintings were traditional linear depictions of Navajo folklore; however, as she began to gain confidence in her art, she developed a style that combined realistic images with abstractions. *Origin Legend of the Navajo* is both a meaningful interpretation of a primary Navajo legend and an innovative twentieth-century painting.

The creation legend teaches the Navajo how to relate to nature and how to live in harmony with one another. The Navajo creation legend explains that today the Navajo live in the Fifth World. Earlier worlds were worlds inhabited by insect people, bird people, grasshopper people, and Pueblo people. These were miraculous worlds with such powerful supernatural deities as Changing Woman, who taught the Navajo to control wind, lightning, and storms, First Man, First Woman, and the Hero Twins. All are protagonists of the Navajo creation legend.

The roots of Navajo symbolism can be found in the creation legend. Identifiable images and symbols of the creation legend include the Four Sacred Mountains, male and female Corn Spirits, birds, a rabbit, a coyote, a turtle, and insects. There is a central deity, a small Yei figure, an image of the first Navajo, and Coyote, who inhabited the Third World. When Coyote stole one of the babies of Water Monster, his punishment resulted in a great flood that brought an end to the Third World. The turkey, with the colorful foam from the flood still on his tail, was the last to reach the ladder to the Fourth World. Many other figures in the painting have symbolic meaning. The bat announced that a flood was coming to end the Third World, and the curvilinear forms on the bottom of the painting represent the feathers of the eagle, who is a messenger in the world today. The central figure, whose rectangular head features a diamond across its face, once was so evil that it was changed into a snake.

Morez also includes a Navajo wedding basket in her composition. The design on all wedding baskets features an opening, a symbolic lesson that the mind of the Navajo must never be closed. When it was no longer possible to live in a world that was ending, their open minds helped guide the Navajo to the next world. In *Origin Legend of the Navajo* Morez limited her colors to creams, oranges, browns, grays, black, and white. These are the colors of the primal blackness and the earth.

Morez believes that her goal in art is not to record, but to interpret. Hers is a personal iconography in which traditional Navajo symbols are elevated from the specific to the universal.[1] *Origin Legend of the Navajo* epitomizes Morez's ability to create a Navajo work of art devoted to tradition and innovation. It is evident that Mary Morez has indeed achieved her goal.

45. *ORIGIN LEGEND OF THE NAVAJO*, 1969
14 X 18", WATERCOLOR AND INK ON RICE PAPER
COLLECTION THE WHEELWRIGHT MUSEUM OF THE AMERICAN INDIAN, SANTA FE
PHOTOGRAPH BY HERB LOTZ

LAURA G. SHURLEY-OLIVAS (b. 1961)

Ahééznibaa (My Father Went to War and Came Back) ✦ Navajo

❋

AUTHENTIC INDIAN CURIOS, 1989

In 1989 Laura Shurley-Olivas painted *Authentic Indian Curios,* a realistic representation of two elderly Navajo women on a street in Gallup, New Mexico, a border town of the Navajo Reservation. Shurley-Olivas's paintings of the Navajo People in the border towns epitomize realism in American Indian art. Skilled in creating detailed, three-dimensional realistic representations of the people and the streets of Gallup, from 1986 to 1991 she focused on a dimension of the Indian world that those who politicize and idealize Indian life avoid.

Authentic Indian Curios depicts two Navajo women who live on the streets. Shurley-Olivas explains that they are homeless alcoholics, beggars who have learned to survive by any means possible. Shurley-Olivas writes, "The Indians in the border towns have come to town from their homes on the reservation. They have no home in town and that's why they are so visible."[1]

The border town is a world suspended between two worlds—urban mainstream America and the Indian reservation—and its American Indian street people truly belong to neither world. Shurley-Olivas paints the border town men and women who are in a constant battle both to maintain a tribal identity and to fit into the society of mainstream America. In this struggle some are victors, some are victims. Shurley-Olivas paints a world of cement and stucco, paved streets and plaster buildings. Although the colors of the Gallup streets are a composite of earth tones, there is no sign of the natural world here.

The clothing of these women caught in limbo represent a composite of urban and reservation lifestyles. They wear the traditional Navajo velvet skirts, together with jackets and scarves bought on main street. One woman carries a small plastic bag for her few possessions and potential handouts. One woman wears everyday tie shoes, the other sneakers as they approach a sign offering AUTHENTIC INDIAN CURIOS. Gallup for many years has been known as a commercial center for antique and newly made American Indian jewelry, baskets, and pottery which mainstream America values as collectors' items. The designation "Authentic Indian Curios" is a term from the past—ironically appropriate in describing two unfortunate women whose lives have deteriorated with time.

Laura Shurley-Olivas was born in Winslow, Arizona, a town on the border of the Navajo and Hopi Reservations. As a child she frequently saw alcoholism, a common disease of border towns, and encountered the prejudices of non-Indian residents of border towns who accept negative stereotypes of Indian people.

Shurley-Olivas has an artistic heritage. Her father, Walter, who belonged to the Tseng-kini (cliff dweller clan), was an artist and silversmith and her mother, Margaret, was a weaver. As Navajo are matrilineal, Laura's clan identity is that of her mother, but she maintains close ties to both clans.

Laura attended grade and high school in Winslow, where she often used a camera to record vignettes of border town life which later would serve as source material for her paintings. During her school years she often went to Gallup. Laura also visited her father's people in Sawmill, north of Winslow, as well as her mother's people who lived in Cayman, near Tuba City. After high school, she enrolled in classes at Grand Canyon College in Phoenix, then transferred to the University

46. *AUTHENTIC INDIAN CURIOS, 1989*
48 X 36", OIL ON CANVAS
PHOTOGRAPH COURTESY OF THE ARTIST

of Arizona in Tucson where in 1984 she received a B.A. She was accepted at the Parsons School of Design in Los Angeles but could not afford the $12,000 annual tuition, a temporary setback which she feels changed the course of her life in a positive direction, because it was at this time she returned to her painting.

Beginning in 1985 Laura supported herself by designing and making handbags, tote bags, and belts that incorporated designs from traditional Navajo weaving and Southwest pottery designs. She also designed custom clothing; however, her primary focus was on her painting and graphic arts. In 1985 she was the recipient of the Ford Foundation's Minority Fellowship, and in 1986 she began to enter her paintings in a series of Native American exhibitions and competitions where she was rewarded with success. That year she won the Best Painting Award at the Gallup Inter-Tribal Ceremonial. In 1988 Laura Shurley-Olivas had her first one-woman exhibition at the Bahti Indian Arts gallery in Tucson. The exhibition displayed her paintings that featured street scenes of Gallup and portraits of the Indian street people of the border town.

In 1989 she won the award for best painting at the Scottsdale Native American Indian Cultural Foundation Arts and Crafts Competition. That same year she had the distinction of a one-person show at the Wheelwright Museum of American Indian Art in Santa Fe. In 1994 Shurley-Olivas was commissioned by the City of Denver to paint a mural for the new Denver International Airport. That painting, *Mother Earth, Father Sky,* is a landscape featuring sacred Mt. Blanc.

Shurley-Olivas also has had a career as a teacher. From 1990 to 1991 she was an instructor at the School for Art and Design at Northern Arizona University in Flagstaff and in 1991 she worked as an instructor in the Outreach Program painting workshops sponsored by Northern Arizona University for Navajo and Hopi Reservation students. In 1993, sponsored by Northland Pioneer College, she was an instructor in the program at the Hopi Center in Kykotsmovi, Arizona. The experience of working with Native American students was personally rewarding and prompted her to pursue an M.F.A. degree. In 1996, while working as an instructor in the fine arts department and as a lecturer in the anthropology department, she enrolled in the program at the University of Colorado in Boulder, and in 1996 she received her degree in painting.

At the time of her graduation, the university presented a one-person show of her paintings in the University of Colorado Art Gallery. Shurley-Olivas writes of her art:

I feel my strongest source of information for my art is my Diné-Navajo culture. As a contemporary Native American woman living in mainstream America I feel privileged to have access to an indigenous tribal culture. There is an inseparable connection between my art and the influences of my culture. My art is a personal narrative. The experience of being who I am in relation to my tribal heritage is reflected in my art.[2]

47. *DINÉ DICHOTOMY,* 1989
48 X 36", OIL ON MASONITE AND CANVAS
PHOTOGRAPH COURTESY OF THE ARTIST

LAURA G. SHURLEY-OLIVAS (b. 1961)

Ahéézhnibaa (My Father Went to War and Came Back) ◆ Navajo

※

DINÉ DICHOTOMY, 1989

Diné Dichotomy is Laura Shurley-Olivas's tribute to Navajo women. (*Diné* is a Navajo word that means the People and is the term that the Navajo use to identify themselves.) She sees this painting as the personification of the strength of Navajo culture. Today the Navajo, like all Native American people, must live in two worlds—the world of their indigenous culture and that of mainstream America. Shurley-Olivas looks at contemporary life as a continuous struggle to maintain a balance between these cultures and to retain an identity with the primary values of her Indian heritage.

Two women, one mature, the other elderly, are the heroines of Shurley-Olivas's work. She explains that these women represent the strength and beauty of Navajo women, strength and beauty that has endured through the centuries. Shurley-Olivas first painted these women on masonite, then cut out their images and pasted them to her canvas, which depicts a typical scene on the streets of Gallup, New Mexico. The women are seated figures, heroic icons of the Navajo world, rather than genre figures strolling down the street.

As is customary in Indian dress, the women are wrapped in blankets, not the hand-woven Navajo blankets traditionally worn by their people, but Pendleton blankets, high-quality commercial blankets with pseudo-Indian designs which for many years have been sold to the Indian people as well as to tourists. Both women wear a lavish amount of turquoise jewelry. Since the mid-nineteenth century, turquoise jewelry has served as the bank account for the Navajo People who proudly wear all they possess at one time and, when in need, pawn the jewelry for temporary cash. The streets of Gallup are lined with pawn shops offering cash for American Indian jewelry. This silver and turquoise jewelry is securely kept in a special pawn room, "living pawn" until the date the loan must be repaid. If the loan is not repaid, the pawn becomes "dead pawn" and is sold to tourists and collectors.

The street scene of Gallup stands in stark contrast to the beauty and serenity of Navajoland. Shurley-Olivas depicts this city of bright sunshine, alcoholics, shoppers, bars, and signs advertising beer. She includes a COORS sign in her painting as well as a beer advertisement for Schlitz featuring the popular Navajo greeting "Yah ta hay," "things are good with me."

These two worlds create an ever-present dichotomy in contemporary Navajo life, and Shurley-Olivas in this painting has portrayed two women who can successfully live with this dichotomy. Shurley-Olivas writes, "My Diné origins are the source from which I gather personal and artistic sustenance and stimulation. Art is a vehicle through which I can further my personal examination of myself and my tribal heritage. My People, culture and the land where I am from are integral to who I am as a Diné, a woman and an artist."[1]

EMMI WHITEHORSE (b. 1956)

Navajo

✹

SILENT OBSERVER, 1991

The Navajo People have a daily prayer, "Walk in beauty, speak in beauty, act in beauty, sing in beauty."[1] The paintings of Emmi Whitehorse, which exemplify the beauty of Navajo creativity, give a visual dimension to this prayer. Whitehorse says of her work, "My art is influenced by my grandmother and my native surroundings, in that it too reflects a relationship between the earth and geometry. By mixing atmospheric space, the colors of the land and a sprinkling of geometric personal iconography (from my grandmother), I am able to express the things that are important to me."[2]

Whitehorse's colors often come from her grandmother's weavings, a choice she describes as a personal statement of homage to a beloved family elder with whom she identifies. Her personal iconography includes a spindle form, a reference to her heritage of weavers; her father's brand; a shaped shepherd's crook; and musical notations. Whitehorse's imagery and colors evoke a sense of the Navajo world—the clear blue sky, distant mountains, and the heat of the sun. Whitehorse recalls, "I want to make use of the abstractions I remember, use them aesthetically to help me create my work. This way I'm closer to building that bridge between not only the old and the new—but between the two cultures in which I live."[3]

Emmi Whitehorse was born in Crownpoint, New Mexico, a community on the Navajo Reservation. A child of a traditional Navajo family, Emmi watched her mother weaving and joined her father in his chores, which included sheep herding. Young Emmi's home was near Whitehorse Lake in an area northeast of Chaco Canyon. During childhood Emmi often had the opportunity to visit Anasazi ruins and to see the ancient pictographs, the historic recording and artistic creations of the earliest inhabitants of the Southwest.

At age five Emmi was sent to the first of a series of government boarding schools. An outstanding student, after two years of study at Crownpoint High School, she received a P.T.A. scholarship to attend Page Arizona High School. During her high school years, she studied photography and painting, and when she won an art competition, this achievement instilled in her the ambition to pursue a career as an artist. Upon completion of high school, thanks to a combination of a Bell Scholarship and a Navajo Tribal Scholarship, she attended the University of New Mexico, from which she graduated in 1980 with a degree in painting. In 1982 she received an M.A. in printmaking.

While at the University of New Mexico, Emmi met Jaune Quick-to-See Smith, whom she joined in the founding of the Gray Canyon Artists, an alliance of young Native American artists with the purpose of creating "a forum for discussing and supporting their individual and collective artistic interests."[4] Their first exhibition was in 1978 at the Pueblo Craft Center in Albuquerque.

Following graduation, Whitehorse spent five years (from 1982 to 1987) in Connecticut, where she dreamed of her youth in the Southwest and painted the *Kin nah zin (Standing Ruin) Series,* landscapes of the land of her childhood. Whitehorse explains, "The 'Kin nah zin' series . . . dealt with landscapes, a marriage of sky and earth, and exploration of my surroundings, personal growth and maintaining strength through memories, symbols with personal iconography laced through each painting."[5] She also utilized her environment, painting a series of leafy forms, fish, and clam shells to create atmospheric aesthetic statements of her Connecticut environment. Whitehorse did not feel in harmony with the Northeast. "I felt like an ant under all those leaves. I hated the dark green color that sucked in all the light and that hatred became my artwork."[6]

In 1987 Whitehorse returned to New Mexico and began to paint in a sunlit studio in Santa Fe, where she worked to music. "I have no idea what I'm going to create and it just grows, putting color on paper, working from all directions and not knowing what's going to be top or bottom."[7] Whitehorse developed a technique described by William Clark in the Albuquerque Journal as a "transparent layering of chalk and

pencil drawings covered with clear, acrylic matte medium on which she applies coat after coat of subtle color with oil sticks, rubbing and spreading the pigment with her hands. Fine markings etched through the acrylic coating attach and hold color to create webs of texture. Whitehorse adds more pencil and chalk drawings to that surface, rubs it with a clear wax stick to hold everything together, and finally adheres the finished paper-on-paper to a stretch white-primed canvas."[8] Whitehorse paints primarily on handmade paper. Today Whitehorse is one of the best-known, most successful contemporary Native American artists. In 1991 the Wheelwright Museum of the American Indian mounted the exhibition *Neeznaa: Emmi Whitehorse: 10 Years* and in 1997 the Tucson Museum of Art mounted a one-person show of Whitehorse's most recent works. Whitehorse writes of her art:

> In my work, I try to recreate my mind's memory of childhood surroundings. I improvise my images out of feelings for and memories of the landscape from home. Thus linking cultural climate with certain personal elements.

These images are meant to hover in a non-confining atmospheric space. Each picture holds within itself images that are intimately tied to nature and personal emotions and iconography. These images evoke only the moods and the feel of the landscape, not the realistic recordings of a camera or that of eyes.

Color and rice paper, as well as the gestural marks, are important insofar as they create a certain kind of illusionistic space and movement. The colors are intentionally selective, but must relate to nature and also retain the moods of the land. The rice paper is meant to imply human presence. It is also the counterbalance of color.

In essence, these images relate my understanding of the landscape and emotional ties to my homeland. I want the work to be a sharing of information: information that is intimately tied to nature and personal emotions and tactile information that is relayed visually for the senses. It is a sharing of personal information with the viewer.[9]

48. *SILENT OBSERVER*, 1991

51 X 78", OIL ON PAPER ON CANVAS

PHOTOGRAPH COURTESY OF THE LEW ALLEN GALLERY, SANTA FE

LUCILLE HYEOMA

Hopi

❋

SUN BIRD, 1966

Every summer in the villages of the Hopi Mesas, a yellow bird can be seen, which is a member of the finch family. This bird in the Hopi language is named *Dawamanaoya*. In translation, *dawa* means "sun" and *manaoya* means "little maiden." Appearing annually when the summer crops are growing, this small bird is thought of as a young girl who, thanks to the nourishing rays of the sun, will blossom and grow to womanhood.

To the Hopi People, who are both matrilineal and matrilocal, women are all-important participants in the Hopi life. Thanks to women's capacity to bear and raise children, life in the Hopi world continues from generation to generation. Thought of as the spirit of a young woman and a spirit of the sun, *Dawamanaoya,* the sun bird, represents the power and endurance of Hopi life. The sun bird, which suggests images of a young maiden in the sunshine, is a part of the everyday Hopi world, yet it has symbolic importance that confirms Hyeoma's Hopi heritage.

Lucille Hyeoma painted *Sun Bird* during her student years at the Institute of American Indian Arts. Using the techniques and artistic motifs of the twentieth century in her painting of this bird, which has symbolic importance to those who live on the Hopi Mesas, she identified with both her traditional heritage and the contemporary art world. Hyeoma studied at the I.A.I.A. in 1965 and 1966. During that time she exhibited her painting at the Riverside Museum in New York City.

Hyeoma's multiwinged bird reveals her knowledge of the Futurist tradition of dynamic motion. The energy and vitality of this bird in motion reflect the power of regeneration and growth in the Hopi world. Hyeoma's choice of the yellows, reds, and oranges of sunlight and the blue of the sky reconfirm the identity of this bird as a sun bird.

49. *SUN BIRD, 1966*

27⁷/₈ X 20¹/₄", ACRYLIC ON CANVAS

PHOTOGRAPH COURTESY OF THE INSTITUTE OF AMERICAN INDIAN ARTS MUSEUM,

SANTA FE, PHOTOGRAPH BY LARRY PHILLIPS, SANTA FE

EARTH SONGS, MOON DREAMS

JENEELE NUMKENA

Hopi

HOPI HARVEST CEREMONY, 1995

Hopi Harvest Ceremony is a visual celebration of a sacred Hopi ritual, a mid-summer Kachina Dance, in which the Hopi People pray for an abundant corn crop to sustain life for another year in the Hopi world. This harvest ceremony begins at sunrise and lasts until sundown. The Hopi give thanks for the summer corn that has been harvested and offer prayers for the continued growth of the late summer corn crop that has not yet ripened and for a bountiful autumn harvest. Corn is the principal staple of the Hopi People.

In her painting, Numkena depicts a moment at sunrise when a line of Kachinas comes out from the Kiva, the sacred ceremonial chamber, to dance in the village plaza. These are Long-Haired Kachinas whose flowing beards are symbolic of the rain necessary to nourish the corn crops. These Kachinas are Rain Spirits with powers to influence human and crop reproduction.

The Hopi believe that the San Francisco Mountains are the home of the Kachinas. Many years ago when the Hopi came to the Mesas, the Kachinas lived year-round in or near the Hopi villages. Many legends explain why the Kachinas left the villages to live in the San Francisco Peaks; however, six months each year, they return to dance while the Hopi pray.

The Kachinas exist on at least three levels. On the highest level, the Kachinas are important members of the Spirit World, spiritual guardians of the Hopi People and intermediaries who carry the prayers of the Hopi to the Spirit World. They are ancestral spirits whose beneficence is necessary to maintain order in the Hopi world, provide prosperity for the Hopi People, and ensure the continuance of Hopi life. On the second level, the Kachinas are masked dancers who participate in rituals during six months of the calendar year. The dancers are priests who, during the time they wear the sacred masks, embody the spirits of the supernatural Kachinas. On the third level, the term *Kachina* refers to the ceremonial dolls presented to the children by the Kachina dancers. These dolls never are idols or icons, but are educational tools that help the children understand the ceremonial and ideological functions of the different Kachinas.

Jeneele Numkena was born and grew up in Tuba City; however, she traces her ancestry to the village of Moenkopi. The Hopi are matrilineal and matrilocal, and children take their clan identity from their mothers. As the maternal uncle is a most important figure in the education of a Hopi child, Numkena learned most of her Hopi teachings from her two uncles. During childhood, Numkena frequently attended Kachina Dances, for in the Hopi world, children always are encouaged to witness the sacred Kachina ceremonies. Numkena attended the local Tuba City grade school, graduated from Tuba City High School, and then attended Southwest Polytechnic Institute.

Numkena included in her paintings the Hopi women wrapped in ceremonial shawls as they witness the procession of Kachinas entering the plaza where they will begin their dance. In the foreground of the painting are pottery jars containing ears of multicolored Hopi corn and a basket of fruit. Each of the four colors of the Hopi corn are symbolic of one of the Four Directions. Numkena uses primarily earth colors and turquoise, the color of the stone loved by the Hopi People. She also includes images of the rocks and the sparse greenery of the Mesas.

For centuries Hopi women have been important participants in both ritual and daily life. They grind the corn, which will be used as sacred cornmeal in the Kachina ceremonies, and they provide food for the dancers and for the ceremonial feasts. Hopi women make all pottery and baskets. Women are all-important in the Hopi world. They are honored as the source of life because in the arid, rocky world of the Hopi Mesas, the creation of life and the act of giving birth are sacred. Hopi women do not participate as Kachinas; however, male dancers frequently impersonate female Kachinas. They are known as *Kachina manas.*

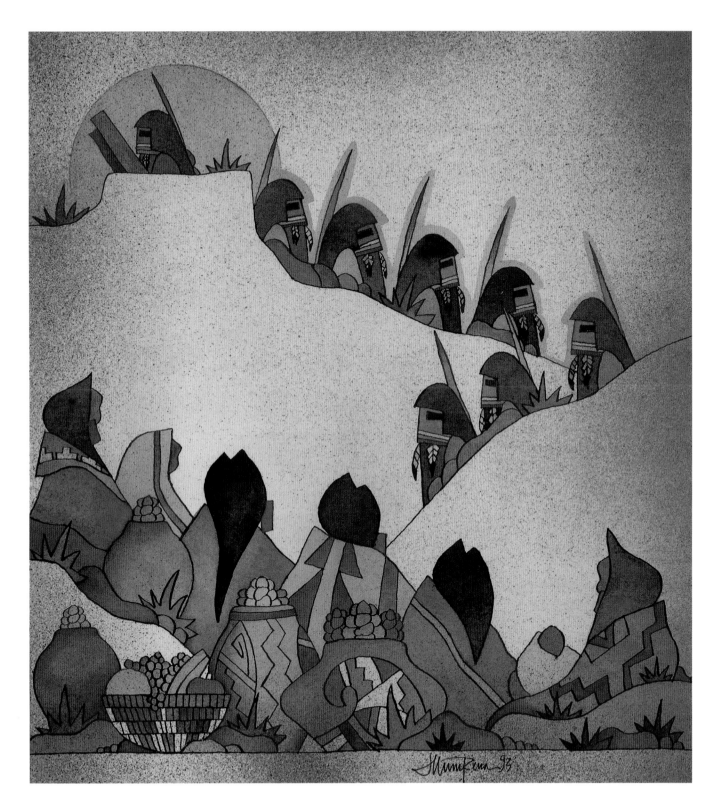

50. *HOPI HARVEST CEREMONY*, 1995
$10^{3}/_{4}$ X $9^{3}/_{4}$", WATERCOLOR ON PAPER
PRIVATE COLLECTION

OTELLIE LOLOMA (b. 1922)

Sequafenema (The Place in the Valley Where the Squash Blossoms Bloom) ♦ Hopi

❋

NATURE'S ALTAR, ca. 1950

In all of her art—paintings, sculpture, and pottery—Otellie Loloma always pays homage to her Hopi heritage. Born in the village of Shipolovi, a village on Second Mesa best known for its plaques and baskets, Loloma was educated in the regional Bureau of Indian Affairs (B.I.A.) schools, Second Mesa Day School, and Phoenix Indian High School. While in high school, Loloma first won recognition for her artistic ability when she was awarded a scholarship to Alfred University where she studied ceramics. Following graduation, she attended Northern Arizona University and the College of Santa Fe.

Having completed her formal arts studies, Loloma returned to Second Mesa and taught at Shungopovi Day School. After marriage to jeweler Charles Loloma, she moved with her new husband to Scottsdale. During these years, she and Charles ran a pottery shop at the Kiva Craft Center and during the summer, Otellie taught art courses at Arizona State University in Sedona.

In 1961 she was chosen by Lloyd Kiva New to be an instructor for the Southwestern Indian Art Project sponsored by the Rockefeller Foundation at the University of Arizona in Tucson. In 1962, when the Institute of American Indian Arts was founded in Santa Fe, Loloma was selected by New to become one of the original members of the teaching faculty. At the I.A.I.A., Loloma taught painting, traditional design, traditional Indian dance, and ceramics. Throughout her life, Loloma has been devoted to teaching.[1]

In 1965 Otellie and Charles Loloma were divorced when Otellie decided that, rather than return to the Mesas with Charles and travel extensively with him, a necessity for his flourishing career as a jeweler, she would remain in Santa Fe as a teacher at the I.A.I.A. and pursue her individual creativity. During her years as a teacher, Loloma devoted a portion of her time to her own art. Creating innovative paintings and sculptures, she entered and won many major competitions and exhibited widely in the United States and many countries around the world including Brazil, Argentina, Chile, Scotland, and Germany.

In 1991 Loloma was honored by the National Conference of the Women's Caucus for Art. The theme of this conference at the National Museum for Women in the Arts in Washington, D.C., was "Extending Visions, the commitment of women artists to explore and honor the difference and commonalities across regional, ethnic, and professional lines."[2] Loloma was one of five elder women recognized for their artistic achievements. The citation honoring Otellie Loloma read:

> Otellie Loloma, we honor you for your dedication toward what is creative, beautiful, and eternal in your Hopi Indian culture. You are honored for your ancient tradition in working in clay and teaching what is important of Hopi values and your continuing tradition of creating new forms of art from the traditions of your Hopi people. You have made your Hopi traditions visible for all of us to share through your art.[3]

Nature's Altar is Otellie Loloma's tribute to Hopi women. In the Hopi world, the woman is honored for her powers of procreation. She is the source of life. On the windswept mesas high above the desert floor, where the survival of the Hopi People is the focus of all daily and ceremonial life, the Hopi woman is respected and honored. In the Hopi world, the mother is the head of the house and all children take their clan identity from her. A girl child is most desirable for she will perpetuate the clan. The mother educates her daughters and the father educates his sons. Both parents train their children to honor and follow traditional roles. In *Nature's Altar,* there is a clear demarcation between the worlds above and below the earth's surface. Above are the women who will ensure that life will continue in the Hopi world. Below are the roots of the corn plants, which will nourish and ensure the survival of the Hopi People.

51. *NATURE'S ALTAR*, ca. 1950

32 X 25", MIXED MEDIA ON CANVAS

PRIVATE COLLECTION

❋

HOPI SYMBOLS, ca. 1950

The world of the Hopi is the primary subject for Otellie Loloma's paintings. A member of the Sun Clan, Loloma returns to the Mesas each year to participate in the most important rituals of the Hopi Ceremonial Year. She is drawn to the land and to the ancient rituals that give sustenance to her life as an artist living in modern America. Although the First Mesa villages are best known for their pottery, generations ago, before the availability of metal cooking utensils, the women of Shipolovi (on the Second Mesa) were proud of their skills as potters. Loloma's grandmother served as a role model by continuing to create pots of clay despite the disapproval of her peers who devoted their skills to weaving.

In both her paintings and sculptures, Loloma uses twentieth-century techniques and artistic innovations as well as the traditional symbols and the stylistic conventions of ancient Hopi art to reaffirm her artistic identity. *Hopi Symbols* is Loloma's celebration of the Hopi world. At the base of the painting are the homes of the Mesas, which are made of stones because the Hopi world is a world of stone. The rocks of the Mesas and the Hopi ancestral homes are one in the minds of the Hopi.

The Hopi have survived for thousands of years in the land that is a windy, dry desert. Survival has depended on their ability to plant suitable crops, then successfully nurture and harvest these crops. The clouds that will bring rain to this desert world are celebrated in Hopi ritual art. In the upper right corner are three sacred clouds.

Loloma includes images of corn and of a tadpole as primary iconographic features of her painting. The Hopi believe that corn is the principal source of life. They think of corn as the Corn Mother, for corn was given to them by their Creator as their principal source of food. The Hopi draw life from the corn as the child draws life from the mother. The most sacred rituals of the Hopi are the prayers for water which will ensure the growth of crops and the life of the people. A symbol of water is the tadpole. Because in time the tadpole metamorphoses into a frog, the tadpole also is a symbol of germination. Loloma uses primarily earth, water, and vegetal tones because *Hopi Symbols* celebrates the earth, the sacred land of the Hopi. Here corn will sustain them as they pray for water, the source of life.

The Hopi believe that the world today is the Fourth World. They believe that once long ago their ancestors emerged from the Sepapu, a pool located at the confluence of the Colorado and Little Colorado Rivers. Following Emergence, the Hopi made sacred Migrations in the Four Directions. There was a period of wandering and searching that lasted for centuries. Finally, they reached the Mesas, their given home, a land of stone and sunshine, which the Hopi believe is the center of the world. Loloma includes the Migration spirals three times in her composition. The Migration spiral, one of the most important ancient Hopi symbols, can be found in the pictographs etched in the rocks throughout the Southwest.

52. *HOPI SYMBOLS*, ca. 1950

18 X 20", WATERCOLOR ON PAPER

PHOTOGRAPH COURTESY OF THE NATIONAL MUSEUM OF THE AMERICAN INDIAN,

SMITHSONIAN INSTITUTION (231263)

YEFFIE KIMBALL (1914–1978)

Mikaka Upawixe (Wandering Star) ♦ Osage

※

ZUNI MAIDEN, 1939

Yeffie Kimball was one of the first American Indian artists to pursue an education in mainstream modern art and to embrace the tenets of modernism. Born in Mountain Park, Oklahoma, she first studied at East Central College in Ada, Oklahoma, then graduated from the University of Oklahoma. From 1935 until 1939, she studied with George Bridgeman, Jim Corbin, and William McNulty at the Art Students League in New York City. During these years, she spent her summers in Italy. She studied in Rome with Petroncini from 1936 to 1941, and she intermittently traveled to Paris to study with Fernand Léger.

In the course of her career, Kimball worked in a great variety of styles. Her early work, of which *Zuni Maiden* is a prime example, is figurative whereas her later works are more abstract. During the early years of her career, Kimball painted primarily American Indian subjects. In 1946 Henry McBride, art critic of the *New York Sun,* wrote of Kimball, "Georgia O'Keeffe had better watch out. Her rival now appears on the desert horizon. Yeffie Kimball not only paints Indian themes, but is herself of Indian extraction."[1]

All through her life, Kimball was devoted to the art of the American Indian, especially to the art of the modern American Indian. She was vice president of ARROW, an organization focused on the progression and artistic, social, and economic welfare of the American Indian.

An authority on American Indian art and culture, she served as consultant on Native arts for several museums and was involved with the INCA, an organization that mounted exhibitions of contemporary Indian art. Kimball worked for the State Department, selecting the Indian Art section of *America 1953* and was an advisor on Native American films. In 1957 and 1958 she did the research and illustrations for the *Book of Knowledge* and the *World Book of Knowledge.* During the 1950s she also worked for the State Department, selecting American Indian paintings to be given to the heads of state of countries throughout the world.

YEFFIE KIMBALL (1914–1978)

Mikaka Upawixe (Wandering Star) ♦ Osage

OLD MEDICINE MAN, ca. 1959

January 4, 1966, marked the opening of a thirty-year retrospective exhibition of the paintings of Yeffie Kimball, an artist of Osage heritage. This exhibition at the Philbrook Art Center in Tulsa was Kimball's fifty-fifth one-person show. It traveled throughout the United States. Her first one-person show had been in 1946, at the Rehn Gallery in New York City. Yeffie Kimball was one of the first American Indian artists to be honored by mainstream American museums, universities, and art galleries. Her work has been exhibited at the National Academy of Art in New York City, the Carnegie Institute, the Museum of Art in Pittsburgh, and the Smithsonian Institution in Washington, D.C. In 1948 her paintings were the featured attraction at the Galerie Giroux in Brussels. Today her work is in the permanent collection of many major American museums and private collections.

In 1948 Yeffie Kimball wrote an impassioned response to *Time* magazine's critique of the Philbrook Art Museum's third annual *American Indian Painting Competition*:

Contrary to *Time Magazine*'s implied theory that the Indian must be protected from modern life, must continue to paint formalized "pictures to heal the sick, encourage the warriors, and bring rain for the harvest," the modern Indian artist has painted his own particular "Declaration of Independence," now insists on participating in the 20th Century. *Time* regrets that the Philbrook exhibits have "little magic about them." For the Indian to think and feel other than as a 20th-century artist is as futile as forgetting that the atomic bomb swept away the very roots of mysticism.[1]

In 1959 Kimball entered and won the Philbrook's competition in classification two, Non-Traditional Styles of Painting. There were thirty-three entries in that category. Kimball's winning entry was *Old Medicine Man,* which the museum subsequently purchased for their collection. This painting is a stylized portrait of a Northwest Coast Medicine Man wearing a traditional Chilcote blanket. In the background is a carved totem. In 1949 Kimball had catalogued over six thousand art objects made by Pacific Northwest Coast Indians for the Portland Art Museum.

Old Medicine Man illustrates Kimball's successful use of contemporary materials and modern aesthetic theories to create a traditional Native American image. In this painting, Kimball reaffirms her dual allegiance to the tenets of modern art and to the cultural heritage of the American Indian people.

Married to an atomic scientist, Harvey Slatin, Kimball was inspired in later years to paint the phenomena of outer space. Striving for a surface of sculpted pigments, she created abstractions of astronomical phenomena. Using acrylic resin and dual pigments, Kimball's paintings are distinguished by their intense yellows and glowing reds.

For many years, Kimball lived in New York City and spent her summers in Provincetown. She died in Santa Fe in 1978.

54. *OLD MEDICINE MAN*, ca. 1959

24 X 20", OIL ON BOARD

COLLECTION THE PHILBROOK MUSEUM OF ART, TULSA

MUSEUM PURCHASE 1959.5

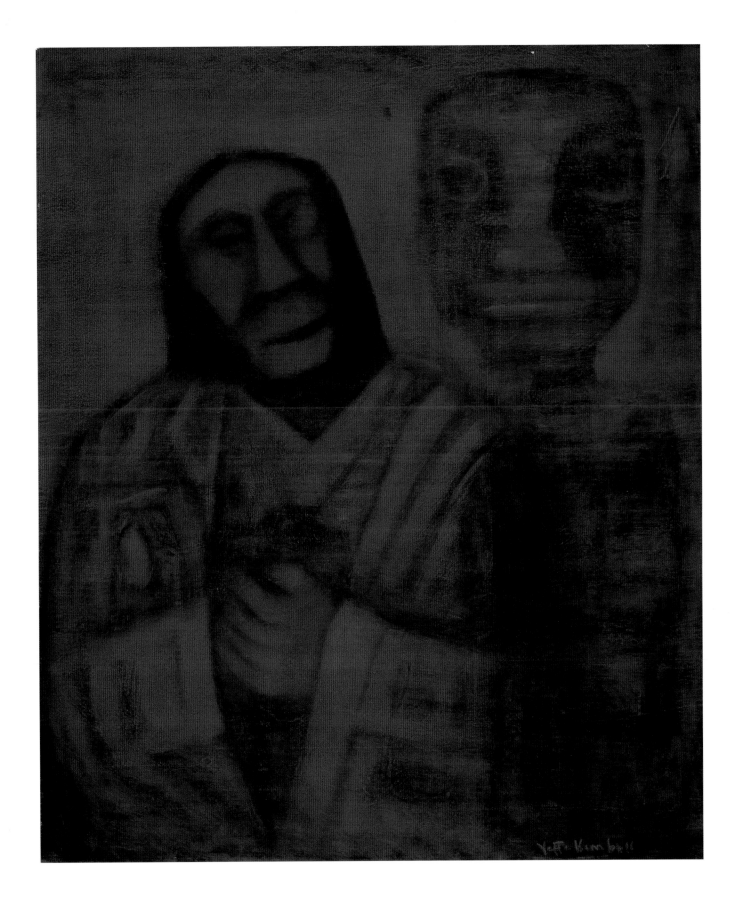

LINDA LOMAHAFTEWA (b. 1947)

Hopi / Choctaw

✦

HOPI SPIRITS, 1965

Although Linda Lomahaftewa was born in Phoenix and spent her formative years in the urban centers of Phoenix and Los Angeles, her art was inspired by her Native American identity. Lomahaftewa writes, "The subject matter in my work I feel is Indian. I use designs and colors to represent my expressions of my being Indian. I think of spiritual aspects of my tribe, and of the American Indian, when I paint. I think of ceremonies, praying to the sun, and praying for all Indian people for strength and happiness."[1]

Born to a Choctaw mother, Mary Wright, and a Hopi father, Clifford Lomahaftewa, she came from an artistic family. Her mother was accomplished in beadwork, feather work, and quilting, and her father carved and painted Kachina dolls. Lomahaftewa grew up with primarily a Hopi identity, as her father had an all-important role in determining his daughter's values and beliefs. The artist recalls, "My father is a traditional Hopi. He knows all the dances and the meaning of the ceremonies. He made me aware of my Indian culture and the responsibilities that go with it. Even though we didn't actually live on the reservation, he taught us things that go on during the year."[2] The Lomahaftewa family celebrated the Hopi ceremonial cycle of the year, devout observances that include fasting and singing. They would frequently travel to the Mesas for the Kachina Dances.

In 1962 Linda Lomahaftewa enrolled in the Institute of American Indian Arts in Santa Fe where she studied painting. Following graduation from the I.A.I.A. in 1965 she entered the San Francisco Art Institute where she received a B.F.A. in 1970 and an M.F.A. in 1971. Although the I.A.I.A.'s art education had affirmed her Native American identity, the course of study at the San Francisco Art Institute was focused on European techniques and aesthetic values. Lomahaftewa recalls:

While I was studying European techniques and style at art school, I started on my own evolutionary path as an artist. I got tired of painting the model the way I had been instructed, so one day I flipped my canvas around and started painting parts of the body and putting in my own color scheme. I began drawing all these Indian geometric designs. More and more of the imagery began surfacing. . . . For me, the artistic process can be described as unlearning and remembering: "unlearning" the overlay of European cultural values and "remembering" the basics, where I receive my strength. It's getting back to innocence. . . .

My imagery comes from being Hopi and remembering shapes and colors from ceremonies and from the landscape. I associate a special power and respect, a sacredness, with these colors and shapes, and this carries into my work.[3]

Throughout her career Lomahaftewa has found inspiration in the Hopi world, and her paintings frequently include images that can be traced to the sacred and secular world of the Hopi—parrots, mountain lions, corn maidens, animal

55. *HOPI SPIRITS,* 1965

30 X 40", MIXED MEDIA ON CANVAS

PHOTOGRAPH COURTESY OF THE INSTITUTE OF AMERICAN INDIAN ARTS MUSEUM,

SANTA FE, PHOTOGRAPH BY LARRY PHILLIPS, SANTA FE

EARTH SONGS, MOON DREAMS

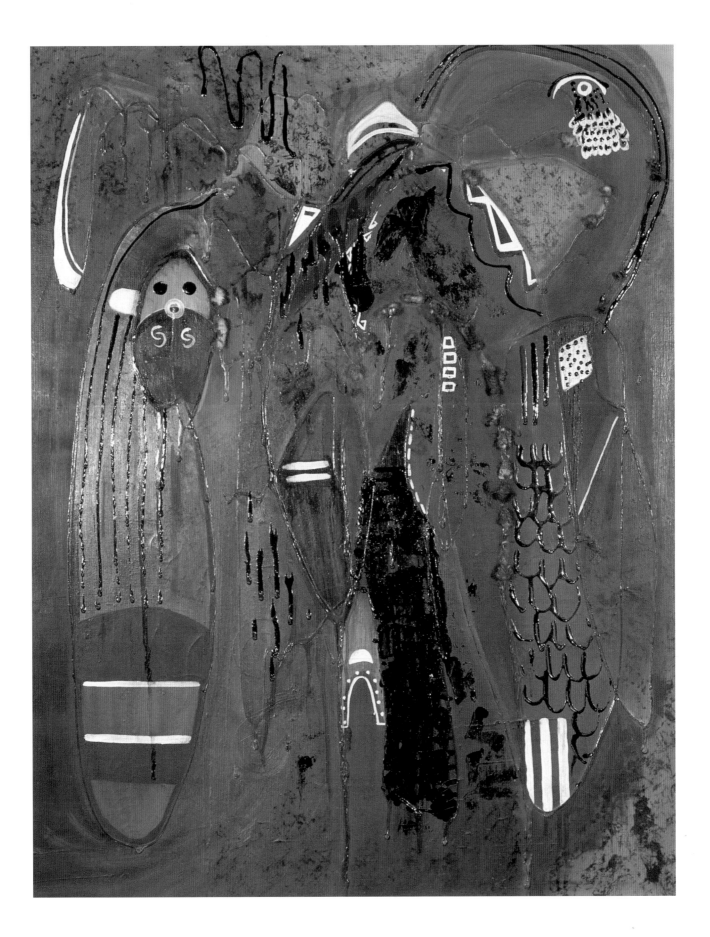

spirits, and Kachina spirits. Lomahaftewa includes in her work such traditional Hopi symbols as terraced clouds, rainbows, and lightning. Her choice of colors, frequently the colors of the Four Directions, reinforces her identity with her Hopi heritage.

Linda Lomahaftewa does not paint in the traditional style encouraged by the Indian schools across America. Her work is distinguished by a contemporary approach to painting based on traditional Hopi symbols and subject matter. Lomahaftewa frequently visits sites that have spiritual importance to the Hopi People—historic ruins, rocks covered with petroglyphs that bear the incised drawings of her ancestors (whom she refers to as my "old masters"), and images of the historic Kiva wall painting. Because her art is based on themes and symbols of the historic Hopi world, it represents a synthesis of tradition and innovation, continuity and change.

Hopi Spirits, which was painted early in Lomahaftewa's career, was inspired by images of Hopi Kachinas. In *Hopi Spirits,* Kachina spirits, often thought of as "cloud people," are painted against a background of blue, which suggests the heavens. Lomahaftewa did not paint identifiable Kachina spirits, spirits sacred to the Hopi People. Although she suggested specific Kachina spirits and their markings, the One Horn Kachina and the Bearded Kachina, she has created an imaginative composition filled with personal innovation. *Hopi Spirits* is Lomahaftewa's personal celebration of the Hopi Spirit World.

LINDA LOMAHAFTEWA (b. 1947)

Hopi / Choctaw

✳

MORNING PRAYER, 1989

In the Hopi world, prayer is a vital part of daily life. Linda Lomahaftewa believes in the power of prayer, and her painting *Morning Prayer* is a confirmation of this belief.

When I create a painting, I am giving information to my viewers, information about who I am. My paintings tell stories about being Hopi and how I was taught. Being Hopi means praying, having respect for everything, believing that everything in life has a purpose. It means asking for good things to happen. . . . My father would always say "Whatever you work on, any kind of artwork or whatever you're doing, pray for it to come out well." My paintings are all like individual prayers. When I'm really concentrating on a line or a color, I can think that it's like a prayer, remembering what my father told me. That's what I'm doing when I do my work. I have this prayer when I'm working—not only for myself, but for all people.[1]

In *Morning Prayer,* Linda Lomahaftewa has painted a Hopi priest offering a prayer before sunrise. The sky is still filled with stars as the first light appears on the horizon. Four parrots fly across the sky. On the left, lightning flashes, a traditional Hopi symbol for rain. For centuries in the Hopi world rain has been all-important because rain nourishes the crops and thus assures the survival of the Hopi People. On the right is an evergreen, a symbol of the continuance of life in the Hopi world. The evergreen is sacred to the Hopi People.

Parrots have always been an important icon in Lomahaftewa's art. Lomahaftewa explains:

One of my favorite images is the parrot. I've always liked birds, but the parrot just appeared in my work. Afterward, I remembered how I had noticed in scenes of traditional Hopi homes that frequently there was a parrot that had been traded as a pet. Also parrot feathers are greatly valued. I started doing research on parrots and discovered parrots in the kiva mural paintings. I use several of these parrot images, but changed the colors and put them in the landscape and the sky.[2]

Lomahaftewa describes the colors of the four parrots as the colors of the Four Directions: red for south, white for east, yellow for north, and blue and green for west. Historically the Hopi traded with the indigenous people of Mexico for ceremonial parrot feathers.

Since childhood Lomahaftewa has attended sacred Hopi ceremonials, and while working she listens to traditional Hopi songs. In the Hopi world, art is a form of visual prayer. Lomahaftewa writes:

My imagery comes from being Hopi and remembering shapes and colors from ceremonies and from the landscape. I associate a special power and respect, a sacredness, with these colors and shapes, and this carries over into my work. My dad told us that whenever you're doing your work, you should always pray and sing a song because things come out better that way. So I think about this while I work. For me, art is not just slopping paint around, but something very sacred and spiritual.[3]

Morning Prayer is an example of Lomahaftewa's art as it has evolved since her days at the Institute of American Indian Art. Her art is distinguished by bold colors and a careful selection of simplified two-dimensional forms. Both color and image relate to her Hopi heritage.

Since completing her formal art education, Lomahaftewa has divided her time between a career as a professor of art and one devoted to personal artistic creation. From 1971 to 1973

123

she was assistant professor of Native American art at California State College in Sonoma, and from 1974 to 1976 she was a professor of painting and drawing in the Native American Studies Department of the University of California at Berkeley. In 1976 Lomahaftewa returned to Santa Fe and since that time has been a professor of painting, drawing, and two-dimensional design at the Institute of American Indian Art.

Since 1982 Lomahaftewa's work has been featured in exhibitions of Native American art in the cities across the United States as well as in Latin America, Europe, and New Zealand. She has entered competitions devoted to American Indian painting and prints and won many awards, including the Helen Hardin Award for Creative Excellence in Painting at the sixty-seventh annual Indian Market in Santa Fe and the Best of Division, Mixed Media at the thirty-ninth annual Heard Museum Indian Fair and Market in 1997.

Lomahaftewa has achieved her artistic goals and a balance of priorities in her life.

I feel I am fortunate enough to have artistic abilities and strengths to reach that point of one's own "successfulness" as far as my goals are concerned. To think of myself as a striving American Indian artist is being proud of the fact that I am a woman, a mother, and an instructor, and that I am where I am today in the arts.[4]

56. *MORNING PRAYER*, 1989
38 1/2 X 30", MIXED MEDIA ON CANVAS
PHOTOGRAPH COURTESY OF THE ARTIST

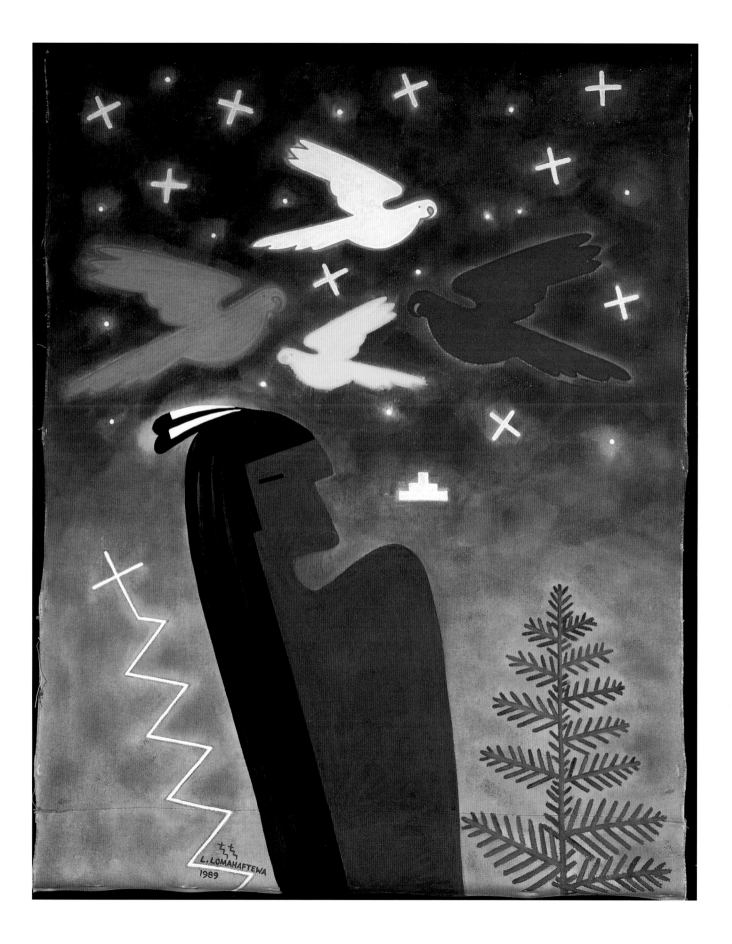

MARIAN TERASAZ (b. 1916)

Aukemah ✦ Comanche

✺

COMANCHE GIRL

Marian Terasaz belonged to the third generation of traditional Oklahoma American Indian artists. The first generation was the Five Kiowas, the group selected in 1923 by Dr. Oscar B. Jacobson, director of the art department of the University of Oklahoma, to study painting in a special program with Edith Mahier, a professor of art at the university. The second generation included three artists, Acee Blue Eagle, Cecil Murdock, and Woody Big Bow, who enrolled in 1935 as special students in a nondegree art program at the university. Terasaz, a student of Blue Eagle, represents the third generation.

Comanche Girl was in the personal collection of Dr. Jacobson, who greatly admired the work of Blue Eagle's Comanche protégée. Jacobson described this painting as follows: "The Indian girl in buckskin, here represented, is a typical example of her work. She did not attempt any complicated arrangements of color. Few Indian paintings of today are heavy or robust, but Marian's work possesses a delicacy, grace, and charm that could be described by no other term, but feminine."[1]

Jacobson included this painting in his 1950 folio, *American Indian Painters*. Aukemah and Lois Smoky were the only women who were not Pueblo painters from the Southwest to be included in that folio. Jacobson wrote of his selection:

Among the Indians, the pictorial art has by tradition been a man's art. Women rarely participated in it. . . .

Marian Terasaz is a pure blood Comanche girl who was born in 1916. She is included in the work because she is talented and painted some splendid watercolors of Indian women and children while she was a student at Bacone College, and because her paintings are rare.[2]

In traditional Comanche communities, there was a close tie between a young girl and her mother's sisters, whom she would also call "mother." It was considered proper for a Comanche maiden, hoping for a romantic liaison, to approach a young man, but it was not considered proper for the young man to approach a young woman. In the traditional Comanche world, courting couples could not be seen together in public, so most courtships were held in secret in the dark.

Women had an active role in traditional Comanche life. War was a central part of Comanche life, for wars were fought to protect territory and food supplies and to revenge previous wrongs. Bravery and success in war gave all-important prestige to young warriors. If an impending raid was for a popular cause, young Comanche women, chanting songs recalling the victories of ancestors and the bravery of their contemporaries, serenaded the lodges of those warriors they hoped would join the war party. Those women who promoted a successful raiding party expected that, upon the warriors' return, they would be rewarded with horses or other captured booty.

57. *COMANCHE GIRL*

11¹/₂ X 8¹/₂", TEMPERA ON PAPER

PHOTOGRAPH COURTESY OF THE NATIONAL MUSEUM OF THE AMERICAN INDIAN,

SMITHSONIAN INSTITUTION (236049)

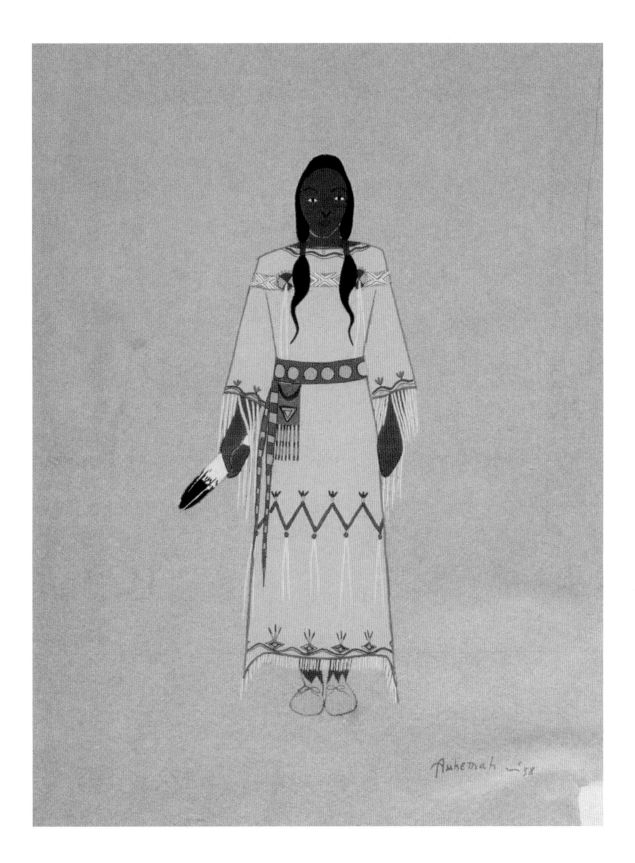

MARIAN TERASAZ (b. 1916)

Aukemah ✦ Comanche

⚙

WOMEN DRYING HIDE, 1938

Marian Terasaz was the first Comanche woman to break with the tradition that women artists should concentrate on clothing, crafts, and decorative designs. Terasaz decided to paint Comanche women and the rituals of daily life in the traditional Comanche world. Aukemah was a pioneer, not only because she chose to create paintings of the Comanche world, but because she rejected the traditional subjects of American Indian painters of the 1930s—tribal warfare, the hunt, and religious rituals—and focused on Comanche women and the activities of their world.

Aukemah studied painting at Bacone College with Acee Blue Eagle, who from 1935 to 1938 was the first director of the art department there. At Bacone, Blue Eagle was an exponent of Dr. Oscar B. Jacobson's atheistic beliefs and the sanctioned Kiowa style of painting—outlined flat areas of color painted against a plain background. Blue Eagle stressed authenticity of subject matter and encouraged his students to utilize library research for their paintings. Aukemah, in her paintings, followed Blue Eagle's rules for Indian painting. However, she would also achieve a sense of perspective through her understanding of the vanishing point and her use of overlapping forms.

Aukemah's paintings are distinguished by the delicacy and grace of her carefully drawn figures and her attention to detail. In *Women Drying Hide,* she included the sparse vegetation of the Plains and peppers drying in the sun. She limited her use of color to the blues of a woman's dress, the brownish yellow of the buffalo hide, the greenery of the vegetation, and the red of the peppers. The women wear authentic Comanche dress with their hair in braids.

The Comanche People of Oklahoma trace their heritage to a migrating branch of Mountain Shoshone, who following the acquisition of the horse from the Spanish moved from the slopes of the Rocky Mountains to the Plains. The Comanche migrated to Texas and Oklahoma in the eighteenth century in order to be nearer to the Spanish supply of horses. The Comanche were renowned as horsemen and warriors.

Women Drying Hide depicts two women sitting on either side of a huge buffalo hide drying in the sun. In the traditional Comanche world, once the hunters had returned to camp with the buffalo, it was the women's job to skin the animal, scrape the skins, stretch the skins, and lay them out into the sunshine to dry. Once the skins were dry, the women would sew the skins together and would erect the tipi. The hides, when sewn together to cover a tipi, were up to twenty-five feet in diameter. In her painting, Aukemah placed the Comanche women in front of a buffalo skin tipi that serves as their home.

58. *WOMEN DRYING HIDE,* 1938

13 X 18¹/₂", TEMPERA ON PAPER

COLLECTION THE THOMAS GILCREASE INSTITUTE OF AMERICAN HISTORY AND ART, TULSA

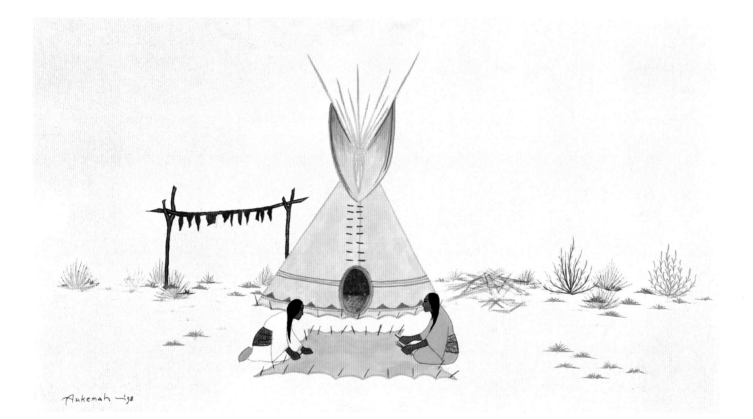

DIANE O'LEARY (b. 1935)

Opeche-nah-se ✦ Comanche

✸

THE WALKING WHEEL, ca. 1970

During the twenty-five years that Diane O'Leary worked at easel art and printmaking, almost all of her artistic creations expressed her concern for the relative position of women, both individually and in the community. O'Leary is not only a trained professional artist, but she is a scholar whose studies have focused on Native American archeology, history, and physics.

Born in Waco, Texas, Diane attended elementary and high school in Fort Worth. Graduating at age fifteen, she attended Texas Christian University and graduated in 1956 with two degrees, a B.A. and an R.N. Soon after she graduated from Texas Christian University, O'Leary and her family moved to Muskogee, Oklahoma, where her father worked on animal development for poultry processing. O'Leary, then twenty years old, enrolled in Bacone College where she spent a year studying painting with Dick West, director of the college art department. She also worked as program director for the local television station. At the television station she met and became friends with Acee Blue Eagle, the well-known Creek/Pawnee painter who hosted a local children's television show and owned a sign shop. In the evenings, O'Leary painted signs for Blue Eagle's shop and watched the artist work on his watercolors. Blue Eagle introduced her to Native American artists Fred Beaver and Woody Crumbo. Today, O'Leary credits Blue Eagle, Beaver, Crumbo, and Dick West as her true artistic mentors.

After Bacone College, O'Leary studied at Stanford University, where she focused on Native American studies and physics. In 1959 O'Leary enrolled in the graduate study program at Harvard University. Although initially she had hoped to complete a degree in physics, she was told by her advisor that this was not possible, as physics was not an acceptable field for a woman. O'Leary then completed an M.A. degree in Southwest archeology but audited as many physics courses as possible. During these years, O'Leary, a woman of many abilities, worked as a laboratory technician, a nurse, a sculptor, and a painter. In the years that followed she also worked on programs at Los Alamos and participated in research for the Gulf Diving Bell, the first underwater oil exploration equipment.

Upon receiving her degree from Harvard, O'Leary moved to Taos, New Mexico, where she studied painting with Eric Gibberd, a New Mexico landscape artist, and with Emil Bisttram, a member of the Cinco Pintores and one of the founders of the Transcendental Painting Group, a group of New Mexican artists devoted to the creation of art forms with universal meaning. Periodically, Bisttram and Gibberd would pile O'Leary's paintings into a car and drive her to Abiquiu for a critique with Georgia O'Keeffe. These early Taos paintings were O'Leary's first American Indian paintings. O'Leary recalls that at O'Keeffe's house the paintings were propped up against the walls. O'Keeffe would look at them, then push most of them over onto the floor. When she saw one she liked or found interesting, she would read from a series of bound spiral notebooks, and discuss problems in painting.[1]

O'Leary at first devoted her art to the creation of images of the lives of Native American women as they must have been in the past. An advocate of the women's movement, O'Leary depicts women's work in many of these paintings.

59. *THE WALKING WHEEL*, ca. 1970
23¹/₂ X 29¹/₂", ACRYLIC ON CANVAS
COLLECTION JAMES T. BIALAC, SCOTTSDALE

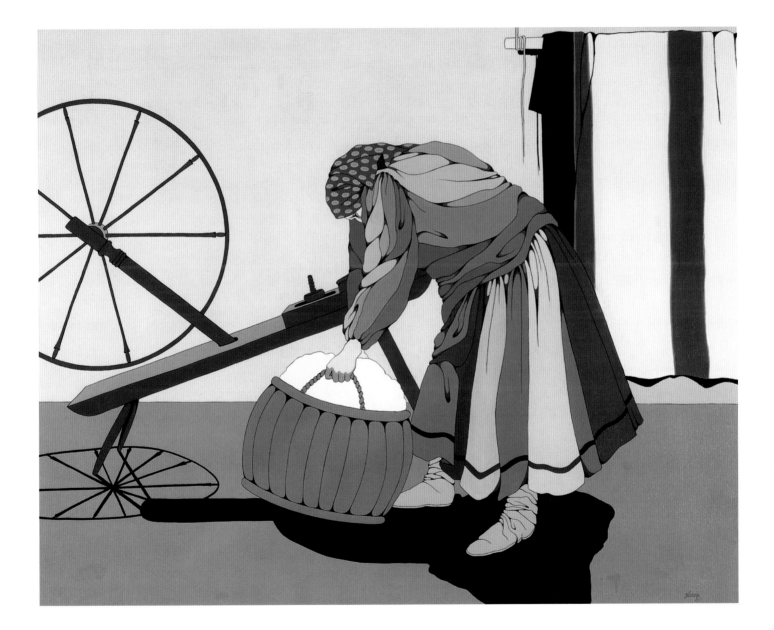

The Walking Wheel celebrates generations of women whose work was focused on artistic creations of fiber. O'Leary writes of *The Walking Wheel:*

> Almost all my creative output has concerned itself one way or another with the lives of women, especially their daily work and how they incorporated artistic expression into it. From humankind's earliest age, fiber has lent itself admirably as a medium for this particular exercise. . . .
>
> All raw fiber requires some preparation if it is to be transformed into an advanced state of existence. Of all those preparatory processes, the art of spinning has fascinated me most throughout my life. I always longed to learn to spin, but time and conditions never conspired to allow it. I did, however, have acquaintances who were spinners. I buy their yarns for knitting and other needlework projects, and sometimes paint them at their work. *The Walking Wheel* is one of those pieces, a study of a professional rug maker who creates all her thread from her own flock of sheep and prefers the large walking wheel to the more common spindle.[2]

At about age thirty, O'Leary began to suffer from an inherited neurological disease, dystonia, which results in tremors of both her head and hands. In about 1988 she decided it was necessary to give up painting and began to work with fiber. When she moved to the Northwest in 1989, she apprenticed herself to fiber artist Marial Wilson and to loom weavers Lois Zimmerman and Shirley Medsker. Thanks to the patience and expertise of these women, O'Leary was able to embark on a new career. Today she uses a painterly approach to quilt making. She is currently enrolled in an M.F.A. program in textiles and is working toward a Certificate of Excellence for the National Handweavers Guild, a project that involves the completion of a museum-quality project and a thesis. Truly appreciative of the three women who enabled her to continue artistic creation, O'Leary looks upon *The Walking Wheel* as a personal tribute to these women.

60. *MOON WALKER*, LATE 1970s
16 X 10", WATERCOLOR ON PAPER
PRIVATE COLLECTION

DIANE O'LEARY (b. 1935)

Opeche-nah-se ✦ Comanche

❋

MOON WALKER, late 1970s

During the late 1970s, Diane O'Leary painted *Moon Walker,* which was inspired by a traditional Comanche legend. All of O'Leary's paintings, whether they celebrate rituals of daily Plains Indian life or the ancient legends of the Comanche People, express the fundamental beliefs and values that are the focus of her life. O'Leary writes of *Moon Walker:*

There is a story about a young woman who was kidnapped during a raid on her family camp. As she was being carried away, Moon Mother suddenly rose over the hills and lighted the path along which she was being taken by her captors. All that night Moon Mother shown brightly so that the young woman could see exactly where she was going. Moon Mother was still visible in the sky at dawn the next day when the kidnappers reached their destination.

That night Moon Mother came to the young woman in a dream and said, "Stay with these people until I come to the sky again as brightly as I did last night. Then I will light your path through the woods back to your family. Until then, I will be your mother and keep you safe."

The young woman did as she was bidden by Moon Mother. Later, after Moon Mother had visited all her other children in the sky, she returned to the young girl and caused a path of big white flowers to bloom in the dark through the woods. The captive followed the path back to the place where her family was still camped. She was home and safe, just as Moon Mother had promised.

This young woman lived a long, long time and had daughters and granddaughters of her own. But all her life, whenever the Moon Flower bloomed she burned a little sweet grass for Moon Mother in thanks for that bright white path, the safe way through the darkness.[1]

The story of a young woman who was abandoned then makes her way back to her people is a recurring theme in the legends of the Plains Indian people. O'Leary sees this theme as expressing a fundamental experience that extends to all humanity: "the archetypal woman waiting, and the isolation and weariness of women making their way through life."[2]

JEAN BALES (b. 1946)

Iowa

※

IOWA WOMAN

Jean Bales has devoted her art to preserving the culture of the Plains Indian people. She is the official historian of the Iowa tribe. Bales's work focuses on the activities and dress of the Plains Indians of the late nineteenth century. The primary subjects of her paintings are women.

Throughout her career, Bales has focused on the culture of the everyday life of the Plains Indians. Bales explains:

> Art, among the American Indian, has been and continues to be the communication of the history and values of the people. Art can communicate excitement and celebration or anxiety and mourning. . . .
>
> More and more I realize the humanity of my ancestors. The past is no longer impersonal; it is filled with people being people. As all people do, they change with time.[1]

Born in Pawnee, Oklahoma, Bales was educated in the Chickasaw pubic schools and in 1967 earned a B.A. in fine arts from the Oklahoma College of Liberal Arts. She also studied at the Institute de San Miguel Allende in Mexico. After graduation from the Oklahoma College of Liberal Arts, she first taught crafts at the Bureau of Indian Affairs school in Fort Sill. When a teacher resigned, Bales was asked to teach a course on Indian history. Preparation for her course reinforced her interest in her people and opened new vistas for a career. After one year, realizing that the world of her people would be the focus of her life, she resigned to pursue a full-time career in art. Bales's work includes sculpture, beadwork, woodcarving, printing, and painting in oil, acrylic, and watercolor. During the early years of competition, she signed her work J. Bales. Only when she arose to accept an award would it become clear that J. Bales was a woman.

Today, Bales is one of the most honored Indian artists, having won over one hundred awards. In 1973 she received the Oklahoma Governor's Cup for Outstanding Indian Artist of the Year; in 1982, the Oklahoma Diamond Jubilee Award for Outstanding Woman of the Southern Plains; and in 1984, she was hailed as Indian Artist of the Year by the Indian Arts and Crafts Association. In 1984 she also received a citation from the House of Representatives of the State of Oklahoma for exceptional abilities in the creation of visual arts and in bringing positive recognition to the State of Oklahoma in its pursuit of excellence in the arts.

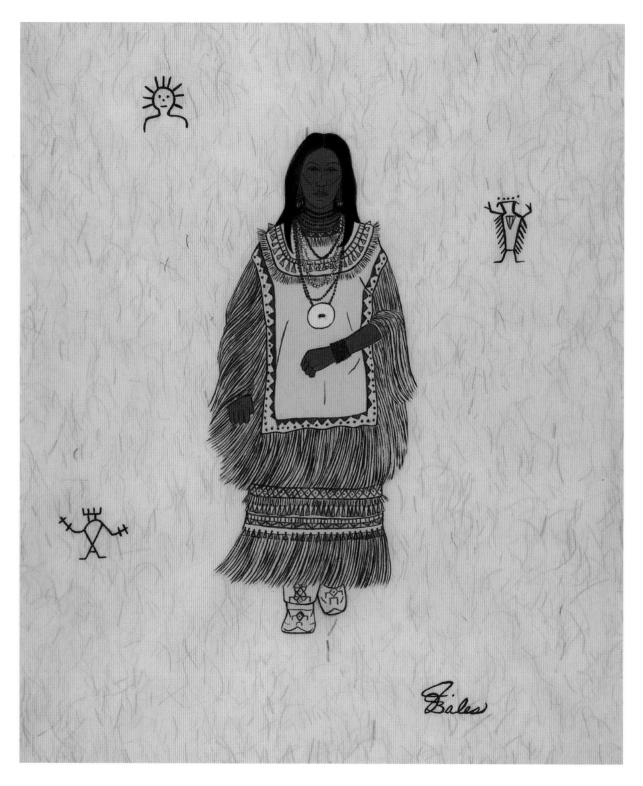

61. *IOWA WOMAN*

13 X 10³/₄", WATERCOLOR ON PAPER

PRIVATE COLLECTION

MARLENE MARY RIDING IN

Ska-Dodah-Dah-Sak ♦ Pawnee

MORNING STAR CEREMONY, ca. 1950

Mary Riding In was born in 1933 in Council Valley, a Pawnee settlement in Oklahoma. After attending Chilocco Indian School, she studied at Bacone College during the period when Dick West was in charge of the Art Department. In 1950 she entered the *Fifth Annual Exhibition of American Indian Painting* at the Philbrook Museum of Art in Tulsa and won the First Purchase Prize in the Plains region division for *Morning Star Ceremony. Morning Star Ceremony* depicts one of the most sacred rituals of the Skidi Pawnee, one of the tribes of the Pawnee Confederacy. The Skidi sometimes are called "Wolf Pawnee" because the name "Skidi" derives from the word *Skirirara*, "Wolf Standing On Water," a term referring to a tribal tradition.

According to tribal history, several hundred years ago, after separating from the Arikara Pawnee, the Skidi settled in the Loup Valley in Nebraska. In 1874 the Skidi, having fought in vain to retain their hunting grounds, were moved to Indian Territory (present-day Oklahoma). Having signed treaties with the United States government, the Skidi were settled on land intended for all the Pawnee.

The Skidi have religious beliefs and follow religious ceremonies separate from other Pawnee tribes. They believe that the stars used their powers to make them into families and villages, and taught them how to live and how to perform their ceremonies. The Skidi villages on earth were thought to be reflections of stars in the heavens.

The Skidi believed that the perpetuation of all forms of life on earth depended on the conjunction of the male and female forces in the universe. In *Morning Star Ceremony,* the participants enact a symbolic sacrifice of the feminine Evening Star to the masculine Morning Star, a ceremony ensuring the continuation of the Skidi People. The Morning Star ceremony was performed until the early nineteenth century.

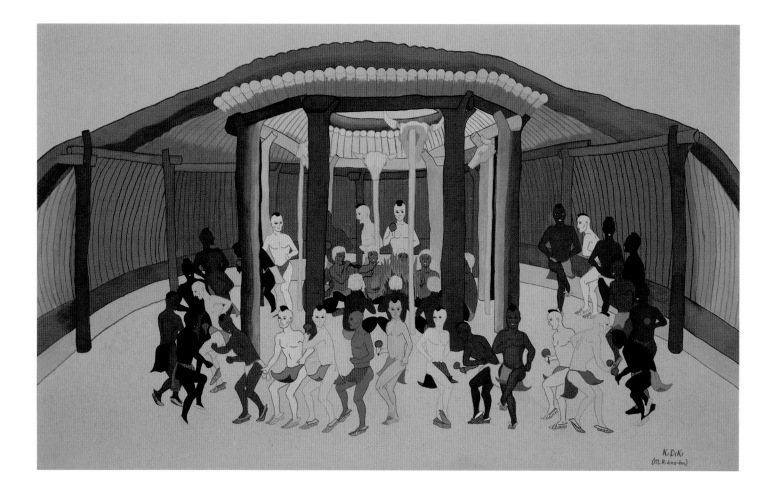

62. *MORNING STAR CEREMONY*, ca. 1950

19 1/2 X 37 15/16", WATERCOLOR ON PAPER

COLLECTION THE PHILBROOK MUSEUM OF ART, TULSA, MUSEUM PURCHASE 1950.8

RUTHE BLALOCK JONES (b. 1939)

Chu-lun-dit (Little Bird) ♦ Delaware

❋

DELAWARE WOMAN WITH CEREMONIAL DOLL, 1984

Ruthe Blalock Jones has devoted her art to recording the ceremonies, sacred and social, historic and contemporary, of the Delaware People. The Ceremonial Doll Dance is a historic ritual in traditional Delaware life. In Oklahoma, it was last performed in the late 1920s in the area near Bartlesville. Jones's mother, who was born in 1906, saw this dance performed. The origin of this ceremony is the belief that long, long ago the sanctity of Mother Corn had been violated. To restore harmony and avoid revenge by angry spirits, dolls representing the Spirit of Corn were feasted and danced by members of those families involved in the original acts of desecration.

The Doll Dance also confirmed the Delaware belief that, in the course of a woman's life, the transformation of the young girl from a child into a woman must be final. When a young girl reached ten to twelve years of age, she was expected to confirm this rite of passage to puberty by putting away her dolls. It was a serious taboo to violate this order. The resultant punishment was that for the rest of their lives, annually, each autumn, all women who had violated this taboo had to sponsor and participate in the Ceremonial Doll Dance. Each year new clothes had to be made for the dolls. It was believed that all dolls not put away would come alive; therefore, after a lifetime of ceremonial dances, these dolls had to be buried with their owners. This annual ceremony served as a lesson to young girls and their parents: If they did not obey rules of behavior that had been observed for centuries, they had to accept all subsequent punishment and obligations for the rest of their lives.

Jones has painted a participant in the Ceremonial Doll Dance. The woman holds a stick with her doll fastened to the end. As she dances with the stick held in front of her, the doll actually leads the dance. Jones believes in authenticity of detail in her work. She has painted the woman wearing one of her own dresses, a traditional Delaware dance costume. The style of dress dates back to the time of the Delaware People's first contact with the European world. Her dress is made of trade cloth, a broadcloth, and her leggings and ribbons are trade items, as are the silver ornaments on the dress. The dancer wears soft-soled leather moccasins that historically were worn by the Delaware People. This painting was reproduced on a poster for the exhibition *Ornament and Symbol: The Illuminated Garment of American Indian Women,* presented at the Museum of Art of the University of Oklahoma, Norman, in December 1984.

Ruthe Blalock Jones was born in Claremore, Oklahoma. She first attended grammar school at the Lincolnville District School in Ottawa County, then Miami (Oklahoma) Junior High School. She won an art scholarship to Bacone College and from 1954 to 1955 she attended high school there. In 1970 she returned to Bacone College and that year received an A.A. Throughout her life, Jones has continued her formal education, completing a B.F.A. in painting at the University of Tulsa in 1972 and an M.S. in the humanities and fine arts at Northeastern Oklahoma State University in Tahlequah in 1989.

Jones has enjoyed art since she was eleven years old. Some of her first painting materials were given to her by the Oklahoma painter Charles Banks Wilson, who corrected her drawings and encouraged her to enter regional competitions. When she was fifteen years old, Acee Blue Eagle purchased one of her watercolors and took an interest in the aspiring artist and offered her encouragement and advice. In 1954 she first entered the competition at the Philbrook Museum of Art and received an award. It was not until she became a student at Bacone College that she made her first attempt at traditional Indian painting. Jones recalls:

> I studied under Dick West. In the back of my mind,
> I had knowledge of the Indian style of painting, but
> never had attempted it. I had been working in the
> European style, then I had to learn to flatten out the

work with the use of masses and lines. From then on I was able to do the traditional Indian painting.[1]

Jones works in all media—oil, watercolor, acrylic, and silk-screening. In the course of her career, she has won many honors and awards and has participated in exhibitions in American Indian art in museums and galleries across the country. In 1979 Jones was appointed art director of Bacone College, the first woman to serve in this position. That year she was honored by a one-woman exhibition at the college.

In recent years, she has been the recipient of several prestigious awards—in 1993 the Governor's Art Award for the State of Oklahoma, in 1994 the Crumbo Memorial Award from the Southwestern Association on Indian Affairs, in 1995 she was chosen as Oklahoma Woman of the Year by the Oklahoma Federation of Indian Women and was inducted in the Oklahoma Women's Hall of Fame. Jones serves on the Governor's Advisory Committee on the Status of Women.

63. *DELAWARE WOMAN WITH CEREMONIAL DOLL*, 1984

10$^{1}/_{4}$ X 6$^{3}/_{8}$", WATERCOLOR ON PAPER

PRIVATE COLLECTION

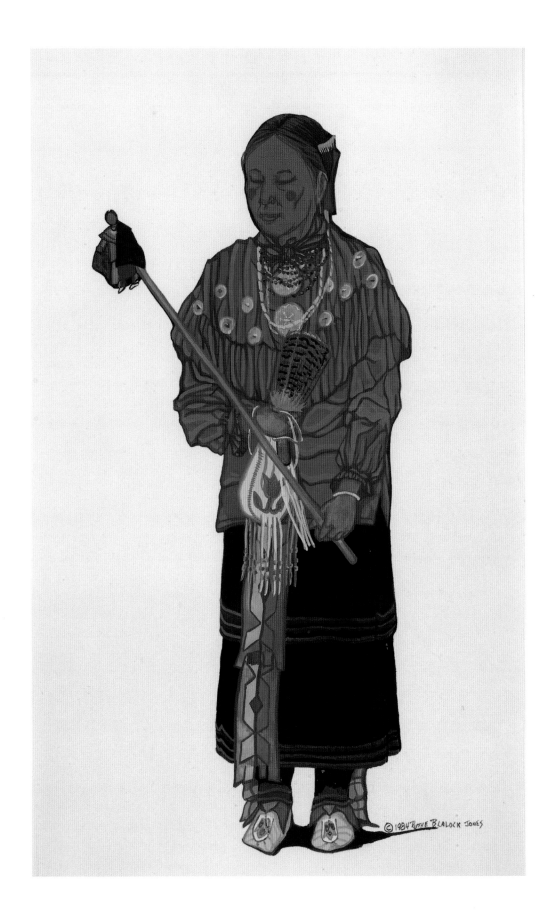

© 1984 Ruthe Blalock Jones

RUTHE BLALOCK JONES (b. 1939)

Chu-lun-dit (Little Bird) ♦ Delaware

SHAWL DANCERS, 1981

Shawl Dancers by Ruthe Blalock Jones was inspired by a social dance in which the Delaware women confirm their identity as Native Americans. Jones believes that today it is important for Indian people to have a traditional upbringing and on special occasions to return to the rituals honored and performed by their ancestors through the centuries. By honoring tradition, she believes Native Americans can achieve a sense of balance, the "centeredness" necessary to live in two cultures, the mainstream culture of the United States and the culture of their native people.

Throughout her career, Jones has focused on portraying Indian women and Oklahoma dance costumes. Her paintings record the joys and experiences of a lifetime of attending and participating in traditional Indian social gatherings. Jones achieves several goals, for her paintings serve both as visual testimony of her dedication to the portrayal of the traditional world of the Delaware People and as studies in design and color.

In this painting, Jones celebrates a traditional ceremony of the Delaware People. For generations, the Shawl Dance has been a favorite social dance of Delaware women. Following tradition, all Delaware women who participate in dances must wear a shawl, in both religious rituals and social dances. All women, even the youngest girls, must wear a shawl before they are permitted to enter the dance circle. In this painting, the dancers have neither bodies nor feet. In performing this dance, they have come to embody their shawls. Jones explains that while dancing and thinking of another era and other places where the Delaware People performed this dance, the dancers can enter another state of consciousness. They are not aware of either their body or feet, for they have become part of this ancestral ceremony.

Shawl Dancers was painted as a demonstration for her students at Bacone College. Jones writes:

> Beginning students work in primary colors and white. That is the key to the colors in *Shawl Dancers,*

and I also like them as shawls, ribbons, etc. Other aspects of the composition show fringes, hair and ribbons in motion. I love to dance, the dance clothes, and being at a dance and all of that is brought here together.[1]

This painting was part of the series of paintings of shawl dancers completed in the 1980s. In 1981 one painting in this series was exhibited at the *Night of the First Americans,* an exhibition of Indian art at the Kennedy Center in Washington, D.C. In 1982 *Shawl Dancers* was the poster image for the exhibition *Contemporary North American Indian Art* at the National Museum of Natural History in Washington, D.C.

Jones sees her role of artist and teacher as that of the pathfinder for Native American women who aspire to careers in painting. She writes of the difficulties of this choice:

> Indian people refer to life as a journey or circle. At times, this journey has been difficult, for like mainstream art, Indian art is a male-dominated profession. Women are very cognizant of the belief, particularly among Indian people, that a woman's place is in the home doing women's work, such as bearing and raising children, cooking and cleaning, sewing, and generally making a home for men. If women artists do continue to paint, many people believe it is because they can "afford" to paint or be artists, implying that they are supported by men and do not possess the entrepreneurship or business acumen necessary to be professionals. True there are women artists whose husbands are successful and are financially supported; however, they are the exception. For most of us, our families depend on our incomes. Single parents can hardly "afford" to paint. Some of us who "veered off" and who dared to be different and would not. "stay in our places" have found a measure of success.[2]

64. *SHAWL DANCERS*, 1981
36 X 24", OIL ON CANVAS
PRIVATE COLLECTION
PHOTOGRAPH COURTESY OF THE ARTIST

AGNES GOUGH (1902–1988)

Cherokee

※

ESKIMO CEREMONIAL DANCERS, ca. 1952

Agnes Gough was one of few American Indian artists to devote her efforts to painting the ceremonies of the Alaskan Eskimo. Born and educated in the regional schools of Benton, Kentucky, Gough studied at Western Kentucky University in Bowling Green and Murray State University in Murray, Kentucky. After completing her education, she traveled across the country, then north to Anchorage, where she taught studio art at a local high school. All during her years of teaching Gough continued to paint.

In 1952 Gough sent a watercolor glued to a board to the *Seventh Annual Exhibition of Contemporary American Indian Painting* at the Philbrook Art Center. She won a prize of fifty dollars in the Woodlands division, and the museum purchased the painting from the exhibition. Gough had simply sent the painting from Anchorage with no details of her background. She was listed in the catalogue as an Eskimo exhibitor and her painting, part of the permanent collection of the Philbrook Museum, was listed as recently as 1991 as "Painting, American Indian, Eskimo." It was not until after many years in Alaska, when Gough returned to her hometown of Benton to care for her aging mother, that her Cherokee identity became known.

Eskimo Ceremonial Dancers is a lively composition of fur-dressed participants, including three dancers in the first row, three singers seated behind them, and three drummers in the last row. The ceremony takes place outdoors, for the participants are gloved and wear heavy fur costumes. During her years in Alaska, Gough attended many Eskimo ceremonies where she studied rituals and recorded the details of the costumes and masks. Gough, who had served as a judge for a Fur Rendezvous in Alaska, paid close attention to the different types and colors of fur. In *Eskimo Ceremonial Dancers,* the three dancers wear fur dresses over long fur trousers and white fur boots. Gough depicted a dance movement that suggests the dancers are women Gough's painting has great authenticity of detail, for example, the embroidery and use of different materials for the decorative bands of the costume. Each of the individual masks is presented with great precision—stylized facial images, fish, feathers, and fur.

65. *ESKIMO CEREMONIAL DANCERS,* ca. 1952

15^{15}/$_{16}$ X 15^{5}/$_{8}$", WATERCOLOR ON PAPER GLUED ON BOARD

COLLECTION THE PHILBROOK MUSEUM OF ART, TULSA, MUSEUM PURCHASE 1952.15

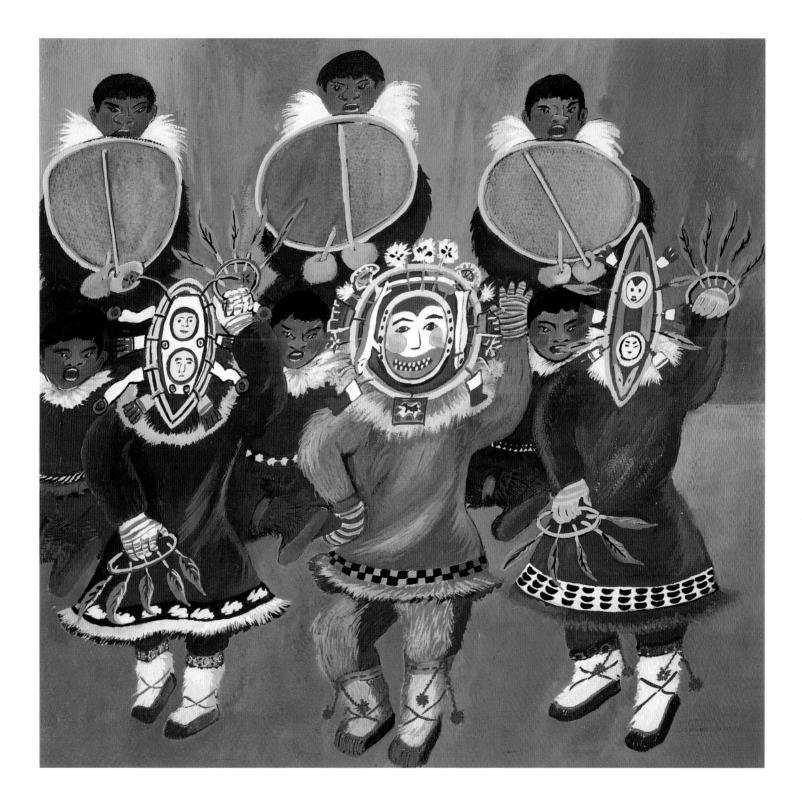

CONNIE JENKINS (b. 1955)

Te-go-nil ✦ Cherokee

❂

GENERATIONS OF MOTHERHOOD, 1996

In traditional American Indian beliefs, the moon is closely associated with the creation of life. Throughout the world, the reproductive cycle of women mirrors the cycle of the moon. The majority of Native American peoples see the moon as female, a symbol of motherhood and the continuance of life. Unlike the majority of Native American peoples, centuries ago the Cherokee thought of the moon as masculine and the sun as female. In *Generations of Motherhood,* Connie Jenkins uses the moon and a Cherokee woman as complementary images, primary symbols of procreation and the sustenance of life.

In *Generations of Motherhood,* a Cherokee woman sits pensively, her figure silhouetted against a full moon. It is night and Jenkins has painted the woman's clothing, her hair, and her face in blue, brown, and white, which are the colors of sky, earth, and moon. To her left are leafless winter trees, complementary masculine images of potential creation. Jenkins paints realistic rather than stylized figures. The pose of the woman in *Generations of Motherhood* illustrates the artist's knowledge of foreshortening.

Connie Jenkins was born in Tahlequah, Oklahoma, the daughter of Emma Saunders and Winfred Watkins. She attended regional public schools and in 1973 graduated from Locust Grove High School and attended Miami College in Miami, Oklahoma. Since childhood Jenkins has lived in Locust Grove, a community in the heart of the Cherokee Nation.

A self-taught artist, soon after graduation Jenkins began to enter her work and win awards in competitions at the Five Civilized Tribes Museum in Muskogee, Oklahoma, and at the Cherokee National Museum in Tahlequah, Oklahoma. At one of the regional Native American competitions Connie met Bill Rabbit, a distinguished Cherokee artist, who became her friend and mentor.

Jenkins sees herself as both a visual storyteller and a Cherokee woman, as evidenced in her art. In *Generations of Motherhood,* the seated woman symbolizes the power of Cherokee women, generation after generation, to create and sustain life and thus ensure that the Cherokee Nation will continue to be a vital community.

66. *GENERATIONS OF MOTHERHOOD, 1996*
6³/₄ X 8¹/₄", CASEIN ON PAPER
PRIVATE COLLECTION

connie jenkins ©

JOAN BROWN (b. 1955)

Cherokee

✺

ANCESTRAL PRAYER

A Cherokee legend recalls how many years ago the Cherokee People set out on a long migration toward the Rising Sun. After many years (one night's encampment was the equivalent of one year), they reached their destination, the ordained home of the Cherokee People in the center of the earth.

During the 1830s the Cherokee people were forced to leave their ancestral home in the East and travel to Indian Territory, today the state of Oklahoma. Having completed a journey of exceptional hardships during which the Cherokee faced disease and death, they finally arrived in the land that was to be their home. *Ancestral Prayer* is Joan Brown's tribute to the fortitude of the Cherokee People who survived the Trail of Tears and who were determined to establish a new homeland.

Joan Brown has painted a Cherokee man and woman in traditional Cherokee dress as they reach Indian Territory. Silhouetted against the sun, the two figures are seen in profile. The man stands, holding a staff of office, and the woman is seated, her hands raised in prayer. Together they celebrate the dawn of a new day and their arrival in their promised homeland. Brown writes:

> The male is facing the East from which they had been moved. . . . Even though they were torn from their homes they would never forget where they came from or who they are. The female continues to bear children to give to the future for the Indian People and offers prayers that they will always know who they are.[1]

Joan Brown was born in Yatula, Oklahoma, and grew up in a region that was Creek territory. Brown's paternal grand-mother was of Creek heritage and her paternal grandfather was of Cherokee heritage. Brown has spent almost all of her life in her home state. She received her formal training in art at Bacone College in Muskogee, where she was a favorite of her instructor, Terry Saul. *Ancestral Prayer* is painted in the sanctioned two-dimensional style of American Indian painting taught at Bacone College.

Brown began to exhibit her work in 1972 and over the years has won many awards, distinctions, and honors. In 1986 she was designated a Master by the Five Civilized Tribes Museum. Brown always has had a dedication to her people. While attending Bacone College, she was asked by Mary Adair (HorseChief) who was then Director of the Murrow Indian Children's Home in Muskogee to work in this ministry. Brown, who has a special dedication to children, was ready to begin service at the Home and has continued to work there for the past twenty-two years. In addition to her work as a professional artist, for many years she has taught art and crafts in regional schools. Brown lives in Muskogee and in 1988 the city celebrated Joan Brown Day. The mother of six, Brown taught all of her children the history and values of their heritage and the importance of honoring their ancestors.

In recent years, Brown has concentrated on painting sentimental images of children. In 1985 Brown completed a series of images of Storytellers. Brown is interested in the concept of the Storyteller, for she believes that Cherokee Storytellers play an important role in preserving their heritage. Often depicting the tender relationship between Storyteller grandmothers and their grandchildren, Brown has been called the "Norman Rockwell of Indian Art."

67. ANCESTRAL PRAYER
16¹/₂ X 17¹/₂", WATERCOLOR ON PAPER
PRIVATE COLLECTION

MARY ADAIR (HORSECHIEF) (b. 1936)

Cherokee

※

SELU, 1993

Mary Adair painted *Selu* for the cover of a book by Maribou Awiakta, *Selu: Seeking the Corn Mother's Wisdom.* This book focuses on the legend of Selu and Kanah, givers of life and wisdom. In her book, Awiakta explains how people, by applying ancient legends to their contemporary lives, can keep the world in balance. Mary Adair explains, "Briefly, basic imbalance, a lack of respect between genders or peoples, etc., disturbs the balance in the environment. Imbalance in an individual invades the web of his/her life and affects all relationships. Going back to the root of the error and making a correction brings back the balance."[1]

The majority of Mary Adair's paintings are devoted to Cherokee history and legend. This focus is important to Adair because "knowing who we are and where we have come from is important to our self-worth and is encouragement for us to make a contribution of our own. It is well for us to know something of the many struggles and achievements of those who have gone before us."[2]

Women, both the spiritual figures of legends and the women of the traditional Cherokee world, are of primary importance in Adair's work. Throughout history, women have been respected as central figures in Cherokee life, powerful figures in traditional government and in the home. Adair writes, "Being a woman, I relate most closely to the experiences of women, and our roles in centering families. This is where the core is, where it all begins, where everything else is developed out of—continuing the cycle of life. Everything else people do with their lives reaches out from that center. That is what I try to express in my work."[3]

The central figure in this painting is Selu, Grandmother Corn, who from her own womb brought forth corn for the Cherokee People. Adair depicts this sacred figure as having a body that is an ear of multicolored kernels. Long leaves of corn and long strands of hair, which echo the shape of the corn leaves, sprout from Selu's head. The streaming hair and leaves, as well as Selu's arms, envelop the people and land of the Cherokee. It is clear that this scene is not in the legendary past but in the twentieth century because Adair has painted oil wells and an atomic reactor on the flatlands in the foreground of the landscape. In the distance are mountain ranges and sky. Selu reaches down protectively over a Cherokee man and woman who hold a basket of corn. For centuries, corn has been a primary food staple in the Native American world. Kernels of the multicolored corn drop down from the Corn Grandmother, a blessing on the Cherokee couple. These kernels are seeds that will be sewn and harvested. Adair believes that adherence to tradition will protect the Cherokee People from unregulated nuclear energy and oil recovery.

Mary Adair was born in 1936 in Sequoyah County, Oklahoma. She is the great-great-granddaughter of Nancy Ward, "Naynyi-hi," the last Beloved Woman of the Cherokee people. The Beloved Woman, a title given for leadership and deeds of valor, was believed to speak for the Great Spirit and had great powers. She was entitled to speak in the councils and often cast the deciding vote for chieftainship. Naynyi-hi was an advocate for peace in the years before the Cherokee Removal of 1838 and throughout her life urged the Cherokee People to hold on to their ancestral lands. She also

68. *SELU*, 1993
24 X 18", WATERCOLOR ON PAPER
PRIVATE COLLECTION
PHOTOGRAPH COURTESY OF THE ARTIST

© M.Adair '93

was known as Wild Rose. Holding office in Echota, the capitol of the Cherokee Nation, Naynyi-hi guided and sustained her people during the years in which the federal government attempted to negate the power of the Beloved Woman and her sisters on the council.

Educated in the local middle and high schools, Mary Adair attended Bacone College in 1955 and in 1957 graduated with a B.A. in education from Northeastern Oklahoma State University in Tahlequah. In 1983 Adiar received an M.E. from Northeastern Oklahoma State University. In 1967 she received a B.F.A. from the University of Tulsa. That year she began dual professional careers, artist and art teacher, careers she continues today. Throughout her life Adair has actively served her community. She was director of the Murrow Indian Children's Home in Muskogee and served as an officer for the Health and Human Services Department of the Cherokee Nation.

Soon after graduation, Mary Adiar married Pawnee craftsman Sam HorseChief, who worked with bone, feathers, and beads. The couple had four children, three sons and a daughter, all of whom have become professional artists. Although for many years Mary Adair used Mary Adair HorseChief as her professional name, when her children all began independent careers as artists, she discontinued using her married name in order to avoid confusion. Her daughter, Mary Katherine HorseChief, has won regional recognition for her paintings. Mary and her four children have had several HorseChief family exhibitions.

JEANNE WALKER ROREX (b. 1951)

Cherokee

✹

TRAIL SISTERS, 1991

Jeanne Walker Rorex has great pride in a legacy of generations of strong Cherokee women. Rorex depicts women whose lives are determined by their strength to overcome the hardship, pain, and deprivation that define their world. Rorex says of the women who are the focus of her paintings, "I want my women to be three-dimensional expressions of the importance of how gentleness and strength can mean survival."[1]

One of six children raised on an east Oklahoma farm, Rorex married and cared for two young sons before attending and graduating from Bacone College, where she studied with Dick West and Ruthe Blalock Jones. She then graduated from Northeastern Oklahoma State University with a degree in graphic art. Rorex grew up with an inspirational role model, her uncle, poetic woodcarver Willard Stone.

Today Rorex lives in Otaha, Oklahoma, on farmland that has belonged to her family for three generations. *Trail Sisters* is part of *The Sister Series*. Rorex writes of *The Sister Series*:

The relationship between Africans and Native Americans began soon after the first African people were brought to the American shores. Escaping slaves often found refuge in the Eastern Mountains among the Indian living there.

Eventually, generations later, many of the Southeastern tribal members had adapted more and more to the European ways and began to utilize slave labor on their own farms and plantations and in their businesses.

When the fertile lands of the Five Civilized Tribes also began to produce gold, the greed of the Europeans became unbearable and, even in the direct conflict with a U.S. Supreme Court order to leave the tribal lands alone, they took them. Even though many of the tribal members had intermarried with the whites, they were all treated the same. Whatever cruel force needed to get the people out was used with no threat of punishment. Along with the tribal people who were often dragged out of their homes to stockades to await the unlawful removal to the lands West, were their African slaves and friends. In other words, many black people were facing the same nightmare. They were also instrumental in settling the new lands in Indian Territory, helping build homes, farms and schools.

There is so much which should be known about the shared history of races and what trials they faced together. I want to share my knowledge about this history through my paintings, *The Sister Series*. I also want to express what my personal history of working in Eastern Oklahoma fields with other members of my family and alongside our neighbors who were black, Indian, and mixed-bloods like us, meant to me. The crops we worked—men, women, and children—were needed by us all and the work was shared by all. We got to know each other as individuals.[2]

Trail Sisters depicts a Cherokee woman and a black woman working side-by-side as they progress along the Trail of Tears. Rorex writes of this painting:

Along the Trail of Tears, stations in life were unimportant . . . forgotten. People united for survival. The only thing these two women see or feel is another woman in the midst of a shared tragedy and facing an equally unknown future. They have joined hands . . . united by the need for support and for the need to give support. . . . They are not alone. They are Sisters through this Journey.[3]

69. *TRAIL SISTERS*, 1991

20 X 17", ACRYLIC ON WATERCOLOR PAPER

PHOTOGRAPH COURTESY OF THE ARTIST

JOAN HILL

Chea-se quah (Red Bird) ♦ Creek / Cherokee

※

MORNING OF THE COUNCIL, 1971

Joan Hill is the descendant of both Creek and Cherokee chiefs. Her paternal grandfather, George Washington Hill, was Chief of the Creek Nation from 1922 until 1928, when he died in office. Her maternal great-great uncle, C. J. Harris, the brother of her grandfather, Red Bird Harris, prosecuting attorney for "Hanging Judge Parker," was Chief of the Cherokee Nation from 1891 until 1895. George Washington Hill led an exceptional life during which he held the positions of deputy marshall, prosecuting attorney for the Creek Nation, postmaster, president of the Creek Board of Education, chief of the Light Horse Brigade, and owner of an oil company. G. W. Hill was a member of the House of Kings and the House of Warriors, the two branches of the Creek government. Joan Hill's maternal great-great uncle, C. J. Harris, served in the Cherokee Senate and was sent to Washington, D.C., as on official delegate of the Cherokee Nation.

Joan Hill was born in Muskogee, Oklahoma, and was raised in a home built on an eighty-acre plot of land that had belonged to her family since they came to Oklahoma from Georgia in the 1850s. Years later, this land was deeded to the family as their land allotment in accordance with the program ordered by the Dawes Commission. On the family land is a Ta-wa-gone Temple Mound, a reminder of the Touacara Village built there in around 1200 A.D. During the Civil War, this land became the site of old Fort Davis, a fort of the Confederacy. During this war, Hill's grandfathers fought on opposite sides, Great Grandfather Hill for the Union, Great Grandfather Harris for the Confederacy. All through her career, Hill has worked on a studio on this site.

Young Joan grew up with a minimal awareness of Native American culture because, for generations, her family had felt that assimilation with mainstream American society was the best path to achieving success (note the name George Washington Hill). At one time before he was appointed chief, Hill became a minister of the Methodist-Episcopal South Church and denounced several Creek ceremonies as pagan.

Joan attended the local Muskogee schools, graduated from Central High School, completed an A.A. degree at Muskogee Junior College, then graduated from Northeastern Oklahoma State University in Tahlequah with a B.A. in education. Although since childhood Joan had had the desire to become an artist, she had been told that she would never be able to support herself if she chose that profession. Therefore, upon graduating from Northeastern Oklahoma State University, she accepted a position teaching at Roosevelt Junior High School in Tulsa, a job she held for four years. During these years, she attended night classes in painting at the Philbrook Art Center.

In 1956 Joan Hill made a critical decision, the decision to become a professional artist. She enrolled in Bacone College to study painting with Dick West, who proved to be her mentor and the defining influence on her art. He advised her to turn to her native heritage and become a painter of Native American history and legend. He advocated intensive research so that her work would have authenticity of detail. Under West's guidance, Hill painted traditional, two-dimensional images of the Native American world. She personalized her work by using her favorite colors, yellow and orange and a variety of rich earth tones. Hill subsequently studied with a variety of teachers. Following her studies with West, she joined the Art Guild of Muskogee and studied watercolor with George Calvert. For many years she enjoyed traveling around the world, participating in painting courses with a variety of artists, for example, Dong Kingman and Millard Sheets.

West suggested that Hill have the self-confidence to enter her work in competitions of Native American paintings. Thanks to West's encouragement, while still a pupil at Bacone College, she entered her work in competitions at the Five Civilized Tribes Museum, at the Philbrook Museum of Art, and at the All American Indian Days in Sheridan, Wyoming, and won awards in all of these competitions. She also received a commission from the Western Hills Lodge at Sequoia State Park to paint a record of Cherokee civilization.

In 1971 Hill entered her painting *Morning of the Council* in the Heard Museum annual competition and won the Museum's Purchase Award. This painting depicts a historic council of Cherokee women. Hill describes her painting and the importance of women's councils in Cherokee society:

> On the occasion of a great council to discuss matters of war and state, my painting depicts the importance of women in ancient American Indian society. The painting's central focus is the Beloved Woman who was the head of her tribe's women's council and spoke with a Great Spirit. Many tribal cultures were traditionally matriarchal and consequently, women were afforded great respect.[1]

Morning of the Council is a two-dimensional painting in which Hill limits her colors to black, white, and very light earth tones. The only strong color is a lacra red, the color of the women's skin and the color of the sun, which Hill uses as a symbol of infinity, the never-ending cycle of life. The perpendicular lines in the distance represent smoke rising from the council fire. Hill demonstrates her knowledge of perspective in both the poses of the figures and in the diminution of the distant figures.

Morning of the Council, which is part of the permanent collection of the Heard Museum, has over the years proved to be of great interest to visitors of the museum. In 1990 the Governor's Commission on the Status of Women commissioned Hill to paint a second version for the collection of the State of Oklahoma, a painting that they would use as a poster; however, they asked Hill to include a child, so that it would represent women of all ages. For the Governor's Commission painting, *Women's Voices at the Council,* Hill added a girl clinging to the hand of the woman seen in profile.

70. *MORNING OF THE COUNCIL,* 1971

39 ³/₈ X 29", OIL ON CANVAS

COLLECTION THE HEARD MUSEUM, PHOENIX

EARTH SONGS, MOON DREAMS

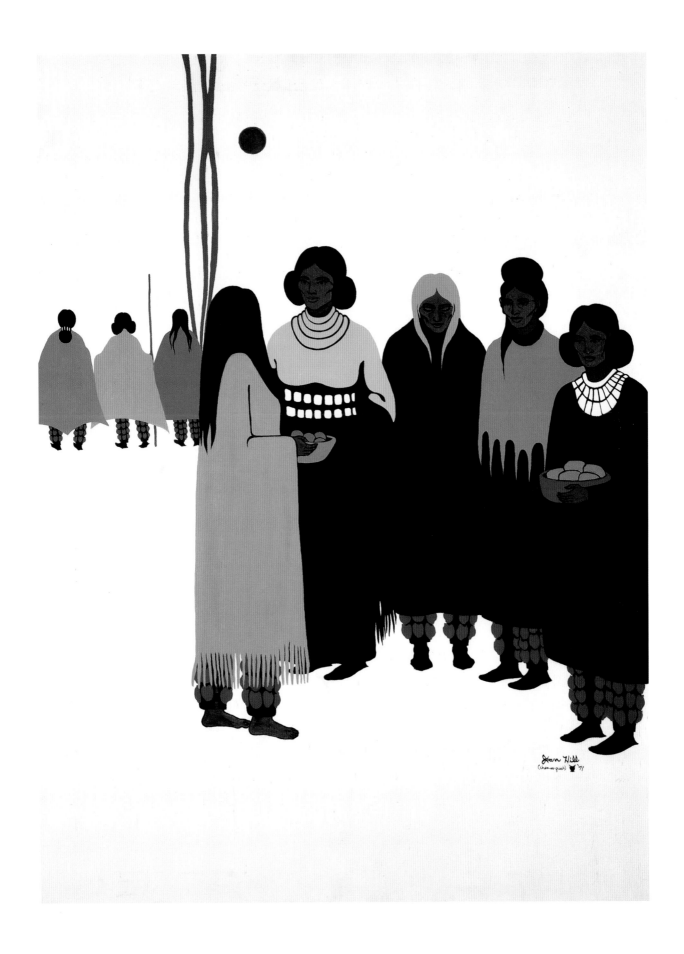

JOAN HILL

Chea-se quah (Red Bird) ◆ Creek / Cherokee

※

EVENING AT THE PUEBLO, 1967

From 1966 to 1970 Joan Hill made a series of trips to the art centers of Arizona and New Mexico and visited the nearby pueblos and Navajoland. These trips inspired her to paint historical homes of the indigenous peoples of the area. Hill describes *Evening at the Pueblo,* a painting of the Taos Pueblo, "I loved the shapes and colors of the pueblo, as the villagers went about preparing for the evening's activities. The majority of tasks were done by the women. Heavier work was done by the men."[1]

In the course of her career, Joan Hill has painted in a wide variety of styles ranging from representational realism to nonobjective painting. Hill describes *Evening at the Pueblo* as painted in a style she calls "subjective expressionism." In *Evening at the Pueblo,* the Taos pueblo buildings are composed of a series of elongated walls that tower above the tiny blanketed men and women. A dark rectangular form in the foreground of the painting is a "symbolic path to the Pueblo."[2] The sky above the pueblo is composed of a dark central panel flanked by lighter side panels. Hill uses earth tones for the colors of both the sky and the pueblo walls. Although it is evening, a sun appears in the sky. Hill sees the sun as the symbol of eternity and wishes to include it in all of her paintings.

Hill bases her paintings of Native American history and legend on extensive research. She is fascinated by the history of Native American art and the changing role of the Native American artist. Hill writes:

The artist was traditionally an integral part of the community in ancient tribal culture. Since there was no written language and only oral history passed down from the elders to the young, the artist served as both historian and philosopher for his or her peo-

ple. Whether on hide, cave walls, on pottery, as personal adornment, or woven into fabric or baskets, the artist's work was an ethnographic record of the tribal history, religious and ceremonial life, personal exploits and nature. In this capacity, the artist was a contributor to tribal welfare and considered as an accepted part of the community. . . .

Although contemporary Indian art is a living, evolving art form, it owes a debt to tradition, for it gives a base or sustenance to the contemporary artist, enriching and enhancing the creative work. The modern Indian artist takes traditional stylized motifs and incorporates them into his or her work, filtering them through his/her emotional responses, fusing the elements of traditional design from within the framework of his/her heritage and integrating them with the artist's own personal experience of today's culture. . . .

Art exists for me not to reflect reality as it is, but to create some other reality. Through my paintings I wish to transform my visual conceptions into a material form which can be shared with the world.[3]

Since the beginning of her career, Hill has enjoyed competitive success. Indeed, today Hill is the winner of the most awards of any Native American artist. In 1974 she became the first woman to be designated a Master by the Five Civilized Tribes Museum in Muskogee. Hill has enjoyed a multidimensional painting career: She has accepted commissions for portraits, book illustrations and cover art, and several murals. She also has painted nudes, a subject rarely seen in American Indian painting. Hill completed several versions of *Indian Madonna* in which the Madonna is naked above the waist.

71. *EVENING AT THE PUEBLO*, 1967

30 X 40", OIL ON CANVAS

COLLECTION JAMES T. BIALAC, SCOTTSDALE

JIMALEE BURTON (1906–1954)

Ho Chee Nee (The Leader) ♦ Cherokee / Creek

BUFFALO DANCE, 1947

Jimalee Burton was the first woman to exhibit at the annual *Indian Painting Competition* at the Philbrook Art Center. In 1949 she exhibited *Buffalo Dance* and won the Third Purchase Prize for the Woodland Region. Burton described the oil painting:

> It is night. The fire burns red. You hear the beat of the drum. The singers start their song. The dancers with their spears in hand leap forward and spear the buffalo hide, dancing and stomping in time with the music. This they hope will bring them good luck in the hunt.[1]

Born in 1906 in El Reno, Indian Territory, an area which today is Oklahoma City, Burton first was educated at the Indian schools in Colony, Geary, and Weatherford, Oklahoma. Her father, James A. Chipwood, was of Cherokee descent and her mother, Mary Beck, was of Creek/Cherokee descent. James Chipwood, a Texan, had come to El Reno in 1889 as a participant in the "Cherokee Land Run," and the claim he staked is now part of Oklahoma City. Burton wrote of her father and the 1889 Oklahoma Land Run:

> At sixteen my father was a pony-express rider from Quitman to Quanah, Texas. In 1889 he was among the thundering thousands of stampeding, land-hungry people, who swept into Indian Territory at a signal—the crack of a pistol, to take up homes in the new country. This was a terrific medley of humanity. Life was cheap, land the prize.
>
> Indian Territory by sacred treaty belonged to the Indian. It was confiscated by the United States government, thrown open to settlement, a complete betrayal of trust. These were thrilling days, terrible days, for the helpless Indian silently watching. Though a daughter of both Indian and white cultures, I am always Indian, devoting my life to the cause of my people.[2]

Chipwood had helped to build the first railroad to Oklahoma, a branch of the Santa Fe Railroad. He first met his wife at the celebration of the joining of the northern and southern spurs of the railroad by the planting of a golden spike at Purcell, Oklahoma.

Jimalee Burton first studied art at the Southwestern Teacher's College in Tulsa. She then attended the University of Tulsa, where she studied painting with Alexander Hogue. She later studied painting at the University of Mexico with Carlos Merida. Burton was one of the first Indian artists to be exposed to mainstream American art and the tenants of modern art. Although initially she exhibited and won ribbons at regional state fairs, in the course of her career, her paintings were exhibited in museums and universities across the United States and Canada. Burton led a rich and multifaceted life. For ten years she produced a radio program, was associate editor of the *Native Voice* in Vancouver, and was a songwriter and poet as well as a painter.

Throughout her life, Burton was fascinated by Indian folklore. Married in 1933, she became widowed in 1954. Following her husband's death, she moved from Tulsa to Sarasota, Florida, where she devoted the rest of her life to creating a painted and written record of Indian legends. In the years following her move to Florida, Burton traveled extensively, studying the legends and lores of the Caribbean as well as the United States. Burton achieved success as a writer as well as a painter. She won the National Penwoman Association Award for a short story, *Indian Legend of Creation*. In 1963 she won a commission to write a documentary, *The Indian Legends of Ho-Chee-Nee* (Burton's Indian name), and in 1974 she wrote *Indian Heritage, Indian Pride,* published by the University of Oklahoma.

72. *BUFFALO DANCE*, ca. 1947

21⁷/₈ X 17¹/₁₆", OIL ON CANVAS

COLLECTION THE PHILBROOK MUSEUM OF ART, TULSA, MUSEUM PURCHASE 1947.24

DANA TIGER (b. 1961)

Creek / Seminole / Cherokee

❋

PATROL OF THE LIGHTHORSE, 1990

Dana Tiger in her paintings portrays Native American women as historical and contemporary leaders. Tiger's women, distinguished by wisdom and spirit, are determined to resolve conflicts and to persevere. Her art is inspired by the traditional strength of the women of her Indian ancestry and by the dignity and determination of contemporary women. These primary themes are dominant forces in her life and art. Throughout her life, Dana Tiger has been a highly visible advocate for the rights of women and minorities, especially Native American women. She is personally involved in campaigns on both community and national levels and frequently donates paintings for poster projects.

Dana Tiger has a rich cultural legacy. She is the daughter of Jerome Tiger, who created "Oklahoma legend painting," a style of painting and a selection of historic subject matter that has served as a guide and inspiration for subsequent generations of Oklahoma artists. Jerome Tiger's paintings, eloquent expressions of Indian spirituality and mysticism, focused on the Trail of Tears, which for him symbolized the exile of the American Indian, their forced removal to Indian Territory in the mid-nineteenth century, and the isolation experienced by the American Indian in the twentieth century. Jerome Tiger was a master of understatement and his work has a lyrical quality, a delicacy, and a subtlety of line and color.

Dana Tiger was only five years old when her father died in a tragic accident; however, as she grew up she was inspired by the genius of her father's work. Her fraternal uncle, Johnny Tiger, Jr., who was also an accomplished legend painter, served as her mentor and tutor. He encouraged Dana to continue the family tradition, and thanks to his instruction, she achieved a facility in working with the delicate brushstroke that is the mark of the Tiger legacy.

Patrol of the Lighthorse initially was commissioned by the Tulsa Police Force to celebrate the historic Lighthorse Patrol. Tiger's figures on horseback on the snow are not historic individuals but icons of heroism and integrity—Cherokee men and women, past and present, who bring criminals to justice and represent courage, fortitude, and a sense of honor.

By 1808, the Cherokee Nation had set down the first Indian code of laws and set up an agency to enforce these statutes. This agency created regulatory companies, known as the Lighthorse Patrol, to perform the function of police. The United States government recognized the value of the Indian Police and, after moving the Indian peoples to Indian Territory, present-day Oklahoma, made grants of financial assistance so that the Lighthorse Patrol could continue. Members of the Lighthorse Patrol were not allowed to apprehend white men unless accompanied by a U.S. marshal because American citizens were not subject to the laws of the Indian people, who were considered to belong to a separate nation.

In *Patrol of the Lighthorse,* Dana Tiger includes two members of the Lighthorse Patrol, a man and a woman. Tiger explains that although women had great value in the Cherokee world, there is no documentation that historically women were members of the Lighthorse Patrol. Her painting is therefore a poetic representation of a historical scene that she hopes had reality. Today the Lighthorse Patrol continues in Oklahoma and there are both male and female members.

73. *PATROL OF THE LIGHTHORSE*, 1990

26 1/2 X 27 1/2", TEMPERA ON PAPER

COLLECTION THE THOMAS GILCREASE INSTITUTE OF AMERICAN HISTORY AND ART, TULSA

JIMMIE CAROLE FIFE STEWART (b. 1940)

Creek

❁

STUDYING THE TREATY, 1967

During the nineteenth century, the life of the Creek or Muscogee People was determined by a series of treaties. The Creek were a proud people, known for courage in war, but by 1805 the United States had carried out an agreement with Georgia to extinguish the Indian title to all lands within the borders of the state and had secured the relinquishment of millions of acres from the Creek Nation. This treaty led to a division among the Creek People, the foundation of a hostile Red Stick faction, and ultimately the Red Stick War.

Following the Red Stick War, during which Andrew Jackson and allied troops pursued a scorched earth policy in Creek country, the Creek Treaty of 1814 was signed, forcing the Creek Nation "to abandon all communication, and cease to hold any intercourse with any British or Spanish post, garrison, or town."[1] The Creek Nation was forced to cede to the United States all of their country in southern Georgia. Further cessions of land were agreed to in the Indian Spring Treaty signed in Georgia in 1825, followed by a treaty signed in Washington in 1826 which declared the Indian Springs Treaty null and void and ceded all Creek lands in Georgia to the United States. In 1932 another treaty was signed in Washington by a Creek delegation of seven members. This treaty ceded all land east of the Mississippi to the United States. Members of the Creek Nation were to leave this area within one year and the United States was to pay all expenses for their removal and pay one year subsistence after their arrival in sanctioned Indian Territory. This treaty led to years of chaos in the Creek world.

Jimmie Carole Fife Stewart in *Studying the Treaty* has painted the members of the 1932 delegation to Washington, D.C., who ultimately signed the treaty of that year. Among the members of this delegation were William McGillivray, Benjamin Marshall, and Opothleyahola, the speaker of the Upper Creek People. Stewart describes the reaction of the delegates to the treaty that government officials have given them to study:

> They viewed with astonishment the steps taken by the United States to rob them of their rights. After every treaty, the citizens of the United States were daily encroaching and building on the Creek land. A series of dubious treaties made between 1783 and 1786 drove the Creek Nation from their lands in Georgia. Now, in 1832, the Creeks ceded to and signed a removal treaty, according to which no Indian would be forced to move, but "shall be free to go and stay as they please." Could this be true, they pondered. (By 1836 the Creeks of the Treaty of 1832 were driven from their lands in Alabama and Georgia and 15,000 set on the road to disappear forever from their homeland.)[2]

In Stewart's painting, one man is seated, holding the treaty. The other six surround him, five standing and one seated on a tree stump. Three of the delegates wear business suits, dress they deemed appropriate for negotiation with the U.S. government. The other delegates wear cowboy boots, shirts, pants, vests, and neckerchiefs, also documenting acculturation.

74. *STUDYING THE TREATY, 1967*

14½ X 18¾", WATERCOLOR ON PAPER

PHOTOGRAPH COURTESY OF THE MUSEUM OF NORTHERN ARIZONA, FLAGSTAFF

(CATALOGUE # C.1644)

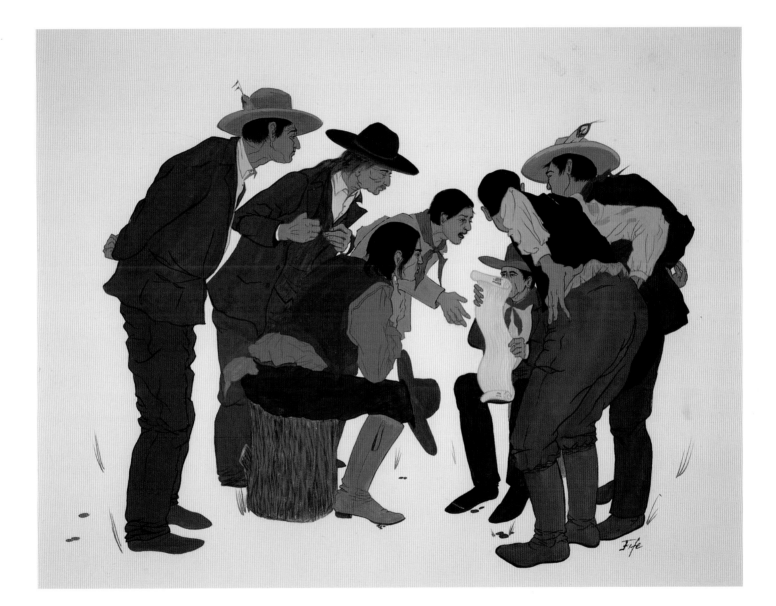

Although Stewart in *Studying the Treaty* initially appears to have followed the tenet of traditional Indian paintings, upon closer observation, this work clearly shows her academic training. The seven men are three-dimensional figures in naturalistic poses. Their composition is one in which the diagonals of the painting meet at a focal point, the treaty. The figures have distinct facial expressions of interest and concern. The delegate with his hand extended and his mouth open appears to be voicing an objection to the treaty.

Since childhood, Jimmie Carole Fife Stewart has been interested in her Creek heritage. As a child she wished to paint images of the American Indian. When she asked her mother, who owned a collection of Native American paintings, mostly by Kiowa artists, for suggestions of some subjects, Carmen Griffin Fife advised Jimmie to study the history of her people.

Stewart was born near Dustin, Oklahoma. She attended grade school at the local Graham School, then was sent to Chilocceo, a B.I.A. boarding school, which she attended from 1954 to 1958. In 1960, having completed a course of study focusing on painting and textile design, she received a B.F.A. from Oklahoma State University in Stillwater. During the summers of 1960 and 1961, she was a participant in the Southwest Indian Art Project headed by Lloyd Kiva New at the University of Arizona. The Southwest Indian Art Project served to heighten her awareness of her cultural heritage.

Stewart has worked in a multitude of careers—teacher, illustrator, fashion designer, and painter. She has continued her education and received a commercial art degree from Oklahoma State University in 1979 and completed graduate work in education at the University of Oklahoma in 1980. Today she lives in Oklahoma and has dual careers: She is a professional artist and a teacher in the Washington public schools.

Throughout her career as a painter Stewart has focused on Creek history, although occasionally she selects a subject that is a reminder of a personal experience which typifies Indian life in America, for example, her painting *Train to Euchee Boarding School*. In the course of her painting career, she has participated in many American Indian art competitions and won many awards. In 1967 she entered *Studying the Treaty* in the competition of the Five Civilized Tribes Museum. When the judges awarded this painting the first prize and called upon the artist to come forward and to receive the award, they were startled to learn the Jimmie Fife was a woman.

In 1976 Stewart completed a commission for an eight-by-ten-foot mural for the City of Seattle, Washington, for the Day Break Art Center. The mural, *The Earth Is Our Mother,* celebrates the cultural history of the Five Civilized Tribes: Cherokee, Choctaw, Chickasaw, Creek, and Seminole.

MINISA CRUMBO (b. 1942)

Creek / Potawatomi

✺

THE PUEBLO DRESS, 1976

In 1979 Minisa Crumbo traveled to the Soviet Union for a one-person exhibition of her art in Moscow, Leningrad, and Kiev. The exhibition was informally entitled *The First American Indian Art Traveling Exhibition in the Soviet Union.* Her work won the hearts of the Soviet people, critics and audience alike. Professor Andrei Chegodayev, who has won renown in the Soviet Union as an expert on American paintings, wrote of Crumbo's work: "American art is very rich. Its greatest asset is that it reflects the real world—the feelings, emotions, and thoughts of the people. Minisa Crumbo's paintings are a tribute to the art of her people and a folk art is always rooted in realism."[1] Today the exhibited engravings and Crumbo's portrait of Makombo, *Evening Thunder*, are part of the permanent collection of American Art in the Pushkin Museum of Fine Arts in Moscow.

Minisa Crumbo was born in 1942 in Tulsa, Oklahoma. She is the daughter of Woody Crumbo, a Potawatomi artist who was born on his mother's share of the Potawatomi allotment in Lexington, Oklahoma. Woody Crumbo was the director of the art department at Bacone College and during the 1940s won acclaim as one of the outstanding traditional artists of the day. Her mother, Lillian Hogue Crumbo, was a schoolteacher and an accomplished water-colorist.

Crumbo's father was the primary influence on her art. In 1995, in an essay on her father for a book on Indian paintings in the collection of the Philbrook Museum of Art, Crumbo described the attitude toward art that has defined her work and her life:

Basically it [art] is a reflection of the person's life. You know, in the past, I'm told there did not used to be a word for art and that separation didn't exist. Clothing, housewares, everything needed flowed from a personal vision of life.

There were words for beauty, harmony, balance—that was art. But the impetus of creation, for instance, flows through everyone. The raising of a generation of children is art.[2]

When Minisa was six years old the Crumbo family moved to Taos, New Mexico. Crumbo's first nonfamilial art instruction was with Ray Vinella, with whom she studied for two years at the Taos Academy of Fine Art. She subsequently studied at the School of Visual Arts and the Society of Illustrators in New York City. In 1976 she was the second American Indian artist honored by a one-person show at the Gilcrease Institute of American History and Art in Tulsa.

Crumbo is devoted to the study of tradition in the American Indian world. At one time, she was apprenticed to a medicine man. She is a firm believer in the innate artistic ability of the Indian people. Recognizing the influence that her ancestors have on her life and art, she especially is impressed by the independence and strength of American Indian women. In a poem entitled "Grandmother" Crumbo wrote:

Grandmother: speak to us
of the fires that made you strong
of the love that made you whole

Grandmother: tell us
of yesterday's labor
that fed and nourished in silence and unnoticed

Grandmother: accept our praise and thanks
for we grew strong by you
that we in turn may serve

Grandmother: bless us
that we, too, may see many days
and follow the path of wisdom and love.[3]

Throughout her career, Crumbo's priority has been Indian portraiture and costumes, as reflected here in *The* *Pueblo Dress*. For Crumbo, a woman's dress serves as a personal shield, revealing her hopes, dreams, and accomplishments.

75. *THE PUEBLO DRESS*, 1976
25 X 19³/₄", WATERCOLOR, PASTEL, AND CHARCOAL ON PAPER
COLLECTION THE THOMAS GILCREASE INSTITUTE OF AMERICAN HISTORY AND ART, TULSA

EARTH SONGS, MOON DREAMS

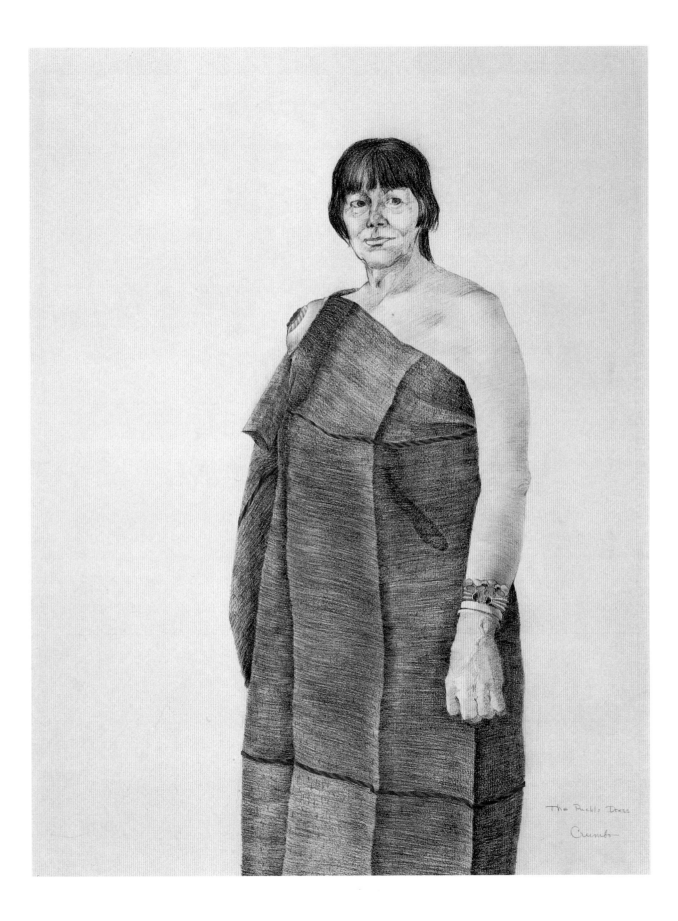

The Pueblo Dress

Crumbo

BRENDA KENNEDY (b. 1951)

Citizen Potawatomi

✹

PROVISIONS, 1976

Brenda Kennedy's painting *Provisions* depicts an American Indian couple buying food staples at the Kennedy Trading Post in Gallup, New Mexico. Kennedy reflects on the inspirations for this work:

> When I was a young girl, my parents and I were traveling on vacation in the Southwest. They were intrigued by the common name they shared with the owner of the Kennedy Trading Post in Gallup, New Mexico. Upon going inside, I noticed several photographers lined up to take pictures of two Indians. As I was constantly searching to improve my camera technique, I decided it would be a good idea to mimic what the more knowledgeable adults were shooting. Some twenty years later, I used this old picture as the basis for my painting.[1]

Kennedy grew up on the family wheat and cattle farm west of Geary, Oklahoma. Her father was a member of the Citizen Potawatomi Nation and her mother, who did not have Indian blood, was a teacher in the local elementary school. The Kennedys, who had achieved acceptance as members of this rural community, which did not place a high value on Indian heritage, did not instill a vivid sense of Indian identity in their daughter. Although for many years Kennedy signed her paintings "Brenda Kennedy Grummer," today she signs her work "Brenda Kennedy." The artist explains:

> In no way did I grow up with the traditional Indian background. Because of local prejudice, and out of respect for my parents' wishes, I did not identify myself as an "Indian artist" for many years. When I chose intensely to explore my Native American heritage through my art, I hoped to avoid family discord and reluctantly began to sign my paintings with my married name, Brenda Kennedy Grummer. Only recently, since my parents are deceased, am I again using my maiden name, in the belief that doing so will afford me a more authentic voice.[2]

Following graduation from college, Kennedy worked as a writer and a photographer in addition to being a painter. She completed commissions for medallions commemorating regional Oklahoma milestones, such as the 1972 Muskogee Centennial. In 1978 she decided to devote her life to painting. The wisdom of this decision was confirmed when, in the following year, she was chosen to be the featured artist in the Governor's Gallery in the State Capitol Building in Oklahoma City. Today Kennedy has won national recognition for her paintings of contemporary Indian life. Kennedy reflects on her art:

> I depict today's Indians as I know them from personal experience. While recognizing the importance of the historical aspects of Native American culture, I usually prefer to emphasize the Indian as an individual rather than as an ethnic stereotype. My subjects speak from themselves only, not their whole culture.[3]

76. *PROVISIONS, 1976*
18 X 18³/₈", OIL ON PAPER
COLLECTION THE PHILBROOK MUSEUM OF ART, TULSA, MUSEUM PURCHASE 1976.11.8

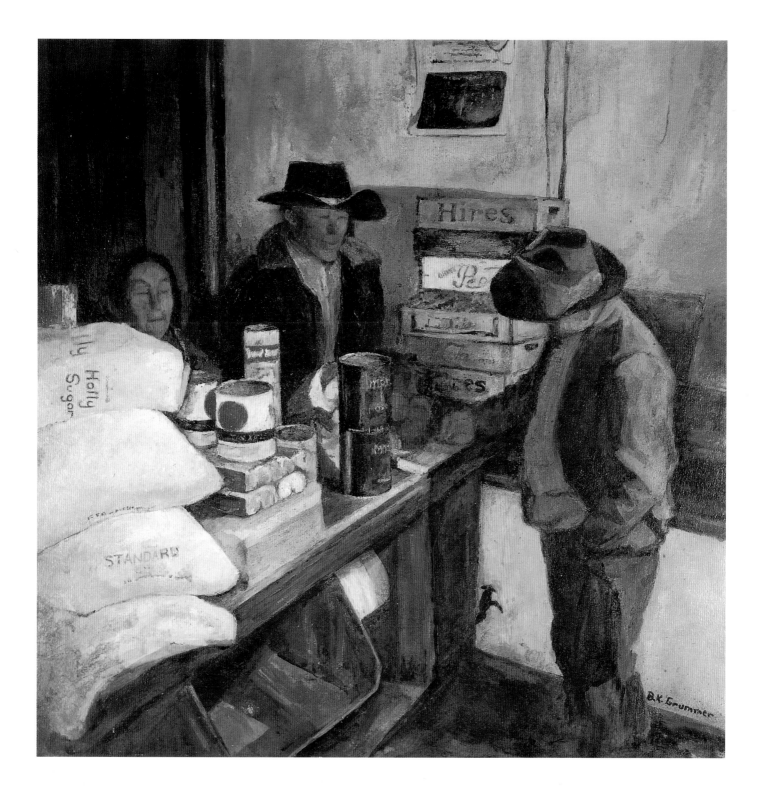

BRENDA KENNEDY (b. 1951)

Citizen Potawatomi

※

ONE SUNDAY AT SHAWNEE, 1979

The focus of Brenda Kennedy's art is contemporary American Indian culture. Although during the early years of her career she chose to focus on the daily activities of women and children, in recent years she has concentrated on the pageantry of the powwow scene. Her initial success was the painting *One Sunday at Shawnee,* which she completed in 1979 and entered in the thirty-fourth annual *American Indian Artists Exhibition* at the Philbrook Art Center. She won the Grand Award for this painting depicting a group of visiting Caddo women dancers at the Inter-Tribal Powwow, which is sponsored each year by the Citizen Potawatomi Nation in Shawnee, a town in Potawatomi County, Oklahoma.

Kennedy's painting depicts a quiet moment before the dancers begin to perform one of the traditional dances of the Caddo People. A line of Caddo women, in colorful blouses, long dance skirts, and ceremonial shawls, their heads bowed, stand listening to their leader, an older woman who carries a ceremonial cane of office. Nearby is seated a group of drummers waiting to accompany the dancers. In the distance waves an American flag, which Kennedy observes is always an important feature of a contemporary powwow ritual and is the central motif in the iconography of her powwow paintings.

Kennedy was born in El Reno, a small town west of Oklahoma City. An only child, she recalls a lonely childhood during which she developed into a voracious reader and taught herself to paint by copying illustrations from the family dictionary. Kennedy graduated magna cum laude from Southwestern Oklahoma State University. Although during her years at the university Kennedy completed a series of basic art courses, she attributes the development of her art to a lifetime of independent study.

Kennedy works in a variety of media including acrylic, alkyd, oil, gouache, pencil, ink, and prismacolor. She describes her style of painting as "academic impressionism." Invited to participate in many juried and invitational museum shows, she has achieved her greatest successes with her works in oil—primarily the paintings in her powwow series. Kennedy's most recent success was in 1997, when she won first prize at the Red Earth Competition in Oklahoma City for *Requiem,* a painting of the annual Cheyenne-Arapaho Labor Day Powwow at Colony, Oklahoma. *Requiem* was painted as a tribute to the many Native Americans who died in the 1995 Oklahoma City bombing.

77. *ONE SUNDAY AT SHAWNEE, 1979*
30 X 40", OIL ON PANEL
COLLECTION THE PHILBROOK MUSEUM OF ART, TULSA, MUSEUM PURCHASE 1979.4.1

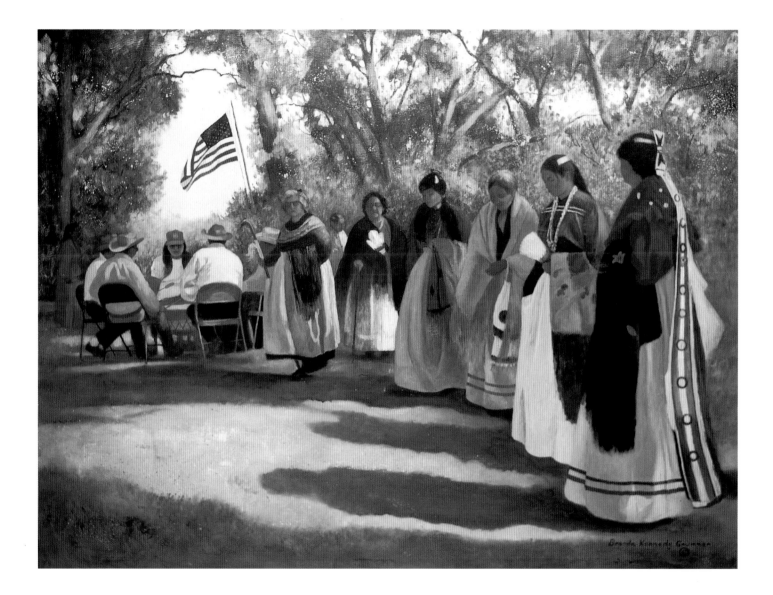

NORMA HOWARD (b. 1958)

Choctaw / Chickasaw

❀

DOORWAY TO THE PAST, 1996

In *Doorway to the Past,* Norma Howard has recaptured a moment from her childhood in Stigler, Oklahoma. She has painted from memory an image typical of family life, when her grandmother, mother, and younger brother were together in front of the family clapboard house. The majority of Howard's paintings are scenes from the daily life of her people, a combination of her personal, family life, and her Native American heritage.

Howard is proud of her American Indian heritage. Her father's family, Choctaw and Chickasaw People, came to Oklahoma on the Trail of Tears in the 1830s. Her maternal ancestors were Choctaw People who, at the time of the Trail of Tears, refused to leave their homeland in Mississippi and for over seventy years hid in the neighboring swamps. Some relatives who had followed the Trail of Tears to Oklahoma returned to visit their homeland, and only then were they able to convince the remaining renegade Choctaw to take advantage of the land allotment program and move to Oklahoma. In 1903 Howard's maternal grandmother, Ipokni, walked about five hundred miles from Tupelo, Mississippi, to southeast Oklahoma and received a land allotment which today still is the family land in Stigler and is Norma Howard's home. In 1996, Howard, tracing her ancestral roots, visited Mississippi.

Howard attended a country school through third grade, then received the balance of her formal education at the Stigler middle school. She was a small child when she made her first attempts at drawing, and all through her youth, her family encouraged her artistic endeavors. A self-taught artist, she is unable to remember a time before she was drawing and painting the people and animals of this southeastern Oklahoma community.

Doorway to the Past is a realistic genre scene of a Choctaw settlement in southeastern Oklahoma. Howard totally ignores the traditions of stylized Oklahoma American Indian painting. Her three-dimensional figures are in positions that reveal her understanding of foreshortening. Their faces, hands, and feet, as well as their clothing, show her interest in modeling while the wooden boards of the house and varied materials of the family's clothing show her concern with texture and pattern.

Norma Howard has included details of the past which give a reality to her work. Howard's maternal grandmother is holding two of the baskets that she has made from dried split cane, a skill in which she had great pride. The wooden basket hangs on the doorframe. Howard explains that when they had drawn water from the well, it was necessary to hang the bucket high, out of the reach of the neighborhood dogs. The family members all are barefoot, and Howard explains that even today in Stigler everyone goes barefoot unless they are going to town.

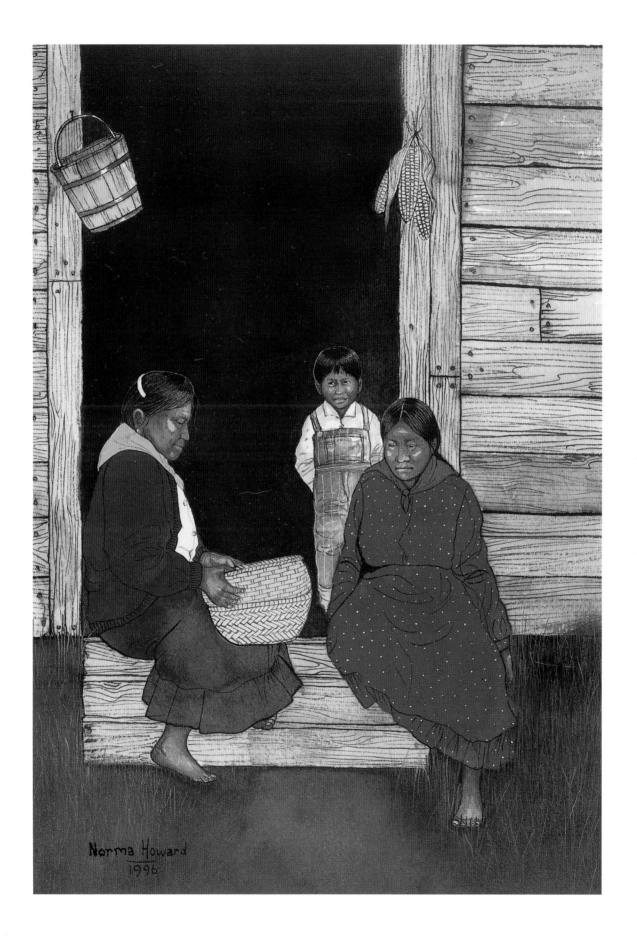

DOLONA ROBERTS (b. 1936)

Cherokee / Choctaw

❋

BEAUTIFUL BLANKETS, 1985

The paintings in the *Blanket Series* by Dolona Roberts synthesize the different influences on the artist's career. Roberts studied nonrepresentational or abstract art with Elaine deKooning and representational art, art focused on images of New Mexico, with Jozef Bakos, Kenneth Adams, and Randall Davey. Roberts acknowledges the contributions of each of her teachers:

In high school, I was fortunate to have Jozef Bakos as a teacher, and it really was he who was instrumental in my deciding to dedicate myself to art, as a lifetime work. He was one of the Cinco Pintores [a group of artists] who had settled in Santa Fe in the 1920s. . . .

At the University of New Mexico, after I had transferred there from Colorado College in Colorado Springs, I had Randall Davey as one of my teachers, as well as John Tatschl and Kenneth Adams. Adams was one of the members of the Taos Society of Artists. Elaine deKooning, one of the early abstract expressionists, was one of my teachers at UNM. I learned so much from all of them, and everything I learned was different.[1]

All of Dolona Roberts's teachers were colorists. Living in the high mountain country of New Mexico, all through her life she had a special awareness of the colors around her, and these colors had personal significance:

Some people see a mountain as brown; others, blue or green; the fortunate see it red with pink rocks.

There are the golden grasses of the fall, that I used to run my toes through when I was little; my mind, or sometimes my physical self, is up in the Sangre de Cristos [mountain range] with the sweet green of the aspens in early summer or my spirits lift to the pale turquoise sky that Victor Hagens painted in Taos. Perhaps this is the way I see my life . . . colored, in hues.[2]

Dolona Roberts was born in Santa Fe, where she attended the local grade and high schools. Her father was the owner of a Santa Fe flower shop and during childhood Dolona watched him make floral arrangements, played with the colored ribbons, and mashed blossoms to make colors to apply to white paper. She often listened to the stories her grandfather told and attended Indian ceremonial dances, a practice she continues today. Her great-grandmother, Nancy Lady, a woman of Choctaw/Cherokee ancestry, was also an artist. As Nancy Lady suffered from arthritis in her fingers she encouraged her very young great-granddaughter to mix her paints for her. This task served as a lifetime inspiration to Dolona. "I remember how the colors just seemed to jump alive and I love the smell of turpentine. It was there I knew I was an artist."[3] By age seven, young Dolona, guided by her aunt, was sketching Pueblo women who sat beneath the portal of the Palace of the Governors and sold their craft arts. Aware of their daughter's talent, Dolona's parents asked the Santa Fe artist Louise Crow to encourage and instruct their child. Dolona recalls, "The women back then wore blankets which were more colorful and traditional than the ones you see today. By sketching them, my art teacher, Louise Crow—

79. *BEAUTIFUL BLANKETS*, 1985
30 X 40", GROUND PASTELS ON PAPER
COLLECTION THE HEARD MUSEUM, PHOENIX

an artist from the East who moved to the Santa Fe art colony in the 1920s—hoped I would get a feel for form and mass."[4]

Upon completion of her studies at the University of New Mexico, Roberts began her professional career as an abstract artist. In order to support herself, for four years she worked by day as a bank teller in Santa Fe and painted at night. Slowly her work won recognition. In 1960 she won the Prix de Paris (unable to afford the airfare to France, she received the award by mail) and in 1961 her work was exhibited at the Musée Duncan in Paris.

Soon after winning these honors, Roberts married and with her husband traveled to Mexico City where the couple lived for a short time. They then settled in Schaffer, Texas, a poverty-stricken border town that proved to be a turning point in Roberts's life. Roberts wrote of her decision to end her unhappy marriage: "I came to a fork in the road. I came to the decision to be an artist—not a wife, not a mother. Not to take abuse anymore. Not to color my life black, not even gray . . . I left the darkness of my marriage. I wed painting . . . My life's companion has been my work . . . my painting."[5] Roberts borrowed money from a friend and returned to Santa Fe where, until she could support herself solely by her art, she continued working at a daytime job and painting all through the night. Her first paintings featured figures of Indian dances.

During this time she began to combine realism and abstraction in representational subjects, an approach to painting which since that time has been her trademark. Roberts began to paint the backs of blanketed Indian figures, single and multiple figures huddled together. The artist recalls:

> The back is a kind of an abstract image yet it has a representational human aspect. It started a few years ago. I had done some Mexican women in their blankets, or carrying children on their backs. It gradually evolved. Most of this inside. You have to go through various stages.
>
> I think people are primarily attracted to my sense of color rather than my imagery. When I use a single image, it's to be more abstract. Also there is more of a sculptural quality with the individual image. To give the feeling that there is somebody inside that blanket. I think it is timeless. I guess it goes back to all the mysteries of the eternal woman.[6]

The blankets of these larger-than-life figures serve as her canvas for abstraction. These paintings feature ribbons of color and geometric forms that impart a sense of timelessness:

> I am capturing the intensity of what I feel and see, not copying images. The blankets are colored, patterns and sculptural properties which express the sense of mysticism I feel. They have movement and form, with figures showing representational aspects as well.
>
> At heart I will always be an abstract-expressionist. Colors and shapes are preferable to compositions. The paint or medium becomes the important vehicle, not the subject matter.[7]

Each blanket is the creation of Roberts's imagination. Her paintings are distinguished by rich hues and the vibrancy of her colors. She has developed a technique of applying watercolor pigment, so that they have the luminosity and depth of oil. Roberts liquefies ground pastel chalk in a fixative, then applies the mixture as a wash. The finished work has the softness of watercolor and the glow and layered depth of oil.

During the 1980s Roberts again won international approval when she was one of six artists invited to participate in the 1981 exhibition *Indien d'Amérique du Nord*, at the Salon d'Automne at the Grand Palais, and in 1987 she accepted an invitation to participate in an exhibition in Basil, Switzerland, and Heidelberg, Germany, *Indianerkunst Nordamerikas*.

Beautiful Blankets is a painting of three blanketed men from the Taos Pueblo. "I'm particularly fond of Taos men as my subjects. At their traditional Sundown Dance held in September on San Geronomi Day, the men come down from Blue Lake, carrying golden aspen branches and each man makes a noise like a wild animal or bird. It's truly moving, a mystical experience."[8] The heads of the figures are carefully defined; the men's hair has a suggestion of braids and a section drawn into a chonga. By contrast, the free-flowing stripes of color, a symphony of pinks, lavenders, and purples, cascade over the blankets that shroud the figures. Roberts sees her paintings as "the combination of concepts—space, color, and tradition."[9]

DYANNE STRONGBOW (b. 1951)

Choctaw

※

HER FLOCK, 1981

In 1981 Dyanne Strongbow painted *Her Flock,* a watercolor painting that includes an image of a Navajo woman, her flock of sheep, and a distant mounted rider set against a background of desert and sky.

Strongbow, a Choctaw artist born in 1951, belongs to a contemporary generation whose work is inspired by a pan-Native-American identity rather than an identity that confirms a specific tribal heritage. Dyanne Strongbow was born in Austin, Texas. During childhood, her only tie to the American Indian world was her Choctaw grandmother.

Strongbow studied art and advertising at Southwestern Texas State University in San Marcos, Texas, where she earned a B.A. in commercial art. Her first paintings were traditional landscapes of rural Texas. She worked for ten years as a commercial artist and illustrator for the Texas Department of Agriculture and the Texas Department of Water Resources. During this time, she also completed commissions for book and album covers.

Slowly Strongbow's focus shifted to independent work in watercolor. Realizing she had Native American ancestry (she is half Choctaw), Strongbow in the early 1970s completed her first paintings of American Indians. They were watercolors of the Native American people of the American Southwest, and they were basically products of her imagination. She found her first efforts unsatisfactory, for she was a strong believer in historical accuracy. She therefore began to use the library for her research on American Indian people. As she studied the myths, legends, and activities of daily life of the Navajo, the Apache, and the Pueblo People, her paintings began to focus on specific activities of these American Indian people and were based on the knowledge of their history and contemporary life.

Today Strongbow's primary interest is the traditional life of the Native peoples of the American Southwest. She has developed an individual style in which she employs the use of composites of overlapping subjects and subtle washes. In *Her Flock,* images of white sheep overlap the figure of the Navajo woman standing with her back to the viewer and looking out over the Navajo desert to the horizon where she sees a herder on horseback. Although similar images exist in the Navajo world today, Strongbow selects images and uses colors which for her typify the Navajo world of the eighteenth and nineteenth centuries. Strongbow explains:

> I do composites. . . . I'm trying to give the viewer a look into the past, with several different views. . . . Some of the colors I use have a definite tie to the individual tribes I'm painting. . . . Everything has a meaning in Native American design and trappings; they're not just decoration. So, if the color needs to express a meaning, I will stay with the color that's needed.[1]

Since she has concentrated on painting the Indian people of the American Southwest, Strongbow has enjoyed great success. Her work has been included in many exhibitions, including the 1981 *Night of the First Americans* at the Kennedy Center in Washington, D.C. In 1983 her painting *The Drummers,* depicting two Pueblo drummers standing beneath small white images of their ancestors, was selected by the Southwestern Association on Indian Affairs (S.A.I.A.) as the poster for the sixty-second annual Indian Market in Santa Fe. That same year, her painting *They Came with Banners Flying,* with its images of the conquistadors crossing in front of the Sandia Mountains, was awarded the Purchase Prize by the Museum of Albuquerque and selected for the city's promotional poster.

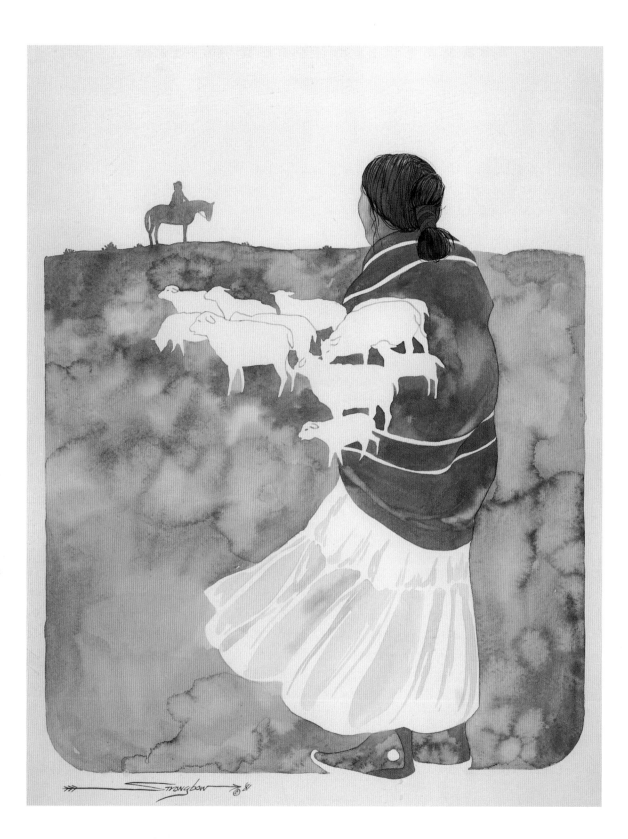

80. *HER FLOCK*, 1981

18 X 14", WATERCOLOR ON PAPER

PRIVATE COLLECTION

MARY C. YOUNG (b. 1928)

Choctaw

❋

BEAR DANCE, 1965

In 1965 Mary Young completed *Bear Dance*, a painting inspired by the teachings of the art department at Bacone College, where she studied in 1960 and 1961. At Bacone College, Young was a student of Dick West, who followed the path established by his predecessor Acee Blue Eagle, the founder of the art department. Blue Eagle wished to inspire the creation of a comprehensive visual record of the history and daily and ceremonial rituals of the American Indian peoples. Like Blue Eagle, West stressed the importance of authenticity of detail and the use of library research to ensure accuracy.

Unlike the Santa Fe Indian School, where the students were taught to select subjects relevant to the histories and lives of their peoples and to include symbols and designs of their tribal origin, the Bacone students were encouraged to read histories and research the customs and lives of Indian people from across America. They then were expected to select a subject that would instruct and inspire American and European viewers who knew little of the Native People of America.

Mary Young was born in Muskogee, Oklahoma, to Herman Bresse and Lillie Willis. She first was educated at Sacred Heart School in Muskogee and at Muskogee Central High School, then in 1947 attended St. Mary's of Notre Dame in South Bend, Indiana. In 1950 she married Revere A. Young. It was not until 1960, following the birth of two children, that she came to study painting with Dick West at Bacone College.

Mary Young immediately showed an aptitude for Dick West's approach to painting. Her first year at Bacone she exhibited *Eagle Dancer* in the sixteenth annual *American Indian Artists Exhibition* at the Philbrook Museum of Art. During the late 1960s and early 1970s, she was a frequent participant in the exhibitions of the Five Civilized Tribes Museum. Young completed the majority of her paintings in the 1960s and early 1970s.

Mary Young chose to paint *Bear Dance*, a historic social dance of the Ute People. The Bear Dance usually was held in March, a traditional welcome to spring. The bear is a symbol of spring, because every spring bears recover from hibernation. The bear is believed to be the wisest of animals and, except for the mountain lion, the bravest. Bears are thought to possess magic.

The Ute believe that bears are fully aware of the relationship existing between themselves and the Ute People and that the Bear Dance strengthens their friendship. Ute People from far and near come to participate in the Bear Dance. Led by a Medicine Man or chief with several assistants, everyone dances. The dancers are accompanied by musicians and singers who play moraches, or "singing sticks," which make a rasping sound like muffled cymbals. The music is thought to be transformed into thunder that will awaken the sleeping bears in their mountain caves. At the conclusion of the dance, the bears are believed to have been provided with food, to have fully regained the use of their facilities, and to have found mates. It is believed that in gratitude and as payment the bears will assist the Ute People in the practice of magic.

Young has painted the dance leader, who wears a bearskin. His head is covered by the bear's head and the claws of the bear cover one arm and dangle from the other. A turtle, a squirrel, fish, eels, a frog, and other small animals hang from the dancer's arms and over his shoulder. Strips of white and light brown fur are wrapped around his arms and legs. In one hand, the dancer waves a tambourine. In the other, he holds a staff that has an arrowhead at one end, a huge tassel, and small animals along the side.

The Bear Dance is one of the oldest Ute ceremonies. During the eighteenth century, ancestors of the Ute held great hunts on the Mississippi bottom. The inclusion of the small animals on the costume of the dance leader suggests that the Bear Dance recalls past days of hunting. The Bear Dance still is performed by the Ute People. Young's *Bear Dance* suggests the energy and vitality of spring. She has created a three-dimensional figure that evokes a sense of movement and the spirit of the Bear Dance.

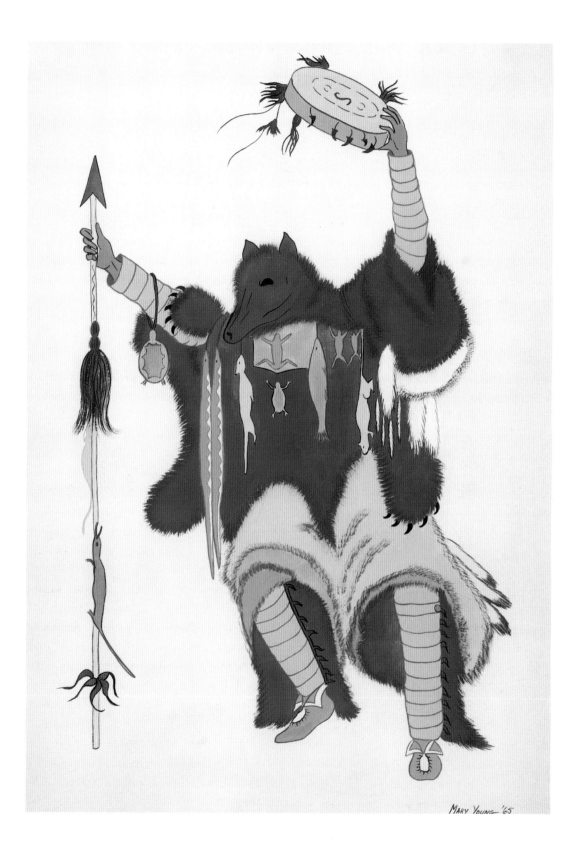

81. *BEAR DANCE*, 1965

16 X 11¹/₄", CASEIN ON PAPER, PRIVATE COLLECTION

VALJEAN McCARTY HESSING (b. 1934)

Choctaw

✷

CHOCTAW REMOVAL, 1966

Valjean McCarty Hessing has devoted her art to preserving the cultural and historical legacy of the Choctaw People. Born in Tulsa in 1934, Hessing is the daughter of Madelyn Helen Beck, a woman of Welsh ancestry, and Vernon Clay McCarty, an honorable chief of the Choctaw People. Vernon McCarty was a plumber and cartoonist for the magazine of the local plumbing union.

Young Valjean attended the regional public school where, when she was eleven years old, she won a scholarship to the weekend educational enrichment program at the Philbrook Art Center that included writing, dancing, painting, pottery, and the study of art history. There, for the first time, Hessing had the opportunity to see traditional American Indian paintings and developed an interest in the legends of the Indian peoples.

During Hessing's childhood years, it was frequently necessary for her father to travel far from home in order to find enough work to support his family. (Indoor plumbing was not yet an ever-present feature of Tulsa homes.) In order that young Valjean might continue her education without interruption, she was sent to live with her maternal grandparents who, as managers of the K.C. Auto Hotel, lived in an apartment atop this downtown Tulsa landmark which was next door to a bus station. Hessing recalls that every Saturday Indians would come there and she remembers seeing them in blankets and long braids.

In 1952 Hessing graduated from Tulsa High School where, having excelled in her studies, she won three college scholarships. She chose to attend the University of Mary Hardin-Baylor in Belton, Texas. There, for two years she studied European art history and was introduced to the techniques of modern art. During her second year of college, Valjean met Robert Hessing, an air force officer at Texas A&M, and in 1954 the young couple married. Soon after their marriage, however, Robert Hessing was sent to Korea, and Valjean returned to her native Tulsa and enrolled in the

University of Tulsa, where for a year she studied painting with Alexander Hogue.

During the next few years, Valjean accepted the social dictates of the 1950s and devoted her life to her husband and children. It was not until 1963 when Hessing, the mother of four children, began a career as a professional artist and accepted her American Indian identity:

> It was my father who encouraged both my sister, Jane Mauldin, and me to resume our art careers. He hoped that we would some day go into Indian art.... To continue my father's investigation into our family history and learn the teachings of the Choctaw. I had to read countless history books, pore over old newspapers like the early *Oklahoma Chronicle,* delve into court records and obtain oral histories from still-living relatives.[1]

Vernon McCarty inspired not only Valjean but her younger sister, Jane, who went on to win individual recognition as a painter.

Hessing chose to work in the traditional two-dimensional style that she had learned to appreciate during her days at the Philbrook Art Center. The artist recalls: "When I began in the early 1960s there was no one who taught traditional techniques so I set about teaching myself. I studied old paintings and practiced, practiced, practiced. It took me years of hard work but eventually I mastered the technique."[2] In the course of her career Hessing has developed the ability to work in many media, including acrylic, watercolor, pen, pencil, and even clay.

In 1820 the Choctaw had signed a treaty with the United States and thus became the first of the Southeastern tribes to be ceded land in Indian Territory, which today is in the state of Oklahoma. In 1830 the signing of a second treaty gave official sanction to the final removal of the

Choctaw Nation. The removal continued for three years, from 1831 to 1834. In parties of five hundred to one thousand, the immigrants traveled mostly on foot, facing starvation and diseases against which they had no natural immunity. In some instances entire communities of Choctaw died. In 1966, Valjean Hessing painted *Choctaw Removal,* a dramatic painting that captures the reality of the forced removal of the Choctaw People to Indian Territory, a tragic ordeal which is known as the Trail of Tears. Hessing's painting depicts the misery of the Choctaw men, women, and children encountering the ravages of winter on the Trail of Tears.

82. *CHOCTAW REMOVAL,* 1966

7 $^7/_8$ X 21$^1/_2$", WATERCOLOR ON PAPER

COLLECTION THE PHILBROOK MUSEUM OF ART, TULSA, MUSEUM PURCHASE 1967.24

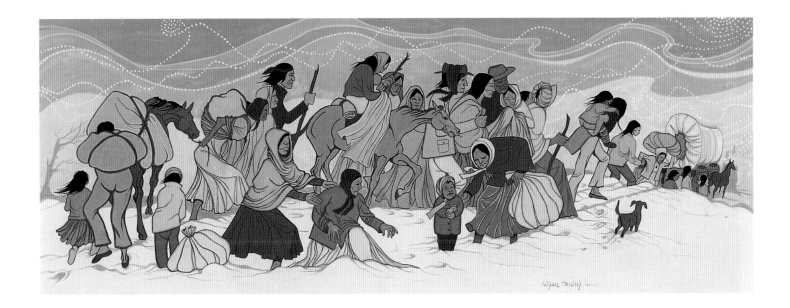

VALJEAN McCARTY HESSING (b. 1934)

Choctaw

※

CHOCTAW MOURNING RITES

Valjean Hessing has won national recognition for her paintings of the traditional Choctaw world. In the course of her career, Hessing has won more than seventy-five major awards, and her work is part of the permanent collections of American Indian art in museums across the United States. In 1972 Valjean Hessing and her sister, Jane McCarty Mauldin, were honored by the Heard Museum in Phoenix by an exhibition of their paintings, and in 1973 Valjean Hessing was honored with a one-woman exhibition of her work at the Heard Museum. In 1986 the Five Civilized Tribes Museum in Muskogee, Oklahoma, recognized Hessing's accomplishments in painting by elevating her to the Masters category, a special level reserved for a few outstanding artists of the Choctaw, Seminole, Creek, Cherokee, and Chickasaw Nations.

Throughout her career it has been important to Valjean Hessing to work in a two-dimensional linear style used by traditional American Indian artists throughout the twentieth century. Hessing explains that two-dimensional painting is "a very demanding, disciplined art form and there are only a few of us left who practice it. I continue because I am just as concerned about preserving the traditional Indian art techniques for future generations as I am their legends."[1] Hessing's work is distinguished by the subtlety and beauty of her palette which features earth tones and celebrates the harmony of nature. The artist explores the expressive potential of earth colors by her placement of adjacent areas of single color with increasing and diminising values.

In *Choctaw Mourning Rites,* Hessing has painted five Choctaw women gathered around a burial site. Prior to the nineteenth century, the Choctaw covered the corpse with skins and bark and placed it on a scaffold near the homes of the survivors. The relatives of the deceased went to the burial site to mourn and wail. When the body reached an advanced state of decomposition, the relatives sent for the bone pickers who were honored officials. Surrounded by the relatives of the deceased, the bone pickers used their fingernails, which they grew especially long for this task, to clean the bones of putrefied flesh, then passed the bones to the mourners. Finally the flesh and scaffold were burned and the bones were put in the coffin, which was placed in the bone house where the bones of generations of Choctaw were preserved.

In *Choctaw Mourning Rites,* Hessing has painted a moment in the observance of a more modern burial ritual, which was observed by the generations who had abandoned the ceremony involving the scaffold and bone pickers. Friends and relatives dug a grave near the home of the deceased. In the grave they placed clothing and special ornaments of the deceased as well as favorite weapons for males and personal pots and kettles for females. They also slew and placed in the grave of the departed the ponies and dogs which, they believed, would accompany them after death. Six poles were smoothed and painted red then placed around the grave. At the head of the grave stood a taller pole decorated with grapevine loops and bearing a white flag. The family of the deceased observed a formal period of mourning that lasted from thirty days to thirteen months. During this time the families visited the grave two or three times a day to weep and wail. At the end of this mourning period, friends and relatives joined together for final rites, which included extensive weeping and the pulling out and removal of the poles. The mourning would conclude with a lavish feast. In her painting Valjean Hessing has painted the mourning relatives during one of their many visits to the grave of the departed.

83. *CHOCTAW MOURNING RITES*

25¹/₂ X 20¹/₂", WATERCOLOR ON PAPER

COLLECTION JAMES T. BIALAC, SCOTTSDALE

VALJEAN McCARTY HESSING (b. 1934)

Choctaw

❋

THE CAPTURE OF THE CRAWFISH BAND, 1974

Throughout her career, Valjean Hessing has had a great love of the legends of the Choctaw People. Inspired by her father, who was an honorary chief of the Choctaw, Hessing sees as her aesthetic mission the creation of paintings that give two-dimensional form and vital color to the legends of her people. The artist observes, "Many of the old legends have been recorded and preserved in print. I draw upon my imagination and knowledge of Indian icons to visualize the stories, then I translate them into traditional art."[1]

In 1974 Hessing painted *The Capture of the Crawfish Band,* which depicts an ancient legend of the Choctaw People. Hessing tells the story of the Crawfish Band:

Long ago, under the face of the earth and mud lived a band of Crawfish people. Long nails grew from their fingers and toes; their hair was thick and long and their eyes were almost colorless. They spoke no language. Walking on all fours, they seldom left their subterranean homes. Passageways were mined to their watery caves and they lived a quiet life, subsisting on the animal life which was trapped in the muddy entrances to the tunnels. For much time, the Choctaw people were unable to catch these elusive creatures of the underground. The Choctaw would wait patiently for the Crawfish people to emerge from the mud for sunning.

Then one day, a few crawled out of the mud. Lying lazily around the rocks, the Crawfish people found themselves surrounded by the Choctaws! Unable to reach their mud holes for a fast escape, they hid in the rocks for safety, but the Choctaws made a large fire and smoked them out! The Crawfish people were treated kindly and were taught the Choctaw way. They were adopted into the Choctaw Nation. Those uncaptured Crawfish people are still living underground to this day.[2]

84. *THE CAPTURE OF THE CRAWFISH BAND, 1974*
22$^{1}/_{2}$ X 24$^{1}/_{4}$", TEMPERA ON BOARD
COLLECTION Q.V. DISTRIBUTORS, INC., PHOENIX

JANE McCARTY MAULDIN (1936–1997)

Choctaw

❁

PRAYER, 1972

In *Prayer,* Jane McCarty Mauldin captured in watercolor her vision of a sacred moment in the autumnal forest. The focus of Mauldin's painting is an Indian man wrapped in a blanket with a single eagle feather in his hair. He is standing against a tree-covered mountain, his head bowed in prayer. It is late autumn and there are only a few remaining patches of colored leaves. The mountain is covered with leafless trees and outcroppings of rock. In front of the man, a group of small animals, ready for their winter hibernation, underline the serenity of the scene.

When Mauldin first began to paint, she tried to achieve photographic realism in her work; however, as she developed her skills and confidence, she employed a deductive method of painting. Mauldin wrote of her approach to painting:

> So, I usually paint a background, then I look at it and I study it to see something in it, or whatever it looks like to me. So I'll end up drawing either faces or a feature or person or it could be trees; it could be an animal—it's just whatever I see in that.[1]

> A lot of my pictures just happen—things come out as I paint along and I enhance what I see—a feeling, a color, a shape. These I call "controlled accidents," again using enhancement to bring forth the major structure of the painting.[2]

Working with finger-painting techniques, Mauldin applied watercolor washes and watercolor highlights in *Prayer.* She then worked with a tiny brush and dark brown and gray watercolors to draw outlines of the skeletal barren trees, grasses, rocks, and animal forms. Using a limited palette of autumnal colors—blues, russets, ochres, yellows, and grays—for the costume of the man, the tree foliage and their spires, rocks, and small animals, Mauldin established a sense of the total harmony of the Indian man and the natural world around him.

Jane McCarty Mauldin was born in 1936 in Tulsa, Oklahoma. Her mother, Madelyn Helen Beck, came from Welsh ancestry and her Choctaw father was a descendant of people who came to Oklahoma from Mississippi and settled in the vicinity of Otakha and Lehigh. She was born two years after her older sister, the painter Valjean Hessing. Unlike her sister who was sent to live with her maternal grandparents, young Jane remained with her parents and accompanied them on their travels as their father pursued work as a plumber. Jane attended elementary schools in Oklahoma and Texas, then attended Tulsa Central High School. During her senior year she began to work as a commercial artist for the Floyd Gates Studio. For the next twenty-four years, she continued to work in this income-producing profession.

In 1963, a year after the birth of her fourth child, Mauldin followed the pattern of her older sister, Valjean, and began to enter art competitions. She was intent on succeeding in her careers as a commercial artist and an independent painter. She was forced to work at night on her personal creative art. Although until 1977 Mauldin was able to devote limited time to her painting, from the very beginning she enjoyed success as an independent artist. In 1965 the two paintings that she entered in the Philbrook Art Museum competition were purchased by the Department of the Interior. In 1972 she and her sister, Valjean Hessing, were honored with a two-person show at the Heard Museum in Phoenix. Although over the years Mauldin won many competitions and awards, a highlight of her career was the Jerome Tiger Award in 1978 from the Five Civilized Tribes Museum in Muskogee, Oklahoma. In 1981 both Mauldin and Hessing were invited to participate in the *Night of the First Americans* exhibition at the Kennedy Art Center in Washington, D.C. In 1982 the Department of Interior Indian Arts and Crafts Board presented an exhibition, *Paintings by Jane McCarty Mauldin,* at the Southern Plains Indian Museum and Crafts Center in Anadarko, Oklahoma. Mauldin continued to work independently and to enjoy success as a painter until her death from cancer in 1997.

85. *PRAYER*, 1972

19 X 11", WATERCOLOR ON PAPER

COLLECTION THE HEARD MUSEUM, PHOENIX

CHRISTINE MUSGRAVE (b. 1959)

Osage

❁

BEAR DANCE, 1990

Christine Musgrave believes in the power of the traditional spirits of the American Indian people to serve as protective forces in the contemporary world. Above all, her focus is on animals as protective spirits. Historically, the Osage People believed that there was spiritual power in the images of the animals painted on shields and medicine shirts. Musgrave writes, "I think of warriors carrying a shield for protection even long after they had lost any effectiveness against bullets. It was an animal depicted on the shield that the warrior was depending upon for protection. It was the same with medicine shirts. I wish now for that kind of protection against modern enemies like poverty and child abuse."[1]

Christine Musgrave, hoping that animal images—turtles, bears, fish, wolves—would serve as a protective force in the modern world, completed a series of paintings which she refers to as *Shirts, Shields,* and *Blankets. Bear Dance* is the celebration of the powers of this historic animal in protecting the Osage People. Musgrave's bears dance in a star-filled sky. They serve as her personal prayer for world peace, a prayer that her sons never will go to war.

Since childhood, Christine Musgrave has lived in Baldwin City, Kansas. Her childhood mentor was her Osage grandfather who took her to tribal events. She also had a close bond with her aunt, Alice, a professor of art who took her on trips to art museums and galleries and took her to her art classes where young Christine had the honor of serving as projectionist for slide lectures.

For a short time Christine Musgrave attended Kansas University and the Kansas City Art Institute but returned to Baldwin, married, and began a family. She did not concentrate on art until after the birth of her two sons. Balancing her career and her family responsibilities, she carefully schedules time for painting: "When I finally do arrive at that period of time in which I will be painting, I celebrate. The pictures and the time I take to do them are gifts to myself. The subject matter I choose is a direct reflection of what interests me and gives me joy."[2] Musgrave's art is influenced by traditional American Indian creativity, especially hide paintings and rock drawings. Having tried both abstract and representational styles, she chose to work as a representational painter concentrating on her favorite images, animals, with references to water, grasses, fire, and the night sky.

Musgrave's *Bear Dance* includes the images of bears against a background that is part night and part day. Here are the bear spirits with their powers to protect believers. Night includes brown- and red-colored bears, the outline of bear paws, bear tracks, a migration spiral, and a small bear image that suggests a pictograph. Day includes a large green bear and, overhead, a bear outline. Bears enter on the left and right edges of the painting, and a fox image and a bear covered with triangles and separate triangular designs suggest pictographs of ancient days. Green is the complementary color to red as day is the complement to night. Although Musgrave's work is two-dimensional, there are no solid areas of color as in traditional American Indian art. Musgrave loves pattern and texture, and both the background and animal skins give clear evidence of the artist's hand.

86. *BEAR DANCE*, 1990
22¹/₂ X 47⁵/₈", MIXED MEDIA, OIL, PASTEL, INK, ACRYLIC COLLAGE
GREAT PLAINS ART COLLECTION, UNIVERSITY OF NEBRASKA-LINCOLN
GIFT IN MEMORY OF GEORGE M. AND HELEN G. BUFFETT

ANITA LUTTRELL (b. 1951)

Osage

❄

OSAGE WOMAN, 1973

Anita Luttrell painted *Osage Woman* during her student days at the Institute of American Indian Arts. She used ink, charcoal, and acrylic paint to create this life-sized image of an Osage woman in contemporary dress facing a range of snowy mountains and remembering the heritage of her people. Anita Luttrell was born in Hominy, a town in Osage County, Oklahoma. The family lived on her great-grandfather's land allotment until Anita was nine years old, when her family moved to Denver. Before Anita attended the Institute of American Indian Arts, she studied at Northeastern Oklahoma State University in Tahlequah and in 1992 graduated with a B.F.A. from Oklahoma State University in Stillwater.

Traditionally in Osage society, leadership in government and religious activities was the domain of men, whereas women's role was primarily domestic. Osage women were famed for their skill in craft arts. They excelled in ribbon work and finger weaving. They also won praise for their cooking, creating such dishes as meat pies and dried corn soup. Contemporary Osage family life follows a line of male descent. Each male child has a distinctive name; however, only the first and second daughters are given a name. Any girl children who are born subsequently must share these names.

Historically, the Osage were a hunting tribe from the Great Plains. The Osage People in the area that is today western Missouri were buffalo hunters, depending on the buffalo for food, clothing, and the majority of their daily necessities. When the white men slaughtered the great herds of buffalo, the Osage were forced to turn west to hunt buffalo. During the early nineteenth century, each summer whole villages of Osage men, women, and children would set out on foot to western Kansas and northern Oklahoma to hunt buffalo.

It is believed that in prehistoric times the Osage, a Siouan people, migrated from the West to the Atlantic Coast, settling in the region between the James and Savanna Rivers in Virginia and the Carolinas. In time, they turned west, then descending the Ohio River to its mouth, then crossing the Mississippi River, then

the Missouri River, where they settled briefly, and ultimately the Osage River. This region was their home until the forced removal of the Osage between 1825 and 1836. In 1825 the Osage signed a treaty at St. Louis in which they ceded all their land to the United States. In 1828 they were given a reservation in northern Kansas. In 1870, under pressure for opening Kansas lands to white settlers, the Osage were persuaded to sell a great portion of their land and were offered a new reservation in Indian Territory, present-day Oklahoma. In the years following this forced migration, almost half of the Osage People died from inadequate medical supplies. Because of the destruction of the buffalo herd, there was a dire lack of food and clothing. This new reservation land, however, proved to be a financial bonanza for the Osage; the combination of pasturage leases and the discovery of oil on reservation land made the Osage the wealthiest of tribes.

Thanks to the focus of the Institute of American Indian Arts, Anita Luttrell's painting is an individually creative artistic statement rather than a stereotypical mid-twentieth-century American Indian work. Instead of relying on the traditions of American Indian painting developed by the early-twentieth-century Indian schools, Luttrell, although employing flat areas of unmodulated color, used a vanishing point and the layering of spatial areas to give this work a sense of infinite distance and timelessness and emphasize the powers of endurance of the Osage People, specifically Osage women. Luttrell had no interest in depicting a detailed representation of a ritual of her people. This simple silhouette of the stylized figure turned away from the viewer and facing the distant snowy mountains and the clear blue sky suggests the emotions and mind-set of the artist.

Today Anita Luttrell is married and concentrates on sculpture, which she exhibits under her married name, Anita Fields. In 1993 the U.S. Department of the Interior Indian Arts and Crafts Bureau presented an exhibition of her work, *Women, Windows and Dreams: Ceramic Sculpture by Anita Fields,* at the Southern Plains Indian Museum and Crafts Center in Anadarko, Oklahoma.

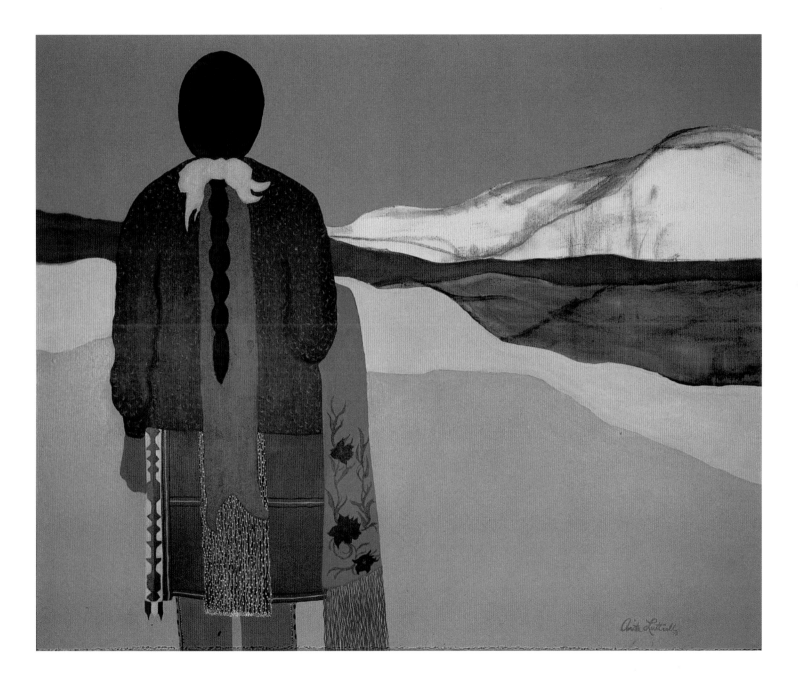

87. *OSAGE WOMAN*, 1973

66 X 72$^{1}/_{4}$", MIXED MEDIA ON CANVAS

PHOTOGRAPH COURTESY OF THE INSTITUTE OF AMERICAN INDIAN ARTS MUSEUM, SANTA FE

PHOTOGRAPH BY LARRY PHILLIPS, SANTA FE

GINA GRAY (b. 1954)

Osage

✹

THE RETURN OF THE CLAN SEEKERS, 1994

The Return of the Clan Seekers is based on the creation myth of the Osage People. Gina Gray wrote of her painting, "Inspired by historical Osage tribal images, I have depicted Warriors and the spiritual forces that guided the Osage peoples' twenty-four clans, using my art as a vehicle to celebrate *my* culture's heritage."[1] Gray's painting is a celebration of Osage history; it depicts three Warrior Spirits, who are Clan Seekers, returning to their homeland. These Warrior Spirits are the spiritual forces that once guided the Osage to form twenty-four clans. The warrior clans were divided into two groups, Sky People Clans, whose headdress feathers hung to the right, and Earth People Clans, whose feathers hung to the left. Warrior Spirits wore what is known as the roach, with each side of their head shaved and a shock of hair remaining in the center, decorated with feathers, horsehair, and porcupine quills. Unlike the historic Osage warriors who had painted faces, the faces of the Warrior Spirits are unmarked.

The returning Clan Spirits examined the earth and sky for stars, moon, deer, and fish—symbols of future clans. Gray explains, "The animal clans, they were the earth people in our mythology, and then the sky clans, like eagles, the sun, the clouds, those were other clans. And at one time the sky people and the earth people were separate and they would travel to each other's different lands, like earth people would travel to the sky people."[2]

The robe of each Spirit has special significance. One robe displays the horse because the Osage warriors were accomplished riders and because horses running across the arid plains were a prominent feature of their historic homeland. The middle Warrior Spirit is a Medicine Man who wears sky imagery—the moon, the stars, a bird, and lightning. The robe

of the third Spirit is decorated with four crosses, images of the stars and the Four Directions.

Behind the Spirits are peyote birds, reminiscent of historic Osage rituals, and clouds, fish, turtles, and a deer representing clans of the sky and the earth. All are set against swirling designs that are Gray's personal creations. Gray has painted a border around three sides of her painting; it includes a design inspired by the ribbon work of the Osage women.

Born in 1954 in Pawhuska, Oklahoma, Gina was eleven when the family moved to Denver. Her art training began at this time, as she became the apprentice and assistant of a retired commercial illustrator. By age fifteen, she enrolled in the lower school of the Institute of American Indian Arts in Santa Fe, which served as a combination high school and art school for qualified American Indian youths. Upon graduating from the I.A.I.A. in 1972, she spent a year at the California Institute of the Arts, hoping to develop her skills as a commercial artist. Gray found this program, sponsored by the Disney Corporation, disappointing, but it was at the California Institute that Gray first began to incorporate Osage imagery in her work. She recalls, "That's when I switched to doing my Indian images, my warriors, and they didn't like that. They wanted me to stick with the abstract."[3]

Gray subsequently moved to New York City and married Dan Halleck, an actor. In New York, Gray worked with the Native American Theatre Ensemble acting, singing, and dancing Native American legends and stories. The couple had two children who today are both artists, but the marriage ended in divorce. In 1974 Gray returned to Santa Fe where she lived for many years. There, Gray worked in watercolor, oil, and pastels and completed a series of monoprints. During these

88. *THE RETURN OF THE CLAN SEEKERS*, 1994
16 X 10", WATERCOLOR ON CANSON BOARD
PRIVATE COLLECTION

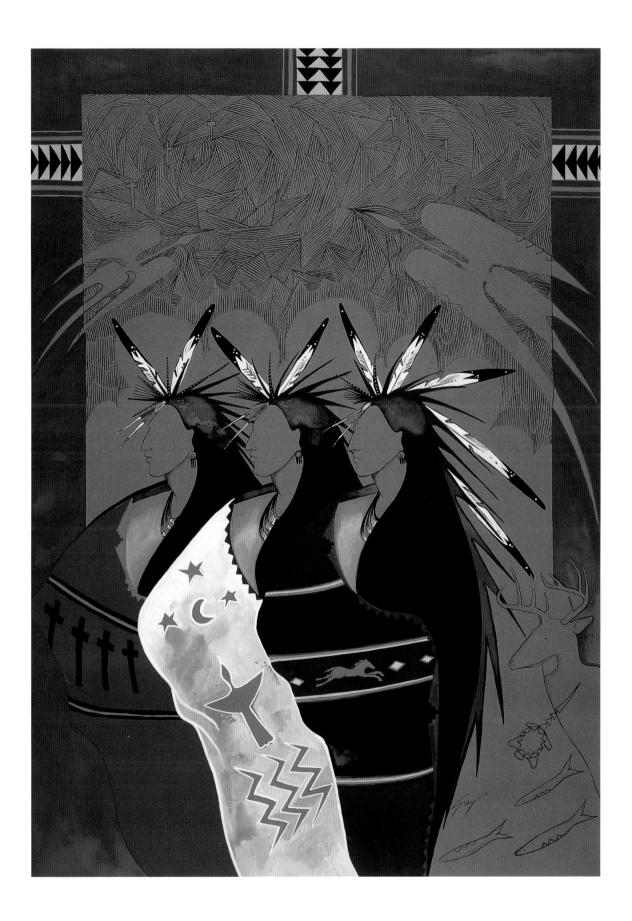

years, she entered her paintings and graphics in competitions across the United States, and her works were included in exhibitions in major museums devoted to Native American art. Gray has enjoyed great success with both her paintings and her graphics.

In Santa Fe, Gray owned an art gallery, named the Roan Horse Gallery, devoted to the work of Osage artists. The gallery was named for her great-grandfather, Henry Roan Horse, who was murdered by settlers greedy for "head rights," shares of the oil-rich land on the Oklahoma Osage Reservation. Roan Horse was thirty-two years old when he was killed for reporting oil-motivated murders on Osage lands to local authorities. His frozen body was discovered on the open plains. Gray never knew Roan Horse or any of her Osage grandparents, but she strongly identifies with her people:

I have always drawn from my Osage traditions, incorporating those traditions into my own contemporary lifestyle; particularly with my paintings. I do not consider myself a traditional Native American artist, however. In my younger years, my family was encouraged to move to a more urban settlement, as were many Osage families at the time, and experience the mainstream of society; so, technically, my cultural upbringing was very diverse. This is probably the origin of my strong usage of colors; the brilliance of our universe, the multi-heritages of an urban collaboration, the personalities and influences that this multi-cultural lifestyle has had upon my people, however corrupt or divine."[4]

In 1991 Gray returned to Oklahoma, first to her native Pawhuska, then Tulsa, where she lives today. In 1996 she received an appointment from the Secretary of the Interior to serve as commissioner for the Native Indian Arts and Crafts Board.

Gray's paintings are distinguished by her use of bold, bright colors and forceful lines. These vibrant images testify to her pride in her people. Her art is a visual celebration of the endurance of Osage culture and the ability of the Osage People to have survived the hardships and trials that have defined their history. She has many accomplished Osage artists in her family heritage, including painters Loren and Paul Pahsetopah and her aunt Georganne Robinson, who was honored by the Smithsonian Institution for her skill in traditional Osage ribbon.

MARY GAY OSCEOLA (b. 1939)

Seminole

✺

SEMINOLE DANCE, 1962

The paintings of Mary Gay Osceola depict the world of the Florida Seminole People. By the early nineteenth century, the Seminole People in Florida were the product of intermarriage of fugitive Creek with a mixture of southeastern tribes—the Hitchiti, the Oconee, and the Cunaway—and runaway black slaves.

In 1817, in a military action known today as the First Seminole War, Andrew Jackson led troops into the Florida territory that had been returned to Spain at the end of the American Revolution. In 1819 Spain ceded this land to the United States, and the Seminole came under the jurisdiction of the United States government. As Seminole holdings in Florida were rich agricultural land, during Jackson's second term as president, a treaty was signed to remove the Seminole to land west of the Mississippi River. The subsequent fight to retain the Seminole homelands, a seven-year struggle (1835–1842), was known as the Great Seminole War.

In the course of the Great Seminole War, the Seminole were pushed to a tract of land in the Everglades. Those Seminole who surrendered were sent west to Indian Territory, present-day Oklahoma; however, in 1842 the United States government agreed that a few hundred Seminole households could remain in Florida. There, on a reservation tract in the swamplands of the Everglades, the Seminoles faced disease and starvation. The effort to remove the Seminole from Florida cost twenty million dollars in military expenses and the lives of fifteen hundred American troops. Today, the Seminole Reservation in Florida is populated by the descendants of those who fought to retain their homeland.

Mary Gay Osceola was a student at the Studio when the Institute of American Indian Arts was established on the premises of this historic Indian school. Osceola enrolled in the new program of studies sponsored by the Bureau of Indian Affairs. This program, under the leadership of Lloyd Kiva New, the first director, underlined the importance of a thorough knowledge of each artist's tribal heritage and offered instruction in both traditional and modernist art.

Seminole Dance was painted while Mary Gay Osceola was a student at the Studio. In this work, she captured a festive moment in traditional Seminole life. The women wear colorful shawls and ribboned skirts that are instantly recognizable as Seminole work. Missionaries introduced these bright fabrics to the Seminole and taught the Seminole women the use of sewing machines. Thanks to the creativity of these women, each skirt became a kaleidoscope of hundreds of tiny pieces of brightly colored fabric in brilliant bands of color. Today, the Seminole Reservation in Florida still belongs to the Seminole People. Here, the women continue to sew the colorful creations that are traditional Seminole clothing.

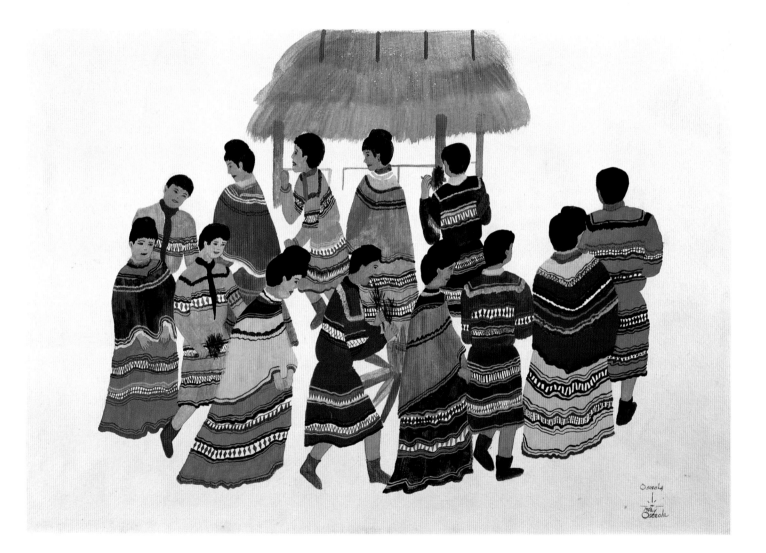

89. *SEMINOLE DANCE*, 1962

15 $^1/_8$ X 22 $^1/_8$", WATERCOLOR ON PAPER

COLLECTION DOROTHY DUNN KRAMER

PHOTOGRAPH COURTESY OF MUSEUM OF INDIAN ARTS AND CULTURE/LABORATORY OF

ANTHROPOLOGY, SANTA FE (52820/13)

PHOTOGRAPH BY BLAIR CLARK

MARY GAY OSCEOLA (b. 1939)

Seminole

✺

SEMINOLE MOTHERS AND CHILDREN

Mary Gay Osceola was born in Florida and, although educated in Bureau of Indian Affairs boarding schools, has spent most of her life in Florida. In Florida, the name Osceola is held with great pride, for the Osceola families trace their heritage to Osceola, a young Seminole chief who was a fierce leader in battle. Unable to capture Osceola in battle, the American troops, in 1837, under the leadership of General T. S. Jessup, sent an officer to an appointed place of conference under a flag of truce. There, in an act of treachery, Jessup had the grounds of the conference surrounded by a body of troops, then gave a signal and had Osceola and his followers captured. Three months after his capture, Osceola died in prison, but the war continued. In later years, General Jessup wrote: "No Seminole proves false to his country, nor has a single instance ever occurred of a first rate warrior having surrendered."[1]

During the years of the Great Seminole War, a number of Seminole women, in acts of total desperation, killed their children in order to be free to fight beside the Seminole men. The memory of this sacrifice lives on in the Seminole world, and the mother-child relationship has special meaning. Children truly are treasured by the Seminole People. Mary Gay Osceola in *Seminole Mothers and Children* pays a personal tribute to the bond between Seminole women and their children.

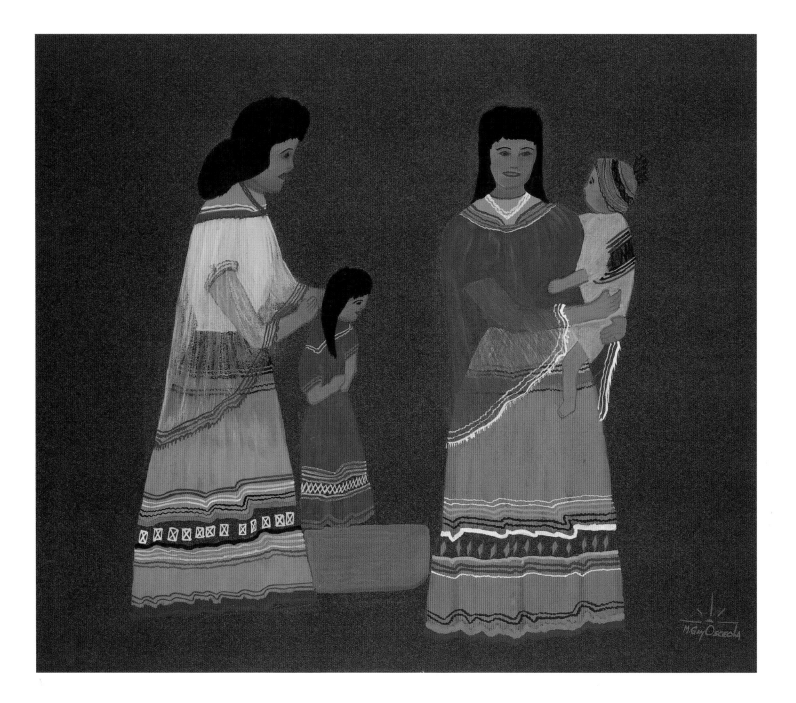

90. *SEMINOLE MOTHERS AND CHILDREN*

11³/₄ X 13⁷/₈", WATERCOLOR ON PAPER

PRIVATE COLLECTION

AGNES BIRD

Chippewa

✹

CHIPPEWA WOMAN STRIPPING BIRCH BARK

Agnes Bird painted *Chippewa Woman Stripping Birch Bark* during the first days of the art school of the Santa Fe Indian School. September 1932 marked the beginning of the Studio, and in May 1935, at the third annual *Exhibition of the Museum of New Mexico,* a selection of paintings by the students of the Studio included the work of Agnes Bird, a young Chippewa artist. Dorothy Dunn, the director of the school who had selected the paintings, described Bird's painting as "one of the first works from the Great Lakes area. True to the art concepts of her people, Miss Bird shows a fondness for plant forms."[1]

Chippewa Woman Stripping Birch Bark portrays a traditional activity of Chippewa women. The Chippewa use sheets of bark from birch trees for covering their lodges, for conical bark shelters, and for making canoes, thereby transforming fast-flowing rivers into forest highways. Fish was a primary staple of the Chippewa diet and canoes were important for fishing. During the 1700s, canoes were also used for warfare on Lake Superior.

The Chippewa originally came from the East and by the mid-seventeenth century settled in the Great Lakes Region. A hunting and fishing people, the Chippewa picked berries in the spring, and gathered wild rice and tapped maple trees in the autumn. The Chippewa were the first Great Lakes people to receive firearms from the white settlers and, therefore, were able to help end the Hundred Years War by driving the Sioux onto the plains.

In *Chippewa Woman Stripping Birch Bark,* Bird has painted a young woman in traditional Chippewa dress, hard at work. Bird has paid close attention to such details as the tiers of fringes and embroidery on her dress, as well as the beading on her moccasins. The delicate, lyrical, curving forms of the different species of greenery stand in contrast to the solid, perpendicular trunks of the birch trees. In deference to the sanctioned style of the Studio, Bird uses plain light brown paper as a background with no demarcation between ground and sky. Bird's placement of the trees and fauna gives her painting a sense of three dimensions.

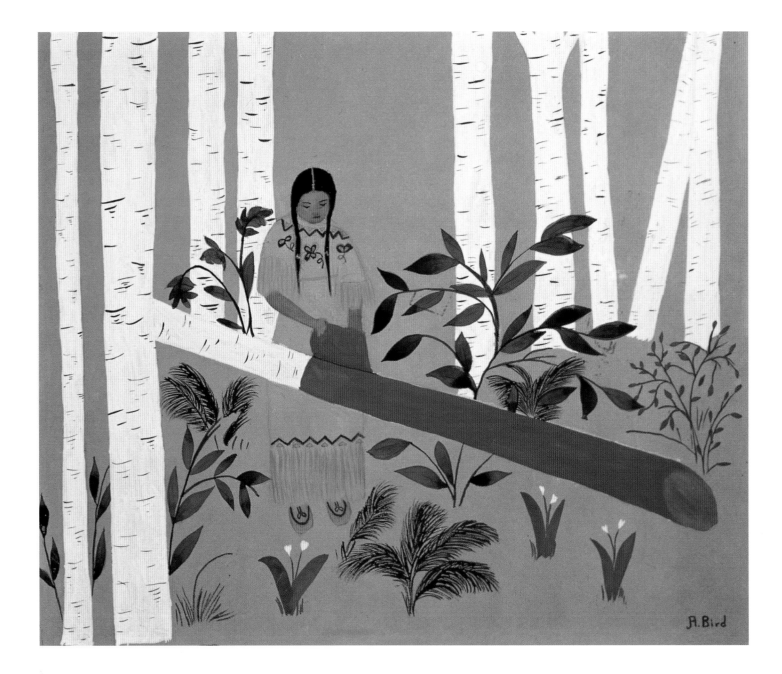

91. *CHIPPEWA WOMAN STRIPPING BIRCH BARK*
15¹/₄ X 13¹/₄", WATERCOLOR ON PAPER
COLLECTION DOROTHY DUNN KRAMER
PHOTOGRAPH COURTESY OF MUSEUM OF INDIAN ARTS AND CULTURE/LABORATORY
OF ANTHROPOLOGY, SANTA FE (51357/13)
PHOTOGRAPH BY BLAIR CLARK

SHARON BURNETTE

Chippewa

✸

PORTRAIT OF A LADY, 1967

Sharon Burnette's *Portrait of a Lady* is a study of a traditional Chippewa woman. Burnette has painted a portrait of a woman wearing a traditional dress and hairstyle, placed against a solid dark background with stylized sprays of flowers on each side. Burnette showed her interest in Chippewa craft arts by representing her subject wearing a colorful beaded pendant and headband.

Historically, the home of the Chippewa People was the extensive region around the upper Great Lakes, a region defined by water and timber. The name *Chippewa* results from a European mispronunciation of the name *Ojibwa*. In the area at the eastern end of Lake Superior, near present-day Lake Sault Sainte Marie, the Ojibwa, the Ottawa, and the Potawatomi joined in a loose confederation known to white traders as the Three Fires. Many tribal histories relate that once long ago these three peoples were one.

The Chippewa were a hunting and fishing people who lived in bands of 100 to 150 people, all of whom were blood relations. They looked to Shamens for guidance, and their rituals were focused on maintaining harmony with supernatural beings who gave form and meaning to the natural world.

Winters in the northern Great Lakes region were difficult for Chippewa women, who were expected to clothe and feed their families and make their homes a comfortable refuge. During the freezing winters in the area near Lake Winnipeg, the primary means of transportation were long, slender toboggans. Women often pulled those sleds from the St. Lawrence River to the Mackenzie River.

In *Portrait of a Lady,* Burnette's subject looks straight ahead, expressionless. She lacks all emotions and human vitality. *Portrait of a Lady* is a painting of an icon, a symbol of Chippewa history, not a realistic representation of an individual.

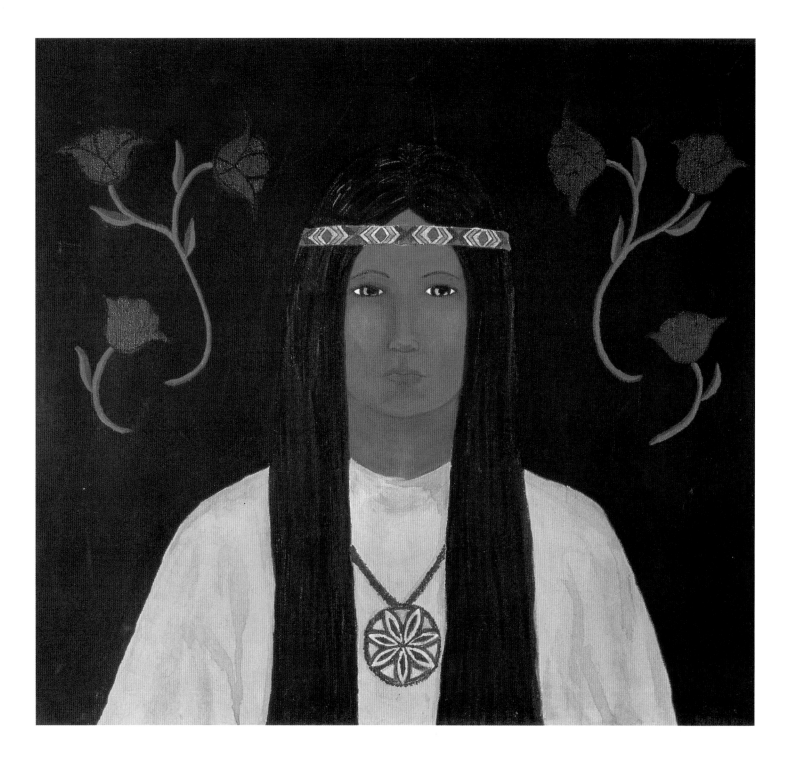

92. *PORTRAIT OF A LADY*, 1967

20 X 22", OIL ON CANVAS

PHOTOGRAPH COURTESY OF THE INSTITUTE OF AMERICAN INDIAN ARTS MUSEUM, SANTA FE

PHOTOGRAPH BY LARRY PHILLIPS, SANTA FE

ALICE LOISELLE

Chippewa

✸

NINE PEOPLE, ONE DOG, 1968

Nine People, One Dog is a representational portrait of a contemporary Chippewa family. Alice Loiselle, a Chippewa woman, is a graduate of the Institute of American Indian Arts. During her student years, she painted this composition, one of a series of family portraits focused on present-day Chippewa life. Loiselle had no interest in creating a record of her people and of their life in the past. All of her images are of her contemporaries, the Chippewa people of today.

In *Nine People, One Dog,* the subjects of Loiselle's painting stand close together, looking at the artist or viewer as if they were posing for a family portrait. Even the dog seems to be aware that he is a portrait subject, for he sits up, presenting his best self. The nine people fill the entire canvas. They stand against an orange background that is brighter at the top and lighter at the bottom, a bright optimistic background. There is nothing in the painting to indicate a household or landscape.

The participants are graded as to size, the largest figures standing in the rear, a woman who is considerably smaller and a young girl standing in the next row. Two children and a dog are in front. The smallest child with a full head of blond hair is perhaps a child of European origin who has joined the group, or perhaps this child is a product of intermarriage. The portrait subjects wear a wide variety of contemporary clothing. Two of the men wear coats and fedoras. One man wears a uniform, including a necktie and a hat, another overalls, his everyday work clothes.

These portrait figures are basically two-dimensional types rather than specific individuals. Although Loiselle has not painted realistic, three-dimensional figures, her portrait subjects have a humanity as they relate to each other; for example, two figures hold hands and one man rests his hands on the woman's shoulders.

Alice Loiselle, rejecting traditional American Indian painting as defined at such schools as Bacone College and the Studio, utilized modern techniques to portray this group of Chippewa People who are part of the contemporary world. Traditional Indian painting demands set stylistic conventions and focuses on the historical past or on ceremonial rituals and routines of daily life which distinguish and define the different Native American peoples. Loiselle followed the direction advocated by the Institute of American Indian Arts, which encourages each student to create art that expresses his or her own vision of the world. Loiselle's portrait *Nine People, One Dog* represents vital people who are participants in modern America.

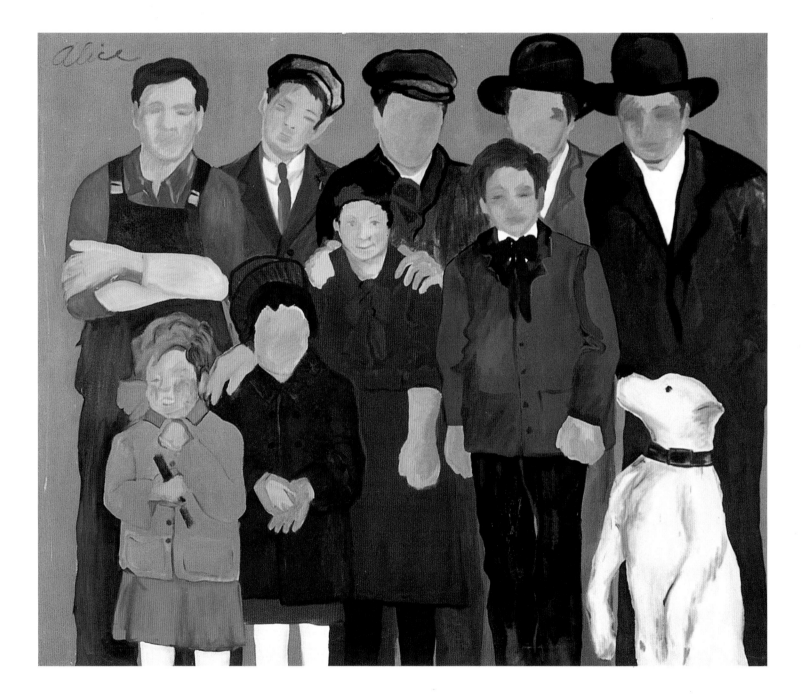

93. *NINE PEOPLE, ONE DOG*, 1968
50 X 60", OIL ON CANVAS
PHOTOGRAPH COURTESY OF THE INSTITUTE OF AMERICAN INDIAN ARTS MUSEUM, SANTA FE
PHOTOGRAPH BY LARRY PHILLIPS, SANTA FE

CAROL SNOW (b. 1943)

Seneca

❋

NIGHT SINGER, 1990

The coyote has played a major role in the life of Carol Snow, a Seneca artist. In traditional Seneca lore, Coyote is a trickster and a teacher. Through the antics of Coyote, human beings can recognize their weaknesses and foibles and learn meaningful lessons. Snow writes that *Night Singer* is her way of honoring the Coyote People.

Born on the Allegheny Indian Reservation in New York State, Snow is a tenth generation descendant of Chief Hiakatoo, and his wife, Mary Jamison, an Irish woman captured by the Seneca when she was a young girl. Mary Jamison was raised by the Seneca and when she came of age married a Seneca man. When, in time, "rescuers" came to take her away from the Seneca, she refused to leave, choosing to stay with her husband and her adopted people. Chief Hiakatoo was her second husband.

Snow's childhood on the Allegheny Indian Reservation instilled in her a love of nature and respect for all living creatures. Snow recalls, "Life on the Allegheny Reservation when I was growing up was fairly isolated. I spent a great deal of time in the woods around our house. I liked building caves out of the great ferns that grow in the East, then sitting quietly watching the birds and squirrels and chipmunks."[1]

Snow's father is an enrolled member of the Seneca Nation. Her mother, a first generation German-American, earned two degrees in zoology. Snow attended the local reservation school through sixth grade, then attended regional public school. She graduated from the local Salamanca High School, where she was named valedictorian, the first student of Seneca heritage to achieve this honor. The recipient of scholarships, Snow continued her education by completing a B.A. degree at Syracuse University, where she majored in zoology, then in 1968 received an M.A. in zoology and wildlife biology from the University of Wyoming. That year she presented a paper on coyote behavior at the World Symposium on Wild Canids in Washington, D.C. Snow was selected to present this paper because her master's thesis had been a study of the behavioral and morphological developments of captive coyote pups. In the course of her studies, Snow hand-raised two female coyote pups from the age of three days. Snow writes:

I think I learned how to really see the incredible richness of our planet because of these two teachers of mine. I would spend time sitting with them, watching what they did. I discovered my own ears and nose because I saw them use theirs so much to take in their surroundings. I began not only to use my eyes, but my other senses as well. Beyond that, I began to learn that my intuition was a valid sense, regardless of how much it was dismissed and devalued in our culture. . . . I learned about trust and unconditional love from these two ladies. They help me to realize that all my life, I had been granted trust by animals of various kinds. I had just not recognized these experiences for the levels of communication that they were. I was at the time inculcated with the dominant attitude in our culture that other species (and all too often, even our own) exist solely for human needs, desires, and purposes, no matter what these may be.[2]

Snow began drawing when she was three years old, for, as she recalls, "artwork became a way for me to communicate with other people. The spirituality and connectedness and love we share with other species."[3] A self-taught artist, Snow initially painted wildlife subjects, then concentrated on a mixture of wildlife and Native American themes. During the late 1960s and early 1970s, she wrote and illustrated several reports on endangered and rare species for the Bureau of Land Management. In 1973 she decided to

become a professional artist and sold her first works, small pen-and-ink drawings of wildlife. By 1980 Snow began to experiment with color. In 1984 she joined the Indian Arts and Crafts Association (I.A.C.A.) and in 1993 was voted the I.A.C.A. Artist of the Year.

Night Singer is typical of Snow's current work, in which she first completes ink drawings on illustration board, then uses acrylic paint as a watercolor wash. Snow writes of *Night Singer*, "The song of the coyote is most often heard at night. It is a way for family members to locate each other, a way to strengthen family bonds. A variety of messages are delivered in coyote songs from 'danger' to 'here I am.'"[4]

LISA A. FIFIELD (b. 1954)

Oneida / Iroquois

※

THE WOODLANDS LOON WOMAN, 1997

Lisa A. Fifield has created a series of watercolors, *Totem Clanswomen,* that underlines the importance of Native American women as clan mothers and as the balancers of life. Fifield's ancestors belonged to the Oneida Nation. During the sixteenth century, the Five Nations—the Oneida, the Onondaga, the Cayuga, the Mohawk, and the Seneca—united to form the Great Peace, a confederacy of Iroquois tribes which was later known to white settlers as the League of the Iroquois. The Indians of the Five Nations spoke mutually intelligible languages and shared many legends of the heavens, the earth, the waters, and of the creatures who live beneath the waters. For nearly two hundred years, the League of the Iroquois was feared by neighboring Indians and respected by white settlers. The confederacy of the Iroquois served as one of the models for the Constitution of the United States.

Women had a great importance in the Iroquois governing process. The chief governing body was the Great Council Fire, which met annually. Members were chiefs, or sachems, selected from the councils of each tribe. The tribes in turn were composed of clans. In the Iroquois nations, women chose the sachems, evaluated their performance, and, if necessary, asked the council to depose the sachem and then chose his successor. Women also were an influential part of the Great Council, for by nominating members of the tribal councils, they controlled membership.

Fifield's art is inspired by the Iroquois Spirit World, a world in which animals and women have a special bond. Fifield writes:

The American Indian's way of life has been one of a natural relationship. It was an intimate one that associated the Indian as a partner with the animals, the seasons, and the earth. Therefore, since they have always lived as one with nature, they came to act as nature did. This concept was the basic foundation and basis which literally shaped their beliefs, standards of wisdom, mythology, and religion.[1]

Fifield was born in Milwaukee, Wisconsin, to an Oneida mother, Nina Mae Webster, and a German father, Everett Arthur Rusch. Everett Rusch was an engineer whose work required him to settle with his family in different parts of the nation. Young Lisa spent her childhood years in Washington State, California, and Minnesota. Everett Rusch loved touring and had a lifelong interest in the history of the railroad. During the winter the family took weekend trips and during the summer they made longer excursions which introduced Lisa to the world of many different Native American peoples. The artist recalls visits to the missions of the Southwest, trips to the Northern Plains where she first learned to appreciate the region's indigenous art, and trips along the Northwest Coast and Alaska to visit the many native cultures.

Following graduation from high school Lisa followed in her mother's footsteps by enrolling in nursing school but had little interest in these studies. She then worked in the health-care field and in merchandising. In 1990 Fifield,

95. *THE WOODLANDS LOON WOMAN,* 1997
30 X 22", WATERCOLOR, GOUACHE, AND ACRYLIC ON PAPER
COLLECTION RICHARD URI, FRIDAY HARBOR, SAN JUAN ISLAND
PHOTOGRAPH COURTESY OF AMERICAN INDIAN CONTEMPORARY ARTS, SAN FRANCISCO

having been diagnosed with lupus, decided it was time to focus on her true interest. She completed a course of study at the Atelier LeSueur School of Art in Wayzata, Minnesota, and then began a career as a professional artist. Fifield entered and won recognition in regional competitions and exhibited her work in galleries in the United States. She has won acclaim for a series of watercolor images of the people and events of the Wounded Knee massacre. These images were exhibited in Scotland and in galleries across the United States.

Although she is fascinated by the art, history, and culture of many Native American peoples, Fifield has a special interest in the history and culture of her people, the Woodlands People, and often chooses Woodlands subjects for her paintings. In *The Woodlands Loon Woman,* Fifield focused on the bond between the Woodlands People and the loon, the state bird of Minnesota. Fifield writes of her painting:

Some Woodlands Tribes have clans that are of birds of the wetlands. In the Totem Clanswomen series, the women are so closely spiritually related to the animal or bird of that clan that it seeks her out for protection because of an innate bond and trust. On either side of her you see the great white egret which was hunted at the turn of the century almost to extinction because of the fashions of ladies' hats of the time. To her left is the whooping crane which is still one of the world's most endangered species. The loon and the other birds sitting around are all squawking in communal concern.[2]

BONITA WAWA CALACHAW (1888–1972)

Calachaw (Keep from the Water) ♦ Luiseno

✺

CHIEF RUNS THEM ALL, 1947

During her career as an artist, Bonita WaWa Calachaw was best known as Princess WaWa Chaw (perhaps she created this title for theatrical impact). Indeed, WaWa Chaw was a woman ahead of her times, for prior to 1920, she was a feminist and a highly vocal proponent of Native American political rights. Hers truly was an atypical biographical history for a Native American woman.

Born in 1888 in Valley Center, California, on the Rincon Reservation (the Rincon are a division of the Luiseno People), she was adopted, while still a baby, by a wealthy New Yorker, Dr. Cornelius Duggan, and was raised and educated by his sister, Mary. WaWa Chaw attended a private school in New York City. A precocious child, at the age of ten she addressed a convention on women's rights on the suffering of Indian women. As she approached womanhood, she was introduced to New York society. In the recollections of her life, *Spirit Woman: The Diaries and Paintings of Bonita WaWa Calachaw Nunez, An American Indian,* edited by Stan Steiner and published in 1980, she recalled parties at the Astor home and séances with the Vanderbilt family.

Mary Duggan encouraged her young protégée to paint. She insisted that she study anatomy and interested her in a style of painting that primarily utilized free brushstrokes. Mary Duggan arranged for young WaWa Chaw to study painting with Albert Pinkham Ryder, who encouraged her to tone down her colors and taught her to paint in the style of his circle. He was an American modernist known for his melancholy vision and use of expressive colors.

At age eighteen WaWa Chaw married Manuel Carmonia-Nunez, a businessman who was an organizer for the Cigar Workers' Union. They had one child who died in infancy and the marriage quickly ended. The young artist found herself destitute, a "city Indian." A survivor, she first sold liniment on the streets of New York City, then her paintings in Greenwich Village.

A lifelong fighter for the rights of the American Indian, she worked with Dr. Carlos Montezuma as an activist for Indian causes and lectured widely. During the 1940s she wrote of her experiences as a struggling American Indian artist in New York City, "We seemed to be accepted as foreigners. . . . My life experiences and personal observations have been on trial for almost 60 years. Not because I am guilty of having Committed a Crime, but because I was born I am spotted as if I were a Leopard."[1] In 1972, WaWa Chaw died penniless in New York City.

In 1946 the Philbrook Museum of Art purchased *Chief Runs Them All* from WaWa Chaw. Although this forceful image of a Native American never would meet the criteria required for the traditional paintings accepted for the museum's annual competitions, the Philbrook Museum of Art purchased this work hoping to give stylistic depth to their collection of Native American art. Based on WaWa Chaw's writings, it is reasonable to assume that *Chief Runs Them All* is an Indian leader born in her imagination. WaWa Chaw used broad brushstrokes to define this powerful androgynous figure, who perhaps is the embodiment of Spirit Woman. WaWa Chaw wrote of her work, "My paintings are Creative. I never need one to pose for me [for] my Friends Live for Ever in my thoughts."[2]

96. *CHIEF RUNS THEM ALL*, 1947

20 X 16¹/₂", OIL ON PANEL

COLLECTION THE PHILBROOK MUSEUM OF ART, TULSA

MUSEUM PURCHASE 1947.58

JUDITH LOWREY (b. 1948)

Hahoyce (The Light Complexioned Indian Person Who Can Pass for White and Purchase Alcohol) ♦ Mountain Maidu / Pit River

❋

WILIS-KOL-KOLD (SUSIE JACK), 1994

Wilis-Kol-Kold (Susie Jack) was the maternal grandmother of Judith Lowrey's father. In 1994 Judith Lowrey, using tiny faded photographs belonging to her family, painted a portrait of this Pit River woman who was raised in California during the last days before the culture of the Anglo-European settlers became the dominant culture in northern California. Wilis-Kol-Kold, Medicine Woman, was a healer with an extensive knowledge of traditional cures and connections to the Spirit World. In Judith Lowrey's painting, this elderly woman is central to the composition. Looking directly at the viewer, she holds a container with a two-headed snake that is turquoise with a purple pattern. She is wearing a pale gold upper garment with a pale lavender and pale gold skirt that is floor-length. A potted flower is at her right, while two upright feathers atop a rock are at her left. A red kerchief with yellow polka dots is in her right hand.

A snake, a potted flower, and feathers, all are featured in Lowrey's painting because they all had a special significance in her great-grandmother's life. Lowrey includes a container with a two-headed snake because just prior to her death, Wilis-Kol-Kold had a vision of a two-headed snake. The potted flower is a reference to Wilis-Kol-Kold's close friend, Tesudi, who was a very powerful healer. Tesudi would find a plant in the desert, bring it home, and observe the plant in the presence of a specific patient. The state of the plant gave Tesudi information on her patient's health. For the Pit River People, feathers, which the Medicine Woman placed on the earth on end and read, played an important role in the healing process.

Judith Lowrey was born in 1948 in Washington, D.C. Her father, Leonard Lowrey, of Pit River and Mountain Maidu ancestry, was a career officer in the U.S. Army. During World War II he met and married June Harrison, a woman born in Australia. Leonard Lowrey was stationed in many parts of the world and young Judith experienced school and home life in Europe, Japan, and cities across the United States. In 1988 Judith Lowrey earned a B.A. from Humboldt State College in Arcata, California, and in 1992 she completed her M.F.A. at California State University in Chico.

Judith had considered herself an artist since age six; however, her first profession was as a photographer. In 1990, while at California State University, she turned to painting and developed the style of symbolic painting that has remained her trademark. In 1993 she completed a commission from the Lassen County Arts Council for a community mural entitled *Tribute to the Women of Lassen County*. Lassen County, which is in a region of the drainages of the American and Feather Rivers in the Northern Sierra Nevada Mountains, was the historic home of Lowrey's ancestors. The Pit River Indians were a northern California people who lived side-by-side with the Mountain Maidu People. Hunting and gathering peoples, these inhabitants lived in a series of mountain villages at least twelve hundred meters above sea level. They lived in permanent villages on lower levels and had seasonal hunting camps in higher regions.

The people of this region had a tradition of oral history, and Lowrey's father served as tribal and family historian. The majority of Lowrey's paintings are stories of her family. Although Lowrey describes her art as "folk mannerism," since college she has been a great admirer of early Renaissance painting and as a self-taught artist she learned primarily from European models. Her paintings feature highly realistic details, but she strives for emotional rather than academic truth. *Wilis-Kol-Kold (Susie Jack)* is Lowrey's personal tribute to the Pit River women who were healers.

97. *WILIS-KOL-KOLD (SUSIE JACK)*, 1994
78 X 54¹/₃", ACRYLIC ON CANVAS
COLLECTION Q.V. DISTRIBUTORS, INC., PHOENIX

KAREN NOBLE (b. 1955)

Karuk / Chimariko

THE FLOOD, ca. 1985

Many cultures have legends that focus on a great flood that cleansed society and offered a new world to the surviving people. Karen Noble, who is also known as Karen Noble Tripp, painted *The Flood,* which depicts an ancient legend of the Karuk People, an American Indian people from northern California.

This legend recounts that once long ago the Karuk world needed cleansing. The Karuk People were told to weave a huge basket because it was going to rain, to rain so long and hard that the rains would cause a great flood. The Karuk People were to weave the basket tightly and seal it with pitch so that the basket would be watertight. Then the basket could float because this basket would offer them the only means of survival.

The Karuk People wove a tremendous basket, a beautifully woven Karuk basket with a traditional Karuk design motif. Roots of the willow and spruce were woven between supports made of hazel and willow sticks. The Karuk People carefully made the dyes from the natural world around them—black from ferns and grasses, red from crushed fern mixed with elder bark, and yellow from porcupine quills.

The rainstorm began with thunder and lightning and the rains continued until the earth was covered. After the storm had lasted for many weeks, the waters finally receded and the basket landed in the area that the Karuk People to this day call their homeland. This land is on the Upper Klamath River in northwest California.

Noble has painted a moment during the height of the storm. The Karuk basket floats on the tumultuous waters of the flood. Overhead are storm clouds and lightning. Flying over the basket, three eagles look down on seven naked Karuk men and women who peer out over the rim of the basket searching for the land that will be their destination. These figures represent the Klamath People who will survive the flood and begin a renewed life in cleansed homeland.

Karen Noble was born and educated in Arcata, a community in northwest California, and continues to live and work in the ancestral land of her people. Noble, who has painted since childhood, is fundamentally a self-taught artist, although she had some formal art instruction while a student at Humboldt State University. Throughout her career, she has tried to give visual reality to the Native American world of northwest California. Although she has focused on the myths and legends of her people (Noble traces her Karuk ancestry to her paternal grandfather), she also has painted landscapes of the area.

Noble's paintings are distinguished by the realistic details and by the dramatic intensity of her composition and color. Noble's images of the basket, of the foaming waters, and of the eagles in flight show her facility in depicting three dimensions and movement. Noble sees her paintings as a spiritual mission: "To be an artist is to be a channel through a higher intelligence which may manifest itself on our earthly plane. One could call it God, The Creator, or The Universal Spirit. It works through me in order to make the viewers more aware of the spirit within themselves."[1]

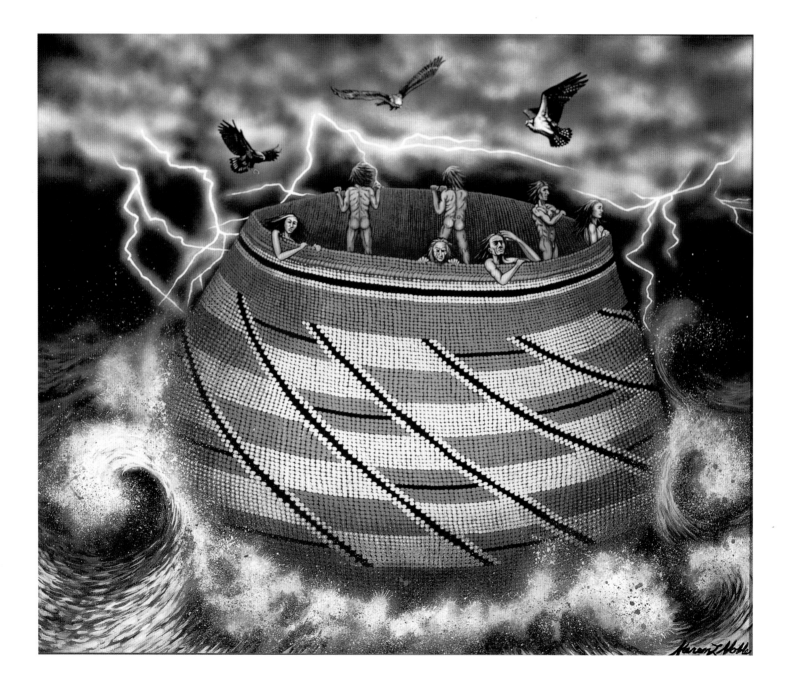

98. *THE FLOOD*, ca. 1985

20 X 24", OIL ON CANVAS

COLLECTION Q.V. DISTRIBUTORS, INC., PHOENIX

EVELYN TETON

Shoshone / Bannock

✸

BANNOCK MADONNA AND CHILD, 1968

Historically, the Bannock People were a mountain branch of Paiute in Idaho and Wyoming and a branch of Paiute in the Great Basin of Nevada and Utah. Life in the Bannock world was hard because the people subsisted primarily on roots dug from almost barren soil. Their homes, known as *wicki-ups,* were shelters made from dirt and brush.

One of the low points of Bannock existence came in the 1870s when local developers and corrupt officials whittled away pieces of the Bannock Reservation. At this time food supplies were allocated to the people living on the Bannock Reservation at a cost of two and one-half cents per person. The loss of their harsh land and this policy of enforced starvation triggered several uprisings by these traditionally peaceful people.

In 1889 a Paiute prophet, Wovoka, announced the impending arrival of an Indian messiah who would bring back the buffalo and revive the dead. The Indian would be restored to power, and life would resume as in the days before the coming of the white man. When Wovoka called on his people to perform the Ghost Dance, the Bannock People embraced the Ghost Dance religion as their last hope for renewal as a tribe. In 1890 both the Bannock and the Shoshone Peoples in Idaho performed the Ghost Dance.

Evelyn Teton painted *Bannock Madonna and Child* while a student at the Institute for American Indian Arts, and this painting is today part of the permanent collection of the I.A.I.A. Like many young Indian people, Evelyn Teton grew to maturity as a participant in two cultures, the traditional culture of the Bannock People and the mainstream culture of the United States, which included an introduction to Christianity. *Bannock Madonna and Child* is the synthesis of two worlds. The Bannock woman wears the clothing and hairstyle of the Bannock People and her baby is strapped to a cradleboard which traditionally was made from tanned leather. The baby, swaddled in a blanket, was bound into the bag of the cradleboard, which offered protection for the child's head and served as a foundation for a straight back.

Teton's work features skilled representational images true to the ideals of mainstream realistic painting. Her portraits of both Madonna and child are not stereotypical images of the American Indian, but rather are detailed naturalistic representations of specific individuals. The Madonna is a figure of humanity and compassion. Her figure is set against a cloudy sky which suggests an undefined location and infinite time.

By giving this painting the title *Bannock Madonna and Child,* Teton suggests that the Bannock mother is presenting her child as the potential savior of her people. Although she knows that sacrifice will be necessary, her hope is that the next generation will bring a renewal of life and salvation to the Bannock People.

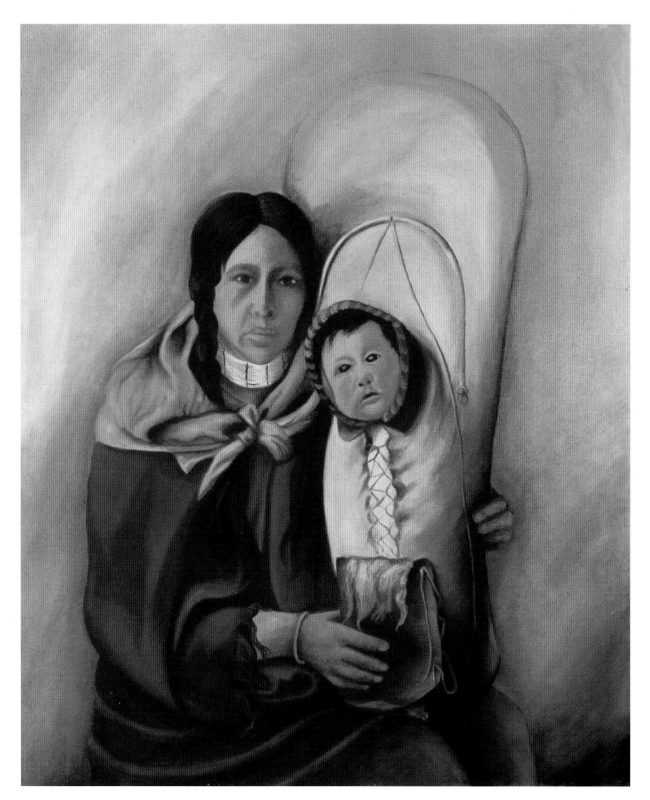

99. *BANNOCK MADONNA AND CHILD*, 1968

36 X 30", OIL ON CANVAS

PHOTOGRAPH COURTESY OF THE INSTITUTE OF AMERICAN INDIAN ARTS MUSEUM, SANTA FE

PHOTOGRAPH BY LARRY PHILLIPS, SANTA FE

PEGGY DEAM

Squamish

❁

METIS OF MONTANA, 1969

Peggy Deam (Margaret Lee Deam), a Squamish artist, grew up in a small island community in Washington State. Deam describes her village:

> Our village is small, about six or seven hundred people. We're located in that cluster of islands in the middle of Puget Sound. A ferry boat ride will take you to the city of Seattle, and practically anywhere you'd like to go. . . . Our town is situated next to the water, near the site of the Old Man House where our tribe had settled many years ago. This is very good, because every year we have a celebration in commemoration of our last and great Chief Seattle. This is my town, and I'll always hold in my memory its easy, slow, loving ways.[1]

After attending regional schools, Deam in the autumn of 1964 began a course of study at the Institute of American Indian Arts, which she completed in the spring of 1969. The focus of her program at the I.A.I.A. was painting. On completion of her studies, Deam stated that her goal was to "help my people live a better life, to strengthen the American Indian image as a strong, straight, self-supporting human being, the first and true American, to help the Indian help himself."[2] Deam's painting *Metis of Montana* was completed during her student years and is part of the permanent collection of the I.A.I.A. museum.

The Metis are a people whose origin can be traced to the valley of the Red River of the North, a river that forms the border between North Dakota and Minnesota. This valley marks the division between the Eastern Woodlands and the Western Plains. Here in the late seventeenth century, French traders, following the St. Lawrence River and Great Lakes canoe route from Montreal, and the British, traveling down from Hudson Bay, encountered and intermarried with the Cree, an Algonquin band whose women were famed for their beauty. In time, the many descendants of these unions became a proud independent people known as the French Algonquin band of Metis. During the eighteenth century, the Assiniboin, a Sioux-speaking tribe that not long before had separated from the Dakota Nation, also intermarried with the French traders.

The Canadian Metis, a mixed-blood people of the Plains who were primarily French Cree and French Assiniboin, had converted to Catholicism. In 1870, under the leadership of Louis Riel, they took up arms against Protestant Ontario and tried to set up an independent semi-Indian state near Fort Pitt in Saskatchewan and failed. In the years that followed, a band of Metis People moved into Montana.

Peggy Deam has painted women and children gathered around a fire that the women are using to cook. Deam uses flat areas of unmodulated color, but unlike the traditional paintings of the Santa Fe Indian School, the areas of color in Deam's painting do not have dark outlines. The artist employs contiguous complementary colors, areas of purple, yellow, red, orange, green, and blue. There is no attempt at either naturalism or lyrical romanticism in this work. Deam's people have no individual features. Thanks to her limited palette, their skin color is close to the red-orange color of the earth of the Plains. The form of their heads against the clear blue horizon is almost as much a part of the prairie world as are the rising mountainous forms. Deam's painting has the sense of the eternal—the eternal land and the people of the Plains.

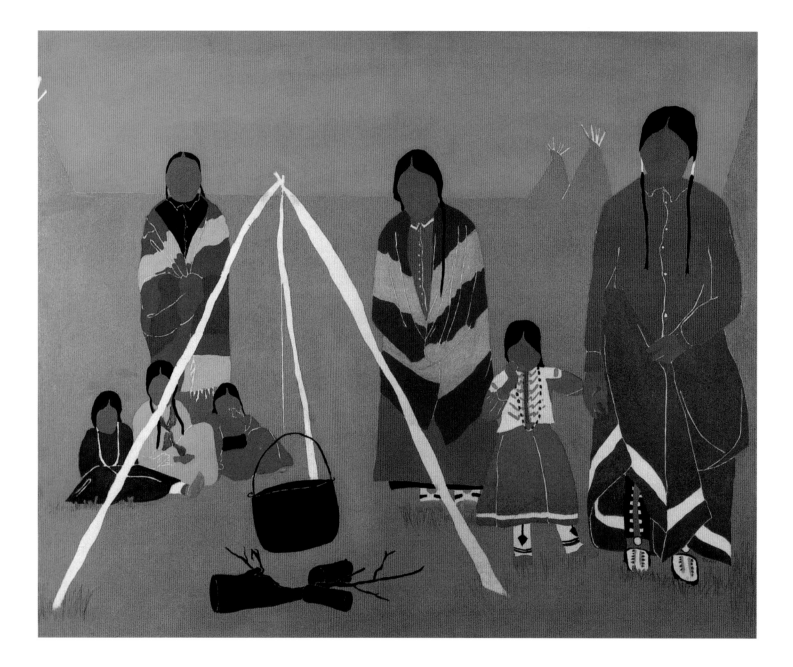

100. *METIS OF MONTANA*, 1969

30 X 36", OIL ON CANVAS

PHOTOGRAPH COURTESY OF THE INSTITUTE OF AMERICAN INDIAN ARTS MUSEUM, SANTA FE

PHOTOGRAPH BY LARRY PHILLIPS, SANTA FE

YVONNE THOMAS

Lummi

✺

BEAVER PEOPLE, 1980

Beaver People is Yvonne Thomas's symphonic celebration of the beaver totem in the Lummi world. This painting features beavers in every conceivable place. Lines of beavers walk in opposite directions across the distant horizon. Two large realistic beavers stand by a tree that has vague white images of beavers climbing along the sides. A mother beaver sits with her cubs in the grassy middle section of the painting. In the foreground at the very bottom of the painting, two middle-sized, realistic, rather anthropomorphic beavers stand on a pile of wood which they have cut for a dam. The central feature of the painting is a huge copper featuring a beaver totem, a stylized image of the beaver spirit. The beaver, a traditional Northwest Coast totem, is identified by its large front teeth, square ears, and a crosshatched tail. The copper, which was made of beaten metal, was a symbol of wealth and status that increased each time it changed hands. The copper was the possession of greatest material value to the Northwest Coast people.

Thomas is of Lummi ancestry. Historically, the Lummi People lived on Nootka Sound on the northwest coast of what today is the state of Washington. Fishermen through the centuries, these inhabitants of the coastal northwest proclaimed that the water was their way of life. The Lummi believed that the supernatural world was inhabited by spirits that presented themselves to human beings in animal form. The Lummi believed that the spirits of the natural world would help them throughout life, as the animal spirits could provide power and protection from danger, or create change. These animal spirits could warn of danger or help an individual in a crisis. The most fortunate of the Northwest Coast people were those who had Spirit Helpers. After fasting, a Spirit Helper would appear to an individual in a vision or a dream. The Lummi sought the aid of Spirit Helpers when they performed spirit dances at potlatches and festivities. The potlatches were public ceremonies with lavish gift-giving, conspicuous consumption, and destruction of possessions.

The stylized images on Northwest Coast totem poles and coppers often were of those animals that the Lummi saw as supernatural beings—beavers, killer whales, ravens, and the sandhill cranes that enabled women to be skilled in digging roots and clams. Beaver spirits were known for their power over water, a power of ultimate importance in a community dependent on sea life. The totem spirits represented ancestors who had originated the lineage or clan. Only their descendants were permitted to use their symbols on totem poles or coppers.

Yvonne Thomas was born and spent her youth in Washington State. She attended Burlingham Edison High School, then completed the course of study at the Institute of American Indian Arts in Santa Fe, where in 1981 she received a fine arts degree. In 1984 she received a B.A. at Evergreen State College in Olympia, Washington. Following graduation, she returned to Santa Fe, which today is her home.

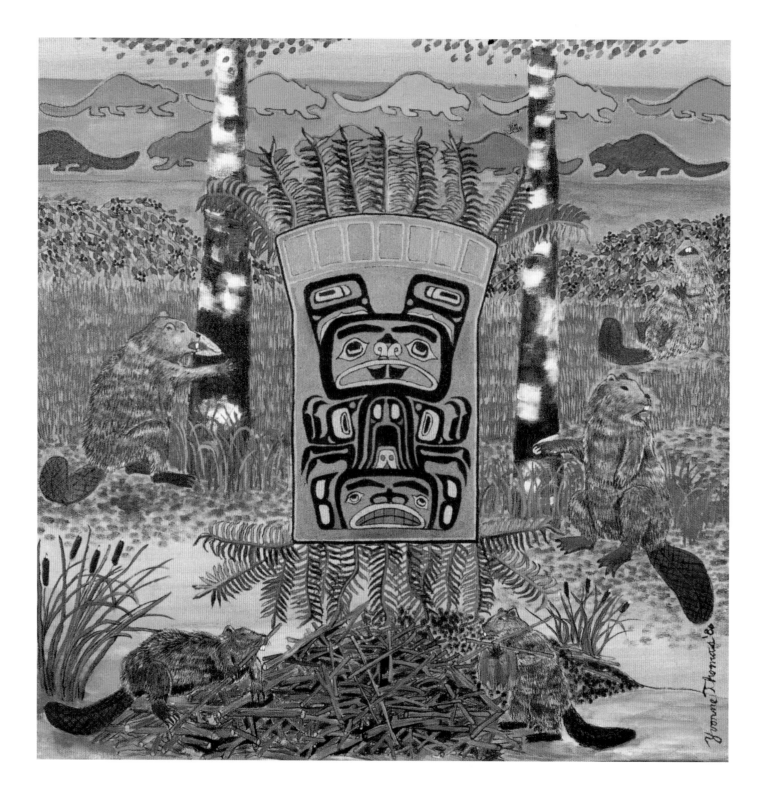

101. *BEAVER PEOPLE*, 1980

18 X 18", OIL ON CANVAS

PHOTOGRAPH COURTESY OF THE INSTITUTE OF AMERICAN INDIAN ARTS MUSEUM, SANTA FE

PHOTOGRAPH BY LARRY PHILLIPS, SANTA FE

JOANE CARDINAL-SCHUBERT (b. 1942)

Blood / Blackfeet

※

MINUS BEAR SOLUTION

Minus Bear Solution, a painting twenty-three inches in height and eight inches in width, painted on mulberry bark paper, was inspired by the birchbark scrolls used by Joane Cardinal-Schubert's ancestors, the Blood People, to record personal events. Traditionally, these scrolls were stored in a hollow log sealed with moss at each end. *Minus Bear Solution* is one of a series of bark paintings completed as a personal political statement. This Blood/Blackfeet artist is truly disturbed by the possession and presentation of both sacred and secular creations of Native American peoples in museums. She feels that ancient Native American art must remain with Native peoples, not stored as historical artifacts of ancient cultures. She also wishes to see contemporary Native American artwork exhibited in galleries, examples of living art. One day, when Cardinal-Schubert saw a Blood birchbark scroll that had been deaccessioned from a museum and offered for sale to the non-Indian public, she attempted to buy it, to "save it"; however, she could not afford the price. She explains that as a form of catharsis she then painted a series of bark paintings.

The name "Minus Bear Solution" comes from Cardinal-Schubert's solution to a problem of composition, how to present two bears in the narrow format of a scroll. The solution was a full image of a bear at the top of the painting, the front half of a bear in the mid-section, and the rear section toward the bottom of the painting. Throughout her career, blood and earth colors have been the primary colors of her paintings, and Cardinal-Schubert used blood colors for the background for *Minus Bear Solution.*

Cardinal-Schubert's iconography is both personal and spiritual. The bear is so personal an icon that it must remain unexplained. Cardinal-Schubert simply states, "I have had a long relationship with bear."[1] The bird is another of Cardinal-Schubert's personal symbols. The bird was her mother's recurring sweatlodge vision. Cardinal-Schubert explains, "At first [the bird] seemed to be kind of pressed down; to be contained under the sweatlodge. But gradually it became more powerful, more dominant than my mother. It stands for more than my mother now; it's like a universal Mother, the person in charge of the order of things. It is a spiritual vehicle, part of the symbolic vocabulary that I use."[2]

Born in Red Deer, Alberta, Cardinal-Schubert comes from a heritage of the Indian and non-Indian people in Alberta. Her maternal great-grandmother, a Blood Indian named Rose Bobtail, was a Holy Woman, a covener of the summer solstice Sundance. In 1849 her great-grandfather, William Samuel Lee, left England to become one of the early settlers at Crowsnest Pass in present-day Alberta. Lee subsequently married Rose Bobtail. Another great-grandmother, Marguerite Rach, an Albertan of German extraction, was a religious woman who held her own services and won the respect of the community for her knowledge of the natural world, her use of herbs, and her wealth of folk wisdom.

Cardinal-Schubert was educated in a combination of religious and secular schools. Encouraged by her father, a photographer, she began to study art. In 1968 she received a certificate from the Alberta College of Art in Calgary and in 1977, having majored in printmaking and painting at the University of Calgary in Alberta, she received a bachelor of fine arts. Her early work was figurative and its content primarily social commentary.

Cardinal-Schubert has traveled extensively in Europe and Japan. She has exhibited her work internationally in cities such as Rome, Paris, Rio de Janeiro, and Berlin. In 1983 she was the only Canadian resident to have her work featured at the Stockholm International Art Exhibition. Cardinal-Schubert also has won recognition in her native Canada. She has had one-person shows at the Thunder Bay National Exhibition Centre and Centre for Indian Art in Ontario in 1985 and 1998. In 1986 she was elected to the Royal Canadian Academy of Art and in 1992 she received the Commemorative Medal of Canada.

Throughout her career, Cardinal-Schubert has used a

symbolic vocabulary to create artistic statements that bring together Indian spiritual values and political issues. Indian history and symbolism is Joane Cardinal-Schubert's primary subject matter, but her art is always based on personal expression. Cardinal-Schubert writes:

> People labeled my work as political art. But my real concern was for the land and its people. Living is a political act. After 30 years as an artist I now have the responsibility of being a role model to young artists and to young people considering their future. . . . Faced with this responsibility I have been doing a lot of looking at self, looking back to the mirror . . . of self. Pulling off all the layers of imposed sensibilities, pronouncements and concerns I am back to being myself. . . . I am—Prairie Mask.[3]

102. *MINUS BEAR SOLUTION*

23 X 8", MIXED MEDIA ON MULBERRY BARK PAPER

COLLECTION Q.V. DISTRIBUTORS, INC., PHOENIX

EDNA DAVIS JACKSON (b. 1950)

Ka-Swoot ♦ Tlingit

✸

KA-OOSH AND COHO SALMON, 1980

Edna Davis Jackson's collage and painting features three cast-paper images of the face of her husband, Michael. Michael's Tlingit name is Ka-oosh, and his family crest is the Coho salmon. Below the cast-paper facial images, Edna Davis Jackson has painted four Coho salmon which she covered with copper wire so that they appear to be jumping behind a net, and on the faces she has drawn black and red Tlingit design elements.

Jackson was born, grew to maturity, and still lives in the Alaskan village of Petersburg. She writes of her early life:

> I have lived most of my life in a small Tlingit town in Southeast Alaska. I was born 38 years ago to a Tlingit fisherman/carpenter and a Michigan woman. Both parents were teachers; my father was the owner of a seiner (a large fishing net made to hang vertically in the water by weights at the lower edges and floats at the top), and my mother has a farming background. I was the eldest child that moved seasonally from Michigan for the school year, to Kake for the fishing season. We found ourselves outside either world on initial arrival, followed by the process of assimilation into the new country.[1]

Since childhood Jackson has worked at craft arts:

> My mother was my first teacher; although when she was teaching me various skills, I'm sure she never considered them "art lessons" and I never considered

the work I was doing "art." Our family was not well off; we learned to improvise, to make our own play things, to use our own resources, and to use our imaginations. My mother's early lessons in sewing, darning, recycling yarn and fabric are very evident in my artwork today.[2]

Jackson did not begin a college education until after she had married and had begun raising a family. She received a bachelor of fine arts from Oregon State University in 1980 and a masters of fine arts from the University of Washington in 1983.

Papermaking always has been an important part of Jackson's life. The artist recalls:

> When I was a child in Kake, our back yard was the beach and the ocean. If we tired of playing on the beach, my cousins and I would head for the woods and follow the animal trails. My involvement with cedar paper allows me to keep in touch with these two important elements: the water and the woods. The process of paper making involves plenty of water, which I thoroughly enjoy, and working with cedar bark which I gather in the spring and break down into pulp for my paper.[3]

Today Jackson teaches papermaking both to high school students and to college and graduate students at the University of Alaska. Over the years she has made cast-paper

103. *KA-OOSH AND COHO SALMON*, 1980
27$^{1}/_{2}$ X 31", HANDMADE PAPER, GOUACHE, STRING, AND COPPER WIRE
COLLECTION Q.V. DISTRIBUTORS, INC., PHOENIX

images of members of her family and enhanced them with decorative elements that are abstracted Tlingit design motifs. Jackson describes the evolution of her cast-paper masks:

> I also began to experiment with mask forms that incorporated Northwest Coast art styles. My early mask pieces were technical exercises as I experimented with different styles of Northwest Coast masks. I feel these pieces were less successful than my later pieces because they were attempts to duplicate carved wooden masks. It also bothered me that these masks just sat on a background and didn't act with it; they were too static.
>
> At this point I began to do more with paper masks' inherent properties. I began to stitch on them, give them ragged and torn edges, distort them while they were still wet, laminate them with flat sheets of paper; they began to have possibilities. My later pieces use the masks as a focal point, but rather than being the art piece *per se,* the mask is a single element in the larger structure. They could be comparable to traditional Northwest Coast art in their narrative quality.[4]

There is also a political side to Jackson's art. During the 1980s she collaborated with a Native American writer to "deal with issues that we native Alaskans have to confront— alcoholism, 1991 legislation, subsistence living, tribal versus corporate mentality."[5] Whether paying tribute to her Native American heritage or crusading for a Native American cause, Edna Davis Jackson has devoted her life to her art.

> I now spend my days doing art work, taking care of my family, demonstrating my work in museums, teaching workshops in other small towns, logging camps and fishing villages. I love this job that allows me to meet other artists who are in similar situations as mine, i.e., doing art work in a small isolated community. . . .
>
> My work is a creative process from the beginning in the woods to the completion in my studio. I enjoy the diversity of activities that go into my work: being in the woods in the spring to gather bark, beach combing after a big storm for shells and other surprises, recycling other people's garbage into something of beauty, eating a turkey and saving the bones for art, spinning, weaving, drawing, painting.[6]

In 1988 Jackson was honored by a one-woman exhibition at the Southern Plains Indian Museum and Craft Center in Anadarko, Oklahoma, an exhibition that featured mixed media and paper works. Cast-paper masks with painted Tlingit design elements were a primary part of that exhibition.

KENOJUAK ASHEVAK (b. 1927)

Inuit (Cape Dorset)

✺

WOMAN WITH ANIMALS

Kenojuak Ashevak is today one of the most celebrated Inuit artists. In 1964 the National Film Board produced a film on Kenojuak, entitled *Eskimo Artist—Kenojuak.* Filmed at Cape Dorset, this film focused on Kenojuak's drawings and the process of stone printing. In 1964, the year when Kenojuak and her husband moved to Cape Dorset, she was awarded the Order of Canada, Medal of Service from the Governor General. In 1970 a Kenojuak print entitled *The Enchanted Owl* was reproduced on a stamp commemorating the Centennial of the Northwest Territories. In 1980 another Kenojuak print, *The Return of the Sun,* was reproduced on a stamp issued by the Canadian post office. In 1974 Kenojuak became a member of the Royal Canadian Academy.

Kenojuak Ashevak was born in 1927 in Ikerrasak, an Inuit camp on south Baffin Island. During the 1950s Kenojuak, her husband, and their adopted son lived in Kungia, a fox-trapping camp near Cape Dorset. As the Inuit of this area could no longer adequately support themselves by fox trapping, men and women carved in order to alleviate their poverty.

The people of Kungia often went to Cape Dorset, the regional commercial center, for trade goods. There, in 1955, Kenojuak came in contact with Alma Houston, the wife of the Cape Dorset Cooperative founder, James Houston. Alma Houston encouraged the Inuit women to sew in order to gain financial independence. Kenojuak began creating sealskin appliqué designs, which she sold for cash to Alma Houston.

In 1957 the family was living in Keakto, a camp near Cape Dorset. While getting provisions in Cape Dorset, Kenojuak met James Houston. She recalls:

> One day while I was getting provisions in Cape Dorset, James Houston gave me paper and pencil, wrapped in a plastic bag, to take back to Keakto. I was uncertain what I should draw, but he suggested I draw whatever was in my mind. I destroyed the first drawing I did in Keakto, but I took later drawings to

him when I traveled to Cape Dorset. I was pleased at the value he assigned to the work. I knew that I would continue.[1]

In 1951 James Houston had been traveling with his wife and an Inuit guide from Frobisher Bay to Cape Dorset. As he passed through all of the camps along the coast, he told the people he was interested in helping them and encouraged the Inuit People to create carvings and other art forms to be sold through the Hudson Bay Company. In 1955 Houston developed an interest in the printing business and became a patron for Inuit drawings. Kenojuak's uncle, Niviqusi, the first in her camp to draw designs and images on paper, served as the young woman's role model. In 1958 the first Kenojuak print, *Rabbit Eating Seaweed,* was made from the design on one of her sealskin bags.

In 1959, under the guidance of James Houston, the Inuit of Cape Dorset formed the West Baffin Eskimo Cooperative, an organization in which they all bought shares. The cooperative bought drawings that were reproduced as prints. Kenojuak was the first woman to draw for the cooperative, and one of her drawings was included in the first collection of prints. In 1963 Kenojuak began to work on copperplate engravings, and in the years that followed the Cape Dorset print collections included Kenojuak's engravings and stone cuts.

For the first eight years that Kenojuak worked for the cooperative, she lived on its land; however, in 1964 Kenojuak, her husband, Johnniebo, whom she married in 1946, and their family moved to Cape Dorset, where the Canadian government offered subsidized housing, medical facilities, and educational opportunities for their children. In 1967 Kenojuak and Johnniebo were honored by an exhibition of their work at the National Library of Canada in Ottawa. Kenojuak and Johnniebo attended the opening of the exhibition that included forty-five prints by Kenojuak and five by Johnniebo. Johnniebo died in 1972.

In the years that followed, Kenojuak had the opportunity to travel across Canada, and in 1980 she traveled to Rotterdam for the opening of the *Inuit Print Exhibition*. Widowed twice, Kenojuak is today married to Johanassie Igiv and lives in Cape Dorset, where she draws and carves in a small canvas tent set beside her small wooden house. This workplace is quite different from the snow house in which she began to draw. During the summer months, Kenojuak and her husband return to their old campsite area to hunt and fish and live as the Inuit lived in the past.

Kenojuak's drawings are distinguished by their precision, clarity, and crispness. Her images are clear, clean, and sharply defined, exhibiting a controlled linear technique. She usually completes a drawing in just one day. In her biography of Kenojuak, Jean Blodget outlined Kenojuak's technique, which the artist had explained to her:

> She usually starts from the top of the image and works down to the bottom; or she starts from the centre and then moves around, as she did in the drawing of a central sun face, surrounded by birds. Once the outline has been done, additional parts will be laid in and filled in. Since the original parts of the form are generally contained within the overall con- tinuous outline, shapes that have been added later can be discerned where their outline meets and connects up with the original line around the initial form. Texturing and filling in are the final stages.[2]

Kenojuak is best known for her drawings of birds—the owl, the seagull, and the ptarmigan. Her drawing *Woman with Animals* includes two owls, two arctic gulls, and two bears. A woman's head serves as the pivotal point for the surrounding animal motifs. Abstracted vegetal forms complete her composition and suggest the land as the base of Arctic life. Kenojuak's drawing is two-dimensional, her figures composed of flat, outlined areas of color against a solid white background. Kenojuak's composition is strictly symmetrical. This symmetrical format is reminiscent of the technique used for sealskin cutout sewings, in which the Inuit fold the skin in half before cutting out the design. Consequently, the final work has identical symmetrical halves.

Kenojuak's goal in painting is beauty, rather than realism. Brightly colored, visually pleasing images of animals, a woman's head, and vegetal forms are joined together to form a network of decorative shapes and empty spaces. There is no interaction between the animal and human figures. All emphasis is on the aesthetic relationship of the component parts.

104. *WOMAN WITH ANIMALS*
22 X 30", CRAYON AND PENCIL ON PAPER
PRIVATE COLLECTION

KEELEEMEEOOME SAMUALIE (1919–1983)

Inuit (Cape Dorset)

❋

SPIRITS WITH CHAR

For centuries the Inuit People have believed in an all-powerful Spirit World. Not only are spirits responsible for the ultimate survival of the Inuit People, but they are responsible for the hardships and tragedies that an Inuit must face in the course of a lifetime. In the traditional Inuit world everything animate and inanimate had a spirit. The moon, the sun, the winds, plants, animals, even stones, all had spirits to be reckoned with and appeased. The moon was thought to be a dangerous male spirit, the guardian of tides, whereas the sun was thought to be a benevolent female spirit whose rays were necessary to sustain life.

Keeleemeeoome Samualie was born in 1919 in Quinqu, near Markham Bay. She became an active participant in the Cape Dorset Cooperative in 1969 and continued to be one of the principal contributors to this cooperative until her death in 1983. The Cape Dorset Cooperative craft center was the first organization to feature and sell the art of the Inuit People. The first portfolio of black-and-white prints of walrus, geese, and caribou was completed in 1959, and each year since that time a new collection has been offered for sale. The Cape Dorset Cooperative served as an example for developing art centers in communities across the Arctic.

The establishment of art centers in the Arctic in the fifties coincided with the final days of traditional camp life in the North. James Houston advised the participants in the Cape Dorset Cooperative to draw the ways of the world that belonged to the past. His advice was welcome, for many of the artists were anxious to preserve the memories of a vanishing way of life and to record the legends and stories of the past for future generations.

Many of the artists of this transitional generation were women, and Inuit women were among the most enthusiastic participants in the cooperative art centers. In the traditional Inuit world, women were forced to depend on their husbands for food and shelter. If widowed, they were cared for by relatives or dependent on the generosity of those in their camp until they could make an alliance with another mate. The aged, unwilling to become a burden on the community, would build their own stone graves, lie down, and wait for death.

Many of the women rescued from starvation and forced to begin a new life in settlements were widows with children. They were totally dependent on their government subsidies, and the art cooperative gave them the opportunity to achieve a degree of self-sufficiency to supplement their government income. Those with families could draw at home and thus fulfill their family responsibilities. The men remained primarily hunters. The creation of art served as an economic supplement, an occupation for free time during the winter. During the summer months they still could return to the land to hunt. In contrast, for many women, artistic creation became the primary means by which they could sustain themselves and their families through their own efforts. Samualie was one of these women who supported herself through her art.

When Samualie completed *Spirits with Char,* she sold the drawing to James and Alma Houston. Samualie in her work offers a glimpse of traditional life as well as an imaginative interpretation of the spirit world. *Spirits with Char* features images of the char, which is a highly edible fish in the trout family and a welcomed source of nourishment for the Inuit People. Two Spirits spring directly from the tails of two char—a visible proclamation that they are the Spirits of the char and will help sustain life in the Cape Dorset settlement. Samualie includes two loons, one on each side of the Spirits. The feathers of their tails echo and harmonize with the feathered headdresses of the Spirits. In this symmetrical composition Samualie has presented a blend of the natural and the supernatural world's, an image of Inuit life that confirms the harmony of the relationship of nature and the Spirit World.

105. *SPIRITS WITH CHAR*

20 X 26", CRAYON, INK, AND PENCIL ON PAPER

PRIVATE COLLECTION

JESSIE OONARK (1906–1985)

Inuit (Baker Lake)

✹

ICE FISHING

Life in the Inuit world always has been harsh. The Arctic is an alien world where survival is the primary focus of life, and it is determined by forces beyond human control—the weather, the migration of the herds, and the availability of sea and land animals.

Over five thousand years ago, ancestors of the contemporary Inuit crossed the Bering Strait, then moved eastward across the land that is today the Canadian Arctic. There, in the frozen north, the Inuit People lived a seminomadic life. Survival was determined by success in hunting and fishing because there could only be minimal agriculture in a land where the ground just under the surface always is frozen and the climate is too cold for trees to grow. As the only wood is driftwood, rocks and blocks of snow served as the primary building materials. Historically, as there were no textiles, all clothing had to be made of animal skins.

Jessie Oonark was born in 1906 in the region of Garry Lake and Back River, a frozen barren land northwest of Hudson Bay. Oonark grew to maturity in isolated camps between Chantrey Inlet, Back River, and Garry Lake. The name *Una,* which means "the one," bestowed on the child the skills of her deceased namesake, her parental grandfather. *Una* was later transformed into *Oonark*. Una's people, the Utkusiksalingmiut, which means "the people of the soapstone pods," historically were nomadic hunters who in summer would disband and wander inland on foot to hunt musk ox and caribou and to fish. In winter they would return to the coast, build stone houses, and hunt seals for food and lamp fuel. Oonark's father, Helaquarq, was said to be a Shaman.

A sickly child, Oonark became a bride at age eleven or twelve. Slow to mature, she did not give birth to her first child until age twenty, but she bore twelve more children before the death of her husband in 1953. Eight children lived to maturity. Following the death of her husband, the tubercular Oonark and her children first lived with her husband's family in their camp, then returned to the camp of Oonark's mother.

During the years that followed, a change in the caribou migration routes, poor fishing, and the decline in the fox population caused the Inuit in the Garry Lake region to face starvation. To keep alive, Oonark hunted ptarmigan, an Arctic bird, and jigged for fish, but she eventually became too weak even to cut a hole in the ice, a necessity for fishing in the Arctic. On the brink of starvation, on March 7, 1958, Oonark and her eight-year-old daughter, Pukingrnak, were noticed by an R.C.A.F. aircraft patrolling the area, and the two women were rescued. They were taken to the Baker Lake community.

In the summer of 1959 Jessie Oonark attempted her first professional drawings. She had mentioned to a school teacher that she could draw, and the teacher had relayed that information to Dr. Andrew Macpherson, a biologist who had traveled to Baker Lake to study foxes. Macpherson looked at some of Oonark's drawings and offered to supply the Inuit woman with art supplies and to pay for her artistic efforts. Oonark accepted Macpherson's offer and thus became the first in the Baker Lake community to sell drawings.

Oonark truly could draw, and before long her talent was brought to the attention of James Houston who purchased several of her drawings, which subsequently served as the basis for prints. Oonark today remains the only artist not living in Cape Dorset to have her work included in the Cape Dorset collection.

106. ICE FISHING

22 X 30", CRAYON AND PENCIL ON PAPER

PRIVATE COLLECTION

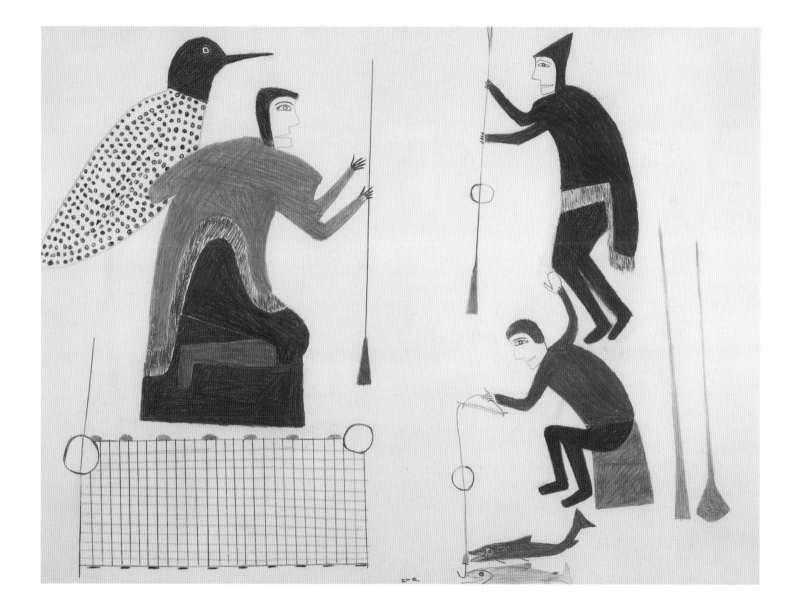

Ice Fishing is one of the Jessie Oonark drawings purchased by James Houston. This drawings depicts three Inuit, a man, a woman, and a boy, fishing through the ice. Two fish are investigating the boy's line. The Inuit are using the "jig method." The jig is an unbarbed iron hook set in under the edge of an oval-bone sinker. Bait is a piece of fish skin. Another method of jigging for fish employs a fish-shaped model, which is jigged up and down in the water. Oonark in her drawing includes a fishing weir and gaffs. The Inuit have great respect for the fish they catch. They believe that each fish has an immortal soul and that after a fish is eaten it will return, prepared to be caught again.

It is possible to identify one of the fishing trio as a woman because she wears an *amautik,* a coat made of two layers of fur, one facing the body, the other the freezing air. The Inuit women carry their babies in the large hood of the *amautik,* which has a back tail and a front apron and was designed to complement the maternal role of women.

During her lifetime, Jessie Oonark became one of the most honored Inuit artists. In 1970 she was one of two Inuit honored by a two-person exhibition at the National Museum of Man (now the Canadian Museum of Civilization). In 1973 an Oonark wall hanging was presented to Queen Elizabeth by the Honorable Jean Chrétien, Minister of Northern Affairs, on behalf of the Inuit of the Northwest Territories. In 1975 Oonark was elected a member of the Royal Canadian Academy of Arts and in 1984 was named Officer of the Order of Canada.

JANET KIGUSIUQ (b. 1926)

Inuit (Baker Lake)

✴

WINTER CAMP LIFE, 1979

In *Winter Camp Life* Janet Kigusiuq has created a series of images that define her frozen world. These vignettes offer a comprehensive glimpse of Arctic life. Kigusiuq's drawing confirms the importance of community in the Inuit world. For centuries, the key to survival has been sharing, cooperation, and mutual respect. Violence and contradiction were not acceptable in the world where life was so fragile.

Kigusiuq presents all of these images on a single plane. There is no sense of perspective because there is neither foreground nor background, top nor bottom. On the upper part of *Winter Camp Life* are two figures walking through the snow. To their right, an Inuit figure is lying down and peering outside through the lower section of a snow wall. In the middle of the painting are the largest figures, which are the central focus of the composition: a man, a woman, and a child, with their dog team and sled. A separate trace attaches each dog to the sled. The Inuit man uses his whip to drive the team forward. The woman, who sits with her legs over the side of the sled, is wearing an *amautik* with a huge hood that may serve as protection for a baby. The child, wrapped in fur, sits on the sled.

At the lower part of the painting is a large white polar bear. Seated on the top of a ledge made of snow blocks, two Inuit converse using animated arm gestures. To their right, two women greet each other with outstretched arms, and at the very bottom of the drawing an Inuit man presents a woman with a pot of fish.

All of Kigusiuq's human figures are two-dimensional, simple outlined figures with dark hair and colored trim on their clothes. That Kigusiuq possessed some knowledge of foreshortening can be seen in the pose of one dog, the turn of the head of a second dog, and the stance of a third dog trying to mount a foreshortened fourth dog.

In the winter, the Inuit People lived in snow-block houses at the edge of the frozen sea. Fish was their primary food, but bear meat was also eaten in winter. In Inuit communities, the division of labor was clear. The man's primary role was to provide food and shelter for the humans and the dogs. The men hunted, built the lodging, and made and repaired tools and weapons. Women made boats and tents as well as all clothing. They prepared the skins by scraping and stretching before sewing them. They also butchered and prepared the meat. Women bore and raised children, many of whom died before adulthood. When necessary, they raised the children of those who died or who were unable to care for their own.

Janet Kigusiuq is the daughter of Jessie Oonark. Born in 1926 in the Back River region, she moved to the Baker Lake community in the 1950s. She depicts life in the traditional Inuit world, a world different from the contemporary Baker Lake community, where people live in prefabricated wooden houses topped with TV antennae. Today, the Inuit have made the transition from a barter and subsistence economy to a cash economy, and they work for wages.

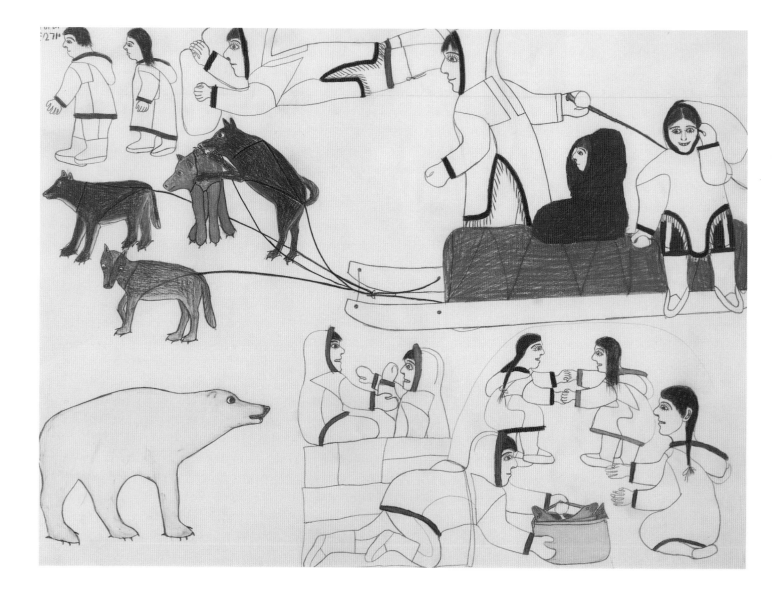

107. *WINTER CAMP LIFE*, 1979

22 X 30", CRAYON AND PENCIL ON PAPER

PRIVATE COLLECTION

VICTORIA MAMNGUQSUALUK (b. 1930)

Inuit (Baker Lake)

✺

SHAMAN CARIBOU

For centuries, it was a fundamental Inuit belief that once long ago all of nature's creatures, animal and human, lived in harmony. Whenever the state of harmony among animals, humans, and the environment was disturbed, it was the role of the Shaman to restore the balance. Traditionally the Shaman, who could be male or female, played an all-important role in Inuit life. In the Inuit world it was not possible to separate the spiritual world from the physical world. The Inuit depended on the Shaman to interpret and control nature and to serve as an intermediary with the Spirit World.

The Inuit believed that long, long ago all human beings had the power to become animal and animals, human beings. Ultimately, only the Shaman retains this power to transform himself or herself into an animal, then return to human form. It is also believed that the Shaman has the power to travel to and from the Spirit World in a transformed state, often traveling as an animal, bird, or a fish. The Shaman has Spirit Helpers, who frequently take the form of wolves or birds.

In *Shaman Caribou,* Victoria Mamnguqsualuk has created a complex composition that depicts many aspects of the Shaman's world. The focal point of this painting is the large head of a Shaman in the process of transformation. His body is part caribou, part human, for he already has spouted horns and caribou ears and has caribou legs and a tail and human hands. The caribou spirits are an all-important part of the Baker Lake Spirit World, because the majority of the people of Baker Lake are inland people dependent on fish and caribou for subsistence. The caribou is prized particularly for both its skin and its meat.

Coming from the Shaman's mouth is a Breath of Life, which contains a fully developed Inuit man, a wolf, four heads of men, two heads of wolves, and a bird's head. These sleeping figures are outlines. Not fully completed, they are not yet ready to spring to life. From the Shaman's hand emerges a small Inuit man. Both this miniature figure and the ones contained in the Breath of Life are fully dressed for the Arctic climate.

The animal forms in this painting may be Shaman Spirit Helpers in the process of transformation. Above the back of the caribou are eight human heads, perhaps Spirit Helpers about to undergo transformation into animals. Between the caribou legs and human arms are the heads of two wolves, a giant bird, and three human heads. These all are in the process of transformation. Mamnguqsualuk's use of color is limited to a rainbow around the Shaman's head, the pink of the Breath of Life, the trim on the Arctic clothing, the red tongue of the wolves, and the green beak of the bird.

Victoria Mamnguqsualuk is the daughter of Jessie Oonark. Born in 1930 in the Back River region, Mamnguqsualuk recalls, "I was born around the Garry Lake area and reared by my grandparents. When I became an adult I returned to my parents. I married a man I had known in my childhood. We have five children who are alive, but I have borne nine children."[1] In 1963 Mamnguqsualuk moved to Baker Lake with her husband and five children. Having a facility for drawing, she followed the artistic path of her mother and has been an active participant in the Baker Lake Cooperative since its inception in 1971. Mamnguqsualuk's drawings, like many of the drawings and prints from the Baker Lake region, are distinguished from those of Cape Dorset by their bold compositions and their subject matter, which emphasize Shamanism and the supernatural.

108. *SHAMAN CARIBOU*

22 X 30", CRAYON AND PENCIL ON PAPER

PRIVATE COLLECTION

ROBERTA A. WHITESHIELD

Cheyenne / Arapaho

❈

WHITE MOUNTAIN APACHE FIRE DANCERS, ca. 1970

In 1970 Roberta Whiteshield entered the twenty-fifth annual exhibition *American Indian Painting* at the Philbrook Museum of Art. Her painting *White Mountain Apache Fire Dancers* won the Special Category, First Award, donated by the American Indian Center of the Association on American Indian Affairs. The Philbrook catalogue defines the Special Category Award as "designed to recognize new trends in American Indian art, abstractions, symbolic designs, or methods of painting which use European-derived shadow and perspective. All works based on an Indian theme."[1]

White Mountain Apache Fire Dancers depicts a ceremony that is part of the most important rite of passage in the life of a young Indian woman. This ceremony, best known as the Mountain Spirit Ceremony, was introduced to the Apache as a sacred curative rite, but over time it became a sacred ritual that was part of a young woman's puberty ceremony. Today, this induction into womanhood is one of the most fascinating public dances of the Apache.

The four dancers known as Gahan, or Mountain Spirits, represent supernatural beings that lived in mountain caves and beneath the horizon in each of the four cardinal directions. A Shaman dresses and decorates the dancers who wear spec-tacular headdresses and brandish painted wands. They appear on four nights, and on each night they are painted differently. The dancers approach single file from the Four Directions and dance around a large bonfire. They appear four times in the course of the evening.

Their headdresses, made of thin strips of wood and colorfully painted with various patterns forming fans, circles, and crosses, are embellished with tin ornaments and downy plumes. The upper decorated part of the headdress is supported by a piece of sapling covered by a black cloth, fitted around the dancers' heads. This black cloth with tiny eyeholes covers the dancers' heads. Metal discs or shiny buttons, which glow in the fire's light, are attached to the headdresses, giving the dancers a fantastic appearance, which may be responsible for the mistaken name of "Devil Dancers." The correct name is Mountain Spirit Dancers.

During the Mountain Spirit Dance, the Shaman, the young girls who are participants, and the mature women who attend them perform sacred rites in a nearby tipi. The ceremony lasts four days, and on the final night, the girls dance throughout the night. Following the ceremony, they are ready for marriage.

109. *WHITE MOUNTAIN APACHE FIRE DANCERS*, ca. 1970

30 X 38¹/₂", WATERCOLOR ON BOARD

COLLECTION THE PHILBROOK MUSEUM OF ART, TULSA, MUSEUM PURCHASE 1970.16

ROSEBUD TAHCAWIN DE CINQ MARS (b. 1929)

Tahcawin (Fawn) ◆ Hunkpapa / Brulé Sioux

✸

ALO'WAMPI CEREMONY, ca. 1940

Rosebud Tahcawin was the daughter of Arthur Edmond de Cinq Mars, an actor and theatrical director in New York City, and Rosebud Yellow Robe, a Sioux woman born on the Sioux Reservation in South Dakota. During her years in New York City, Rosebud Yellow Robe frequently delivered lectures on Sioux history and culture. She was well known as a storyteller and from 1930 to 1950 was director of the Indian Village at Jones Beach State Park. During Rosebud Tahcawin's adolescence, she developed an American Indian identity, which was a clear reflection of her heritage. She grew up with great pride in her Sioux ancestry. Her maternal grandfather was Chauncey Yellow Robe, a hereditary Sioux chief, and her maternal great-great-granduncle was Sitting Bull, the renowned Sioux chief.

Born in New York City, Tahcawin grew up in Douglaston, a community on Long Island in New York. She graduated from Bayside High School in Queens in 1947 and in 1948 studied painting at the Naum Los School of Art, then in 1948 and 1949 studied painting, photography, and ethnic drawing at the Brooklyn Museum Art School. As a teenager, Tahcawin acted as an assistant to her mother at Indian Village and taught a wide variety of Indian arts and crafts there. Rosebud Yellow Robe encouraged her daughter to paint.

In 1949, the year she completed her studies at the Brooklyn Museum, she entered the competition at the fourth annual *Exhibition of American Indian Painting* at the Philbrook Museum in Tulsa, and won one of the awards. In the course of her career, Tahcawin's paintings were exhibited in the Carlebach Gallery in New York City, and her work was included in an exhibition of American Indian art at the William Rockhill Nelson Gallery in Kansas City.

Alo'wampi Ceremony underlines the historic importance of the buffalo to the Plains Indian people. In the mid-nineteenth century, the mass slaughter of the buffalo completely destroyed the culture of the Plains Indian people and dealt the final blow to their struggle for independence and survival against the encroaching white civilization. In Tahcawin's painting, the markings on the face of the woman echo the markings on the cover of the buffalo skull. Historically in the Sioux world, ceremonies were performed each year to call the buffalo—sacred ritual prayers that the herd might return to provide sustenance to the Sioux People. It was believed that the herds migrated according to a divinely controlled pattern and that the performance of special sacred rites would call the buffalo herds to their homeland.

The Alo'wampi or Hunka ceremony was a sacred ceremony that offered protection to Sioux children and placed a child in a position of great respect in the community. In the Sioux language *Alo'wampi* means to sing for someone, and the term *Hunka* particularly referred to the children.

The child's father would invite a tribesman of renown to perform the Alo'wampi ceremony and this man would vow to take the child under his protection until death. A child who had completed this ceremony was regarded as ranking above an ordinary child and was believed to be good in every way. Ceremonial paraphernalia included an altar, a small tree, a special pipe, a buffalo skull, and an ear of corn. Tahcawin, in her painting *Alo'wampi Ceremony,* included many examples of sacred Sioux ceremonial paraphernalia, for she believed in the importance of cultural accuracy.

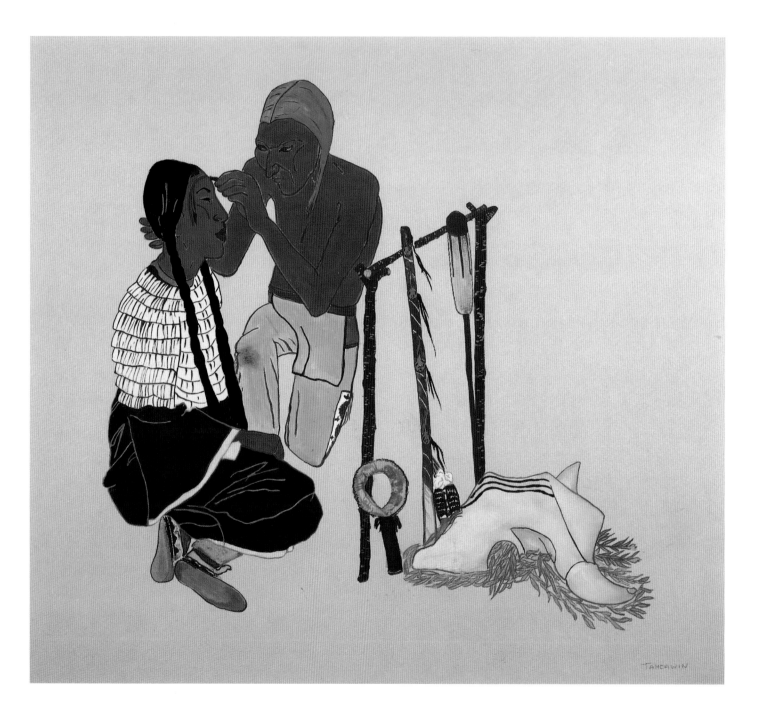

110. *ALO'WAMPI CEREMONY*, ca. 1940

14¼ X 14½", WATERCOLOR ON PAPER

COLLECTION THE PHILBROOK MUSEUM OF ART, TULSA

MUSEUM PURCHASE 1949.29.4, GIFT OF CLARK FIELD

LAURIE HOUSEMAN-WHITEHAWK (b. 1952)

Wakan-Je-Pe-Wein-Gah (Good Thunder Woman) ◆ Winnebago / Santee Sioux

※

OUR PAST, OUR FUTURE, OUR ELDERS, 1991

The keystone of Laurie Houseman-Whitehawk's life and art is her identity as a Native-American woman. Born in 1952 in Omaha, Nebraska, to a Winnebago mother and a Santee Sioux father, Laurie at age two was placed in the Nebraska State Children's Home and adopted at age five by a non-Indian couple who had neither knowledge of nor interest in the child's Indian background. The artist recalls, "They were good people, but I wasn't able to relate to them very well. . . . They didn't know what kind of Indian I was, so there was always this question mark in my identity: who am I and where did I come from?"[1]

Laurie attended the local grade school in Shawnee Mission, Kansas, where in seventh grade a teacher recognized that her strength was in art. All through high school Laurie took all available art courses, and when she graduated from high school in 1971, she studied art for two years at Johnson County Community College in Shawnee Mission.

Interested in attending a four-year college, Laurie, having learned that a Native American could qualify for a scholarship, set out to discover her tribal origin. In 1973 she learned of her Winnebago and Santee Sioux origins and began to study the history of her people. Determined to confirm her identity as an American Indian, in 1977 at age twenty-five she had a reunion with her birth mother and in the course of the next few years made several visits to the Winnebago Reservation. There she met her maternal uncle, Noah White, who became her mentor, teaching her the history and ancient rituals of the Winnebago People and accompanying her to ceremonial dances and powwows. Her uncle gave her an Indian name as well as a traditional dance costume and a ceremonial pipe. As the Winnebago were matrilineal, Laurie took her clan identity, the Thunderbird Clan, from her mother.

Proud of her newly found Indian identity, Laurie Houseman-Whitehawk was ready to paint images of her Indian heritage, the heritage of the Plains and Woodlands Peoples. She attended the Institute of American Indian Arts in Santa Fe from 1966 to 1967, the Kansas City Art Institute in 1978, and the Haskell Indian Junior College in 1978. Unable to accept completely either the tenets of traditional Indian art or the innovations of contemporary mainstream American art, Houseman-Whitehawk developed an individual style distinguished by brilliant color and bold design. She painted primarily in gouache.

In 1980 Houseman-Whitehawk had a one-woman show at the Institute of American Indian Arts. In 1984 she began to enter her work in Indian art exhibitions and compositions and had a series of one-woman shows at regional Indian art galleries. In 1989 she had a one-woman show at the Lawrence Art Center in Lawrence, Kansas, and in 1993 received major recognition for her art in *Paintings by Laurie Houseman-Whitehawk: Winnebago Woman Artist,* an exhibition produced by the Center for Great Plains Studies at the University of Nebraska in Lincoln. Proud of her Indian identity, Houseman-Whitehawk is the founder and spokesperson for the Indian Artists Association, an organization whose purpose is "to promote contemporary arts and traditional crafts of all American Indian tribes who are residing in the State of Kansas."[2]

Today Laurie Houseman-Whitehawk is known for her paintings of dancers. She writes:

> You can hear the bells, the drums, and the singers, you feel the heat and sweat from lodge. . . . I love painting the people as they are. . . each person a beautiful individual, every regalia put together with love and pride, a statement about who that particular person is, his or her identity, family, and heritage. I see all those qualities in my dancers. . . . I believe that when I paint the people in their regalia, it is the twentieth-century statement of what we are, it is the old with the new, the then and now.[3]

Many of Houseman-Whitehawk's paintings focus on Native American women. "More powerful than my portraits of my people is my series on the role of woman in the sacred and the role of the sacred in women. . . . I like to center my ideas on the balance of the female part of the universe. . . . These scenes of women participating in a spiritual quest, replenishment, and fulfillment are an answer in themselves to the stereotype of the 'Medicine Man.'"[4]

Our Past, Our Future, Our Elders is Houseman-Whitehawk's personal tribute to Winnebago women. The painting is a triptych, a form that suggests a sacred work. The painting is a series of images of Winnebago women who appear as a line of dancers in a ceremonial dance. They are marked by distinct differences. The woman on the left is a Winnebago woman of the past. Her head bowed, she is dressed in muted tones standing before a darkened background. She carries a peyote fan, a piece of sacred paraphernalia used in a ceremony of the Native American Church. These peyote rituals gave hope at a time of hopelessness.

The two women in the center are the elders, their faces lined with time. They wear elaborate ceremonial dress and carry small leather bags containing tobacco. Before they begin to dance, the women as a gesture of gratitude will sprinkle tobacco on the ground. As they look straight ahead into the future, they are in total harmony with their environment, the clouds silhouetting their forms.

The woman on the right who represents the future wears brighter colors. Her dress is simple, embellished with touches of white that suggest freshness. The horizon also is brighter and the cloud forms appear to be rising. She turns away from the viewer, her destination unknown.

Martha Kennedy, who was curator of the Houseman-Whitehawk exhibition, wrote of the fundamental harmony and spirituality of the Winnebago women, past, present and future:

> Skillfully using color and stylized elements of landscape, Houseman-Whitehawk also communicates harmony between the women, the land, and the sky or spiritual realm. The dark green shadows cast by the women echo the patterned rendering of the land that stretches to the hills in the distance. The women thus appear as a harmonious part of nature. The light and deep blues in clothing repeat in the cloud forms; the deep pink and rose colors of the sky echo in the women's clothing. Contained within cool green and blue zones, these dignified women embody harmony between earthly and spiritual realms. Combining balanced composition and inspired use of color, Whitehawk evokes the Indian woman's role in sacred and earthly life, a theme she has stated is prominent in her art.[5]

111. *OUR PAST, OUR FUTURE, OUR ELDERS*, 1991
29¼ X 14½", 29½ X 21⅜", 29³⁄₁₆ X 14⅜"
GOUACHE ON PAPER TRIPTYCH, GREAT PLAINS ART COLLECTION
UNIVERSITY OF NEBRASKA-LINCOLN, GIFT IN MEMORY OF GEORGE M. AND HELEN G. BUFFETT

JUDY MIKE (b. 1943)

Winnebago

✲

THREE WOMEN, 1964

Judy Mike was born in east-central Wisconsin in the region of Lake Winnebago and Green Bay, the historical home of the Winnebago People. Many ethnologists believe that historically in the Winnebago world, descent was by the female line. After the Winnebago entered the fur-trading era, however, the economy shifted from agriculture to hunting and trapping, and Winnebago society became totally male-dominated, with citizenship and inheritance through the male line. The only vestige of matrilineal descent is that, in the early twentieth century, children were closer to their maternal uncle than to their father. This uncle was the primary mentor and disciplinarian in family life.

Winnebago women followed a tradition of generosity and hospitality. One of the first lessons taught a young Winnebago woman was "When you have your home, see to it that whoever enters your lodge obtains something to eat, no matter how little you yourself have. Such food will be a source of death to you if withheld. If you are stingy about giving food, someone might kill you in consequence; someone may poison you."[1]

A corollary of sharing with the poor was the necessity of feeding and caring for the elderly and, if necessary, taking the elderly into one's own home. There is an ancient Winnebago saying: "If you see a helpless old person, help him if you have anything at all. If you happen to possess a home, take him there and feed him."[2]

All American Indian people had great reverence for the elderly, believing that old age was a time of wisdom, the harvest of the fruits of a lifetime of learning. Women, as they aged, gained power, since they no longer were restrained by the taboos associated with menstruation. In the Winnebago world, older women dispensed herbal medicine and were considered authorities on traditional history and religious matters. According to another Winnebago saying, an elderly woman was "just like a man."[3]

Judy Mike's painting *Three Women* gives the viewer a sense of the energy and beauty of these young Winnebago women. Mike was a student at the Institute of American Indian Arts and completed *Three Women* during her student days. Completely rejecting the stylized conventions of traditional American Indian painting, Mike's work exemplifies the focus of the I.A.I.A.'s program in which composition, application of paint, and imagery are those of mainstream twentieth-century painting.

SHARRON AHTONE HARJO (b. 1945)

Sain-tah-oodie (Killed with Blunt Arrow) ✦ Kiowa

✺

WE HAD PLENTY, 1984

When Sharron Ahtone Harjo was a young girl, her grandparents gave her a ledger book that documented her family history. Young Sharron treasured her gift, and images of the life of her ancestors have been among her primary subjects throughout her career. Harjo has developed a style of painting that clearly shows a close relationship to the style of her ledger book.

Ledger books were the first attempt at nonritual art by Native Americans. From 1875 to 1878, Southern Plains warriors imprisoned at Fort Marion in Saint Augustine, Florida, filled commercial ledger books with narrative drawings that depicted images of their lives—the freedom of traditional life on the Plains, the confinement of reservation life, and life in the Florida prison. The prisoners were encouraged to make a series of drawings and were paid for their efforts so that they could buy trinkets and small necessities in St. Augustine. Some of the most important ledger books to have survived the ravages of time feature the work of the Kiowa prisoners.

We Had Plenty depicts the Plains Indian world in the years before the U.S. Army took the Kiowa warriors prisoner, a time when the Plains Indians had plenty. Harjo has painted a moment in a buffalo hunt just before the kill. The existence of buffalo on the Great Plains ensured the Kiowa a world of plenty. The buffalo's meat provided food, its bones tools, its skins clothing and shelter (tipi covers). Even buffalo dung was burned as fuel.

More than four million buffalo were killed in the three-year period from 1872 to 1874, years before the imprisonment of the Kiowa warriors and the creation of the ledger books. In 1975 General Philip Sheridan said of the slaughter of the buffalo by the white buffalo hunters: "These men have done in the last two years, and will do more next year to settle the vexed Indian questions than the entire regular army has done in the last thirty years. They are destroying the Indians' commissary."[1] Harjo's painting is a scene of the post-contact world, for Harjo has painted a mounted Kiowa. The Spanish first brought horses to the Southwest in the sixteenth century, but it was not until the mid-nineteenth century that the mass destruction of the buffalo herd took place, all for a price of two dollars per buffalo skin.

Painted on a plain white background, a color similar to that of ledger-book paper, Harjo's two-dimensional images are close in spirit to the historic ledger books. Harjo's use of historic detail, for example, the dress of the Indian, the saddlebags, and the shieldlike emblem in the upper right of the painting, shows the influence of the traditional Oklahoma and Santa Fe Indian School paintings of the first half of the twentieth century. As in traditional ledger-book drawings, there is neither a horizon nor evidence of regional landscape or foliage.

Marcelle Sharron Harjo was born in 1945 in Carnegie, Oklahoma. Her father, Jacob Ahtone, was a soil conservationist and tribal operations officer for the Bureau of Indian Affairs, and her mother, Evelyn Tohome "Tahdo," was a Kiowa woman who worked with skins and beads. Because of Ahtone's work with the B.I.A., the Harjo family traveled continuously and young Sharron attended elementary school in Oklahoma, Washington, D.C., and Utah and high school

113. *WE HAD PLENTY*, 1984

30⅝ X 38⅛", OIL ON CANVAS

GREAT PLAINS ART COLLECTION, UNIVERSITY OF NEBRASKA-LINCOLN

GIFT OF FRIENDS OF THE CENTER FOR GREAT PLAINS STUDIES

in Billings, Montana. She attended Bacone College from 1963 to 1965, when she had the opportunity to work with artist Dick West. She subsequently studied at Central State University in Edmond, Oklahoma, Colorado Women's College in Denver, and graduated with a B.A. in art education from Northeastern Oklahoma State University in Tahlequah in 1968. Following graduation, Harjo taught English, civics, and art at a B.I.A. school, the Concho Indian School in Concho, Oklahoma. Today, Harjo continues to teach and conduct workshops and classes in traditional Indian arts.

Although during her youth Harjo lived in many parts of the country and met many Native American people, her direction in life—her interest in the history, customs, and legends of the American Indian people—resulted from a tour in 1966, when she was chosen as Miss Indian America XII, a ceremony that was part of the All-American Indian Days in Sheridan, Wyoming. In the course of her travels, Harjo developed a complete fascination with Indian art and the creative achievements of her people. The following year at the Sheridan All-American Indian Days, she won the First Place Student Award, a scholarship to continue her studies in art at Colorado Women's College.

In 1966 Harjo's first one-person show of her paintings was sponsored by the B.I.A. at the Federal Building in Billings, Montana. In 1975 she was honored by the Indian Arts and Craft Board by a one-woman painting exhibition at the Southern Plains Museum and Crafts Center in Anadarko, Oklahoma. In 1984 she had an exhibition of her work at the Center of the American Indians in Oklahoma City. Throughout her career Harjo has continued to win awards. In 1974 she was honored as Indian Woman of the Year by the Oklahoma Federation of Indian Women.

Harjo's life and art, which focuses on Kiowa legend, history, and contemporary ceremonial life, are distinguished by her feeling of a continuity of generations. Harjo writes, "In my art I try to bring the past into the present and record the present for the future."[2]

Crow

✸

CROW PARFLECHE, 1967

Connie Red Star has painted *Crow Parfleche* in celebration of her Crow heritage. In the days long before the Europeans brought horses and guns to the American continent, the Hidatsa were Siouan-speaking people, village farmers living along the Missouri River in an area that is present-day North Dakota. A group of Hidatsa, who called themselves *Absaroke,* which means "Crow-people" or "bird-people," separated from the majority of the Hidatsa and traveled west. Settling in the country of the Yellowstone River and of the Yellowstone southern branches, the Powder and Big Horn Rivers, they changed their way of life. No longer pottery-making farmers living in earth lodges, they became hunters living in skin tipis. Historically, these people are known as the Crows. The Hidatsa and the Crows were among the most accomplished hide painters.

Painting, with the exception of the dressing and sewing of skins, is the oldest of the major Indian arts or craft arts. In 1540 Spanish explorer Francisco Vásquez de Coronado learned of skin painting, and early explorers and traders saw the Blackfeet Indians wearing painted robes and living in painted tipis. In traditional Plains Indian society, men painted figurative images—horses, men, and weapons—whereas women painted geometric designs. Traditionally, men painted buffalo-hide tipis, whereas women painted parfleches and tubular cases. Both men and women painted robes.

The parfleche, a painted rawhide container used for storage and transportation, was a favorite article for Crow women to paint. The parfleches used by the Crow People averaged about thirty inches when folded. They usually were made in pairs, as they were suspended lengthwise on each side of the horse. The parfleche remained dry even in the wettest weather.

When it was time to paint a parfleche, women first stretched and pegged the hide, hair-side down on the ground so that they had to crouch or kneel when painting. These artists used neither sketches nor patterns, but worked from memory or created their designs as they proceeded. The earliest colors, made from animal, vegetable, and mineral sources, were brown, red, yellow, black, blue, green, and white. Peeled branches, which served as rulers, enabled the women to make straight lines. The preferred brushes were cut from buffalo bone.

Connie Red Star attended the Institute of American Indian Arts from 1965 to 1969. *Crow Parfleche,* which was painted during her student days, is today part of the permanent collection of the I.A.I.A. museum. In 1968 Red Star, who worked primarily in acrylic and oil, entered *Crow Parfleche* in a competition at the Philbrook Museum of Art in a special category, "designed to recognize new trends in American Indian art, abstractions, symbolic designs, or methods of painting which use European-derived shadow and perspective. All works based on an Indian theme."[1]

In *Crow Parfleche,* Red Star's two-dimensional design covers the entire canvas. By using only an authentic design of the Crow People and the colors first used in painting parfleches, Red Star has created a brightly colored image, which perhaps is the first example of Native American Pop Art.

114. *CROW PARFLECHE*, 1967

30 X 24", OIL ON CANVAS

PHOTOGRAPH COURTESY OF THE INSTITUTE OF AMERICAN INDIAN ARTS MUSEUM, SANTA FE

PHOTOGRAPH BY LARRY PHILLIPS, SANTA FE

NADEMA AGARD (b. 1948)

Winyan Luta (Red Woman) ♦ Lakota / Cherokee / Powhatan

❋

HOMAGE TO PLAINS WOMANHOOD, 1984

In 1982 Nadema Agard painted *Homage to Plains Womanhood,* a dramatic pink and blue symphony of historic and personal imagery. Agard writes of her work:

> This work is a representation of a vision whereby an image of a buffalo skull appeared as a result of a configuration of female figures against the background sky. The symbolism of the buffalo skull took on a cosmic significance as the life-giving womb. The four directional crosses represented three times symbolize time and space, the number 7 and the number 12 which are quite significant in Native American cultures of the Plains and all the Americas. The balance between duality of life is also represented and the 9 symbols are the 9 months of human evolution before birth. This piece honors the women who are the backbone of our Nation. It is said that when the hearts of women are crushed to the ground only then is a nation destroyed.[1]

In Agard's painting the central image is a buffalo skull, which Agard explains is her personal metaphor for the uterus. At the base of the skull is a narrow opening, the birth canal, which Agard sees as a spiritual opening. Rising above the buffalo skull is Grandmother Moon. According to Agard, "Woman is a metaphor for the earth at her most fertile stage while the stars are the celestial male counterpart. Grandmother Moon is the guardian of the earth and the giver of wisdom. Walking in the Moon's glow represents the illumination of wisdom."[2]

Agard painted small circles on the buffalo's skull and in the sky. These circles are stars, which represent time and the energy of fire. The sun is a star and Grandfather Sun is the complement to Grandmother Moon. The four arms on the three crosses on the buffalo skull represent the Four Directions and also are masculine. The number three repre-

sents time, which has three fundamental divisions—yesterday, today, and tomorrow. The four images of women, two on each side of the skull, represent the four phases of womanhood—child, young woman, mother, and elder. Agard writes of her work, "When the sacred feminine images—the doors where one emerges from the spirit world to this material existence—are respected, only then can there be harmony. These are the teachings of our tribal wisdom."[3]

Nadema Agard was born, raised, and educated in New York City. In 1970 she graduated from New York University with a B.S. in art and education and in 1973 received an M.A. in art and education from Teachers' College, Columbia University. Agard also studied at the Università Cattolica di Milano and the Aegina Arts Centre in Aegina, Greece. For seven years she was project director of the Native American Arts Program and supervisor of visiting artists in the education department of the National Museum of the American Indian.

In 1991 she accepted a position at Bemidji State University in Moorhead, Minnesota, teaching studio arts, multicultural arts, and Native American arts with a focus on non-Western aesthetics and culture. The university also published her *Directory of Southeastern Native Arts,* which was funded by the National Endowment for the Arts. From 1995 to 1997 Agard worked as Repatriation Director for the Standing Rock Sioux Tribe in North Dakota, Sioux People with whom she has ancestral ties. Today Agard has returned to New York City where she devotes her energy to her multiple careers as artist, teacher, curator, lecturer, and writer.

Agard always has devoted a significant part of her time to independent creativity. Since 1979 she has exhibited her work in museums and galleries across America. Agard writes of her aesthetic goals:

> My work is a metaphor for the cosmic relationships between the sacred feminine and the sacred masculine. These works are inspired by the images

and cosmologies from Native American traditions of the Southeastern and Great Lakes woodlands, the Southwest, the Plains and Meso-America. These devotional pieces are made in reverence to the Earth Mother, Father Sky, Grandmother Moon, Corn Mother and all creative and regenerative forces of the universe.

Conceived in a dialogue between the spiritual and sensual, political and transcendental, these works mirror the paradox of our human condition. They speak the universal language—a shorthand of the spirit—which connects us with one another and ultimately to the realization that we are all of the same essence. Simultaneously, they speak a particular language to the indigenous community. These works speak of the spiritual tenacity of indigenous people of the Americas, which has not changed for 500 years.[4]

115. *HOMAGE TO PLAINS WOMANHOOD*, 1984
62 X 42", ACRYLIC ON CANVAS
PHOTOGRAPH COURTESY OF THE ARTIST

CHARLENE TETERS (b. 1952)

Spokane

✹

TURTLE SISTERS, 1988

Charlene Teters's life is devoted to two harmonious goals. She is both social activist and artist. Throughout her life Teters has campaigned against symbols that dehumanize and degrade the American Indian. Teters writes:

Indians throughout the world are typically treated as objects of entertainment, objects of curiosity, objects of study, or creatures of exotic fantasy (as in *Peter Pan*). Our existence often openly challenges the dominant culture's distorted ideas of Indian identity as we demand to be recognized as full-fledged human beings. My work today continues to be about identity and our crisis: What it is for me to be Indian in America.[1]

Born and raised on the Spokane Reservation, which lies between the Columbia and Spokane Rivers in Washington, Teters was educated in local grade and high schools, attended Fort Wright College in Spokane, married, and had two children. Teters describes this life:

At home on the Spokane and Colville Reservations, there are few roles that women receive recognition for, few accepted roles of leadership for women. I stayed home with my children, cooked for my husband's family; my home was the center of family gatherings. And I primarily did traditional crafts: beadwork and traditional clothing for pow-wows and ceremonies. Women did traditional art forms (basket, beadwork). There, I was considered a good Indian woman. Yet with a small circle of male artists

I received encouragement for my paintings, and began the process of openly developing my skill. As I gained wider public recognition for painting, my advances were seen as a threat to my pre-defined role as the good Indian woman.[2]

At age thirty-two Teters left Washington and traveled with her children to Santa Fe where she enrolled in the Institute of American Indian Arts. Teters writes, "Redefining of my role began when I left for Santa Fe to enter the Institute of American Indian Arts (I.A.I.A.). . . . My years [there] were about reclaiming myself, and giving integrity and respect back to my identity as a Native woman."[3]

Graduating with an A.F.A. from the I.A.I.A. in 1986, Teters received a B.F.A. at the College of Santa Fe in 1988. In 1988 she won a fellowship to the University of Illinois to pursue an M.F.A., a degree she completed in 1994. Studying and working as a teaching assistant at the university identified by an Indian mascot, Chief Illiniwek, was an experience Teters describes as a challenge to her identity:

To be one of the 3 Native students on a college campus of 54,000 non-Indians who adopted their Indian mascot identity was very surreal for me. Every time I left the safety of my home, I was affronted on the street with distorted images of my people on T-shirts, sweatpants: Indian images on everything including toilet paper. Sororities and Fraternities had for years abused my identity, all in the spirit of athletic tradition, considered good clean fun. One sorority sponsored the Miss Illini

116. *TURTLE SISTERS*, 1988
48 X 36", OIL ON CANVAS
COLLECTION TAMMY RAHR, SANTA FE

Squaw Contest. Fraternities had "buck and squaw" theme dances. Other students adorned themselves in colored paper headdresses to go out drinking and act out their negative stereotype of the drunk Indian. The presence of real Indian people in this community challenged their distorted images and ideas of what it is to be Indian. A challenge that was unwelcome and met with hostility.[4]

At the University of Illinois, Teters began her life as an activist. In 1989 she was cofounder of the Native American Students for Progress, an organization that worked directly within the institutional structure of the University of Illinois to provide a safe, progressive, culture-affirming environment. In 1990 she was cofounder of the American Indian Midwest Alliance, an organization that brings together other organizations throughout the Midwest in order to form a more powerful voice in the human rights struggle for indigenous people.

Since the days in Illinois, Teters has been devoted to fighting the stereotypes that are an ever-present part of American culture.

Hollywood has pictured us as bloodthirsty savages, attacking innocent women and children, or noble but lusty braves or Indian princesses, but rarely as full-fledged human beings. . . . These images are diametrically opposed to the traditional teachings Indian children get at home. At home they are taught to respect and emulate the traditions and values of their parents and ancestors. But when they look outside they see their culture mimicked and misused.[5]

Teters's painting and installations focus on the problems of Indian identity and reaffirmation in contemporary America. *Turtle Sisters* depicts Tammy Rahr, a Cayuga tribal member and good friend. Teters writes, "In my painting the focus is to communicate the humanness of Indian people. Often we are *only* pictured in Tribal regalia (leather and feathers)."[6] This painting includes two images of Rahr, as a young woman in traditional dress walking forward and as the same woman in contemporary dress seated by a window. The two images of Rahr with the same hairdo and a blue dress are both integral parts of Indian identity. Indians can honor their heritage by cherishing the rituals of the past, but "Indians are twentieth-century people and must be seen as such in order to address twentieth-century problems."[7]

In 1994 Teters created an environmental installation, *It Was Only an Indian*. This installation examines the roots of misunderstanding, mistrust, and invisibility for American Indians, the social elements that have blinded the non-Indian to the complete humanity of the American Indian people. From 1992 to 1995, Teters was a professor at the I.A.I.A. and today continues to serve as adjunct professor. Today Charlene Teters is the editor of the magazine *American Indian Artists* and continues her work as teacher, lecturer, writer, and artist.

PHYLLIS FIFE (b. 1948)

Muscogee (Creek)

✸

BUFFALO TWO CHIPS, 1973

Phyllis Fife has won distinction both as an educator and as an artist. Since 1979 Fife has taught applied art, art history, art education, and Cherokee history. For the last ten years she has been devoted to bilingual education. Since 1989 she has been the director of the Northeastern State University Bilingual Education Center and Director of the Title VII Bilingual Education Personal Training Programs for teachers of Muscogee (Creek) and Cherokee students. She also has been public school staff development consultant on art, multicultural, bilingual, and Indian education; and coordinator for the Title VII professional development training. Fife has been a professional painter, designer, graphic artist, and fashion designer for over thirty years. She has entered and won awards in national competitions and exhibited her work internationally. In 1992 she was selected as one of twenty-five Native artists of North and South America to serve on the Smithsonian Project "Celebrations."

Born in Okfuskee County near Dustin, Oklahoma, Phyllis attended rural public schools. In 1963 she enrolled in a high school program at the Institute of American Indian Arts, where she majored in painting. Graduating in 1967, she next attended the University of California in Santa Barbara, where for a year she studied painting with Howard Warshaw. She then attended Northeastern Oklahoma State University in Talequah, the same institution where today she teaches Native American studies and Indian education.(Northeastern Oklahoma State University has the highest per capita enrollment of American Indian students in the United States.) In 1973 she received a B.F.A. with a major in fine arts from the University of Oklahoma. In 1987 she received an M.A. in education from Northeastern Oklahoma State University, and in 1994 a Ph.D. in secondary education from the University of Arkansas.

Phyllis Fife's art is an independent blend of tradition and innovation. Her subject matter is rooted in her Indian heritage, yet she frequently focuses her artistic creations on the contemporary world and the experience of the Native American artist in present-day America. Rejecting the stylized format of traditional Indian school painting, Phyllis Fife works as a modern abstract artist.

Buffalo Two Chips was Fife's personal response to the appearance in the art world of "Nouveau Native Americans," painters with newly discovered American Indian identities focused on commercial success. Fife writes:

In a decade when abstract expressionism was emerging among a generation of artists who were progenies of."Indian art traditionalists," a political movement was also taking place and the stereotypical "Indian" was changing. In the 1970s, the Civil Rights movement and American Indian self-determination generated a new and enlightened interest in "Indian-ness." Humility aside, there also arose certain opportunistic individuals whose self-proclaimed authority gave them recognition in some circles as spiritual leaders, cultural experts, resistance fighters, or similar titles. In the Indian community, meanwhile, they were often referred to as "professional Indians." A satirical look at the fads and fancies of the art movement of the time, and the influences of that particular political character, led to the painting titled *Buffalo Two Chips*. The title was not my own creation, but a nickname bestowed upon one such "professional Indian" by my father.

Whether consciously or unconsciously conceived, the humor and politics of my enculturation have often become statements in my art. Reminders and memorials of the collective histo-

ries of my tribe, my clan, my religion, and my family are realities in my everyday life. The perceptions and emotions that I have materialized when art comes from my hands to the canvas. Indian parents teach us to use humor for many purposes, not the least of which is to overcome sadness and hard times. Sometimes our comedy is, in reality, also our tragedy.[1]

117. *BUFFALO TWO CHIPS*, 1973
48 X 48", MIXED MEDIA ON CANVAS
PHOTOGRAPH COURTESY OF THE ARTIST

EARTH SONGS, MOON DREAMS

KAY WALKINGSTICK (b. 1935)

Cherokee / Winnebago

❋

WHERE ARE THE GENERATIONS?, 1991

Where Are the Generations? is a significant part of Kay WalkingStick's artistic response to the nationwide preparations for the celebration of the Columbian Quincentenary. In 1992 WalkingStick wrote of her painting and of the inscription done by hand in repoussé type on a thin copper sheet:

> On the face of the painting it says: "In 1492 we were twenty million now we are two million. Where are the children, where are the generations never born?" My last name in Cherokee script is a signature at the bottom. If the native people of the Americas had multiplied as the people of other nations have we would now still fill this continent, but we do not. Genocide happened here and this painting made on the eve of the Columbian Quincentary is about that horrific fact. The landscape is barren and empty and echoes the brutal surface of the abstract portion. 1992 was a hard year because most non-Native people were celebrating the Columbus invasion of the Americas.[1]

WalkingStick's painting is a diptych, two canvases joined to represent two kinds of memory of the earth. One is immediate and particular, the other long-term and nonspecific. One refers to the present, the other to both the past and the future. Since the mid-1980s, WalkingStick has used the form of a diptych or triptych for her paintings. She writes:

> The two portions of the work relate in a mythic way—the natural is made fuller, more concrete, more universal, by the abstract. One is not the abstraction of the other, one is the extension of the other. I want the two portions to resonate with one another like stanzas of a poem.[2]

> They relate in the way that multi-part ecclesiastical paintings do. One part is not the abstraction of the other; it is the extension of the other. . . . My paintings show two different perceptions of the world in two different methods of painting, some would say diametrically opposed methods. Yet, I believe in the possibility of unity, of wholesomeness. My goal is to make meaningful, intuitive connections between the different but mythically related views.[3]

The half of the diptych that is momentary and particular is a naturalistic, expressionistic view of the landscape, a memory focused on a range of snow-covered mountains, whereas the half that is permanent and nonspecific is a geometric abstraction. This half, built up with thick layers of oil and wax applied directly with the artist's hand, has an emblematic symbol, a half circle surrounded by black, which is a distillation of the essence of the landscape, the barren land that is Quincentennial America. WalkingStick painted *Where Are the Generations?* as a companion piece to *Tears,* a sculpture with a copper repoussé inscription that utilized the image of a mortuary scaffold to recall lost generations of Native Americans. (Mortuary scaffolds for centuries were used as part of Native American grave sites.) In *Where Are the Generations?* WalkingStick used her hand, a knife, and a razor blade to create an expressionistic surface, which is

118. *WHERE ARE THE GENERATIONS?*, 1991
28 X 50¹/₂", COPPER, ACRYLIC, WAX, AND OIL ON CANVAS
PHOTOGRAPH COURTESY OF THE ARTIST

scraped and layered. WalkingStick believes that the format of the diptych and the two complementary styles enable her to achieve a perfect synthesis of form, material, and idea.

Kay WalkingStick was born in 1935 in Syracuse, New York. She is the daughter of Emma McKaig, a woman of Scottish-Irish ancestry, and Ralph WalkingStick, a member of the Cherokee Nation whose maternal grandmother was of Winnebago ancestry. Emma McKaig met Ralph WalkingStick on a train while traveling to Philadelphia to visit her grandmother. Ralph WalkingStick, who was a student at Dartmouth College, a university that encouraged the enrollment of Native American students, especially Cherokees, was a handsome football player who was traveling around the country on a lecture tour in which he served as a role model and advised American youth to lead a clean life. He did not graduate from Dartmouth but in 1916 joined the British Army as a captain, hoping to participate in the war effort. (Until 1924 American Indians were not permitted to serve in the United States Armed Forces.) Emma McKaig married Ralph WalkingStick before he left for England and upon his return traveled with him to his native Oklahoma, where Ralph, who had studied geology, worked as an oil scout while Emma gave birth to and raised four children. In 1934 the couple separated and Emma, pregnant with Kay, returned to upstate New York.

Young Kay WalkingStick did not meet her father until she was nine years old; however, her mother instilled in her a sense of identity in two cultures:

> Two powerful ideas were continually presented to me in my childhood. The first was that God was the primary part of all life, and that religion is a daily experience; that spirituality is a goal to be sought and lived. The other was my self-identity. I am an Indian, and although I was being raised in a white Protestant culture, I was raised to think of myself as Cherokee. Ideas are powerful, and although I now question the existence of a personal god I will always believe in the possibility of spirituality, just as I will always think of myself as an Indian. For me, in fact, the ideas overlap.[4]

WalkingStick began to draw and paint while still a young child:

> As a child I spent a lot of time in church. My mother always brought pencil and paper so that I could draw during long sermons, and therefore I like to say that I learned to draw in church, but actually I drew constantly and everywhere. Everyone in my family could draw and on both sides of my family there were artists. I have always thought that I, too, was an artist. My commitment to making art has been constant in my life. I love the feel of paint; I love the energy and life that paint can convey; I paint with my hands. The surfaces of the paint are an important part of their message.[5]

Thanks to her Native American identity, she has respect for and love of the land, and as she matured spirituality became the focus of her art:

> I see my work as primal, gutsy, spiritual art. Painting, landscape or otherwise, is not a metaphor for God, or for religion either. It is a dialogue with the mythic, the spiritual, with that which transcends our bittersweet daily lives. In this sense the work is both tribal and also romantic, as Rothko is romantic. I see the earth as sacred, as life-giving, as all Native Americans do. It is the earth that I want to be everlasting.[6]

WalkingStick attended Moreland High School, then won a scholarship to Beaver College in Glenside, Pennsylvania, from which she graduated in 1959 with a major in painting. In 1973 she won a Danforth Fellowship to attend Pratt Institute in Brooklyn, where in 1975 she received a bachelor of fine arts degree. Since, during the mid-1970s, instruction at Pratt Institute was focused on the innovations of mainstream twentieth-century modernism, following graduation WalkingStick created nonrepresentational minimalistic art. Since graduating from the Pratt Institute, she has taught painting and drawing on a university level. Currently she is an associate professor of art at Cornell University.

From the very beginning, WalkingStick won critical acclaim for her efforts. She won a series of fellowships and residency awards including a residency at the Rockefeller Conference and Study Center in Bellagio, Italy, and has

received many national awards for her work. In 1966 she received the National Honor Award for Outstanding Achievement in the Visual Arts awarded by the Women's Caucus for Art. She has had solo exhibitions at galleries across the United States, and her work is featured in many American museum and college collections as well as in the Israel Museum and the National Gallery of Canada. She is the only Native American artist whose work is in the contemporary collection of the Metropolitan Museum of Art in New York City. (In 1993 the Metropolitan Museum acquired *Genesis, Violent Garden* for its permanent collection.)

KAY WALKINGSTICK (b. 1935)

Cherokee / Winnebago

❋

OURSELVES, OUR LAND, 1992

Kay WalkingStick identifies with her art: "What does my artistic heritage have to do with my art? It is who I am. Art is a portrait of the artist, at least of the artist's thought processes, sense of self, sense of place in the world. If you see art as that, then my identity as an Indian artist is crucial."[1] *Ourselves, Our Land* is WalkingStick's aesthetic proclamation of her identity with her native land and her personal aesthetic response to America's quincentennial celebration. WalkingStick writes:

The quincentennial of the invasion by Columbus of this hemisphere took place in 1992. Celebrations of this historic fact were planned all over the country. Very few Americans doubted that it should be celebrated—but like many other people who were of a Native background, I had a different view of the appropriateness of a celebration. I am a bi-racial woman who is very much a part of the mainstream culture—and my painting is consciously a part of the European cultural tradition—yet in times like 1992 my ties to Native American history and thought become paramount. There were many historical truths concerning the indigenous peoples of the Americas that have seldom been addressed, and then only by students of Native American history. I decided to make a series of art works that addressed those issues using the formal and stylistic direction that had recently been engaging me. I worked on this project for about two and one-half years during which time I made a number of paintings, two books, and a small

sculpture. I had never before seen myself as a political artist but these pieces were touchy, angry, and political works.

The piece, *Ourselves, Our Land,* was made during this period, and depicts a desolate western mountainscape empty of people. On one side of the diptych are the words written on copper in the Cherokee language, *Ourselves, Our Land.* It is written in the beautiful Cherokee syllabary, developed and promulgated by a genius, George Geist, Sequoyah, in the mid-nineteenth century. Although most of the land has been taken away from Native people over the last five centuries, it is still ours. We still revere it. But there are not enough of us here to fill the land or even to have a political impact. Our numbers are so few that our votes hardly matter outside of Indian Country. That sad fact is Columbus' legacy to the "Indians." Genocide happened here.[2]

In 1984 WalkingStick developed a dynamic approach to painting, the creation of diptychs and triptychs:

My present paintings are concerned with balance between the concrete visual landscape and archetypal memory of the earth, or one could say, between the physical and spiritual view of the earth. . . . I see balance also between the physical self and the spiritual self. Just as one side of the diptych is not the abstraction of the other, but the extension of the other, so

119. *OURSELVES, OUR LAND, 1992*
22 X 44", ACRYLIC, WAX, AND OIL ON CANVAS
PHOTOGRAPH COURTESY OF THE ARTIST

too, is the spiritual not the opposite of the physical, but its natural extension. The active layered paint surface and the division of the two sides of the painting is thus necessary to convey these ideas of the spiritual and sacred. They are different, but one.[3]

In *Ourselves, Our Land* WalkingStick combines a geometric abstraction, an emblematic symbol that is a black circle in a field of orange, with a naturalistic image of a mountain peak. WalkingStick writes, "The content of all of these paintings is mythic, if one understands myth to be that which expresses the unknown, the inexpressible, or the incomprehensible. They are an attempt to unify the present with eternity. They are a dialogue with the transcendent. The earth is sacred."[4]

JAUNE QUICK-TO-SEE SMITH (b. 1940)

Quick-to-See (Insightful Awareness) ♦ French Cree / Shoshoni / Flathead / Kootenai

✺

BUFFALO, 1992

Nineteen ninety-two was the quincentennial anniversary of the landing of Christopher Columbus and his men on the shores of the Americas. In 1991, in response to this upcoming event, Jaune Quick-to-See Smith served as guest curator for an exhibition at the University Art Gallery at the State University in Albany, New York. For this exhibition, entitled *Our Land/Ourselves: American Indian Contemporary Artists,* Smith invited thirty American Indian artists to express in their work their relationship to the land, the land Christopher Columbus "discovered," although this land had been their ancestral home for centuries. Smith wrote of the exhibition, "I see the land as sacred. I think most native people—regardless of the environment we came out of—believe this really is our home. Whether we occupy it all or not is not really the issue. The fact is that we still think of it as ours—our land."[1] In 1992, the year of the quincentennial, Quick-to-See Smith painted *Buffalo* as her tribute to the Native peoples of America, her contribution to the "Quincentennial Non-Celebration." Smith wrote:

> In the work *Buffalo* I deal with the stereotypical characterizations and myths that are commonly used in advertising, television, the world of sports, and Hollywood to portray Native people. I use all these icons to enlighten and educate the viewer. I used an enlarged pictogram of the buffalo with my abstract painting style, fused with collage, language, and gestural composition, in this work. When I was born only one in ten Indian children survived on the reservation. I honor all these other Indian children who did not survive by enlarging the buffalo.[2]

Smith chose the buffalo, a primary American symbol, because the mass slaughter of the buffalo is readily identified with the destruction of the traditional American Indian way of life. Smith sees her painting as containing many levels.

My work has layered meanings, so you can see many different levels within a single work. I like to bring the viewer in with a seductive texture, a beautiful drawing, etc., then let them have one of the messages. I hope that my art can be read this way through different layers.[3]

Included in this painting are clippings of the contemporary political scene and clippings referring to contemporary news items relevant to the American Indian world, such as, "Columbus Commission on the Rocks." There are cartoon clippings from "Blondie," Indian images, clipping headlines such as "Child's Indian Name Given and War Dances and Dinner," animal images, a torn American flag, images of folded U.S. currency bills with the headline "Keep These Photos in Your Wallet," pseudo-Indian advertisements such as "Plen Tee Color" (an advertisement for apples). Smith calls the use of headlines in her paintings "Madison Avenue SoundBits." The outlined form of the buffalo is the primary icon of this collage of paintings and clippings. Throughout her career, Smith has incorporated in her work images that the popular culture associates with the American Indian world, for example, canoes, tipis, and the buffalo.

Jaune Quick-to-See Smith was born at the St. Ignatius Mission on the Flathead Reservation of the Salish Kootenai People of western Montana. At the time of her birth, her father was a forty-year-old Flathead/Metis/Shoshone man and her mother was a fifteen-year-old half-Cree woman. When Jaune was two and one-half years old, her mother took her and her sister down the road and left them with an elderly American Indian couple. Jaune did not see her mother again until she reached adulthood.

Jaune's father was a primary influence on her youth. His life centered on horses. Rodeo rider, horse trainer, horse trader, he also found work rounding up horses and building corals and fences. It was Jaune's father who introduced her to

the arts. He owned a collection of Charlie Russell prints, enjoyed drawing, and often made drawings which he gave to his daughter. She treasured these and carried them at all times in her pockets. Whenever possible, Jaune helped her father with his chores. He encouraged his daughter to earn money for her education. At one time Jaune worked as a farm hand with Japanese laborers who, following World War II, had been repatriated. With these first earnings, Jaune was able to send away a matchbook cover to begin a correspondence course in painting from the Famous Artists School in Westport, Connecticut.

Jaune had a nomadic youth, traveling with her father to towns across the Pacific Northwest. As a child, she was enrolled in schools in fifty communities. Jaune attended several colleges, including the University of Washington in Seattle and then, with the assistance of a Native American scholarship, she enrolled in Olympia College in Bremerton, Washington, where she received an A.A. Although Jaune, since childhood, had hoped that one day she would become an artist, at this junior college the professor serving as her academic advisor told Jaune that she couldn't become an artist because she was a woman, that only males could be artists and that Jaune should become a teacher. Jaune initially followed this advice and in 1975 graduated magna cum laude from Framingham State College in Massachusetts with a B.A. in art education.

Smith's efforts as an activist extend beyond her personal aesthetic creations. As spokesperson for contemporary Native American artists, she has founded two cooperatives—the Coup Mark, an organization of artists and craftsmen on the Flathead Reservations, and the Gray Canyon Artists, a cooperative of Native Indian artists in New Mexico. Both groups have exhibited in major cities across the United States. Today Smith has a multifaceted career.

She works as a painter, a printer, a curator of exhibitions, and a lecturer. During the past decade, she has turned to public art, completing several commissions including the design of a terrazzo floor piece for the new Denver International Airport.

In recent years Smith has turned from watercolor to mixed media, creating paintings in which she gives a new and deeper meaning to traditional icons. Smith writes:

> I've used large identifiable Indian icons that have been romanticized by movies, novels, and the media. But up close the viewer gets a reading of a different story about Indian life on and off the reservation. Clippings from my tribal newspaper (the *Char-Koosta*), newspapers, books, magazines, tell a story that deals with the reality of Indian life. Our daily concerns about education, our children, health care, the environment, and how to fit our cultural concerns with modern life. So much of what we see in the media leads us to believe that Indians are: 1. Vanished, vanishing, dead; or 2. That we are romantic visions. Neither of which is true. Our population numbers are higher than they've been since the turn of the century and growing at a faster than national rate. Even though the government and the Christian churches banned our ceremonies, dancing, drumming, religions and language all the way through the 1950s, our elders retained our cultural knowledge and are revitalizing our cultural ways. Our strength as Indian People comes from our elders, our culture, and our abilities to govern ourselves in the modern world.[4]

120. *BUFFALO*, 1992
66 X 96", DIPTYCH, OIL, MIXED MEDIA COLLAGE ON CANVAS
COLLECTION ELEANOR AND LEN FLOMENHAFT
PHOTOGRAPH COURTESY OF STEINBAUM KRAUSS GALLERY, NEW YORK

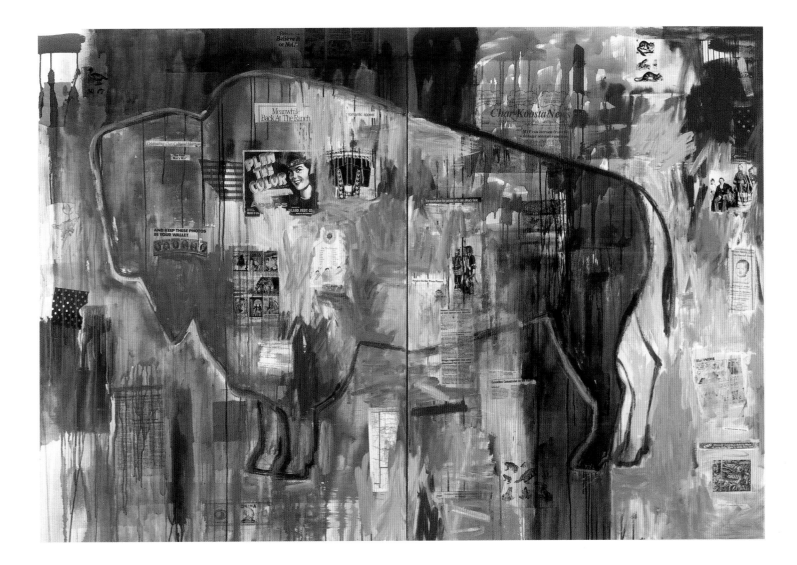

NOTES

INTRODUCTION

[1] In selecting artists for this book, I am neither giving blood tests nor deciding what percentage of American Indian blood or what papers ancestors signed make a woman an Indian. If an artist has a Native American identity, I accept this artist as an American Indian.

4 Lois Smoky, *Kiowa Family*
[1] Edith Mahier, quoted in Lydia L. Wyckoff, ed., *Visions and Voices: Native American Painting from the Philbrook Museum of Art* (Tulsa: The Philbrook Museum 1996), 24.
[2] Oscar B. Jacobson, *American Indian Painters* (Nice, France: C. Szwedzicki, 1950), 7.

5 Lois Smoky, *Lullaby*
[1] Oscar B. Jacobson, *American Indian Painters,* no. 30.

6 Tonita Peña, *Preparing Blue Corn*
[1] Tonita Peña, quoted in Samuel L. Gray, *Tonita Peña* (Albuquerque: Avanyu Publishing Company 1990), 52.
[2] Pablita Velarde, quoted in Gray, *Tonita Peña*, 55.
[3] Ibid., 57.

7 Tonita Peña, *Ceremonial Dance*
[1] Dorothy Dunn, *American Indian Painting of the Southwest and Plains Areas* (Albuquerque: University of New Mexico Press, 1968), 211.

8 Tonita Peña, *Big Game Animal Dance*
[1] Ina Sizer Cassidy, quoted in Samuel L. Gray, *Tonita Peña*, 21.

9 Eva Mirabel, *Picking Wild Berries*
[1] Dunn, *American Indian Painting,* 292.

10 Eva Mirabel, *Taos Woman Carrying Bread*
[1] Dunn, *American Indian Painting,* 292.

13 Merina Lujan (Pop Chalee), *The Forest*
[1] Dunn, *American Indian Painting,* 320.
[2] Pop Chalee, "My People's Art," *School Arts* (November 1938), 146.
[3] Pop Chalee, quoted in Pancho Epstein, "Art Excellence," *The New Mexican* (1 October 1990).

14 Merina Lujan (Pop Chalee), *Forest Scene*
[1] Pop Chalee, "Art That Voices the Spirit of Native " (clipping file).
[2] Pop Chalee, quoted in Margaret Cesa, "Pop Chalee: Magic Color Artist's World," *New Mexico Magazine* (August 1990), 37.

18 Lorencita Bird Atencio, *Women Getting Water*
[1] Olive Rush, quoted in Dunn, *American Indian Painting,* 313.

19 Geronima Cruz Montoya, *Basket Dancers*
[1] Geronima Cruz Montoya, quoted in publicity sheet from Shutes/Mellick, 1979.

20 Geronima Cruz Montoya, *Pueblo Crafts*
[1] Geronima Cruz Montoya, quoted in publicity sheet from Shutes/Mellick, 1979.

21 Lolita Torivio, *Acoma Woman Picking Chili*
[1] Dunn, *American Indian Painting,* 298.

23 Marcelina Herrera, *After the Deer Hunt*
[1] Dunn, *American Indian Painting,* 295.

24 Eileen Lesarlley, *Zuni Girls with Ollas*
[1] Bruce Bernstein and W. Jackson Rushing, *Modern by Tradition: American Indian Painting in the Studio Style* (Santa Fe: Museum of New Mexico Press, 1995), 48.
[2] Dorothy Dunn, *American Indian Painting,* 298.

25 Rufina Vigil, *Mass at Fiesta*
[1] Dunn, *American Indian Painting,* 294.

26 Caroline Coriz, *Textile Pattern from an Acoma Pottery Motif*
[1] Bernstein and Rushing, *Modern by Tradition,* 59.

27 Pablita Velarde, *Pueblo Craftsmen—Palace of the Governors*
[1] Bernstein and Rushing, *Modern by Tradition,* 3.
[2] Olive Rush, quoted in Dunn, *American Indian Painting,* 207.
[3] Dunn, *American Indian Painting,* 320.
[4] Dunn, quoted in Bernstein and Rushing, *Modern by Tradition,* 12.

28 Pablita Velarde, *Song of the Corn Dance*
[1] Dorothy Dunn, quoted in Bernstein and Rushing, *Modern by Tradition,* 38.
[2] Ibid., 40.
[3] Dunn, *American Indian Painting,* 292.
[4] Pablita Velarde, interview with author, 1977.
[5] Dunn, *American Indian Painting,* 341.

30 Helen Hardin, *Winter Awakening of the O-khoo-wah*
[1] Helen Hardin, quoted in Betty Childers, "Indian Artist Remains Outsider," *Albuquerque Journal* (29 August 1976), sec. D., p. 1.
[2] In 1971 the U.S. Information Agency in Guatemala City, Guatemala, also honored Hardin with a one-person show.

31 Helen Hardin, *Mimbres Rabbit*
[1] Helen Hardin, quoted in Wyckoff, ed., *Visions and Voices,* 130.
[2] Hardin, quoted in Lou Ann Faris Culley, "Helen Hardin: A Retrospective," *American Indian Art* (Summer 1979), 74.

32 Helen Hardin, *Prayers of a Harmonious Chorus*
[1] Helen Hardin, quoted in Lou Ann Faris Culley, "Helen Hardin: A Retrospective," *American Indian Art* (Summer 1979), 69.
[2] Hardin quoted in Betty Childers, "Indian Artist Remains Outsider," *Albuquerque Journal* (29 August 1976), sec. D., p. 1.
[3] Hardin, quoted in Patricia O'Connor, "Becoming Creative Woman," *Albuquerque Living* (August 1984), 65.

33 Margarete Bagshaw-Tindel, *Twilight Meets Dawn*
[1] Margarete Bagshaw-Tindel, quoted in "A Glimpse of the Magical World of Margarete Bagshaw-Tindel," *Art Horizons* (May 1996), 1.
[2] Ibid., 3.
[3] Bagshaw-Tindel, unpublished statement on painting, 1995.
[4] Bagshaw-Tindel, letter to author, April 1997.

35 Geraldine Gutiérrez, *Pottery Spirits*
[1] Peggy Beck, "Sacred Clowns." (An introduction to the exhibition *Koshare, Koyemski and Kossa: Native American Clown Painting,* at the Millicent Rogers Museum, Taos, New Mexico, July 6, 1987–January 3, 1988.)

36 Michelle Tsosie Naranjo, *The Fall Is Ending Sisters*
[1] Naranjo, quoted in Patrick D. Lester, *The Biographical Dictionary of the Native American Painters* (1995), 385.

37 Sybil Yazzie, *A Crowd at a Navajo N'da-a*
[1] Jeanne O. Snodgrass, comp. *American Indian Painters: A Biographical Directory* (New York: Museum of the American Indian, Heye Foundation, 1968), 224.
[2] Dunn, *American Indian Painting,* 301.

39 Sybil Yazzie, *Navajo Weavers*
[1] Among the Navajo, weavers are women, whereas among the Pueblo People the men traditionally are weavers. Pueblo looms are stationary and often are set up in the kivas, whereas Navajo looms are portable and often are set up outdoors. In contrast to Pueblo weavers, who must follow strictly defined traditional patterns and designs, Navajo weavers are freer to create individual designs. Navajo women carry their designs in their head and often devote months, even years, to completing a weaving.

42 Beverly Blacksheep, *Navajoland*
[1] Beverly Blacksheep, artist's brochure, 1992.
[2] Ibid.

44 Mary Morez, *Father Sky*
[1] Mary Morez, quoted in "Mary Morez, Navajo Artist," biographical sketch (1993), 1. In archives of the Native American Resource Collection of the Heard Museum.
[2] *Mary Morez: The Story of a Navajo Contemporary Artist,* The Ketoh Presentation of Gloria Gardiner (1993), 3. Native American Resource Collection, the Heard Museum.
[3] Mary Morez explained the iconography of this painting in several telephone interviews with the author April 1998.

45 Mary Morez, *Origin Legend of the Navajo*
[1] Mary Morez explained the iconography of this painting in several telephone interviews, April 1998.

46 Laura G. Shurley-Olivas, *Authentic Indian Curios*
[1] Laura G. Shurley-Olivas, quoted in Kate McGraw, "'Border town' Indian Art," *Pasatiempo* (18 August 1989), 34.
[2] Shurley-Olivas, written statement to author, November 1997.

47 Laura G. Shurley-Olivas, *Diné Dichotomy*
[1] Laura G. Shurley-Olivas, written statement to author, November 1997.

48 Emmi Whitehorse, *Silent Observer*
[1] Lucy R. Lippard, "*Shim'a: The Paintings of Emmi Whitehorse,*" in *Women of Sweetgrass, Cedar, and Sage* (New York: Gallery of the American Indian Community House, 1985).
[2] Emmi Whitehorse quoted in "Emmi Whitehorse," clipping file.
[3] Whitehorse, quoted in "Emmi Whitehorse: Premier Exhibition," Statement for a catalogue, Marlyn Butler Fine Art, 1981.
[4] Exhibition catalogue of Gray Canyon Group Show originated by North Dakota Art Gallery, 1980.
[5] Whitehorse, quoted, ca. 1987, clipping file.
[6] Whitehorse, quoted in William Clark, "Beyond the Surface," *Albuquerque Journal* (17 February 1991), Arts section, p. F4.
[7] Ibid.
[8] Ibid.
[9] Whitehorse, statement sent to author, 1991.

51 Otellie Loloma, *Nature's Altar*

[1] She wrote of her goals as a teacher: "When I teach . . . I try to instill belief in my students, whether Indian or non-Indian. When that belief is alive, their work is alive. . . . This belief and aliveness gives the student strength in what they do in any art form or life work. This belief and aliveness is what makes me the artist I am . . . It is what I am all about." Otellie Loloma, quoted in James McGrath, "Gifts from Second Mesa," *The Santa Fe Reporter* (13 December 1991), 18.

[2] News release for Women's Caucus for Art, national conference, 1991.

[3] Brochure for the Conference of the National Women's Caucus for Art, 1991, quoted in James McGrath, "Gifts from the Second Mesa."

53 Yeffie Kimball, *Zuni Maiden*

[1] Henry McBride, quoted in Jeanne O. Snodgrass, comp. *American Indian Painters*, 94.

54 Yeffie Kimball, *Old Medicine Man*

[1] Yeffie Kimball, quoted in Wyckoff, ed. *Visions and Voices,* 158.

55 Linda Lomahaftewa, *Hopi Spirits*

[1] Linda Lomahaftewa, quoted in Jamake Highwater, *The Sweet Grass Lives On* (New York: Harper and Row, 1980), 138.

[2] Lomahaftewa, statement sent to author, 1983.

[3] Ibid.

56 Linda Lomahaftewa, *Morning Prayer*

[1] Linda Lomahaftewa, statement sent to author, 1983.

[2] Lomahaftewa, quoted in *Women of Sweetgrass, Cedar, and Sage* (New York: Gallery of the American Indian Community House, 1985).

[3] Ibid.

[4] Lomahaftewa, quoted in *The Indian Trader* (1978), 21.

57 Marian Terasaz, *Comanche Girl*

[1] Oscar B. Jacobson, *American Indian Painters* (Nice, France: C. Szwedzicki, 1950), plate 32.

[2] Ibid.

59 Diane O'Leary, *The Walking Wheel*

[1] Diane O'Leary, telephone interview with author, April 1998.

[2] O'Leary, quoted in "The Walking Wheel," statement written for author, April 1998.

60 Diane O'Leary, *Moon Walker*

[1] Diane O'Leary, quoted in "Moon Walker," statement written for author, April 1998.

[2] O'Leary, telephone interview with author, April 1998.

61 Jean Bales, *Iowa Woman*

[1] Jean Bales, quoted in article from clipping file of Dr. Patrick D. Lester, Tulsa, Oklahoma.

63 Ruthe Blalock Jones, *Delaware Woman with Ceremonial Doll*

[1] Ruthe Blalock Jones, quoted in Kathy Callahan, "Artist Portrays Indian Lifestyles," *The Tulsa Tribune* (23 December 1976).

64 Ruthe Blalock Jones, *Shawl Dancers*

[1] Ruthe Blalock Jones, letter to author, September 1997.

[2] Jones quoted in Wyckoff, ed., *Visions and Voices*, 58.

67 Joan Brown *Ancestral Prayer*

[1] Joan Brown, statement sent to author, April 1998.

68 Mary Adair (HorseChief), *Selu*

[1] Mary Adair, quoted in *Native American Invitational: Indigenous Women Artists* (Tulsa: The Gilcrease Museum of American History and Art, 1997), 8.

[2] Adair, statement, ca. 1990.

[3] *Native American Invitational,* 8.

69 Jeanne Walker Rorex, *Trail Sisters*

[1] Jeanne Walker Rorex, quoted in Carol Lea Clark, "Jeanne Walker Rorex," *Southwest Art* (January 1989), 67.

[2] Rorex, correspondence with author, May 1997.

[3] Ibid.

70 Joan Hill, *Morning of the Council*

[1] Joan Hill, statement to author, February 1991.

71 Joan Hill, *Evening at the Pueblo*

[1] Joan Hill, telephone conversation with author, March 1998.

[2] Hill, statement to author, February 1998.

[3] Joan Hill, "Indian Art: A Form of Visual Prayer," *The Creative Woman* (1987), 19-20.

72 Jimalee Burton, *Buffalo Dance*

[1] Jimalee Burton, quoted in the catalogue for the second annual exhibition *American Indian Painting* (Tulsa: The Philbrook Art Center, 1947).

[2] Burton, quoted in Wyckoff, ed., *Visions and Voices,* 103.

74 Jimmie Carole Fife Stewart, *Studying the Treaty*

[1] Muriel Wright, *A Guide to the Indian Tribes of Oklahoma* (1951), 133.

[2] Fife Stewart, statement written for author, April 1998.

75 Minisa Crumbo, *The Pueblo Dress*

[1] Ariadna Nikolenku, "Amerindian Artist Exhibits in Moscow," *Soviet Life* (June 1979).

[2] Minisa Crumbo, quoted in Wyckoff, ed., *Visions and Voices*, 111.

[3] Crumbo, permission given by Minisa Crumbo's granddaughter

76 Brenda Kennedy, *Provisions*
 [1] Brenda Kennedy, correspondence with author, June 1997.
 [2] Ibid.
 [3] Ibid.

79 Dolona Roberts, *Beautiful Blankets*
 [1] Dolona Roberts, quoted in Louise Turner, "Dripping with Color," *Southwest Profile* (November/December 1985), 26.
 [2] Dolona Roberts, quoted in Louise Turner, "Dolona Roberts: Passion for Color Inspires Artist's Work," *New Mexico Magazine* (August 1994), 46.
 [3] Dolona Roberts, quoted in Cindy Bellinger, "Paintings Shimmer with Energy," *The New Mexican* (10 August 1986), 18.
 [4] Dolona Roberts, quoted in Marlene Coe Gordon, "Dolona Roberts: Weaving Vibrant Vision," *Southwest Art* (November 1984), 79.
 [5] Roberts, quoted in Louise Turner, "Passion for Color Inspires Artist's Work," 53.
 [6] Roberts, quoted in Norbert Blei, *Dolona Roberts,* Artist's Brochure.
 [7] Roberts, quoted in Marlene Coe Gordon, "Dolona Roberts," 81.
 [8] Ibid., 80.
 [9] Roberts, quoted in Louise Turner, "Dripping with Color," 23.

80 Dyanne Strongbow, *Her Flock*
 [1] Dyanne Strongbow, "Dyanne Strongbow," *Art of the West* (July/August 1990), 68.

82 Valjean McCarty Hessing, *Choctaw Removal*
 [1] Valjean McCarty Hessing, quoted in Sandy Preston, "Valjean McCarty Hessing: Keeping Traditions Alive," *Southwest Art* (January 1987), 52–53.
 [2] Ibid., 33.

83 Valjean McCarty Hessing, *Choctaw Mourning Rites*
 [1] Valjean McCarty Hessing, quoted in Sandy Preston, "Valjean McCarty Hessing: Keeping Traditions Alive," *Southwest Art* (January 1987), 51.

84 Valjean McCarty Hessing, *The Capture of the Crawfish Band*
 [1] Valjean McCarty Hessing, quoted in Sandy Preston, "Valjean McCarty Hessing: Keeping Traditions Alive," *Southwest Art* (January 1987), 51.
 [2] Hessing, written description of old Choctaw legend.

85 Jane McCarty Mauldin, *Prayer*
 [1] Jane McCarty Mauldin, telephone interview with Andrea Rogers-Henry of Philbrook Museum of Art, 6 September 1995.
 [2] Mauldin, quoted in *Paintings by Jane McCarty Mauldin* (Southern Plains Indian Museum and Crafts Center, 1982).

86 Christine Musgrave, *Bear Dance*
 [1] Chris Musgrave, quoted in "1993 Best-of-Show-Winning Chris Musgrave To Do Indian Arts Residency at Art Center," *The Arts in Action* (21 August 1994), 2.
 [2] Ibid., 2.

88 Gina Gray, *The Return of the Clan Seekers*
 [1] Gina Gray, letter to author, September 1997.
 [2] Gray, quoted in Lesli Allison, "Painter's Spirit Lends to Art Adventures," *The Santa Fe New Mexican* (15 August 1991), 85.
 [3] Ibid.
 [4] Gina Gray, statement, ca. 1989.

90 Mary Gay Osceola, *Seminole Mothers and Children*
 [1] General T. S. Jessup, quoted in Alvin A. Josephy, Jr., ed., *The American Heritage Book of Indians* (1961), 228.

91 Agnes Bird, *Chippewa Woman Stripping Birch Bark*
 [1] Dorothy Dunn, quoted in publicity sheet, Shutes/Mellick (1979).

94 Carol Snow, *Night Singer*
 [1] Carol Snow, quoted in "Carol Snow Is New I.A.C.A. Artist of the Year," *The Indian Trader* (December 1993), 20.
 [2] Snow, letter to author, 10 September 1997.
 [3] Ibid.
 [4] Snow, description written for lithograph of *Night Singer.*

95 Lisa A. Fifield, *The Woodlands Loon Woman*
 [1] Lisa A. Fifield, statement for exhibition, *Seasons of the Woodlands People* (American Indian Contemporary Arts, 1998).
 [2] Ibid.

96 Bonita WaWa Calachaw, *Chief Runs Them All*
 [1] Bonita WaWa Calachaw, quoted in Stan Steiner, ed. *Spirit Woman: The Diaries and Paintings of Bonita WaWa Calachaw Nunez* (San Francisco: Harper and Row, 1980), 196–97.
 [2] Calachaw, quoted in Wyckoff, ed., *Visions and Voices,* 283.

98 Karen Noble, *The Flood*
 [1] Karen Noble, quoted in clipping from the artist's personal collection.

100 Peggy Deam, *Metis of Montana*
 [1] Peggy Deam, statement made to the Institute of American Indian Arts, ca. 1969.
 [2] Ibid.

102 Joane Cardinal-Schubert, *Minus Bear Solution*
 [1] Joane Cardinal-Schubert, telephone conversation with author, March 1998.

[2] Cardinal-Schubert, quoted in *Joane Cardinal-Schubert: This Is My History* (Thunder Bay National Exhibition Centre and Center for Indian Art, 1985), 8.

[3] Cardinal-Schubert, quoted in *Native American Invitational: Indigenous Women Artists* (Tulsa: The Gilcrease Museum of American History and Art), 10.

103 Edna Davis Jackson, *Ka-oosh and Coho Salmon*

[1] Edna Davis Jackson, quoted in *Mixed Media and Paper Works by Edna Jackson,* an exhibition pamphlet published by the Southern Plains Indian Museum and Craft Center, (1988), 4.

[2] Ibid.

[3] Ibid.

[4] Ibid.

[5] Ibid.

[6] Ibid.

104 Kenojuak Ashevak, *Woman with Animals*

[1] Kenojuak Ashevak, quoted in Jean Blodget, *Kenojuak* (1985), 20.

[2] Ibid., 44.

108 Victoria Mamnguqsualuk, *Shaman Caribou*

[1] Victoria Mamnguqsualuk, quoted in Bernadette Driscoll, *Inuit Myths, Legends & Songs* (Winnipeg Art Gallery, 1982), 49.

109 Roberta A. Whiteshield, *White Mountain Apache Fire Dancers*

[1] Catalogue accompanying the twenty-fifth annual exhibition *American Indian Artists* (Tulsa: The Philbrook Museum of Art, 1970).

111 Laurie Houseman-Whitehawk *Our Past, Our Future, Our Elders*

[1] Laurie Houseman-Whitehawk, quoted in Martha Kennedy, *Paintings by Laurie Houseman-Whitehawk: Winnebago Woman Artist,* 3. (This catalogue accompanied an exhibition produced by the Center for Great Plains Studies, Great Plains Art Collection, University of Nebraska-Lincoln, 7 November–17 December 1993.)

[2] Houseman-Whitehawk, statement given to author, November 1997.

[3] Houseman-Whitehawk, quoted in Martha Kennedy, *Paintings by Laurie Houseman-Whitehawk,* 11.

[4] Ibid., 12.

[5] Ibid., 23–24.

112 Judy Mike, *Three Women*

[1] Carolyn Niethammer, *Daughters of the Earth* (New York: Macmillan, 1977), 110.

[2] Ibid., 251.

[3] Ibid., 249.

113 Sharron Ahtone Harjo, *We Had Plenty*

[1] General Philip Sheridan, quoted in Patricia Janis Broder, *Great Paintings of the Old American West* (1979), 64.

[2] Harjo, quoted in *Oklahoma Today* (July –August 1985), 19.

114 Connie Red Star, *Crow Parfleche*

[1] Catalogue for the twenty-forth annual *American Indian Artists Exhibition* (Tulsa: The Philbrook Museum of Art, 1968).

115 Nadema Agard, *Homage to Plains Womanhood*

[1] Nadema Agard, statement sent to author, March 1998.

[2] Agard, statement sent to author, 1983.

[3] Agard, quoted in Phoebe Farris-DuFrene, *Voices of Color: Art and Society in the Americas* (1997), 55.

[4] Agard, statement sent to author, February 1998.

116 Charlene Teters, *Turtle Sisters*

[1] Charlene Teters, statement to author, December 1997.

[2] Ibid.

[3] Ibid.

[4] Ibid.

[5] Charlene Teters, "Stop Denigrating Indians with Worn-Out Stereotypes," *Palm Beach Post* (November 1991).

[6] Charlene Teters, letter to author, September 1997.

[7] Charlene Teters, "Stop Denigrating Indians with Worn-Out Stereotypes," *Palm Beach Post* (November 1991).

117 Phyllis Fife, *Buffalo Two Chips*

[1] Phyllis Fife, statement on *Buffalo Two Chips*, 1973.

118 Kay WalkingStick, *Where Are the Generations?*

[1] Kay WalkingStick, statement sent to author, November 1997.

[2] Kay WalkingStick, statement sent to author, 1991.

[3] Kay WalkingStick, statement from the Morris Museum exhibition, *The Paintings of Kay WalkingStick*, 1992.

[4] Kay WalkingStick, quoted in *Women of Sweetgrass, Cedar, and Sage* (New York: Gallery of the American Indian Community House, 1985).

[5] Kay WalkingStick, 1991 statement.

[6] Ibid.

119 Kay WalkingStick, *Ourselves, Our Land*

[1] Kay WalkingStick, quoted in Erin Valentino. "Mistaken Identity: Between Death and Pleasure in the Art of Kay WalkingStick," *Third Text* (American Indian Community House, spring 1994), 61.

[2] Kay WalkingStick, statement sent to author, April 1998.

[3] Kay WalkingStick, statement sent to author, 1997.

[4] Statement for The Morris Museum exhibition, *The Paintings of Kay WalkingStick,* 1992.

120 Jaune Quick-to-See Smith, *Buffalo*

[1] Jaune Quick-to-See Smith, quoted in Susan Howard, "The Sacred Ground," *Newsday* (19 July 1991), 74.

[2] Jaune Quick-to-See Smith, statement sent to author, February 1998.

[3] Jaune Quick-to-See Smith, quoted in Alejandro Andrews, *Jaune Quick-to-See Smith: A Survey* (Retrospective exhibition at the Jersey City Museum, 1996), 113.

[4] Jaune Quick-to-See Smith, statement for Santa Fe Institute of Fine Arts (1991), 1.

SELECTED BIBLIOGRAPHY

Alexander, Hartley Burr. *Pueblo Indian Painting*. Nice, France: C. Szwedzicki, 1932.

———. *Sioux Indian Painting*. Nice, France: C. Szwedzicki, 1938.

The American West: The Modern Vision. Boston: New York Graphic Society, Little, Brown and Company, 1984.

Bernstein, Bruce, and W. Jackson Rushing. *Modern by Tradition: American Indian Painting in the Studio Style*. Santa Fe: Museum of New Mexico Press, 1995.

Blue Eagle, Acee, ed. *Oklahoma Indian Painting—Poetry*. Tulsa, Okla.: Acorn Publishing Company, 1959.

Broder, Patricia Janis. *American Indian Painting and Sculpture*. New York: Abbeville Press, 1981.

———. *The American West: The Modern Vision*. Boston: New York Graphic Society, Little Brown and Company, 1984.

———. *Hopi Painting: The World of the Hopis*. New York: E. P. Dutton, 1978.

Brody, J. J. *Indian Painters and White Patrons*. Albuquerque: University of New Mexico Press, 1971.

———. *Pueblo Indian Painting: Tradition and Modernism in New Mexico 1900–1930*. Santa Fe: School of American Research, 1997.

Dawdy, Doris O., comp. *Annotated Bibliography of American Indian Painting*. Vol. 21, part 2, *Contributions from the Museum of the American Indian*. New York: Heye Foundation, 1968.

Dockstader, Frederick J. *Indian Art in America*. Greenwich, Conn.: New York Graphic Society, 1961.

Douglas, Frederic H., and Rene d'Harnoncourt. *Indian Art of the United States*. New York: Museum of Modern Art, 1941.

Dunn, Dorothy. "A Documented Chronology of Modern American Indian Painting of the Southwest." *Plateau* (Museum of Northern Arizona) 44 (1972).

———. *American Indian Painting of the Southwest and Plains Areas*. Albuquerque: University of New Mexico Press, 1968.

———. "The Studio of Painting, Santa Fe Indian School." *El Palacio* (Museum of New Mexico) 67, no. 1 (1960).

Dutton, Bertha P. *American Indians of the Southwest*. Albuquerque: University of New Mexico Press, 1983.

Ewers, John Canfield. *Plains Indian Painting*. Stanford, Calif.: Stanford University Press, 1939.

Fawcett, David M., and Lee A. Callender. *Native American Painting: Selections from the Museum of the American Indian*. New York: Museum Publication, 1982.

Feder, Norman. *American Indian Art*. New York: Harry N. Abrams, 1971.

Fewkes, Jesse Walter. "Hopi Kachinas, Drawn by Native Artists." *Annual Report* 21 (1903), U.S. Bureau of American Ethnology.

———. "Tusayan Kachinas." *Annual Report* 15 (1897), U.S. Bureau of American Ethnology.

Harvey, Byron, III. *Ritual in Pueblo Art: Hopi Life in Hopi Painting*. New York: Museum of the American Indian, Heye Foundation, 1970.

Highwater, Jamake. *Songs from the Earth: American Indian Painting*. Boston: New York Graphic Society, 1976.

———. *The Sweet Grass Lives On*. New York: Harper and Row, 1980.

Jacobson, Oscar B. *Indian Artists from Oklahoma*. Norman, Okla.: University of Oklahoma Press, 1964.

———. *Kiowa Indian Art*. Nice, France: C. Szwedzicki, 1929.

Jacobson, Oscar B., and Jeanne D'Ucel. *American Indian Painters*. Nice, France: C. Szwedzicki, 1950.

Mallery, Garrick. "Pictographs of the North American Indians." *Annual Report* 4 (1886), U.S. Bureau of American Ethnology.

The Masters Artists of the Five Civilized Tribes. Muskogee, Okla.: The Five Civilized Tribes Museum, 1976.

Monthan, Guy, and Doris Monthan. *Art and Indian Individualists*. Flagstaff, Ariz.: Northland Press, 1975.

New, Lloyd Kiva. *Future Directions in Native American Art*. Santa Fe: Institute of American Indian Arts, 1972.

Niethammer, Carolyn. *Daughters of the Earth: The Lives and Legends of American Indian Women*. New York: Macmillan, 1977.

"Oklahoma Indian Art." *Gilcrease Journal* 3, no. 2 (Fall 1995).

Petersen, Karen Daniels. *Plains Indian Art from Fort Marion*. Norman, Okla.: University of Oklahoma Press, 1971.

Roessel, Ruth. *Women in Navajo Society*. Rough Rock, Ariz.: Navajo Resource Center, 1981.

Seymour, Tryntje Van Ness. *When the Rainbow Touches Down*. Phoenix: The Heard Museum, 1988.

Sloan, John, and Oliver Lafarge. *Introduction to American Indian Art*. 2 vols. New York: The Exposition of Indian Tribal Arts, 1931.

Snodgrass, Jeanne O., comp. *American Indian Painters: A Biographical Directory*. New York: Museum of the American Indian, Heye Foundation, 1968.

Tanner, Clara Lee. *Southwest Indian Painting: A Changing Art*. Tucson: University of Arizona Press, 1957.

Underhill, Ruth. *Life in the Pueblos*. Santa Fe: Ancient City Press, 1991.

Wade, Edwin L., and Rennard Strickland. *Magic Images: Contemporary Native American Art*. Norman, Okla.: University of Oklahoma Press; Tulsa: The Philbrook Museum, 1981.

Warner, John Anson. "Contemporary Native American Art: Traditionalism and Modernism." *The Journal of Intercultural Studies* (Japan: Kanasi University of Foreign Studies Publication) 24 (1997).

———. *The Life and Art of the North American Indian*. Feltham, Middlesex, England: Astronaut House, 1974.

Wright, Muriel H. *A Guide to Indian Tribes of Oklahoma*. Norman, Okla.: University of Oklahoma Press, 1951.
Wyckoff, Lydia L., ed. *Visions and Voices: Native American Painting from the Philbrook Museum of Art*. Tulsa, Okla.: The Philbrook Museum, 1996.

BOOKS ON INDIVIDUAL ARTISTS

Burton, Jimalee (Ho-chee-nee), *Indian Heritage, Indian Pride: Stories That Touched My Life*. Norman, Okla.: University of Oklahoma Press, 1974.

Gray, Samuel L., *Tonita Peña*. Albuquerque: Avanyu Publishing Company, 1990.

Nelson, Mary Carol. *Pablita Velarde: The Story of an American Indian*. Indianapolis: Dillon Press, 1971.

Scott, Jay. *Changing Woman: The Life and Art of Helen Hardin*. Flagstaff: Northland Publishing, 1989.

Shutes, Jeanne, and Jill Mellick. *The Worlds of P'otsunu: Geronima Cruz Montoya of San Juan Pueblo*. Albuquerque: University of New Mexico Press, 1996.

Steiner, Stan, ed. *Spirit Woman: The Diaries and Paintings of Bonita WaWa Calachaw Nunez, An American Indian*. San Francisco: Harper and Row, 1980.

Velarde, Pablita. *Old Father Storyteller*. Santa Fe: Clearlight Publishers, 1960.

EXTENSIVE BIBLIOGRAPHIES ON THE NATIVE AMERICAN WOMAN

Allen, Paula Gunn. *The Sacred Hoop, Recovering the Feminine in American Indian Tradition*. Boston: Beacon Press, 1986. (Contains a "Selected Bibliography" that includes biographies and autobiographies, histories, novels, poetry, anthologies, and critical studies of the American Indian woman.)

Bataille, Gretchen M., and Kathleen Mullen Sands. *American Indian Women, Telling Their Lives*. Lincoln: University of Nebraska Press, 1984. (Contains an annotated bibliography of American Indian women's biographies and autobiographies.)

Green, Rayna. *Native American Women. A Contextual Bibliography*. Bloomington: Indiana University Press, 1983. (An annotated list of approximately 700 entries, including books, articles, films, recordings, government reports, and dissertations about the Native American woman.)

EXHIBITION CATALOGUES

American Indian Painting. Tulsa, Okla.: Annual Exhibition and Competition, The Philbrook Museum, 1946–1980.

Contemporary American Indian Painting. Washington, D.C.: National Gallery of Art, Smithsonian Institution, 1953.

Contemporary Indian Artists: Montana/Wyoming/Idaho. Browning, Montana: Museum Center, Indian Arts and Crafts Board, U.S. Department of the Interior, 1970.

Contemporary Sioux Painting. Rapid City, South Dak.: Sioux Indian Museum and Crafts Center, Indian Arts and Crafts Board, U.S. Department of the Interior, 1970.

Contemporary Southern Plains Indian Painting. Andarko, Okla.: Southern Plains Indian Museum, Indian Arts and Crafts Board, U.S. Department of the Interior, 1972.

Shared Visions: The James T. Bilack Collection of Native-American Art. Phoenix: The Heard Museum, 1957.

Annual Invitational Exhibitions of American Indian Painting. Washington, D.C.: U.S. Department of the Interior Art Gallery, 1965–1969.

The Institute of American Indian Arts Alumni Exhibition. Santa Fe: The Institute of American Indian Arts, December 1973–September 1974.

As the Seasons Turn. Newark, N.J.: The Newark Museum, May–December 1977.

The Great Canyon Artists. Grand Fork, N. Dak.: University of North Dakota Art Galleries, December 1977.

100 Years of Native American Painting. Oklahoma City: The Oklahoma Museum of Art, March–April 1978.

The Unconquered Spirit: American Indian Painting and Objects. Greenvale, N.Y.: C. W. Post Art Gallery, Long Island University, February–March 1978.

Magic Images: Contemporary Native American Art. Tulsa, Okla.: The Philbrook Museum, 1981.

Inuit Myths, Legends and Songs. Winnipeg, Canada: The Winnipeg Art Gallery, March–May 1982.

Uumajut: Animal Imagery in Inuit Art. Winnipeg, Canada: The Winnipeg Art Gallery, March–May 1985.

Women of Sweetgrass, Cedar, and Sage. New York: Gallery of the American Indian Community House, June 1985.

National American Indian Women's Art Show. Washington, D.C.: Viva Gambaro Studio Gallery, August–September 1980.

Our Land, Ourselves: American Contemporary Artists. Albany, N.Y.: University Art Gallery, State University of New York, 1991.

The Art Studio of Dorothy Dunn, 1932–1938. Santa Fe: Museum of Indian Arts and Culture/The Laboratory of Anthropology, Museum of New Mexico, July–September 1992.

A Bridge Across Cultures: Pueblo Painters in Santa Fe, 1910–1932. Santa Fe: Wheelwright Museum of the American Indian, May–September 1992.

Arctic Imagery: Contemporary Inuit Drawings. Montclair, N.J.: The Montclair Museum, November 1992–February 1993.

Watchful Eyes: Native American Women Artists. Phoenix: The Heard Museum, November 1994.

With a View to the Southwest: Dorothy Dunn and the Story of American Indian Painting. Santa Fe: The Museum of American Indian Arts and Culture/Laboratory of Anthropology, Museum of New Mexico, March–August 1996.

Native American Invitational: Indigenous Women Artists. Tulsa, Okla.: The Gilcrease Museum of American History and Art, August–November 1997.

ACKNOWLEDGMENTS

I wish to thank the many individuals and institutions without whose help and cooperation my work would not have been possible:

Jeanne Snodgrass King, of Tulsa, Oklahoma, and Ginger Kingman, also of Tulsa, for making available their extensive research files on Native American artists and providing exceptional assistance and cooperation with my work.

Gillett Griffin, Princeton, New Jersey; Joan Hill, Muskogee, Oklahoma; Mike Kabotie, Flagstaff, Arizona; John Freeman Norton, Santa Fe, New Mexico; Joanie Parks, Berkeley Heights, New Jersey; Tony Reyna, Taos Pueblo, Taos, New Mexico; and Dr. E. R. Smoke, Peapack, New Jersey, for their interest, enthusiasm, and important contributions to this book.

The many artists who cooperated with my research and furnished explanations of their art, as well as biographical and statistical information, and photographs of their work: Mary Adair, Nadema Agard, Margarete Bagshaw-Tindel, Jean Bales, Beverly Blacksheep, Joan Brown, Joane Cardinal-Schubert, Minisa Crumbo, Edna Davis Jackson, Phyllis Fife, Jimmie Carole Fife Stewart, Gina Gray, Helen Hardin, Sharron Ahtone Harjo, Valjean McCarty Hessing, Joan Hill, Norma Howard, Connie Jenkins, Ruthe Blalock Jones, Jeanette Katoney, Brenda Kennedy, Linda Lomahaftewa, Judith Lowrey, Merina Lujan (Pop Chalee), Mary Morez, Geronima Montoya, Christine Musgrave, Karen Noble, Jeneele Numkena, Diane O'Leary, Jeanne Walker Rorex, Laura G. Shurley-Olivas, Jaune Quick-to-See Smith, Carol Snow, Dyanne Strongbow, Charlene Teters, Dana Tiger, Pablita Velarde, Kay WalkingStick, Emmi Whitehorse.

The directors and staffs of museums, libraries, art associations, and universities throughout the United States for biographical, historical, and statistical information and for photographs from their collections: Allan J. McIntyre, Collections Manager, Amerind Foundation, Dragoon, Arizona; Lynn Thornley, Director, The Five Civilized Tribes Museum, Muskogee, Oklahoma; Martha Kennedy, Curator, Great Plains Art Collection, Center for Great Plains Studies, University of Nebraska—Lincoln; Jay Brooks Joyner, Director, Anne Morand, Museum Collections Manager, Kevin Warren Smith, Program Development Coordinator, Sandra Hilderbrand, Museum Events Coordinator, and Kristie Moore, former Registrar, The Thomas Gilcrease Institute of American History and Art, Tulsa; Dr. Martin Sullivan, Director, James T. Reynolds, Archivist Associate, Margaret Archuleta, Curator of Fine Art, Mario Klimiades, Librarian Archivist, Gina Cavallo, Associate Registrar, and Richard Pearce Moses, Documentary Collections Archivist, The Heard Museum, Phoenix; Leigh Jenkins, Director, Hopi Cultural Preservation Office, The Hopi Tribe, Kykotsmovi, Arizona; Jeanne L'Esperence, Research and Documentation Coordinator, Department of Indian and Northern Affairs, Canada; Fred Nahwooksy, Director, Eunice Kahn, Registrar, Diane Bird, Archivist, B. Lynne Harlan, Curator of Exhibits, and Chuck Daly, Professor Museum Studies, The Institute of American Indian Arts, Santa Fe; Bruce Bernstein, former Director and Chief Coordinator, Louise I. Stiver, Curator of Collections, Diane Bird, Archivist, and Paula Rivera, former Assistant Curator of Collections, Museum of Indian Arts and Culture/Laboratory of Anthropology, Santa Fe; Clarinda Begay, Director, Navajo National Museum, Window Rock, Arizona; W. Richard West, Director, Richard Hill, former Special Assistant to the Director, Cathleen E. Ash-Milby, Assistant Curator, Allison Jeffrey, Acting Archivist, Lee Callander, former Registrar, and Mary T. Nooney, former Registrar's Assistant, National Museum of the American Indian, Smithsonian Institution, New York; Joe Trugott, Curator, Phyllis Cohn, Librarian, and Sandra D'Amelio, former Curator of Painting, Museum of Fine Arts, Museum of New Mexico, Santa Fe; Anne Spencer, Curator of the Arts of Africa, the Pacific, and the Americas, Newark Museum, Newark; Michael J. Fox, President and Chief Executive Officer, Ed Wade, Senior Vice President for Curitorial Research in Fine Arts and Ethnology, Deb Hill, Collections

Manager, Tony Marinella, Photo Archivist, and Trudy Thomas, former Curator of Fine Arts, Museum of Northern Arizona, Flagstaff; Marcia Manhart, Director, Lydia Wycoff, Curator of Native American Art, David Gabel, Registrar, Tom Young, Librarian and Registrar, the Philbrook Museum of Art and American History, Tulsa; Rosemary Ellison, Curator, Southern Plains Indian Museum and Crafts Center, Anadarko, Oklahoma; Jonathan Batkin, Director, Janet Hevey, Collections Manager, and Steven Rogers, former Curator, The Wheelwright Museum of the American Indian, Santa Fe; Janeen Antoine, Executive Director, American Indian Contemporary Arts, San Francisco; Dr. Patrick D. Lester, Editor, *The Biographical Dictionary of Native American Painters*.

The collectors of American paintings for providing statistical data and photographs from their collections: James T. Bialac, Scottsdale; Richard C. Cline, Sr., R. C. Cline Land Company, Amarillo, Texas; Howard and Sue Huston, Fort Worth, Texas; Dr. Patrick Lester, Tulsa; QV Distributors, Inc., Phoenix (Albion and Lynne Fenderson); Tom and Robin Or, New York; Richard Uri, Friday Harbor, San Juan Islands; Letta Wofford, Santa Fe.

The directors and staffs of art galleries specializing in American art for providing biographical and statistical information and photographs of the works in their archives and galleries: Linda Greever, The Art Market, Tulsa; Mark Bahti, Bahti Indian Arts, Tuscon; Corin Cain, Corin Cain, Phoenix; Ray Dewey, Dewey Galleries, Santa Fe; Phillip Faust, Faust Gallery, Scottsdale; Arlene N. LewAllen, LewAllen Galleries, Santa Fe; Karen E. Giles, The Center of Native Arts, Woolrich, Maine; Doris Littrell, Director, Oklahoma Indian Art Gallery, Oklahoma City; Cheryl Ingram, Silver Sun Gallery, Santa Fe; Bernice Steinbaum, Director, and Joanne Isaacs, Steinbaum Kraus Gallery, New York; Derek Simpkins, Gallery of Tribal Art, Ontario, Canada.